2011

For a lovely friend,

<u>DEE TUCKER</u>

On the occasion of her retirement.

I wish you "SHADI",
which in Farsi means happiness.

Love Richard x.

EPIC of the
PERSIAN
KINGS

Barbara Brend and Charles Melville

EPIC of the PERSIAN KINGS

The Art of Ferdowsi's *Shahnameh*

The
Fitzwilliam
Museum
CAMBRIDGE

I.B. TAURIS

LONDON · NEW YORK

The Fitzwilliam Museum

CAMBRIDGE

Published in conjunction with the exhibition 'Epic of the Persian Kings: the Art of Ferdowsi's *Shahnameh*', held at the Fitzwilliam Museum, Cambridge, 11 September 2010 to 9 January 2011, in celebration of the millennium of the completion of Ferdowsi's work

Published in 2010 by I.B.Tauris & Co Ltd
6 Salem Road, London W2 4BU
175 Fifth Avenue, New York NY 10010
www.ibtauris.com

Distributed in the United States and Canada
Exclusively by Palgrave Macmillan
175 Fifth Avenue, New York NY 10010

ISBN: 978 1 84885 332 4 (HB)
 978 1 84885 656 1 (PB)

A full CIP record for this book is available from the British Library
A full CIP record is available from the Library of Congress

Library of Congress Catalog Card Number: available

Design and typeset in Garamond by E&P Design, Bath
Printed and bound in Great Britain by Butler, Tanner & Dennis

Presented with the support of:

IRAN
HERITAGE

CONTENTS

FOREWORD

I shall not die, these seeds I've sown will save
My name and reputation from the grave,
And men of sense and wisdom will proclaim
When I have gone, my praises and my fame.
Ferdowsi, *c*.1010[1]

Ferdowsi's *Shahnameh*, or 'Book of Kings', which ends with the
lines quoted above, has for the past thousand years been the
wellspring of Persian culture: the pre-eminent compendium of
legend and knowledge about Iran's epic past; the 'handbook' to
good kingship and heroic valour; and above all the encapsulation,
in both content and language, of what it is to be authentically
Persian. It is also about what Persia is not. Ferdowsi lived nearly
four centuries after the coming of Islam yet he limits his chronicle
to the pre-Islamic past and purges his language of Arabic and other
extraneous influences, seeing the Arab conquest as a disaster for the
culture of his homeland. His poem was to be a paean to a Persian
past that struggled to maintain itself against Arab, Turkish and
other peoples and ways of life. In the event it became much more
than that – the inspiration for a florescence of Persian culture as
grand as any in earlier times. A millennium after Ferdowsi we
are indeed still praising him and the 'seeds' he sowed.

The *Shahnameh* is a truly epic poem, both in content and length
– at over fifty thousand couplets perhaps the longest narrative
poem in any culture. Railing against the culture and mores of his
day, it is not surprising that Ferdowsi's work was not immediately
embraced by his contemporaries. But his towering achievement
could not long be ignored, and by the thirteenth century the
Shahnameh was well on the way to being regarded as the classic
expression of New Persian poetry. Its influence soon spread
beyond the world of letters. To an extent unparalleled elsewhere
in Asia or Europe, the culture of Persia that follows the *Shahnameh*
is unmistakably conditioned by the stories it relates and by the
language and style of their telling. Other cultures have their
literary icons – Homer for the ancient Greeks, Shakespeare for
the English, Dante for the Italians – but none of these exercised
quite the defining influence on so many levels of culture and
identity up to the present day as the *Shahnameh* did for the Persians.

The millennium of Ferdowsi's masterpiece is naturally an occasion
for much celebration by Iranian communities and scholars around
the world. It is in this context that the Fitzwilliam Museum has
undertaken to assemble a selection of the most important painted
illustrations that came to be added as visual accompaniments to

the texts of luxury manuscripts from around 1300 on. Works of great beauty, complexity and sophistication, these miniature paintings represent one of the highest and most distinctive achievements of Persian culture. Lavishly illustrated *Shahnameh*s were produced by courts of Persian, Arab, Turkic, Mongol, Kurdish, Indian and other origins who, despite – or in many cases because of – their varied ethnicities, sought to embrace this quintessentially Persian work as a way of demonstrating their nationalist bona fides and thus their right to rule. The enthusiasm for these miniature masterpieces soon extended beyond Iran and the Arab world to include also European princes and connoisseurs, further fuelling the artistic interchange between the worlds of Islam and Christendom.

The exhibition *Epic of the Persian Kings* was the brainchild of Charles Melville, Professor of Persian History and Fellow of Pembroke College, Cambridge, who is also co-founder of the Shahnama Project and website, which aims to produce a corpus of the illustrations in preserved *Shahnameh*s from around the world. Professor Melville brought the exhibition proposal to Dr Stella Panayotova, Keeper of Manuscripts and Printed Books at the Fitzwilliam, who had little trouble persuading others of us in the museum of the appropriateness of celebrating Ferdowsi's millennium in the university that has done so much to further understanding of his achievement. Professor Melville has applied himself to the exhibition with unrelenting energy and enthusiasm, both in his scholarship and in securing support from the British and international Iranian communities. Dr Panayotova has been responsible for coordinating the design and layout of the exhibition and for its didactic content based on this publication, tasks she has carried out with her characteristic care and efficiency.

Professor Melville co-opted the independent scholar Barbara Brend to curate the exhibition. A noted specialist in the study of Persian miniatures, Dr Brend has been responsible for selecting the works on display and for writing here on their art historical importance. There can be no doubt that the publication she and Professor Melville have edited will make a major contribution to scholarship. To these individuals, to the other contributors to the catalogue and to the many members of the Fitzwilliam's staff who have contributed to the project in myriad ways, we owe a great debt of gratitude.

Britain is fortunate to have in its museums and private collections many of the finest surviving *Shahnameh* manuscripts. We are grateful that so many of these owners have allowed their works to join those housed in Cambridge, making possible an exhibition far grander and more important than would usually be possible, one that does full justice to Ferdowsi's legacy. The greatest repositories of manuscripts have been correspondingly generous: the British Library, British Museum, Bodleian Library, Royal Collection and Royal Asiatic Society; and the Nasser D. Khalili and Keir Collections. To these and all the other lenders we are deeply grateful.

An exhibition as ambitious as *Epic of the Persian Kings* would not have been possible without the generous support of the Iran Heritage Foundation, whose sponsorship of this project is just the latest in a long list of educational initiatives designed to deepen the awareness and appreciation of Persia's cultural heritage they have enabled. I would be remiss not to mention the Chairman of the Foundation Vahid Alaghband, and their past and present executive directors, Farhad Hakimzadeh and Dr Ladan Akbarnia, all of whom have contributed greatly to the fundraising efforts for this exhibition. The other sponsors, no less enthusiastic in their involvement, are the Bahari Foundation, the Parsa Foundation, the ILEX Foundation, Denis and Minouche Severis, Monica and Ali Wambold, the Princess Guity Qajar Fund, the Islamic Manuscript Association and an anonymous donor, to all of whom we extend our sincere and heartfelt thanks.

Timothy Potts
Director, The Fitzwilliam Museum, Cambridge

PREFACE

I believe this to be the first major exhibition in Britain devoted exclusively to the art inspired by the *Shahnameh*: essentially, that art is the Persian miniature painting that adorns the manuscripts of this great epic poem, the 'Books of Kings', together with some examples in other media. The exhibition is the result of the happy coincidence of a number of events and individuals coming together. Happy in the sense of auspicious: Ferdowsi's term for it might have been *bakht-e rowshan* ('shining fortune').

First among the individuals of course is the poet himself, Abu'l-Qasem Ferdowsi of Tus, who was born on 3 January 940, died probably in 1025, and dedicated his long life to versifying the legends and history of ancient Persia. He completed his work on 8 March 1010, one thousand years ago. The exhibition is dedicated to his achievement, which still resounds throughout the Persian-speaking community, now dispersed – like the manuscripts of his poem – around the world.

Britain has played a prominent role in the collection of these manuscripts, thanks to her long interests in Iran and the Persian Gulf, and especially in India; this has been reflected, quite properly, in a prominent role also in the study of the region, its history, languages and culture. Cambridge has traditionally been one of the main centres for the study of Persian, but so far as the *Shahnameh* is concerned, not always wholeheartedly. The great E.G. Browne (d. 1926), appointed Cambridge's first University Lecturer in Persian in 1888, was not sympathetic to the work, and famously wrote that he felt 'great diffidence in confessing that I have never been able entirely to share this enthusiasm ... The *shahnama* has certain positive and definite defects ... and the nakedness of its underlying ideas stands revealed.' Given the esteem in which Browne's influential survey, *A Literary History of Persia*, was held, his opinion carried weight and no doubt deterred others from engaging with the work; but later, Reuben Levy, Professor of Persian, offered a heavily abridged prose translation that was published in 1967 under the title *Shahnameh. The Epic of the Kings*, with a considerably more favourable verdict: 'Ferdowsi proves himself a consummate master. The full range of poetic arts is brought into play so that no two sunrises are described in the same terms and the same manner and no two laments are identical.' This was the first modern English version, followed by several others since, most notably the recent publication by Dick Davis, a British scholar and poet now based at Ohio State University; his translation, in mixed prose and verse, also omits a number of episodes. The only complete English translation is still the verse rendering by A.G. and E. Warner, published in 1908–25 and recently twice reissued, making it still accessible (at a price!). In the catalogue that follows, the reader is

referred to this translation, though it should be noted that the text translated by the Warners is often far from the best critical editions established in the last hundred years. Yet this does not necessarily mean that it is not close to the text of some of the manuscripts on display in the exhibition.[1]

In the last ten years, Cambridge has been home to the 'Shahnama Project', an ambitious research programme funded by the Arts & Humanities Research Board (now Council) with two generous grants (1999–2004; 2006–2009), the first phase of which was carried out in partnership with Professor Robert Hillenbrand at the University of Edinburgh. The Shahnama Project has built an online corpus of illustrated manuscripts of the *Shahnameh* and of the paintings and illuminations they contain, as preserved in numerous museums, libraries and private collections all over the world. The recording of these manuscripts is still in progress, but already some 18,000 paintings have been listed and over 12,000 pictures can be freely viewed and studied online.[2] The project has organised several conferences and published collections of academic papers.[3] Although funding has currently ceased, the present exhibition has been conceived as a continuation of the work, with the aim of bringing Ferdowsi's masterpiece to a wider public, and as a landmark in our programme, which we hope to develop in exciting new directions in the future.

The exhibition comes at an appropriate moment, not only to celebrate the millennium of the completion of the poem, but at a time when a better knowledge of Iran's culture and contribution to world civilization is much needed. Fear is based largely on ignorance, fear of the unknown. Ignorance about Iran is currently deep and widespread, and we hope this exhibition will help to throw some light on an old and sophisticated tradition of art and literature that is still vibrant today and is crucial to the Iranians' own view of themselves.

Given the long gestation of the idea to hold an exhibition of the art of the *Shahnameh*, but also the ending of the financial support for the Shahnama Project in April last year, some more happy combinations were needed. The first was the willingness of the Fitzwilliam Museum to find a place for the exhibition in the *Shahnameh*'s millennium year in its busy schedule, and in this, the enthusiasm, support and energy of Stella Panayotova, Keeper of Manuscripts and Printed Books, has been crucial. Not only did she generously agree to postpone an exhibition of her own planned for 2010, but her experience, professionalism and readiness to embrace an unfamiliar subject have been a source of constant reassurance and conviction in realising our hopes. I would also like to thank the Museum's Director, Dr Timothy Potts, newly arrived in Cambridge, who had the idea thrust upon him and approved it with good grace and firm commitment.

The second need was for someone to be curator of the exhibition, a task requiring an authoritative knowledge of the arts of the

book and Persian miniature painting far exceeding my own, and, as importantly, the time to devote to such a major undertaking. Without Barbara Brend's willingness to accept this challenge, put to her in December 2007, this exhibition, quite simply, would never have taken place. Her idiosyncratic sense of humour has enlivened the inevitably protracted email correspondences concerning the preparations for the exhibition over the last two years.

Finally, of course, the one key element missing from the mixture – if not from the manuscripts themselves – was riches. The commitment of the Iran Heritage Foundation to supporting the exhibition (and the conference planned for December 2010) and to providing such generous sponsorship as to guarantee that planning could go ahead, was vital. This support was agreed first with Farhad Hakimzadeh and concluded with Ladan Akbarnia, when she replaced him as executive director of the IHF. My heartfelt thanks go to both of them and, of course, to all the members of the IHF Board and their legion of supporters. Although it is unfair to single out anyone, I am particularly grateful to Vahid Alaghband, chairman of the Board, whose kind friendship I have enjoyed for many years. Vahid has been steadfast in his commitment to the project, despite the severe financial crisis that has threatened all such philanthropic activities in the past year and which has necessarily meant some curtailing of the more ambitious aspirations for the exhibition and its associated programme of activities. Into this breach many other sponsors have stepped forward with valuable contributions, fully acknowledged as appropriate in this volume and elsewhere. I am also deeply grateful for the support and interest shown over many years by Ali Sarikhani. The splendid result is the achievement of all their combined enthusiasm and generosity.

It remains to mention the hard work and commitment given to the Shahnama Project in the last year, and the help in the run up to the exhibition, especially from Firuza Abdullaeva, and also Carol Burrows, Marcus Fraser, Zahra Hassan-Agha, Mandana Naini, Dan Sheppard, Ursula Sims-Williams, Sotheby's, Daniela Wambold and Roxana Zand.

Charles Melville

It was a great pleasure to be asked to work on this exhibition and I should first of all like to pay tribute to Charles Melville for pioneering the idea and for continuing to foster it with his own contributions and advice. The public and private collections in the United Kingdom offer an abundant treasury of material, in the form of manuscripts, folios and objects, from which to select, and it has been a fascinating task to weigh choice against choice – the website of the Shahnama Project being of course of considerable use in this. For historical reasons the collections in this country are particularly rich,

and so it is fitting that when many nations are celebrating the millennium of the *Shahnameh*, treasures preserved here should be on display.

We have been able to include specimens of three manuscripts that are exceedingly famous, salient peaks in the development of Persian painting. In historical order these are: the *Jamiʿ al-Tawarikh* (which includes matter from the *Shahnameh*), the Great Mongol *Shahnameh*, and the *Shahnameh* of Shah Tahmasp. A more substantial portion is shown of two manuscripts of the highest quality that are particularly interesting when seen together. The beautiful volumes made for two princely brothers, Ebrahim Soltan and Mohammad Juki, grandsons of Timur (or Tamerlane), are the classic representatives of the painting of Shiraz and of Herat of their period, and both have been the subject of recent detailed studies. Other hardly less celebrated manuscripts, such as the 'Small' and the 'Big Head' *Shahnamehs,* are also represented. Though work produced in Iran has been the main concern, a section is devoted to paintings from India in their extraordinary variety.

Some manuscripts come with a colophon that provides date and place of origin, patron and scribe, but often such information is not present so that defining statements must rest at the level of hypothesis – and the play of differing opinions has an interest of its own. Some folios bear the names of artists such as Siyavosh (the Georgian), or Moʿin Mosavver, but this also is rare. The folios and manuscripts shown have – evidently – survived their first patrons. The topic of their subsequent history, of who owned them, and who presented them to various institutions, is here for the most part touched on simply by the mention of names, though it could form a study in itself. A remarkable example of a fine manuscript of known patronage and history, recently treated in a monograph, is the *Shahnameh* in the Royal Collection, made in Iran in 1648, and presented by an Afghan ruler to Queen Victoria.

The intention of this catalogue has been to promote as full an understanding as possible of the arts of the book represented. The point of departure has necessarily been Ferdowsi's narrative. The majority of entries begin with an account of what is taking place; this seeks to go beyond the bald information that such a personage is slaying such another, and to explain who they are and what events have led to their present situation. Inevitably, the subtleties of Ferdowsi's work are passed over too quickly, but it is hoped that non-readers of Persian may be sufficiently interested to explore further in the volumes of Warner and Warner or other translations.

The illustrations are then examined according to what appear to be their most interesting features. The exhibits have been arranged for the most part chronologically, with a view to conveying an impression of successive periods of history with their own particular vision and manners. Thus folios that have been dispersed from their parent manuscripts into several collections are reunited. An exception to this rule are folios from a manuscript of the Fitzwilliam Museum's

own collection, which are used in the introductory section, separated from their peers, since they are particularly suited to the exposition of several points. The calligraphy of the folios, in four or six columns that rhyme two by two on their left-hand sides, is often of great beauty in its rhythms. This has not been discussed in detail since it is best done with a technical vocabulary, but it will surely speak for itself. The examples of decorative illumination, with lapis lazuli and gold, and exquisite flowers and abstract forms, are more easily described. The bindings of manuscripts are very vulnerable to loss, but are sometimes retained or renovated or replaced in interesting ways at later periods, and may show sumptuous leather finely stamped and gilded.

Of course we have been entirely dependent on the generosity of lenders, both private and public. We thank the Royal Collection for the loan of two important volumes, and the Hon. Lady Roberts and Emma Stuart for their assistance. We thank the Keir Collection, and Edmund de Unger and Richard de Unger; and we thank Nasser D. Khalili for loans from his collection, together with Michael Rogers and Nahla Nassar for their assistance. In thanking public institutions, I should like to express my particular gratitude to the Fitzwilliam Museum for accepting the exhibition, and I cannot forbear to add further thanks to Stella Panayotova for her generous guidance and enthusiasm; thanks are also due to David Scrase. We thank the Bodleian Library, and B.C. Barker-Benfield, Lesley Forbes (former Keeper), and Gillian Evison; the British Library, and Muhammad Isa Waley, Jennifer Howes, and Malini Roy; the British Museum, and Sheila Canby (former Keeper) and Venetia Porter; the Cambridge University Library, and Brian Jenkins; Corpus Christi College, and Christopher de Hammel; the Edinburgh University Library, and Andrew Grout; the Royal Asiatic Society, and curator Alison Ohta; the John Rylands University Library, and Carol Burrows; the Victoria and Albert Museum, and Tim Stanley and Moya Carey; the Wellcome Institute, and Nikolai Serikoff; and Fereydoun Ave. Help of various sorts is also acknowledged from Manijeh Bayani, Marcus Fraser, Robert Hillenbrand, Janet Rady and Gabrielle van den Berg. Finally, our thanks are due to the staff of I.B. Tauris, and to Elizabeth Stone as project manager and Ian Parfitt as designer.

Barbara Brend

NOTE ON CONTRIBUTORS

FIRUZA ABDULLAEVA is Lecturer in Persian Literature at the University of Oxford, Fellow and Keeper of the Firdousi Library, Wadham College. Her main research interests are Classical Persian literature and Medieval Persian book art. Her recent publications include: *The Persian Book of Kings: Ibrahim Sultan's Shahnama* (2008, with Charles Melville), 'The Bodleian manuscript of Asadi Tusi's Munazara between an Arab and a Persian' (*Iran*, 2009), 'Kingly flight: Nimrud, Kay Kavus, Alexander' (*Persica*, 2010).

BARBARA BREND is an independent scholar. Her principal research is into form and meaning in Persian and Mughal manuscript illustration. An early interest in Medieval French narratives has been a point of departure for the study of their Persian equivalents. Her publications include: *Islamic Art* (1991); *The Emperor Akbar's Khamsa of Niẓāmī* (1995); *Perspectives on Persian Painting: illustrations to Amir Khusrau's Khamsah* (2003); and *Muhammad Juki's Shahnamah of Firdausi* (2010).

DICK DAVIS is Professor of Persian and Chair of the Department of Near Eastern Languages and Cultures at Ohio State University. He has published scholarly works, volumes of poetry, and is considered to be the best living translator of Persian poetry. His translation of the *Shahnameh* appeared in 2006.

CHARLES MELVILLE is Professor of Persian History at the University of Cambridge and Fellow of Pembroke College and since 1999 Director of the Shahnama Project. His research interests include the history and culture of Iran in the Mongol to Safavid periods and the illustration of Persian manuscripts. His recent publications include edited volumes of *Safavid Persia* (1996), *Shahnama Studies* (2006), and 'Millennium of the *Shahnama* of Firdausi' (*Iranian Studies*, 2010, with Firuza Abdullaeva).

NOTE TO
THE READER

TRANSLITERATION

There are a number of ways in which the Arabic script used for Persian, an Indo-European language, may be transliterated, and hence we may see *Shahnameh*, *Shahnamah*, *Shahnama*, and Ferdowsi or Firdausi. Since the occasion of this exhibition is essentially Persian, the system of transliteration used here is that frequently chosen to represent modern metropolitan Persian speech. As with any such system, the choice entails certain problems. Some words may appear in an unfamiliar mode, 'Esfahan' for 'Isfahan'. Some words are not to be pronounced as at first might seem likely, 'Key' should rhyme with 'say' rather than 'see'. And at a more technical level, 'o' doing duty for a short vowel, is not also available for a long *majhul* one. Where it has seemed that a rigid rule would hinder easy comprehension a number of exceptions have been made. Thus the *Jami' al-Tawarikh*, which is Arabic in title and in text (in the manuscript shown here), has been referred to in its usual transliteration; and similarly 'Timur' and 'Timurid' have been considered sufficiently familiar not to be changed. For the Indian area also, the conventional spelling of place names has been retained, without Persian emphasis or modernisation.

MUSLIM DATES

The Muslim calendar is dated from the Hijrah, the emigration of the early Muslim community from Mecca to Medina, in the AD year 622. The *hijri* year is based on the lunar cycle and hence is some eleven days shorter than the solar year of the AD (*miladi*) calendar. This means that the equivalence of dates in one system to those in the other is not a matter of the simple addition or subtraction of 622, but requires the use of tables, a complex calculation, or a well provided computer. This catalogue follows the convention of placing the *hijri* year first. Unless the month of a given occurrence is known, or sometimes even its day, it is not possible to know in which of two succeeding years of the other system it falls, and hence a double-year solution is offered. The dates of both calendars are here given when colophons allow for precision but not for estimated dates or other events.

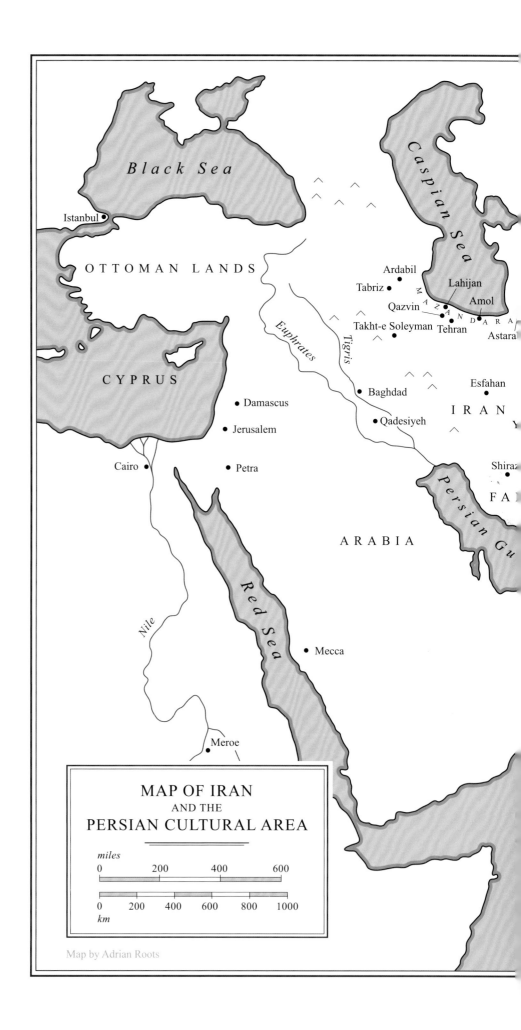

Black Sea

Istanbul •

OTTOMAN LANDS

Caspian Sea

Ardabil •
Tabriz • Lahijan •
Qazvin • Amol •
Takht-e Soleyman • Tehran •
M A Z A N D A R A
Astara •

Euphrates

Tigris

CYPRUS

Esfahan •

I R A N

• Damascus

• Baghdad

• Jerusalem

• Qadesiyeh

Shiraz •

Cairo •

• Petra

Persian Gu

FA

ARABIA

Red Sea

Nile

• Mecca

• Meroe

MAP OF IRAN
AND THE
PERSIAN CULTURAL AREA

miles

0 200 400 600

0 200 400 600 800 1000

km

Map by Adrian Roots

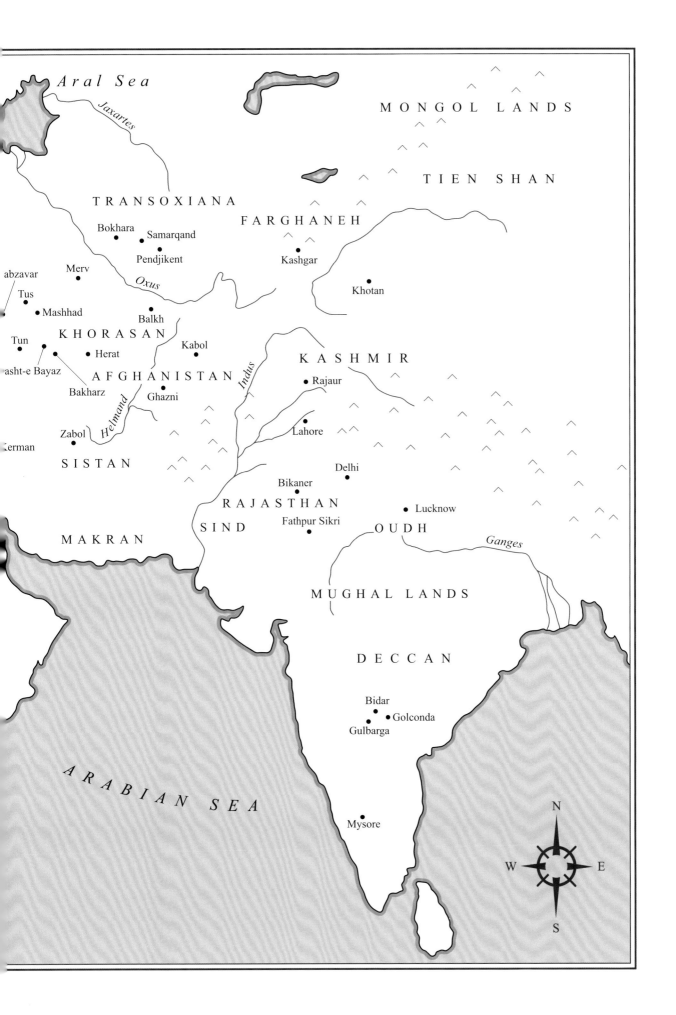

Aral Sea

Jaxartes

MONGOL LANDS

TIEN SHAN

TRANSOXIANA

FARGHANEH

Bokhara

Samarqand

Pendjikent

Kashgar

abzavar

Merv

Oxus

Khotan

Tus

Mashhad

Balkh

KHORASAN

Kabol

KASHMIR

Tun

Herat

asht-e Bayaz

AFGHANISTAN

Indus

Rajaur

Bakharz

Ghazni

Helmand

Lahore

Zabol

kerman

SISTAN

Delhi

Bikaner

RAJASTHAN

Lucknow

SIND

Fathpur Sikri

OUDH

MAKRAN

Ganges

MUGHAL LANDS

DECCAN

ARABIAN SEA

Bidar

Golconda

Gulbarga

Mysore

N

W E

S

THE 'SHAHNAMEH' IN PERSIAN CULTURE

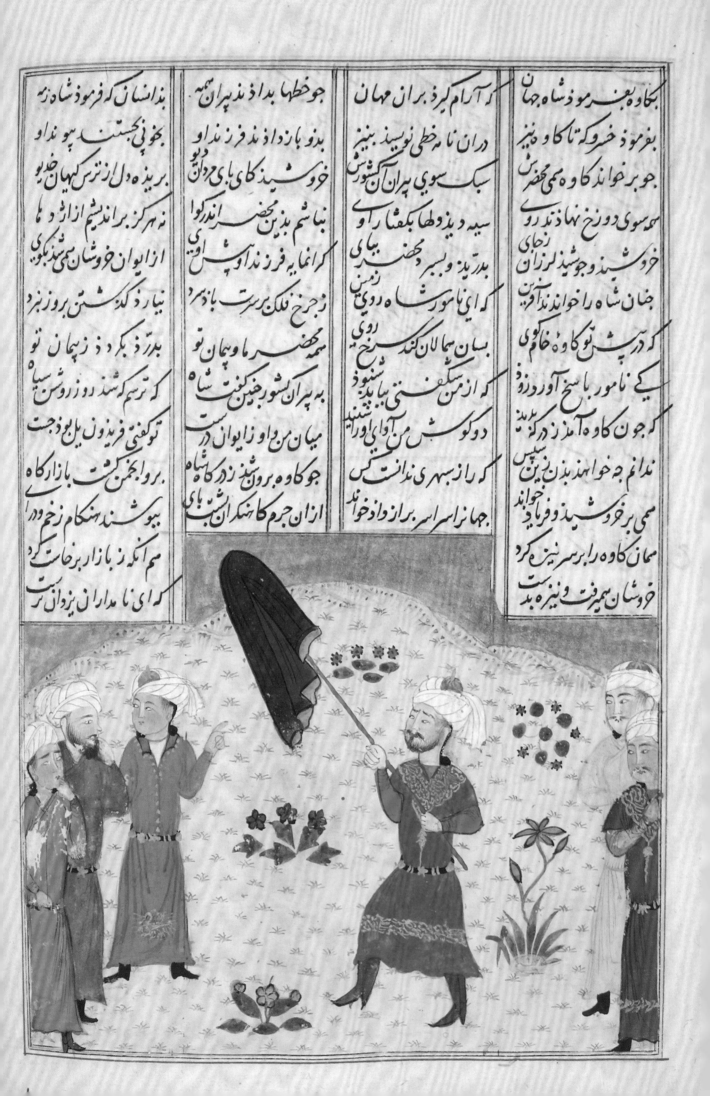

بکاوه پس از نره شد شاه جهان
بفرمود خسرو که تا کاو و پنیز
چو بر خواند کاوه همی محضرش
بهر سوی ز روز نح نهاد نذ روی
خروشید و جوشید لرزان
جهان شاه را خواند نذ آفرین
که در پیش نو کاو و خاکوی
کی نامور با سخ آور و زود
چو کاوه آمد ز در که ببند
نذام به خواهذ بذین بن سپس
همی بر خروشید و فریاد خواند
همان کاوه را بر سر نیزه کرد
خروشان بهم برفت و نیزه بست

که آرام گرد بران مهان
دران نامه خطی نویسند بنین
سبک سوی پیران آن کشورش
سیه دیدها بکشار آوی
بدرید و بسپر بحض بای
که ای نامور شاه روی زمین
بسان بهمالان کند شبخ روی
که از من سگفتنی بایذ شنید
دوکوش من آوای او را نید
که راز سبهری نذانت کس
جهان را سر اسر براز داد خوانذ
از آن جرم کاهنگدان شب بای

جو خطها بدا ذ مذ پیران همه
بدو با ز داد نذ فرز نذ او
خروشید کای بای مردان دیو
بناشم بذین محضر اندرکوا
کرانما یه فرز نذ او شراو
ز جرخ فلک برست باد بمرد
مهبحض ما وهمان نو
به پیران کشور بذین کنت شاه
میان من و او ز ایوان در
جو کاوه بروبیذ زد کاشاه بای
از آن جرم کاهنگدان شب بای

بذانسان که فرمود شاه زم
بخونی نجستن بپو نذ او
بریذه دل از ترس کیهان خذ یو
نه هرکز براندیشم ازاژد ها
ازایوان خروشان همی شذ بگوی
نیار د گذشتن بروز بزرد
بدز بکر د دز زبهان نو
که ترسم که شذ دو ز روشن سپاه
توکفنی فریذون پل بو دچت
بروابجمن کشت بازار گاه
بهوشنذ هنگام زخم در
سم آنکه ز بازار برخاست کرد
کرای نا مذاران بذروان رت

THE 'SHAHNAMEH' IN HISTORICAL CONTEXT

BY CHARLES MELVILLE

fig. 1

**Kaveh carries
his standard**

1490s

Istanbul, Topkapı Sarayı
Müzesi, H.1515, 18b

The *Shahnameh* is an epic poem that narrates the Iranian version of the history of the world from the time of the first men and their colonisation of the earth, up to the fall of the Persian Empire in the early seventh century AD. It is a story of struggle, of good against evil, of man against Fate, of man against nature and the supernatural (dragons, demons and monsters), of fathers against sons and heroes against kings. It also tells of the interior struggle of man within himself, and of the cyclical rise and decay of rulers and dynasties, all ending in death and destruction. Ferdowsi completed his epic a thousand years ago, and it is still an icon of Persian civilisation; indeed, it has been called the Iranians' identity card (*shenas-nameh*). This is largely because the *Shahnameh* is bound up with – indeed, is the symbol of – the whole question of the survival of 'Iranianness' after the traumatic defeat of the Persians by the Arabs and the replacement of Zoroastrianism by Islam. The *Shahnameh* kept alive the knowledge of Iran's ancient glory, political ethics and cultural identity, and in doing so, most importantly, also revitalised the Persian language as a literary medium.[1]

Much of the world view of the *Shahnameh*, and some of its material, reflects very ancient sources of Indo-Iranian (Aryan) origin, preserved in Old Iranian in the *Avesta*, the scriptures of Zoroastrianism that are at least partly contemporaneous with the prophet Zarathustra, who possibly flourished *c.*1000 BC.[2] The *Zamyad Yasht*, particularly, tells the story of the divine grace or charisma (*farr, kh^warnah*), which is possessed by the gods, prophets and great heroes of Iranian myth, and is a vital element of kingship running throughout the *Shahnameh*.[3] We might suppose that any work that straddles the millennia in the way the *Shahnameh* does must have meant many different things to different audiences and readers over this time, even up to the present day. On the other hand, its enduring appeal points to a core of meaning that transcends immediate time and place. This central core is of course quintessentially Iranian. The 'Book of Kings' captures the spirit, style and values of Persian culture and in giving expression to these qualities has struck a resonant chord in the hearts and minds of unfolding generations of Iranians. Yet even allowing for the shrinking of Iran's

3

political borders and the reduction of the Persian cultural area that extended at its peak across Transoxiana, northern India and into Anatolia and the Caucasus, the *Shahnameh* has been appreciated and admired outside its native land. It was translated into Arabic and then Ottoman Turkish and later into many of the world's modern languages.

The *Shahnameh* is clearly more than 'just a poem'. To better understand something of its message and the political significance attached to it, we must put it in historical context. What is the poem's status as history, that is, in its relationship to the 'history' that it recounts? What was the nature of the period when Ferdowsi was composing the *Shahnameh*, at the end of the tenth and beginning of the eleventh centuries AD? For, like any author, Ferdowsi was a product of his time. Finally, it is important to be aware of the circumstances in which the text of the *Shahnameh* was disseminated and reproduced in the centuries that followed – that is to say, through the patronage of the courts of the successive dynasties to rule all or parts of Iran, bearing in mind that it was a 'royal book' par excellence. The production of illustrated manuscripts of the quality of those exhibited here was an expensive undertaking, and the demand for splendid copies of the text over such a long period – up till the mid-nineteenth century at least – also needs some explanation.

THE 'SHAHNAMEH' AS HISTORY

It is normal to divide the *Shahnameh* into three sections: myths, legends and history. The borderline between the mythical and legendary sections is rather blurred, and the 'historical' section begins only with the end of the Achaemenid dynasty and the conquest of Iran by Alexander the Great, *c*.330 BC. Altogether, the poem narrates the reign of fifty kings, from the first, Kiyumars, to the ill-fated Yazdegerd, murdered by a miller as he fled from the invading Muslim Arabs. For much of the story it tells, the *Shahnameh* is almost the only indigenous written source, and was seen as such by later Persian historians.

Given the poem's enormous length and complexity, we cannot give a full synopsis of its contents in this short essay.[4] Instead, we will focus on a few points of particular interest that illuminate some durable aspects of the history of the Iranian people.

The first kings had to fight the demons for control of the world, and to acquire the skills they possessed. The reign of Jamshid, the fourth king, was notable for the introduction of various crafts, of which the first, significantly, was making arms and armour, the weapons of war to satisfy the warrior class. The arts of peace followed, such as spinning, weaving and dyeing clothes for every occasion. Jamshid also organised mankind into four classes: priests, warriors, farmers, and manual labourers. Each had their own rank, a fourfold division that remained

axiomatic in later theories of political organisation; it was the ruler's task to maintain each in his proper place. Ferdowsi thus explains the origin and the basis for the persistent view of what constituted orderly society. Reflecting his sun-like glory, Jamshid introduced the feast of the New Year, or Nowruz, still celebrated at the time of the spring equinox. However, entranced by his own achievements (no. 40), Jamshid forgot God and lost his divine charisma (*farr*), leading to his downfall and the subjugation of Iran to the tyrannical Arab king Zahhak. Thus the first historical lesson of the *Shahnameh* concerns the relationship between kingship and good religion, and the corruption of power. The evil Zahhak's Arab origins also prefigure the long and troubled relationship between the Arabs and the Persians.

Zahhak's brutal regime was brought to an end by a popular uprising of those whose sons had suffered at his hands (devoured by the snakes that grew from the tyrant's shoulders: no. 4). It was a blacksmith, Kaveh,

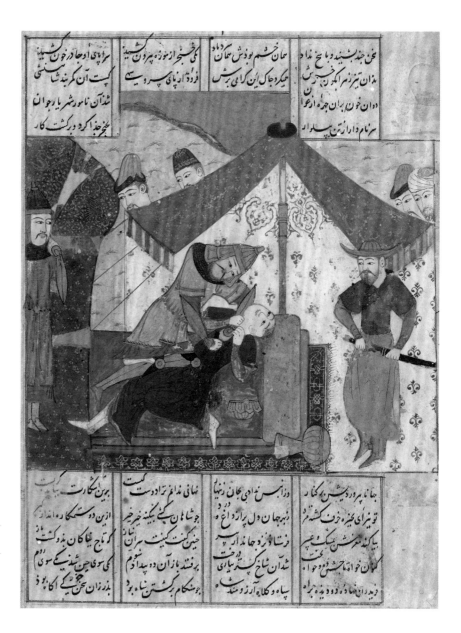

fig. 2

The murder of Iraj

*c.*1435–40

Cambridge, Fitzwilliam
Museum, MS 22-1948, 14b

who raised the banner of revolt, his leather apron – which later came
to be studded with jewels and carried as the battle standard of the
Persian shahs down to the time of the Arab invasions (fig. 1). *Kaveh*
was the name given to the Persian political and literary newspaper,
published first in Iran and then briefly in Berlin, in the period
1916–22 at a time of national crisis.

Another formative episode in the 'legendary' portion of the *Shahnameh*
is the murder of Iraj, son of king Faridun, who divided his realm among
his three sons. Iraj, the youngest, received the choicest part, Iran; his
elder brothers Salm and Tur respectively received the West ('Rum' or
the eastern Roman Empire) and 'Turan' (or Turkestan, Central Asia
to the borders of 'Chin', China). The brothers were jealous of Iraj and
murdered him (fig. 2; see also nos 5 and 103), thus setting off the cycle
of wars that pit the Iranians against the Turanians: a reflection of the
long-term historical confrontation between the marauding nomadic
Turkic peoples of Inner Asia and the sedentary civilisations of the
Iranian plateau. The murder of Iraj has other resonances: he was an
innocent victim, politically naïve and ready indeed to renounce the
trappings of power for a life of contemplation. As such, he becomes
a role model for the more inward-looking and spiritually aware figure
of Siyavosh, a man of conscience, who to some degree goes knowingly
to his fate (nos 49 and 78), like the later archetypal shi'i Imam and
martyr Hoseyn, son of 'Ali, whose murder in AD 680 at Karbela is
still mourned in Iran.[5] The world of the spirit, though not a dominant
feature in the *Shahnameh* (despite the endless invocations to God
and allusions to God's omnipotence), comes into focus periodically
throughout the work, and when it does so, it is generally to highlight
the uneasy relationship between kingly power and religion. The spread
of Zoroastrianism and the conversion of the shah, Goshtasp, recorded
in a passage apparently borrowed from the work of an earlier poet,
Daqiqi (see Firuza Abdullaeva's essay in this volume, p. 19), lent
a further religious dimension to the shah's authority.

The final, 'historical', section actually omits much that we might
expect to find. It begins with the last of the Achaemenids, Darius III,
and the conquests of Alexander (Persian: Eskandar), who is treated
as a legitimate Persian sovereign (no. 86). In other words, there is no
reference to the founders of the dynasty, Cyrus the Great, Darius or
Xerxes. Their exploits were lost to the Persian memory, perhaps owing
to the lack of records kept under the Parthians, who ruled Iran for 500
years or so once the Seleucid successors of Alexander had faded. The
same amnesia affected the site of the Achaemenid capital at Persepolis,
called Takht-e Jamshid ('the throne of Jamshid') by the Persians; the
royal tombs of the Achaemenids near Persepolis were similarly referred
to as Naqsh-e Rostam ('the image of Rostam') in the belief that the
monumental rock carvings there celebrated the exploits of the hero
Rostam, whose career dominates the legendary section of the *Shahnameh*.
The tomb of Cyrus at Pasargadae, also desecrated by Alexander's men,
was similarly thought to be that of Madar-e Soleyman ('the mother of

Solomon'). It was European archaeologists who restored her forgotten past to Iran. The Parthians themselves, a dynasty of nomadic Central Asian origin, also receive scant attention in the *Shahnameh*, despite their long rule (*c.*247 BC–AD 224): a mere twenty verses or so, though the names of Parthian warlords and rulers are preserved in the names of some of the *Shahnameh*'s protagonists, such as the Godarzian family of Godarz, Giv and Bizhan. The neglect of the Parthians cannot be due simply to an effort by their successors, the Sasanians, to write them out of history, for the Parthian nobility remained a potent force under the new regime. The question of the admixture of Parthian (generally eastern Iranian) legendary material with the traditions of western Iran remains a complex issue.[6]

The only genuinely historical section of the *Shahnameh* covers the reigns of the Sasanian dynasty (*c.*AD 224–642), founded by Ardeshir Papakan, who is glorified as a lawgiver and a model for later rulers. He and later historical figures are often treated in a highly romanticised

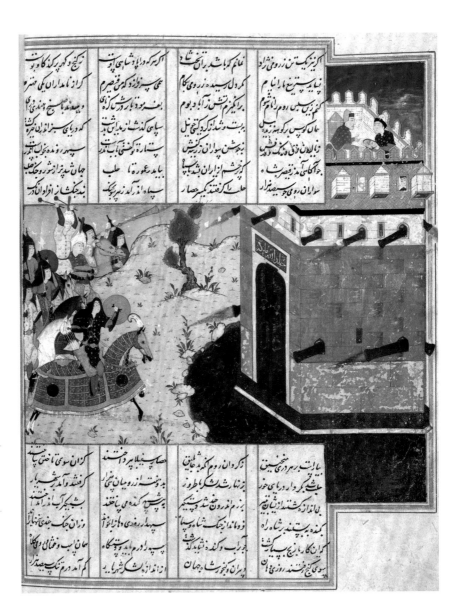

fig. 3

Anushirvan besieges the Rumis in Aleppo

942/1536

London, British Library, Add. 15531, 460b

Detail overleaf

بم آتش زد آباد بوم | بفرمود تا بارش کرد نای | دمیده علم با سنج و هندی درای

وشد ازگرد کنج خ نیل | سپاهی کنش از مدائن بد شن | که دریای سبز اندازان کنش

ن سواران ز رب به کنش | ستاره ز کوفتن آب اندر آست | سپهر روندہ بخواب اندر

هم از ایران بدند باب پی | بیامد رعمورہ تا حلب | جهان شد پر از شور و جنگ چلب

را گرفتند نکمیر حصار | سپاه اندر آمد زهر سوی جنگ | بند جنگ ش ز افزاوان در

کنم زین سپس روم رانام شوم

آسوده زین سپس روم رانام شوم

همان کوس پس برکوه نه زده بل

زنایلت رزی فرنگ نشی

جوآگامی آمد زقیصر شاه

سواران رومی جو سیصد هزار

manner, and there are still plenty of episodes of dragon slaying and heroic acts of prowess, whether hunting or in battle, that chime with earlier sections of the epic.[7] Nevertheless, with the focus switching from conflict in the East to conflict in the West, there are substantial accounts of the wars against Rome, such as the expeditions of Shapur II and Khosrow Anushirvan (fig. 3). Ferdowsi also mentions cultural relations, particularly with India, for instance in the supposed introduction of chess, and the Persians' 'invention' of backgammon (or a variation on the game of chess) in response. This occurred in the reign of Khosrow Anushirvan 'the Just' (*reg.* AD 531–79), fabled for his reforms and his political wisdom, nourished by the vizier and counsellor Bozorjmehr. The necessary combination of monarch and wise advisor (already found in the case of the idealised relationship between Alexander and Aristotle) was an integral part of Persian political thought: the duty to consult, to seek and to offer advice, was the best antidote to rashness and folly. Nevertheless, the difficult relations between Anushirvan and Bozorjmehr are also a paradigm for the dangers of serving a monarch and for the destructiveness of court intrigues.

Ferdowsi's history concludes with the fall of Sasanians and the triumph of Islam (no. 22). The importance of his work, based on indigenous Persian sources such as the Sasanian *Kh^waday-namag* ('Book of Lords'), for recovering the Iranian side of the history of the Arab conquests, so often neglected as irreconcilable with the accepted 'Islamic' version, has recently been magnificently demonstrated in a pioneering study that will surely put to rest the notion that Ferdowsi's epic poem cannot be taken seriously as a history of pre-Islamic Iran.[8]

FERDOWSI'S LIFETIME

Ferdowsi was born in Tus, in the province of Khorasan, north-east Iran, a town controlled at the time of the Arab invasions, and for some time afterwards, by the Kanarang family of noble Parthian stock. It was descendants of this family who were responsible for collecting the materials that made up a prototype prose version of the *Shahnameh*, completed in 957, with an explanatory Preface that has survived in several early manuscripts.[9]

This was a period of intense interest in the Persian epic tradition, at a time when for a brief interval dynasties of Persian origin ruled Iran. Sometimes referred to as the 'Iranian intermezzo', the period fell between the collapse of Arab caliphal power based in Baghdad, and the arrival of a succession of Turkish and Inner Asian regimes that dominated Iranian political life until the start of the twentieth century.[10] In eastern Iran, it was the Samanid dynasty (early ninth century to 999), with their main capital in Bokhara, who sponsored some of the earliest literary works to be written in Persian; they claimed descent from Bahram Chubineh, the famous general in the *Shahnameh*,

himself of the noble Parthian family of the Mehrans. Both the Samanids and their rivals in western Iran, the Buyids (945–1055) – who less plausibly claimed descent from the Sasanian monarch Bahram Gur (despite being apparently of Arab origin!) – at different times revived the title 'Shahanshah' (King of Kings), although the Buyids went much further in drawing upon elements of the ancient Persian past to legitimise their rule. The continuing vigour of the prestigious Persian administrative systems and government models, the survival of the former Persian gentry and the independent spirit of many minor potentates on the peripheries of the Iranian plateau (as in the Caspian provinces or Sistan – the homeland of Rostam – in the south-east) all help to explain the persistence of Iranianness into the late tenth century.[11]

Whatever hopes Ferdowsi may have held of the revival of Persian fortunes under the Samanid family – who came from the same background of the landowning class (*dehqan*) as himself – they were frustrated by the collapse of their rule at the hands of an upstart dynasty of Turkish slave origin, who had begun in the Samanids' military service in Khorasan. The founder of their fortunes, Alptegin, established himself in Ghazni (in modern Afghanistan), his successor Sebuktegin and the latter's son, Mahmud (*reg.* 997–1030), built up a powerful army and extended Ghaznavid control over Khorasan and raided into northern India. Writing almost 400 years after the fall of the Persian Empire, Ferdowsi's conscious aim was to preserve the legends and the memory of the achievements of the past, at a time when even the Persian language was in danger of being entirely superseded as a vehicle for literature by the dominance of Arabic. In Mahmud of Ghazni, moreover, to whom he dedicated the final versions of the poem, Ferdowsi seems to have hoped for a military champion who would rekindle ancient glories, a 'second Faridun'.[12] As we know, in this he was disappointed.[13]

THE 'SHAHNAMEH' AND THE REVIVAL OF THE IMPERIAL DREAM

Although the *Shahnameh* did not disappear entirely from view after its composition, we have only fleeting and scattered signs of its existence for the next two hundred years, from quotations and isolated references to the author and his work.[14] The physical evidence, in the form of copies of the text, comes from the only three manuscripts known to have survived from before the end of the thirteenth century. One is dated 1217, an incomplete copy preserved in Florence, where it was discovered by Professor Angelo Piemontese in 1977; another is datable to 1276 and is kept in the British Library in London. A third, undated copy in Beirut, is thought to have been made sometime before 1300.[15] In other words, our earliest indications of what Ferdowsi wrote come

from copies made between 200 and 250 years after his death: long enough for many changes to have been introduced, whether by the carelessness of scribes or the deliberate 'improvement' of the work by later writers, possibly influenced also by the oral transmission of the poem.[16]

Those two and a half centuries saw many upheavals in Persian history and a succession of dynastic changes. The greatest upheaval of all, however, was the Mongol conquest, which took place in two waves. The first, between 1219 and 1221, in the lifetime of Genghis Khan, brought terrible destruction to the great cities of Transoxiana and eastern Iran (Samarqand, Bokhara, Balkh, Herat, Merv and Nishapur). The second culminated in the sack of Baghdad in 1258 and the destruction of the 500-year-old dynasty of the 'Abbasid caliphs, titular heads of the Muslim world.

The Mongols were not Muslim, and their conquests brought an end to the old order, in which rulers enjoyed legitimacy by virtue of the delegated authority of the caliph. Furthermore, the new rulers, the Il-Khans, brought Iran into the fold of the Mongol Empire, which stretched from China to eastern Europe and southern Russia, deriving their legitimacy from their conquests and their descent from Genghis Khan. Iran thus regained something of its ancient position as an

fig. 4

Sample text page

The manuscript is dated 675/1276 by a note on a folio copied later (297a)

London, British Library, Add. 21103, 197a

independent power united under a strong ruler, within something recognisably akin to its pre-Islamic borders.

For forty years, Iran was under the dominion of the pagan Il-Khans, whose Iranian ministers attempted to steer their masters towards adopting the role of traditional Persian monarchs. Foremost among these advisors were the Joveynis, Shams al-Din the chief minister (d. 1284) and his brother 'Ala al-Din, governor of Baghdad and author of a history of the Mongol conquests (d. 1283).[17] What better text to portray the glories of imperial Persia and to articulate the values by which good rule could be secured, than Ferdowsi's *Shahnameh*? Joveyni's history, completed in 1260, is peppered with quotations from the *Shahnameh*, which, it must be remembered, devotes much time to charting the wars between Iran and her hostile neighbours beyond the Oxus, the Turanians – that is, the Turks:

> *Sea and mountain have seen me in battle; the stars are my witness*
> *to what I did with the heroes of the Turanian host.*
> *The world is beneath my feet through my manliness.*[18]

The conquering Mongols could thus be depicted for the benefit of Joveyni's long-suffering compatriots as the ancient enemy, repeatedly overcome by the Iranians, but they could also be invited to identify themselves more closely with the interests of their new Persian subjects and to assume the historic role of Iranian shahs:

> *Come, let us not give the world over to evil; let us all strive to turn*
> *our hands to good.*
> *Neither good nor bad remain; it is best to have good for a memorial.*[19]

This involved ruling with justice, carrying out building works (construction being the antithesis of destruction) and, most importantly, defending Iran's borders against enemies to East and West. As it happens, the enemy to the East was the rival Mongol realm of the Chaghatay Khanate, across the ancient physical and psychological border of the Oxus region. The Joveynis were great patrons of historians and poets and it is surely no mere coincidence that the first complete text of the *Shahnameh* that has survived is the copy of 1276 (fig. 4), when they were at the peak of their influence.

Neither the 1276 nor the earlier manuscript of 1217 is illustrated. It is also no coincidence that the first known illustrated copies apparently date from around 1300, shortly after the Mongols' conversion to Islam under Ghazan Khan (*reg.* 1295–1304). With this, the Il-Khans took an important step towards becoming more closely associated with their subjects, not only in kingship but also in religion. Ghazan and his successors, down to the collapse of the dynasty in 1335, were open also to the idea of patronising works of art as a reflection of their majesty. The text that received the most attention from patrons and artists alike was Ferdowsi's *Shahnameh*, which served, as we have seen, as a statement

of political ethics and a moral compass for the Iranian lands, recovering their historic territorial and cultural identity. Given the enormous destructiveness of the Mongol invasions (including the recorded destruction of libraries), it is entirely plausible that many earlier copies, both illustrated and unillustrated, perished. But it is also the case that the emergence of Persian manuscript painting at the same time as the regeneration of Iran's political power under the Mongols is a logical development; the timing was right for such skills and such distinctive cultural traits to flourish.

The same conditions prevailed, to a greater or lesser extent, in subsequent centuries, and although many other texts (romantic, mystical or religious poems, historical chronicles and didactic works) came to be enhanced with miniature paintings, the *Shahnameh* never lost its appeal for patrons and audience alike. For a start, successive imperial rulers of Iran were of non-Persian origin, and saw in the sponsorship of the 'national epic' a useful way to establish their Iranian credentials, notwithstanding the innate irony that they were mainly of Turkish background and furthermore equally keen to affirm their Muslim beliefs. This is particularly true of the Timurids, heirs of the Mongol conqueror Timur (Tamerlane), who ruled most of Iran throughout the fifteenth century from their capital in Herat, and the Turkoman dynasties (the 'Black Sheep' and 'White Sheep' regimes), that dominated western Iran from the former centres of Tabriz and Baghdad.

The court of the Safavids (1501–1722), Iran's longest-lived and most successful dynasty since the pre-Islamic period, although perhaps of Kurdish ancestry, was as much Turkish- as Persian-speaking, but during this time the focus of attention switched to the West. The Safavids' main rivals were the Ottomans, who by the beginning of the sixteenth century were consolidating their rule in eastern Anatolia, Egypt and the Levant, and contesting the mastery of Baghdad, which after 1638 remained in Ottoman hands. The *Shahnameh* continued to provide a vehicle for expressing Persian political and cultural superiority especially vis-à-vis the Turks; the most exquisite royal manuscript, completed around 1540, was sent as a diplomatic gift by its patron, Shah Tahmasp (*reg.* 1524–76), to the new Ottoman Soltan Selim II (no. 64).[18] The introductory passage of the *Shahnameh*, with its emphasis on the figure of 'Ali, cousin and son-in-law of the Prophet Mohammad, together with other members of the holy family, provided the opportunity to emphasise the shi'i sectarian character of the Safavid state (no. 2).[19] The Ottomans not only produced their own translations and imitations of the *Shahnameh*, but also constituted a ready market for illustrated manuscripts, stimulating the commercial production of handsome copies especially from Shiraz, throughout the sixteenth century.[20]

Meanwhile, the Timurids established themselves in northern India under Babur (d. 1530), founder of the Mughal (Mongol) Empire, after being expelled from Transoxiana by another regime of Mongol origin, the Uzbeks, who retained control of Turkestan (Central Asia) until

the coming of the Russians in the nineteenth century. Persian culture was dominant at the Mughal court, and although there is little evidence of the Mughal rulers themselves commissioning royal copies of the *Shahnameh*, they were avid bibliophiles and collectors, and many famous copies were preserved in their libraries, such as that made for Mohammad Juki, grandson of Tamerlane (nos 43–55).[21] Numerous copies were made in India, and also a very popular abridgement in prose and verse, composed by Tavakkol Beg, son of Tulak Beg, in 1653.[22]

Another factor in the continuing illustration of the *Shahnameh* over time was the persistent belief in its relevance, not only as a desirable object of royal patronage, but because its message remained pertinent to the question of kingly authority and the exercise of power. Along with the poet's exhortation of obedience to the will of the absolute shah, marked out by kingly charisma despite any individual failings, was the often-stated requirement for the ruler to act with justice and wisdom, to avoid rashness, hastiness and greed. Tyranny and folly never prospered in the long run, even if the agency of their punishment was supernatural intervention, as in the case of Yazdegerd 'the Sinner', who was killed by a kick from a horse that emerged mysteriously out of the sea. Both in the *Shahnameh* itself and other didactic works like historical chronicles, figures such as Jamshid, Ardeshir and Anushirvan 'the Just' were constantly held up as models of behaviour to which contemporary rulers should aspire.

It is also possible that it was convenient on occasions to use an ancient text such as the *Shahnameh* as a surrogate for commenting on contemporary events. The choice of particular scenes to illustrate in a manuscript might reflect the history of the artists' own time, such as court intrigues or the suppression of revolts.[23] The detailed study of individual manuscripts in the context of their time will perhaps allow such messages to be decoded from the choice of illustrations and their iconography. More simply, the *Shahnameh* provided a vehicle for depicting the rulers and other personages at court going about their characteristic activities, hunting, fighting and presiding over feasts, picnics, council meetings and the occasional amorous affair. The characters in the *Shahnameh* are depicted anachronistically in the clothes and fashions of the artists' time, together with the arms and armour, interior furnishings and utensils of successive ages.

In the light of all this, the continuing importance of the *Shahnameh* in modern Iran and among Iranians the world over is not hard to understand. Under the Pahlavi regime, the *Shahnameh* was used as a symbol of Iranianness with an undertone of anti-Arab and even anti-Islamic sentiment; within a few years of the Islamic Revolution, Ferdowsi and his work were again embraced, despite the contradictions inherent in the text, as a national rallying point, now with an emphasis on the author's supposed shi'ism. Meanwhile, the poet's call to a life of wisdom and justice remains as resounding and as politically relevant as when he wrote it a thousand years ago.

THE 'SHAHNAMEH' IN PERSIAN LITERARY HISTORY

BY FIRUZA ABDULLAEVA

It is impossible to overestimate the importance of Ferdowsi's *Shahnameh* within the history of Persian literature. It is variously defined as the 'encyclopaedia of Iranian culture', or the symbol of the Iranian nation. Ferdowsi's role in the formation of the Persian literary language and literary culture in general is similar to that of Shakespeare in the English-speaking world, or Pushkin for the Russians, who consider him 'our all'.

Why is it Ferdowsi who gained such a status, though he was not the first to write 'real' poetry in the New Persian language, nor the first to write the history of the Iranian kings, nor even the first to write it in Persian verse? Ferdowsi is famous for having created the longest poem ever written by a single author,[1] but it is clearly not simply its length that is the secret of the *Shahnameh*'s eternal glory and success. This essay will try to explain Ferdowsi's unique and paradoxical position in Persian literature and account for his continuing fame.

POETRY BEFORE FERDOWSI

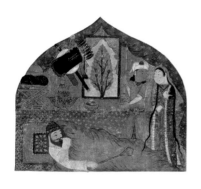

In the first place, little poetry, or little literature in general, has survived from the period before Ferdowsi in the language he was writing – New Persian.[2] Among the most celebrated, one of the earliest figures was Rudaki (d. 940), the great court poet of the Samanid Empire in Transoxiana. He has been called the 'Adam of Poets', as he was one of the first to raise Persian verse to the level of Arabic, which had dominated the Persian-speaking world since the Arab conquest of Iran in the seventh century. His heritage was thus part of the 'Persian Renaissance', which saw a fully shaped literary tradition in the New Persian language that 'suddenly' emerged from 'two centuries of silence', of which almost no written monument in

Persian has survived. The same can be said of the literary heritage of Rudaki himself,[3] but what has been preserved demonstrates a clear and rather simple language in combination with a mature style, rich in sparkling imagery. One of his most famous poems is about the grape, 'the Mother of Wine'. Like many other poets, Rudaki was bilingual and his panegyrics and love poetry display the same style of perfection in both Arabic and Persian.

For Persian poetry to flourish in an environment dominated by the Arabic language, of completely different linguistic origin (Semitic as opposed to Indo-European), and using an alphabet that did not fully reflect Persian phonetics, poets had to adopt, absorb and adapt the Arabic system of prosody (metrics). Originally based on a syllabic system, Persian poetry started to use Arabic quantitative metres (organised as sequences of long and short syllables), rhyme schemes and the system of tropes (metaphors, etc.), but transforming these in such a way that Persian could be comfortably accommodated. The metre used by Ferdowsi (and Daqiqi before him) is called *motaqareb*; despite its Arabic name it is considered to be closer to the ancient Persian metric system than to the Arabic *'arud* (prosodic system). This very rhythmic metre usually consists of three 'feet' each with the same three syllables (short–long–long); in the *Shahnameh*, each verse (*beyt*) consists of two rhyming hemistichs (or half lines, called *mesra'*), with three identical 'feet', and a fourth foot short–long [i.e., ⏑−−/⏑−−/⏑−−/⏑−], which perfectly suits the needs of a long epic narrative – formerly transmitted orally. Generally, each verse is independent and the sense does not run on into the next verse.

We do not know whether Ferdowsi spoke Arabic. As an educated notable and a Muslim he would have been expected to know enough Arabic at least to be able to understand and recite the Qur'an. What we do know is that his deliberate choice of vocabulary in his poem spurned Arabic, reducing the number of Arabic loan words to an absolute minimum. This is the most tangible evidence that Ferdowsi can be associated with the cultural movement known as the *sho'ubiyyeh*.[4] Such a severe self-imposed restriction could have caused some limitations of expression.[5] Certainly, compared with his predecessors and especially his famous contemporaries, serving at the flourishing court of Soltan Mahmud (999–1030) in Ghazni, Ferdowsi's language and style lack some technical sophistication and the complicated rhetorical devices that dominated the poetic fashion of the day. This might be a natural feature of Ferdowsi's own usage and the language he acquired from his family background, deeply rooted in ancient Iranian *dehqan* aristocratic tradition and kept unchanged owing to his rather secluded life style. But, certainly, Ferdowsi's use of archaic lexics was intentional. Later, some *Shahnameh* manuscripts started to be accompanied by special glossaries of difficult words and idioms met in the text, which had become hardly comprehensible for the next generations. It is also true that the relative simplicity of his diction admirably suits the epic genre, with its repetitive and formulaic passages,

easily committed to memory: his characters are constantly involved in battles, hunts and court receptions (*bazm-u razm*) – the traditional elements of the chivalric code and pastimes of the nobles of this age, the description of which is inevitably repetitive.

We can say, therefore, that Ferdowsi's claim to fame rests partly on his deliberate invigoration of the Persian language as a literary medium, standing near the start of the long tradition of poetry in New Persian, and for preserving not only the legendary history of the Iranian people, but also the rich language and vocabulary in which it was expressed.

PRECURSORS OF THE 'SHAHNAMEH'

Most likely, Ferdowsi's interest in ancient national glory was cultivated within his family and his milieu. It is important to remember that Ferdowsi was not the first who decided to undertake this task. Before him there are known to have been several accounts of Iranian history of a similar kind both in prose and in verse, created centuries earlier or by his immediate contemporaries.

It seems that the earliest sources Ferdowsi could find in the Pahlavi (Middle Persian) language were written during the period of the Sasanians, who ruled Iran before the Arab conquest (AD 224–642). Fragments of such chronicles, or complete separate stories about kings and heroes, were popular both at court and in the bazaar, being performed by professional reciters.[6] The *Chronicle of Bokhara* written by Narshakhi (d. 959) mentions two such songs – 'The Magi's Lament' and the 'Revenge for Siyavosh' – one of the key figures in Ferdowsi's poem.[7] His main written sources undoubtedly went back to the *Khʷaday-namag* ('The Book of Lords'), compiled at the time of the Sasanian king Khosrow II Parviz (591–628). This was translated into Arabic, but neither the translation nor the original Pahlavi text has survived.[8]

Simultaneously with the Arabic translations, the *Shahnameh* was produced in Dari, or court (literary) Persian. One of the first prose versions was compiled by Abu'l-Mo'ayyad al-Balkhi. This chronicle was mentioned in the anonymous *History of Sistan* (c.1062) as having a rather distinct Zoroastrian flavour. By 957 a great compendium of chronicles, commissioned by the governor of Tus, Abu Mansur Mohammad b. 'Abd al-Razzaq, was completed.

Abu Reyhan Biruni (973–1048) is the first to mention in his 'Chronology' a versified version of the Persian *Shahnameh*, written by someone named Abu 'Ali Mohammad b. Balkhi. Barthold suggested that this poet was the same person as Daqiqi (935 or

942–976 or 980), with a slightly different patronymic, Abu Mansur.[9] Biruni's evidence in this case is extremely valuable. If we accept that under the name of Abu 'Ali Mohammad b. Balkhi is signified the famous poet Abu Mansur Daqiqi, the direct predecessor of Ferdowsi, we should acknowledge that he had written much more than Ferdowsi incorporated into his *Shahnameh*: according to Biruni, Abu 'Ali had covered the period from Kiyumars to the Arsacids (*c.*247 BC–AD 224).

Daqiqi was thus the first who started to versify in New Persian the universal chronicle of the Iranian kings, but he was murdered by his favourite slave either for personal or political reasons (the poet had a rather scandalous reputation of a bohemian Zoroastrian). However much he wrote, a fragment of 1,000 *beyts* was included by Ferdowsi in his *Shahnameh*.[10] Despite Ferdowsi's acknowledgement of Daqiqi's work, he mentions that he included it to show the superiority of his own talent over the feeble attempt of his predecessor. There was probably another reason: the fragment Ferdowsi used is dedicated to the emergence of Zaratushtra, and the adoption of Zoroastrianism by the Iranian king Goshtasp. It is worth noting that Ferdowsi never mentions a word about the emergence of Mohammad and Islam, and he may also have been reluctant to be associated personally with the account of Zoroastrianism. The only fact we can rely on, which helps to shed some light on the situation, is that Ferdowsi's burial place is on the territory of his family estate, which confirms the evidence of the author of the *Chahar Maqaleh*, who in the mid-twelfth century claimed that Ferdowsi had not been allowed to be buried in the Muslim cemetery for being a 'heretic'.[11] Thus Ferdowsi probably had good reason to be anxious about the political correctness of his poem. Probably 'to save the poet's reputation' another poem on a more proper, Qur'anic subject, 'Yusof and Zoleykha', was later ascribed to him.[12]

THE RECEPTION OF THE 'SHAHNAMEH'

It seems that Ferdowsi saw that his mission in writing the chronicle was to save his country from approaching political disaster, like Leo Tolstoy writing *War and Peace*, secluded on his estate: they had an intuition regarding the approaching crisis and consciousness of their noble aim. Between the time when Ferdowsi started his research and the completion of his life's work, the political situation had completely changed: gradually the old poet saw his country exhausted by foreign and local invasions. The Persian Samanid dynasty vanished from the leaves of history, to be replaced by those against whom Ferdowsi was trying to warn: the Turkic dynasty, represented by Soltan Mahmud of Ghazni (999–1030), whose empire extended over the whole of eastern Iran.[13] Despite his patronage of poets, Mahmud could hardly be expected to appreciate Ferdowsi's efforts; on the contrary, the anti-

Arab and anti-Turk, pro-royalist 'Book of Kings' would have produced a reaction of nothing but irritation if not rage. What a paradoxical situation the pro-shi'i Ferdowsi found himself in when he decided to dedicate his poem to Soltan Mahmud, a grandson of a Turkish slave, a pro-caliphate militant sunni! The main paradox was that Mahmud was the only contemporary monarch to whom Ferdowsi could offer his poem, even if both of them realised the absurdity of such an action. The situation gave rise to many legends, a particularly popular one being that the old poet arrived at the capital himself and managed to get into the Soltan's garden, where the three chief poets of his court were enjoying a conversation. 'Onsori, the Poet Laureate, Farrokhi and 'Asjadi tested the stranger and, once he had passed their charade, allowed Ferdowsi to introduce his poem to the Soltan himself (nos 1 and 44).[14]

All the legends agree that the poem was rejected by Mahmud, which does not seem surprising. Quite apart from the contradictions in its subject matter already noted, the poem was at odds with its time, both as history and as literature,[15] and it may also have fallen foul of the jealousies of the Ghaznavid court poets, who were writing very different work, panegyrics and entertaining short love lyrics. The rejection was legitimised by the court poets, who were organised in a professional guild with their own hierarchy under the head censor, 'Onsori. Their *divan*s contain severe criticism of the poem, demonstrating their loyalty to their patron. Yet all the poets of the Ghazni circle were aware of the high value of the poem, and despite trying to present it and the ideas within it as old-fashioned nonsense, they used the imagery and even the names of the heroes of the *Shahnameh*:[16]

> *If Faridun crossed the Tigris without a ship,*
> *There is a night tale about this in the 'Shahnameh'.*
> *A tale may be truthful, [or] it may not;*
> *Don't believe in it unless you know for sure…*[17]

An even more explicit attitude towards Ferdowsi can be found in Farrokhi's panegyrics dedicated to Mahmud:

> *Your name has erased and destroyed the names of all [previous] kings*
> *The 'Shahnameh' has no value after this.*[18]

Or:

> *He who used to read the tales from the 'Shahnameh'*
> *Is now reading only the stories from the 'Mahmudnameh'…*[19]

In his odes dedicated to other members of Mahmud's family, however, especially to his unfortunate son Mohammad, later overthrown by his brother Mas'ud, or Mahmud's brother Amir Yusof, Farrokhi feels more relaxed comparing them with the main heroes of the *Shahnameh*:

> *The creator of the world gave you*
> *The strength of Rostam and the intelligence of Hushang*[20]

Or

Do the things that
Bizhan [son of] Giv and Rostam [son of] Dastan used to do.[21]

These examples show that the ambiguous, even hypocritical attitude of these poets towards the *Shahnameh*, and their organised hostility, can be one explanation for its almost complete disappearance for two or three centuries after Ferdowsi's death.[22]

Another feature of Ferdowsi's epic that perhaps made it unattractive to his contemporaries was the rigid attitude to social (not to say gender) hierarchies that were an important part of his outlook. The episode of Bahram Gur and his beloved, the slave harpist Azadeh, is a good example, showing that a slave cannot be equal to a prince even if she shares his bed and his heart. Their union is as absurd and mirage-like as the name Azadeh ('free, noble') given to a slave. So when a slave puts a foot wrong, and rebukes the prince, she has to be cruelly punished (no. 16). On the other hand, according to Ferdowsi, a woman of a royal descent has equal rights with men in her personal aspirations: Tahmineh, the daughter of the king of Samangan, comes to Rostam's bedroom in the middle of the night offering herself as a mother for his child, even though they see each other for the first and the last time in their lives (nos 18, 28, 48, 75 and 91). Manizheh, daughter of the king of Turan, orders the Iranian knight, Bizhan, with whom she had fallen in love, to be brought to her palace apartments. In both cases the girls achieve their goals without or even against the will of their partners and they do not deserve immediate punishment from Ferdowsi's point of view.

Such contrasts with the contemporary social norms could also explain the *Shahnameh*'s disappearance from the scene for a while. Ferdowsi, one of the last representatives of the outgoing class of the old Iranian aristocracy, could not but feel himself trapped between his familial traditions and the requirements of contemporary society: on one hand, the relative egalitarianism of Islam, on the other, its more restrictive attitude to women's freedom of action.

POETRY AFTER FERDOWSI

The story of Bahram Gur and Azadeh was later given an 'improved' treatment by the great Persian poet Nezami of Ganjeh (1141–1209), who provides a much softer and happier ending to Ferdowsi's ill-fated hunting expedition, and a further reworking of the story was made by Amir Khosrow of Delhi (1253–1325).[23] While acknowledging Ferdowsi's *Shahnameh* as his source of inspiration, Nezami indicates in his *Haft Peykar* that his aim was to complete the half-done work of his predecessor, using the image of the poet as a jeweller, who pierces a priceless half-

pierced pearl to create his own masterpiece.[24] Nezami also retells the
story of Khosrow and Shirin, and the legend of Alexander (Eskandar)
in his *Khamseh* ('Quintet'). Nezami's *Eskandarnameh* would then be
reinterpreted by Jami (1414–92) and Nava'i (1441–1501), so that an
obsessive conqueror could be successively transformed from an usurper
into a just and legitimate ruler, and a philosopher-saint, sometimes equal
to a prophet. Such a process of 'improvement' to the composition is
called *nazira/tazmin* (Arabic: 'emulation'), or *javab* (Persian: 'answer'),
when each author gives his own interpretation of a well-known story,
trying to surpass his predecessor.[25]

Ferdowsi's *Shahnameh* is the classical example of the Persian epic,
while containing the embryo of other literary genres that developed
later, like romantic, ethical and didactic literature (Mirrors for
Princes).[26] Figures such as Jamshid, the mythological Iranian king,
became stock characters in later works, and his magic cup, the *Jam-e
Jam(shid)*, which revealed the world's mysteries to its owner, became
a favourite Sufi symbol in classical poetry.

The epic genre itself, nevertheless, continued to inspire poets to
emulate the *Shahnameh*. A whole series of poems appeared, imitating
the *Shahnameh* in its style, imagery and metre, but continuing and
'improving' it by filling in stories from the 'Sistan cycle' of the family
of Rostam, omitted by or unknown to Ferdowsi. The first of these
was the *Garshaspnameh* by Asadi Tusi (c.1010–c.1070) (no. 74); the
most substantial was perhaps the epic dedicated to Rostam's grandson
Barzu. Others told of his great-grandson Shahryar, or Rostam's
grandfather Sam, or his son Faramarz, or the representatives of side
branches of the Iranian kings, like Darab, Firuz Shah and Khorshid
Shah. Often, these narratives would be incorporated into the manuscript
copies of Ferdowsi's text.[27] The idiom and inspiration of the *Shahnameh*
was also appropriated to glorify the heroes of Islamic legend, such as
Mohammad's cousin and son-in-law 'Ali.[28]

If the pure epic genre slowly went out of fashion by the end of the
fifteenth century, in favour of versified romances, the fashion for
the epic à la Ferdowsi revived under the Qajars (1797–1925) and the
Bazgasht ('Return'), a literary movement that aimed to resurrect the
great Persian classical tradition of its Golden Age. The *Shahanshah-
nameh* (c.1810) of Fath-'Ali Khan Saba was dedicated to Fath-'Ali Shah
Qajar (1771–1834); a *Georgenameh* was written in honour of the visit
of the British king to India in 1911.

A fitting testimony to the enduring power of Ferdowsi's verse and his
gloomy vision of the decay of Iran's glory is the poem by one of the
most important twentieth-century Iranian writers, Akhavan-e Sales
(1928–90), also a native of Tus, called 'The end of the *Shahnameh*'
(1959).[29] In this poem the author associates the decline of his country
with the loss of the values declared in the *Shahnameh*, which should
be treasured like the mother Iran herself.[30]

THE 'SHAHNAMEH' AS WORLD LITERATURE

BY DICK DAVIS

The great watershed of Iranian history is the Arab–Islamic conquest of the mid-seventh century AD. From the perspective of the present, there are more or less 1,300 years from the founding of the Achaemenid Empire by Cyrus the Great up to the rise of Islam, and more or less 1,300 years since. The first claim that the *Shahnameh* has on our attention is that it is virtually the sole indigenous literary source for the mythology, legends and historical narratives of the Persian people concerning themselves and their own origins before the coming of Islam to their country. As such, the poem is considered to be the Iranian national epic, and its author, Ferdowsi, occupies almost the same place in Persian literary history as Homer does in that of ancient Greece. An equally valid comparison can be made with Virgil's achievement in the *Aeneid*, as Ferdowsi, like Virgil, is writing a poem that traces the mythological origins of his own people, and seeks to provide an account of how they came to be what they are.

There is, however, a major difference between the *Aeneid* and the *Shahnameh*: Virgil's poem is a triumphal work that ends in victory and points to future glory; the end of the *Shahnameh* is elegiac, and its last pages record defeat and uncertainty, and the loss of the glory recorded earlier in the work. But for all its ancient subject matter, the *Shahnameh* is not an ancient work but a medieval one, and the most useful comparisons for a western reader are probably with medieval or renaissance works, like Dante's *Divine Comedy*, or Shakespeare's tragedies and history plays. It is panoramic in the same way as these western works are, with a teeming multifarious cast of characters, some sketched in briefly, some presented with great depth and force and, as with its western counterparts, we have a sense when reading the *Shahnameh* of glimpsing a whole world in all its depth and variety. It has its own perspective on its world too; if we can say that the primary experience presented in Dante is one of categorization and judgement, and in Shakespeare of the acknowledgement of the wealth of human variety, and so of the fallibility of judgement, in Ferdowsi it is of how human beings are tested, physically and morally, by the

vicissitudes of experience, and of the different ways in which they respond to such tests.

Since the *Shahnameh* incorporates within its structure very differing kinds of material (the mythological, the legendary and the quasi-historical), and also carries the added burden of being the major written record in Persian of a pre-Islamic Persian cultural identity, it comes as no surprise that the work is immensely long. It would indeed have to be very long in order to be the vehicle for so much in the way of cultural content and impedimenta, and its vast length, as well as the fact of its having been written within a generation or two of the revival of Persian literature after the Islamic conquest, means that it towers over subsequent Persian literature like an unassailable cliff face, a rocky escarpment that marks both a huge cultural boundary and a new cultural beginning. The author of the poem, Ferdowsi, has traditionally been regarded within the Persian-speaking world as the preserver of pre-Islamic Persian cultural identity, as well as the preserver of its language as a literary and spoken presence in the world. It has often been asserted that, of all the peoples whom the Arabs conquered in the seventh century AD, only the Persians still speak a version of the language they were speaking before the appearance of the Arabs. It is true that, of all the languages that still survive in the Middle East – such as Kurdish and Aramaic – it is only Persian that can boast a major world literature. It is said that an Egyptian historian was recently asked why it was that the vast majority of Egyptians, who of course are also the heirs to a great pre-Islamic civilisation, now speak Arabic rather than Coptic, whereas the Persians still speak Persian, and he answered, 'Because we had no Ferdowsi'.

After an exordium consisting of passages in praise of God and of the Prophet Mohammad, as well as a passage on the poem's sources, the narratives of the *Shahnameh* begin with the creation of the world, and they end with the Arab conquest of the mid-seventh century AD. The poem's basic structure is that of a chronicle of kings, with the larger sections being divided according to the coronations and deaths of individual monarchs; in all, the reigns of fifty monarchs are recorded. Most modern scholars of the poem have divided it into three sections: the mythological, the legendary and the historical. The division between the second and third sections is much more clear-cut than that between the first two, and some scholars ignore the distinction between the mythological and legendary sections altogether.

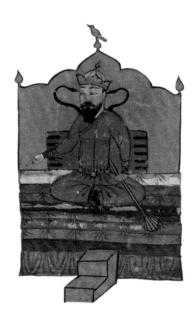

The mythological section, which is by far the shortest (covering five reigns), is largely a cosmogony, and the Western works it most resembles are those by Hesiod. What is notable here is that Ferdowsi treats the creation of the world, and of mankind, entirely in terms of Zoroastrian cosmology, and, unlike his contemporaries who deal with similar material, makes no attempt to integrate this with the Islamic version of the world's creation as it appears in the Qur'an. In this section, the supernatural is omnipresent, almost always in the form

of demons or other malevolent beings who constantly threaten mankind's attempts to establish agriculture, towns, religion and civil order. The early battles of the poem record mankind's gradual subjugation of the demonic representatives of Ahriman, the evil principle of the universe.

The first unequivocally evil human being of the poem is the Arab king Zahhak, who is seduced by a demonic plot and tries to destroy Iran by feeding its youths to the voracious snakes that grow from his shoulders. It is significant that Ferdowsi insists on Zahhak's Arab origins; the poem virtually opens with an Arab would-be destroyer of Iran, and it closes with the Arab conquest of the country in the seventh century. Although we may assume that Ferdowsi was a sincere Muslim, whose allegiance to the religion that the Arabs brought to his country cannot be doubted, it is equally clear that he frames his poem with explicit references to the evils of the Arab conquest.

The reign of Zahhak marks the beginning of the transition to legendary material, which dominates the first half of the poem; it is in this section that the most famous narratives are found. This is the section that most obviously merits the name 'epic', and many of the stories feel Homeric in their concerns and tone. At times they also display similarities to narratives in the great Indian epics, the *Mahabharata* and the *Ramayana*; in both the Indian epics and the *Shahnameh* violent ethnic and tribal differences have their origins in fratricidal family squabbles; in both, an inherently noble person wrongly suspected of sexual misconduct (Sita, Siyavosh) has to prove her/his innocence by passing through fire, and there are distinct parallels between the epic exploits of Indra and Krishna and those of the *Shahnameh*'s chief hero, Rostam. A king's division of the world between his three sons (like Lear's planned division of Britain between his three daughters) leads to fratricide when the two evil older sons kill the innocent youngest son, and from this moment on Central Asia north of the River Oxus, called Turan, the realm of one of the evil brothers (Tur), is almost perpetually at war with Iran/Persia, the home of the murdered youngest brother, Iraj.

The stories in the legendary section are much more complicated than the poem's opening narratives. One reason for this is that we suddenly have two centres of Persian power: the Persian kings themselves and the lords of Sistan (which in modern geographical terms corresponds approximately to Helmand Province in south-west Afghanistan) – Sam, his son Zal and Zal's son Rostam. The lords of Sistan are the champions of the Persian kings, and the uneasy relationship between these two ruling houses generates much of the tension in the legendary stories. The relationship is presented as a gradually deteriorating one: Sam is loyal to his kings come what may, and never voices any objections to their actions; Zal too is loyal, but he often warns his monarchs that they are following bad advice, and he tries hard to dissuade them from actions he thinks mistaken or evil;

Rostam, the greatest hero of poem, is loyal to kings he approves of, but he openly quarrels with two of his monarchs: Kavus, who is perhaps the stupidest king in the poem and Goshtasp, who is presented as one of its most malevolent. Both of Rostam's sons (Sohrab and Faramarz) are to be found fighting *against* rather than for particular Persian kings, and Rostam's last combat is with a Persian crown prince, Esfandiyar. Dissension between monarch and hero is a recurrent motif in the poem, and this is also a widespread theme in Western epics (most famously in the Achilles–Agamemnon tension at the opening of the *Iliad*).

We immediately see that the poem deals with different kinds of kings and different kinds of heroes. Perhaps because of its name (*Shahnameh* means literally 'King Book') and because the poem is structured most obviously as a king list, it has often been taken by those who have not read it as a work that relentlessly praises individual kings, and the institution of monarchy in general. Nothing could be further from the truth. Of the fifty monarchs named by Ferdowsi, perhaps five are given what looks like unalloyed approbation; most are presented as fairly neutral morally or they exhibit a mixture of good and evil, foolish and astute characteristics; a good number are venal and downright evil, or simply very stupid. What is interesting is that it is the venal and stupid kings to whom Ferdowsi gives most space, and he returns with almost obsessive insistence to the problems that come out of disastrously bad government; in a number of stories we see him posing the question of what a good man is to do when he lives under an evil or foolish ruler. Towards the end of the *Shahnameh*, a sage is asked, 'Who is the most desperate of men?' and his answer is, 'A good man who serves a worthless king'. In two of the greatest narratives of the legendary section (the stories of Siyavosh and Esfandiyar) a young prince is faced with an impossible moral dilemma: the king, who is also his father, has ordered him to do something he knows to be morally wrong. One prince (Siyavosh) follows his conscience, and is destroyed by his decision; the other (Esfandiyar) insists to himself that he must obey the orders of his king and father come what may, and he too is destroyed by the decision. The moral urgency of the dramatic ways that Ferdowsi explores these crises of conscience makes for wonderfully moving human, and humane, narratives.

In the same way that the poem gives us portraits of different kinds of kings, so we see various types of hero as the narratives unfold. One kind we might call particularly Iranian, as it reappears in other areas of Persian civilisation, notably the country's religious culture, is the innocent youth who is killed as a result of his desire to do good in an evil world: Iraj, the youngest son killed by his two older brothers, mentioned above, is the first example in the poem of this kind of hero; the most famous example is Prince Siyavosh. Sons of famous heroes are often presented as a completely different sort of hero: they are brash, young hotheads who rush into danger without thinking of the consequences. Rostam's son Sohrab is like this; Siyavosh's son Forud

acts in a very similar way, as does the son of the hero Giv, Bizhan, who has to be rescued from a pit by Rostam because he has become involved in a reckless romantic attachment with the daughter of Iran's mortal enemy. When he is a young man, Sam's son, Zal, becomes involved in an almost equally perilous romance. Other types of hero are represented primarily by one outstanding example. One such is the pernickety follower of every rule in the heroic book; Esfandiyar is the great example. Another is perhaps the most ancient, atavistic kind of hero of all, the trickster hero, and here our great example is Rostam.

Rostam is clearly a composite figure incorporating different strata from different cultures. A number of scholars have remarked on his obvious connections with India, for example, his wearing a talismanic tiger skin instead of armour has been traced to an Indian origin by Djalal Khaleghi-Motlagh,[1] while Mehrdad Bahar[2] has pointed out the similarities between his exploits and those of Krishna and Indra. His legend also shows strong Parthian connections, and some of the stories that concern him appear to be extremely ancient. It seems significant that the two weapons most closely associated with him are the lariat and the club, both pre-metallic weapons. His patronymic, Dastan, means 'Trickery' and he displays most of the characteristics of the typical trickster hero: he is associated with a bird (the magical Simorgh, whose feathers protect him at his birth, and, more ambiguously, in his last combat before death), and with the tiger, an animal known for its slyness. He is a great transgressor of boundaries, both literal and metaphorical; he wins many of his most famous battles by trickery, and he dies enmeshed in trickery, tricked himself and tricking the man who has tricked him. Certainly he is associated with and often represents the most anarchic and chthonic elements of the poem.

Rostam lives for an enormously long time, serving under no less than seven kings, and in the course of his life we see that both he and the narratives in which he is involved undergo substantial changes. In the early stories of which he is the protagonist he is simply a triumphant mythological hero, someone who always wins his battles, enjoys super-natural protection and can solve (either by his valour or his guile) all problems that are presented to him. But all this changes once he has slept with Tahmineh, and fathered his son Sohrab (we are reminded of the mythical Enkidu in one of the earliest surviving Near Eastern epics, *Gilgamesh*, who is brought into the world of human frailty and fallibility by his sleeping with a woman sent to him for this very purpose). After this moment, Rostam leaves the world of the simply heroic and becomes snared in the human; his adventures are now shadowed by inwardness and anguish, a sense that he is marked out for tragedy, an apprehension that the world has, in his own words, become for him 'a thicket' in which he sometimes cannot see his way forward. Through stubborn blindness, he inadvertently kills his young son, Sohrab, on the battlefield; he is unable to save the doomed hero Siyavosh, whom he loves and to whom he has acted as a father figure;

he is presented with an impossible dilemma, all solutions to which seem to him to be evil, during his last major encounter, that with Esfandiyar. And although the Simorgh, his magical protector who was there at his birth, enables him to defeat and kill Esfandiyar, she also tells him that the man who kills Esfandiyar will soon die, 'and torment will be his after death'.

We see a similar development within Rostam's life to one we encounter writ large in the poem as a whole. The early stories present us with characters who function chiefly as emblematic figures acting within largely archetypal situations – for example, the tale of Faridun's division of his kingdom between his sons. Later we see the poetic elaboration of inwardness and conscience, but still tied to a largely legendary representation, in a story like that of Siyavosh, where again we have a well-meaning hero who is murdered, but one who is presented with much more psychological detail and plausibility than is the case with Iraj. In the last, historical, half of the poem, we encounter a number of figures who are drawn with the kind of detailed complexity of motive and character that we might more readily associate with the protagonist of a nineteenth-century novel – Bahram Chubineh, hero, malcontent and rebel, is an example of such a figure.

The uneasiness that frequently pervades the hero–king relationship in the poem is paralleled by another equally strained relationship, that between father and son. Zahhak, mentioned above as the first unequivocally evil person in the poem, murders his father, and towards the end of the poem other sons are responsible for their fathers' deaths. But in the best-known stories of the legendary section of the poem, those concerning Rostam and his son Sohrab, Kavus and his son Siyavosh, and Goshtasp and his son Esfandiyar, it is the father who is responsible for the son's death; directly so in Sohrab's case, as Rostam kills him with his own hand, more indirectly but more culpably in the cases of Siyavosh and Esfandiyar. As with the hero and the king, the supposed superior in the relationship – the king, the father – is shown to be morally inferior to his supposed subordinate – the champion, the son – and our sympathies certainly lie primarily with the 'inferiors', the champions and the sons. In a strange way the greatest loyalty of all, that toward Iran itself, is similarly called into question; the two most unequivocally noble characters of the legendary section of the poem, Siyavosh and, later on, his son Key Khosrow, both turn away from, and indeed abandon, Iran for personal, ethical reasons; their sense of the ethical imperative in their lives transcends their ethnic and national loyalties.

In the three stories of the deaths of sons that lie at the core of the legendary section of the poem, we see a similar development of the kind of story being told to that which we can trace in the narratives connected with Rostam, and in the unfolding of the poem as a whole. In the first such tale, that in which Rostam inadvertently kills his son Sohrab, character plays a relatively minor part in the way the story is

developed; overwhelmingly, what causes the death is fate, and it is the helplessness of the characters involved, their ignorance of what is happening to them, that is emphasised. The death of Siyavosh is more directly linked to his own and his father's characters than is Sohrab's, although the inwardness is still tied to the supernatural, and so to an otherworldly inevitability, as Siyavosh foresees his own death; his conscience, which is what disables him in his dealings with the political world, is presented as an aspect of his closeness to the divine. In the last tale of the three, that of Esfandiyar, human characters – those of Esfandiyar himself, of his father Goshtasp and of Esfandiyar's antagonist Rostam – are what drive the tale, and the supernatural is relegated to a brief moment near the story's opening involving a horoscope, which is immediately transformed into a catalyst for Goshtasp's malevolence.

The historical, last section of the poem, begins soon after the death of Esfandiyar, and the destruction of the independence of Sistan by his son Bahman. A puzzle immediately arises for the reader aware of Iran's ancient history: where are the Achaemenids? Where are Cyrus, Darius and Xerxes? They aren't there, but why? The usual explanation is that the legends of the *Shahnameh* are all from eastern, Parthian Iran, not from the imperial heartland which was the centre of Achaemenid rule, and the dynasty had simply passed out of Parthian memory. Be that as it may, the historical section begins with the last Achaemenid kings, and the conquest of Alexander the Great, who is the son of one of these Achaemenid kings (as he is the son of a pharaoh in the life written by Pseudo-Calisthenes, who is assumed to have been Egyptian). Alexander (called by Ferdowsi Eskandar) is also a Christian; in fact, although the last section of the *Shahnameh* refers to historical figures, it often treats them in a highly romanticised manner, though the anachronistic confusions decrease as the stories get closer to Ferdowsi's own time. The tone of this last section is quite different from that of the heroic and often earnestly ethical stories of the poem's legendary section. The politics are often unrelievedly venal, so that by the end of the poem the reader has the sense that the Persian Empire was destroyed as much by its own internal corruption as by the Arabs. The narratives, which in the earlier sections of the poem had seemed weathered to the point where they were free of all irrelevancies and distractions, are suddenly full of circumstantial detail; virtually for the first time in the poem we move beyond the court and see villagers and townspeople from various social levels; the supernatural is hardly there, and magic is rarely mentioned; there are a number of light, funny stories, as well as love stories – some serious but others that are less all-or-nothing romantic life attachments than (for the male partner at least) amusing flirtations. If the heroic tone, and the sense that every recorded decision marks out the future course of a given life, have been largely lost, much has been gained. Many of the narratives of this section have great vividness, others display a kind of intimate almost domestic pathos that is quite absent from the legendary stories. In particular, the psychological portrayal

of a number of characters can seem almost modern in its startling complexity and accuracy: the rebellious Bahram Chubineh, for example, and his sister Gordiyeh, who is the dominant female in the second half of the poem and is outspokenly loyal to the ancient ways. The very end of the poem, which recounts the Arab conquest, is an astonishing tour de force of writing. The last Persian commander writes a long letter to his brother that prophesies in devastating detail the disasters that will befall Iran under Arab rule; but then in a few scenes Ferdowsi calls up simultaneously the glory that was departing, and the vanity of this glory; and he also shows us, without apparent condemnation or irony, the starkly focused simplicity of the culture's new conquerors. We see the glamour of the civilisation that is dying, and the poignancy of this, but also the valour of the new civilisation that is emerging.

The variety, complexity and depth of Ferdowsi's achievement in the *Shahnameh,* the extraordinary ethical concentration of many of his narratives, the breadth of the human panorama he shows us, the way he draws on utterly different kinds of narrative and weaves them into a compelling whole, the seriousness with which he discusses the problems to which he constantly returns, especially those of authority and loyalty and the circumstances in which these break down, together make his poem one of the most compelling and memorable works of world literature.

THE TRADITION OF ILLUSTRATION
BY BARBARA BREND

The vast sweep of the *Shahnameh* means that it presents a truly enormous range of possible subjects of illustration – as it were, the individual frames of a gigantic film. And the subjects known to have been illustrated are indeed very numerous, though choice and tradition have concentrated much more on some subjects than on others: warfare, especially the single combat and the pursuit, and murder have been chosen more frequently than scenes of triumph, feasting, or even scenes of an amatory nature, and the mythical and phantasmagorical have usually been preferred to the everyday. There are of course notable exceptions to these general tendencies, and of course we need to recall that such sights as an enthroned ruler, though relatively uncommon in our experience, may have been much more usual for the patrons of the manuscripts. The study of the choices made for any particular manuscript, its cycle of illustration, can be very illuminating, but it is beyond the scope of this exhibition; indeed, many of our exhibits are separated folios, whose intention and meaning must be deduced without the support of companion pages. In the study of Islamic manuscript painting we have to deal with many uncertainties. There is constantly the question of how much material that once existed is now lost, and, though precise answers are sometimes available, questions as to origin, dating or patronage must often be answered according to the balance of probabilities.

The question of the earliest *Shahnameh* illustrations is a case in point. Pictorially we can start long before the earliest survival of illustrated manuscripts, and indeed before Ferdowsi himself wrote. Wall paintings made in Pendjikent (now in Tadjikistan) in about the early eighth century, before Muslim rule had become dominant in Sogdia, have been interpreted as showing the adventures of Rostam.[1] The scale is large and the format horizontal: noble warriors ride parallel to the picture plane on heavy horses, similar to those of the Sasanian cavalry seen in the rock carvings of western Iran. There is combat with horses in flying gallop, and an encounter with a serpentine dragon; a degree of spatial depth is indicated by outcrops of rock, from behind which spectators watch the action. These mounted warriors, with their broad shoulders and narrow waists, are reflected in some of the slip-painted pottery of Khorasan of about the tenth century, but are then lost to view.

The next survivals are, however, again in the area of ceramics. On the one hand, by the thirteenth century, lines from the *Shahnameh* are used to adorn grand buildings or elegant bowls. These quotations may have taken on the character of proverbs, or be descriptive: so far as has come light, the inscribed tiles are not much concerned with narrative. But in parallel with these, some ceramics with figural decoration do evoke the stories. There are tiles or bowls with images that are easily recognised: Faridun riding an ox, or Bahram Gur with Azadeh on a camel. There are also vessels with sequences of images unaccompanied by inscription that – at least for us in the present day – may be more difficult to decode.[2] In the *mina'i* technique of under- and overglaze decoration, which permits the use of several colours, these sequences of pictures tend to suggest borrowings from illustrations in manuscripts. At present there is no known copy of the *Shahnameh* that matches them.[3] More easily interpreted are a few tiles that present both a figurative image and a written label. Particularly interesting in this respect is a fragmentary star tile, now in Boston,[4] that is entitled 'The Iranians leaving Forud's castle', for if such an undramatic moment is portrayed, the whole scheme must have been extensive indeed.

Large cycles of illustrations are also found among the so-called 'Small' *Shahnamehs*, four divided works from about the turn of the thirteenth century that benefit from an outbreak of survival (nos 17–22). The dating of these *Shahnamehs* must depend on a network of comparisons with other illustrated manuscripts of known date from 1287 to 1307,[5] and their production is probably to be understood as indicating a quickening of interest in the Persian national epic on the part of Il-Khanid overlords. Though the frequency of illustration in the Small *Shahnamehs* may be related to the tradition of tile decoration, the style of drawing is very different. Illustrations are indeed small, though the folios vary, and they are predominantly horizontal in format. Landscapes display some debt to the Arab school, but they are peopled by figures whose supple movement suggests a contribution from Chinese painting, and who wear correspondingly Eastern armour or silks with lotus designs.

Chinese influence, especially that of pen drawing, together with a contribution from East Christian art, is evident in an important work of the early fourteenth century, which, though not itself a *Shahnameh*, acknowledges the *Shahnameh* as a historical source. The *Jami' al-Tawarikh* ('Compendium of Histories') of the scholar-statesman Rashid al-Din, produced in Tabriz in 714/1314 (nos 23–6), was an intellectual and political project that aimed to situate Mongol history among that of other peoples of the known world, and to assert this achievement by sending copies to the Arab and Persian provinces of the Mongol Empire. As befitting such a scheme, the folio size is large and the scribes are able to produce a more fluent *naskhi* than the rather crabbed hands of the Small *Shahnamehs*. Evidence from the sixteenth century, in the form of a preface to an album of calligraphic specimens and paintings, is understood to indicate that the great

Shahnameh that follows upon this work was produced for Abu Sa'id (*reg.* 1316–35); a dating at the end of his reign now finds general agreement, and this manuscript also would have been made at Tabriz, its cycle of illustration perhaps selected to reflect the patron's life and times.[6] Now known as the Great Mongol *Shahnameh*, though previously as the 'Demotte' after the dealer who dismembered it, this is a work of a majesty and solemnity beyond any previously illustrated in the Islamic field (no. 27). Its pictures tend to a more upright format, though not exclusively, and its colours are rich and somewhat sombre. Landscape and interiors are rendered more fully, detail is plentiful, and the intense figures seem to exercise a hypnotic force upon the viewer (fig. 5). The remains of several other *Shahnamehs* on a grand scale are preserved in albums in the Topkapı Library in Istanbul. The style of the Great Mongol *Shahnameh* is still influential here, but the action is slightly distanced and calmed. In one such group, datable to about the third quarter of the century, a picture, which may show 'Key Khosrow takes possession of Bahman's castle' (fig. 6), is interestingly self-referential, since the wall tiles depicted contain lines from the *Shahnameh*.[7] In the interim between these two grand copies the first known illustrated copy of one of the successor epics, the *Garshaspnameh*, was produced in 755/1354, very probably at the

fig. 5

Iskandar and his men slay a dragon

*c.*1335

Keir Collection, PP2

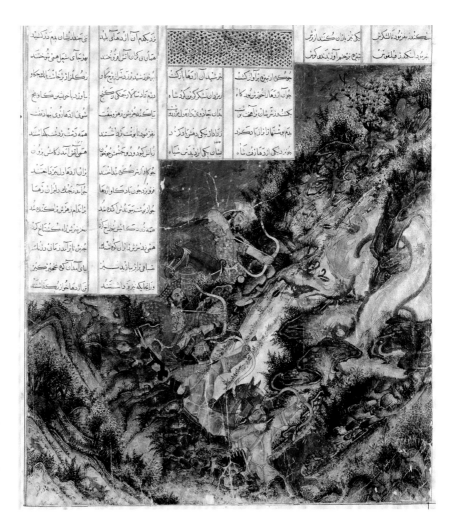

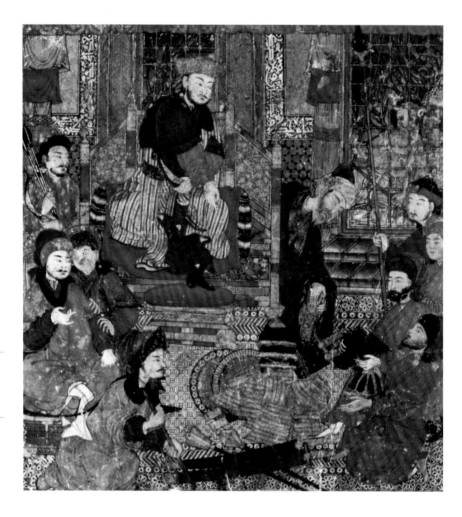

fig. 6

**Kay Khosrow
takes possession
of Bahman's castle**

Third quarter
fourteenth century

Istanbul, Topkapı Sarayı
Müzesi, H.2153, 55a

Jalayerid court in Tabriz.[8] Meanwhile, provincial schools had
developed highly distinct styles. Mainly concentrated in the second
quarter of the fourteenth century, in Shiraz under Inju rule, is a
style possibly derived from a tradition of wall painting: the format
is horizontal, the palette dominated by red and ochre, and figures
are tall in the picture; the drawing is rapid and almost careless,
suggesting that it derives from familiar prototypes. A somewhat
similar style, though smoother and favouring blue and red, is possibly
to be associated with Esfahan.[9] By the late century, with Mozaffarid
rule established in Shiraz, a new style emerges in a *Shahnameh* of
772/1371.[10] More sophisticated than Inju painting, and indeed very
mannered in the presentation of landscape, a notable feature of this
style is the fact that the faces of its figures appear to be set excessively
forward of their necks (fig. 7). This trait appears to have its origins
in Arab painting, and is an early instance of the tendency of Shiraz
painters to imitate work of the more metropolitan centres.

The first member of the Turkish Timurid dynasty to commission
Shahnameh illustrations was probably Timur's grandson, Pir Mohammad
b. 'Omar Sheykh, who was governing Shiraz when – it is thought – a
two-part work was produced there, one volume being dated 800/1397.[11]
Recent work has suggested that illustrations were not a part of the

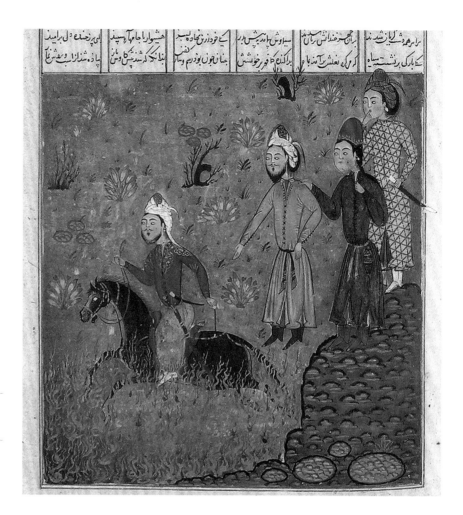

fig. 7

**Fire ordeal
of Seyavosh**

772/1371

Istanbul, Topkapı Sarayı
Müzesi, H.1511, 50a

original scheme; nevertheless, their style would seem to place them
before the governorship of Eskandar, Pir Mohammad's brother and
successor. The volume with the *Shahnameh* contains five illustrations
only (fig. 8); the dated volume has eleven, covering three successor
epics and a Mongol history. The scheme is thus characterised by
restraint as to quantity but the illustrations are beautifully realised,
as is the neat script, and illumination in the 'soft-leaf' manner of Shiraz
at the time; the classical palette of Persian painting with its emphasis
on turquoise, amethyst and lapis lazuli is already in evidence. There
is probably a background aim to weld together Persian and Turko-
Mongol culture, but purely aesthetic considerations are to the fore.
The same highly selective principle is seen at work in anthologies for
Eskandar, which accord single illustrations to their excerpts (fig. 9).[12]

The fascination exercised by the *Shahnameh* is more evident in three
manuscripts commissioned by three sons of Shah Rokh b. Timur
who, some thirty and more years later, perhaps feel that the epic is
fully theirs. Undated but the earliest by style, the volume for Ebrahim
Soltan b. Shah Rokh, governor of Shiraz, may have been made in
the late 1420s (nos 30–9); its compositions are spare though vigorous,
probably because artists had been removed from Shiraz to Herat, but
its rich illumination in the manners of both Shiraz and Tabriz is the

The center title reads:

رفتن رستم زال
بجنگ دیو سفید

رفتن رستم زال بجنگ دیو سفید

بدانک تو پس و زیرباش چکر
براخت چکی نیک رانیم
نه اسناد کس پیش او درجک
بگرداده دنخ نیکی های دل
چو مرکان بماليد وديده
بزنگ شب روی وجهر شری
براشفت برسان شیران
می کوشت کنداباز ازان اژده من
کرایذ ونک انجک این اژده ها
دوش بر زمین هم جوسشین

اکر یاد باشدت پرورگر
بنروبد و جو بعد برکتم
کون یکی رمان کرده باید
تن جان و وی ارتیس کی باید
درغان تاریک چندی
جهان بر زالا بجهای او
یکی تیغ تیزش برده بمیان
می کشد رستم کرا مرود
بریده پی و پوسنان برهاجان
جان کردن تا او ورز کرد

بران تاب ابد بلند آقا
نکرد آبی دفر برستم شا

برستم آمذ جو کوهی
بنیر وی رستم زبا باید
چنک رستم جنده ام جاد دوا
نه بیش بنیم نه بهن زندا

آنا هش ساعد وراهن
معتاد یک ران ویک پای
میان ده دست و برداشتش
قوبو ده پنجه دلس بردی

سربای او لاد و اکرد
میان سپاه اندرآ کرد
وزانجا یکسوی دنید
زمانی همی بود درجک تع
بنابکی اید دیکی کود ویلا
اذ و شده لبین پنب
بدرده شت و برداشش
کشیش

نغم کنذا کینی برنشت
سرابزا بجمر می دکرده
یا منذکرد ازا بنذه شید
بنذه های دینار و جای کی
تن جاذ اذ بریس نیکی یابذ
بنسید کا منذ نیکی کشیش
جوسلی بنا فزار دیوق بنا
کذ انجان نشیر بنیم شاا
نکرد نا آده و افکله کبنیر
جکش از دنی بنه پیروز

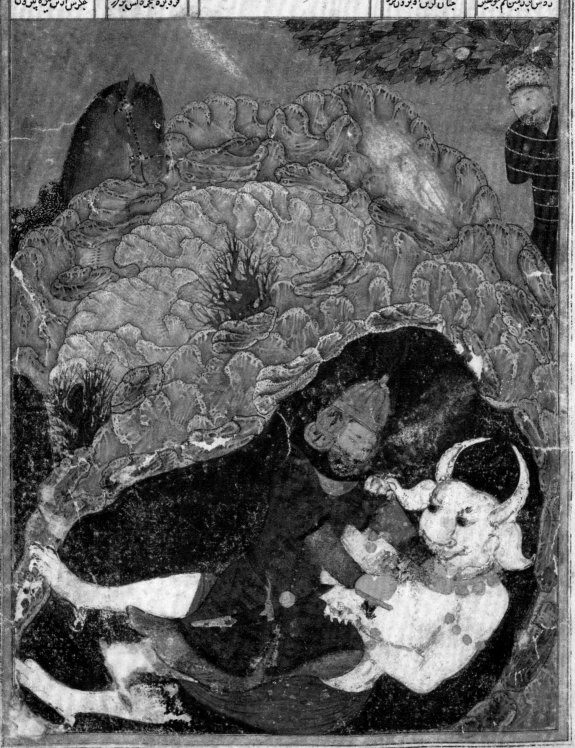

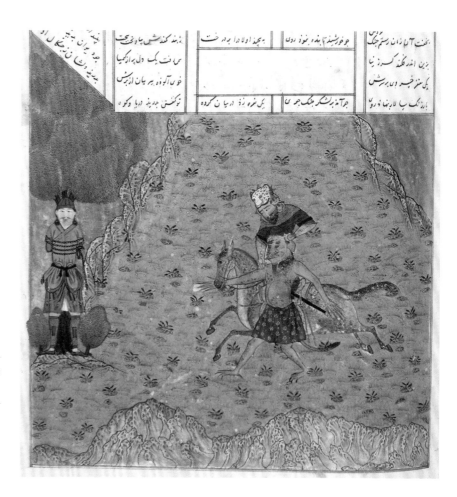

fig. 9

Rostam's fifth Peril: he kills Arzhang

810/1407 Anthology

Istanbul, Topkapı Sarayı Müzesi, H.796, 70a

fig. 8

Opposite

Rostam slays the White Div

*c.*1400

Dublin, Chester Beatty Library, Persian 114, 50a

work of a major specialist who had been retained, Nasr al-Soltani. Dated 833/1430, the manuscript made for Baysonghor b. Shah Rokh was copied by Ja'far al-Baysonghori, a celebrated calligrapher in *nasta'liq*, and its illumination is executed in minute detail in the mode of Herat. Its cycle is of moderate extent, the *Shahnameh* illustrations numbering nineteen (fig. 10), with one more for the *Barzunameh*, but the treatment is extremely sumptuous. Last of the three is the copy made for Mohammad Juki b. Shah Rokh and not entirely finished as a result of his untimely death in 1445: this has poised compositions and a limpid palette, and encompasses humour and a sense of impending doom (nos 43–55).

The court taste of late fifteenth-century Herat appears to have turned away from the *Shahnameh* but production at a lesser level is found at various centres. In Shiraz under the Timurids the style of Ebrahim's volume was perpetuated and elaborated into a more wild and wind-blown look until the mid-century. In the latter half of the century a style developed in Shiraz, under the Aq Quyunlu, that now goes by the name of Commercial Turkman, having round figures and calmer scenery than the previous type, this was probably instituted by painters trained in Herat but displaced on the death of Shah Rokh in 1447. The style has a very steady level of production and there are some indications that associate it with religious confraternities, such

as the Kazaruni – for whom manuscripts may have provided a source of income. There seems also to have been a school of painting in the late fifteenth century in Transoxiana: it manages to unite unimpressive and rubbery figures with occasional instances of dramatic rock in its landscape. Apart from these groups there are occasional manuscripts that seem to represent the single ambition in patronage of an individual of some standing. Seemingly such feelings were particularly cherished in Mazandaran. One example is the 'Dunimarle' *Shahnameh* of 850/1446 for a patron in Mazandaran who records his ancestry through eighteen generations (no. 4). Another is the extraordinary 'Big Head' *Shahnameh,* made in Lahijan in 899/1493–4, which suggests the ferment of ideas that must have surrounded the young Esmaʻil Safavi, who was nurtured there for safety before emerging to take the throne (nos 60–3).

It is at this period also that the influence of Persian manuscript painting begins to make itself felt in other countries. Style from Shiraz, or its variant from Yazd, is transferred to India, perhaps in part by Kazaruni adherents in trading stations, and manuscripts are produced that go by the classification of Sultanate. If much about the Persian tradition is uncertain, the framework of Sultanate painting in India is yet more debatable – including the question as to which manuscripts qualify for inclusion. Traits that are prayed in aid are: any resemblances to Jain painting; resemblances to items of Indian architecture; features of Persian culture misunderstood; and features that appear archaic, when compared with the accompanying script – a class that may include items that convey a strongly Chinese impression and hence an association with the fourteenth century, and instances of the Mozaffarid 'forward-set' face. These matters taken into account, the debate continues as to where and when Sultanate manuscripts were produced. Four *Shahnamehs* datable to the second quarter of the fifteenth century are a divided copy, whose precise origin is uncertain, a 'Jainesque' copy probably from the Deccan (fig. 11), and a copy of 841/1438 that may be from Gulbarga, and exhibit 92.[13]

A more clearly defined instance of the reception of a fifteenth-century style is demonstrated in a two-volume work in the Topkapı Library. This is a Turkish translation ordered by the Mamluk sultan Qansuh al-Ghowri in 1501 and completed in 916/1511, his purpose being to make the epic available to non-Persian speakers. The illustration appears to depend to a considerable extent on a Commercial Turkman model of 1486, and it is thought probable that artists from the Aq Quyunlu area might have taken refuge in Egypt at the coming of the shiʻi Safavids.[14]

The year 1501 sees the Safavid dynasty established in Tabriz. Four illustrations have come to notice from an unfinished *Shahnameh* that is thought to have been begun for Shah Esmaʻil (*reg.* 1501–24), and possibly abandoned following his defeat by the Ottomans in 1514. Proceeding from the Court Turkman style of the previous century (which is not known to have produced a *Shahnameh*) it is buoyant

fig. 10

Faramarz mourns Rostam and Zavareh

833/1430

Tehran, Golestan Palace Library, MS 716 (MS 61) p. 429

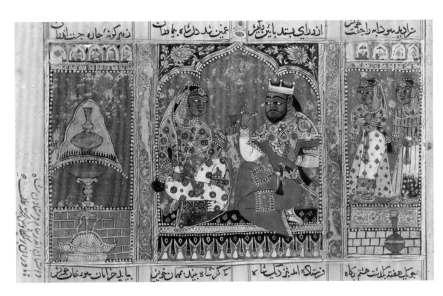

fig. 11

Wedding of Kavus and Sudabeh

Second quarter fifteenth century

Paris, Musée Guimet, MA 5113, 78a

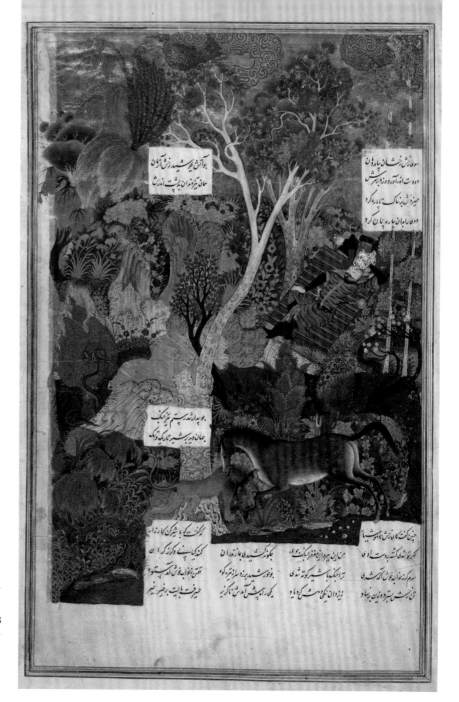

fig. 12

**Rakhsh kills a lion
while Rostam sleeps**

*c.*1505–15

London, British Museum,
1948, 1211, 023

in line and colourful, making educated use of fourteenth-century
work that must have been stored at Tabriz (fig. 12). Esma'il's son and
successor, Shah Tahmasp (*reg.* 1524–76), evidently was not minded
to continue his father's projected volume, but instead commissioned
one of his own. Tahmasp had been brought up in Herat and returned
to Tabriz in 1522 bringing artists in his train, among whom was
the celebrated master Behzad. Their influence added refinement and
elegance to Turkman exuberance. The great manuscript eventually
contained 258 illustrations, in margins sprinkled with gold; its
colophon is not present but a picture in its latter half is dated
934/1527–8. Compositions are orchestrated with verve: the palette
is radiant with a strong role for the blues; figures are relatively small
in the picture and there is thus space for considerable complexity of
action; detail is rendered with inventiveness and subtlety (see no. 64).
Two features that assert the importance of the picture in relation to
the text would prove influential during the following two centuries:

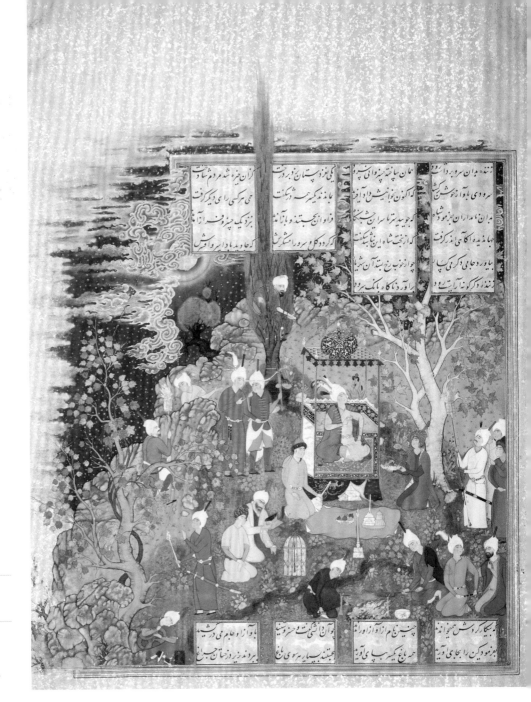

fig. 13

**Barbad plays for
Khosrow Parviz**

*c.*1530

Nasser D. Khalili
Collection of Islamic Art,
MSS 1030, 731A

continuation of the scene between the columns of text; and the use
of such considerable extensions into the margin that large portions
of the rulings are as though swept away (fig. 13). The manuscript
has sometimes been named after Arthur J. Houghton, who
dispersed it.[15]

Whether from growing religious scruples or failing eyesight or a
combination of the two, Tahmasp turned away from painting in
the 1560s. For some court painters this may have been a stimulus
towards the production of single pictures for collection in albums, as
they sought to support themselves. However, in Shiraz the production
of manuscripts, presumably for the merchant class, continued (fig. 14).
By the mid-century there is a reflection of Tahmasp's style, with
spacious compositions and more ornamental detail, though with
a more limited palette and rather mechanical figures. Illumination
and bindings are dependably splendid (fig. 15).

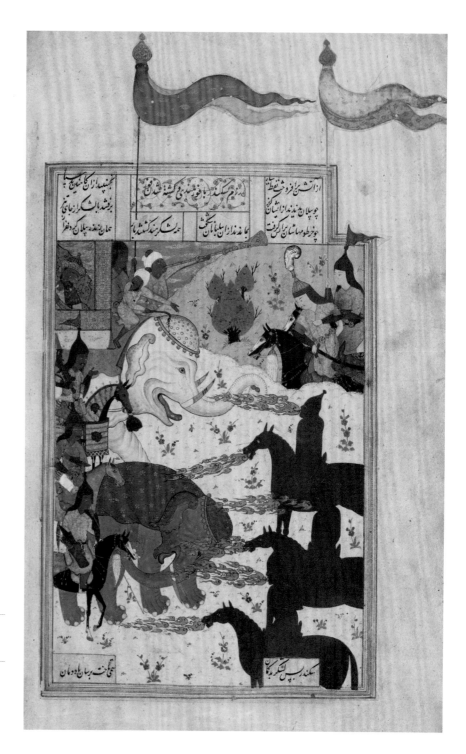

fig. 14

**Eskandar's
iron horses**

949/1542

University of Manchester,
John Rylands University
Library, Persian 932, 381b

Royal patronage returns with the *Shahnameh* datable to 1576–7,
the brief reign of Esma'il II, and now dispersed. Probably made in
Qazvin, this work seems deliberately to turn away from the style
of Tahmasp's volume. Eschewing complexity and detail, it presents
elegantly pared-down scenes, in which landscape may be reduced to
washes of colour, and where extensions into the margin are lent an
ironic emphasis by an additional outer set of rulings (fig. 16 and
no. 73). The names of artists appear on the majority of the pictures.
It may be that the *Shahnameh*, previously felt as an enveloping myth

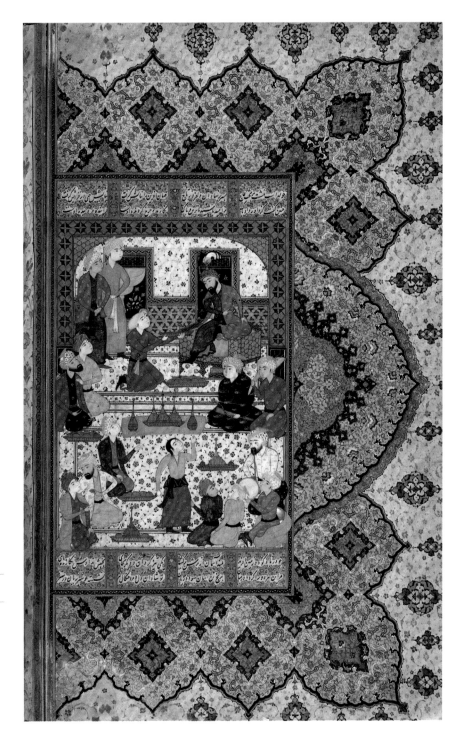

fig. 15

Lohrasp enthroned

Shiraz style
illuminated border
c.1590

London, British Library,
I.O. Islamic, 3540, 307b

Detail overleaf

justifying kingship, here begins to be seen in a more detached manner
as source material for the conscious production of art. Of 991/1584 and
in a style of Qazvin tradition, is a *Shahnameh* once in the possession
of Sir Bernard Eckstein.[16] It is one of the so-called 'truncated' group in
which some of the later and more historical matter is omitted, though
successor epics may be included; it has been suggested that this is an
adaptation to suit the taste of Ottoman Istanbul. Illustrated copies of
the translation made for Qansuh al-Ghowri and of verse translations
continued to be made for Ottoman patrons (fig. 17).[17]

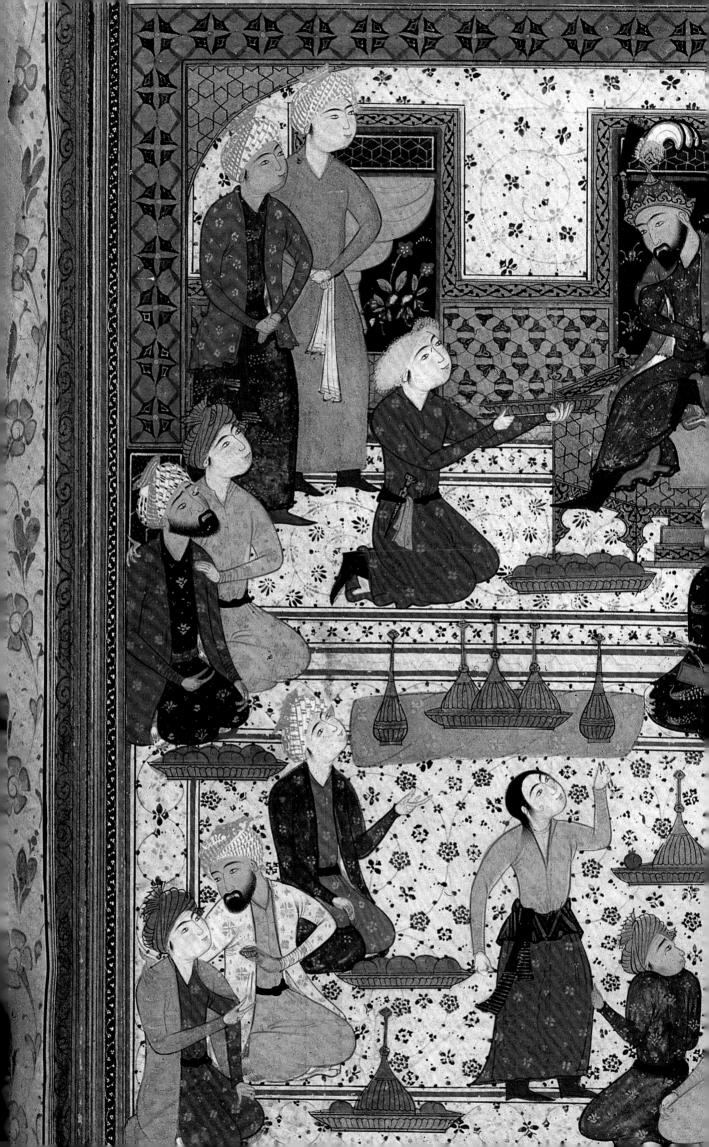

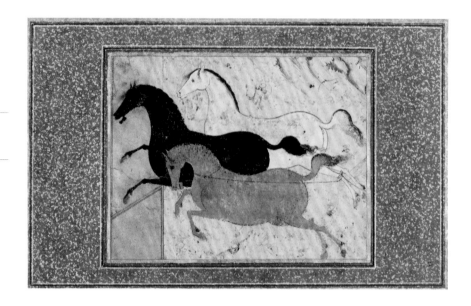

fig. 16

**Three horses
in flight**

Probably part of
an illustration from
the *Shahnameh* for
Shah Esma'il II,
1567–77

London, British Museum,
1930, 0607, 0.10

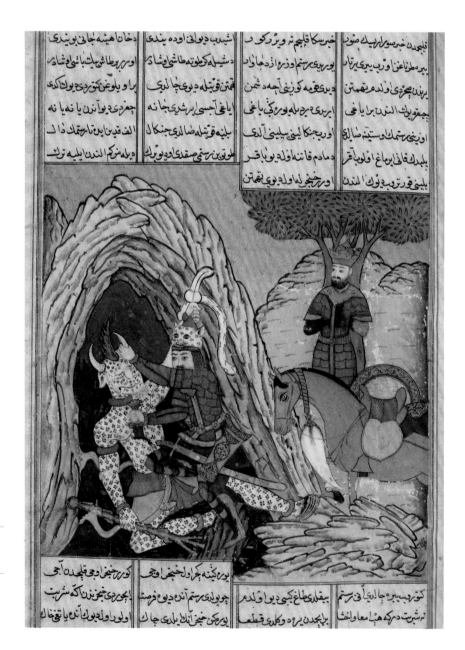

fig. 17

**Rostam slays
the White Div**

1590s

London, British Library,
Or. 7204, 104a

Shah 'Abbas came to power in 1587. His great project was to be the creation of a new capital in Esfahan, to which he moved in 1598, and to which he encouraged the representatives of many nations. In consequence, court artists of the early seventeenth century were somewhat removed from old centres of tradition, but on the other hand more closely confronted than heretofore with the styles and manners of people of other lands, amongst whom were Europeans. In this milieu, it is not surprising that many painters turned their attention to single-figure studies of fashionable persons. Nevertheless, it seems probable that a *Shahnameh*, known only by a few folios in the Chester Beatty Library, was begun in the first decade of 'Abbas' reign.[18] This follows the relative simplicity of composition of that for Esma'il II, but with richer colour and more confident flourishes. Drawing perhaps on the mode of the single-figure pieces for backgrounds of wispy clouds and hills, some illustrations are remarkable for the near dissolution of the rulings that delimit the picture space, so that the scene and marginal illumination tend to blend into a whole (fig. 18).

In the second and third quarters of the seventeenth century a series of *Shahnamehs* was produced with pictures signed by Mo'in Mosavver, who is also known for separate drawings. The prominence of Mo'in suggests a growing respect for, and independence of, the artist. In these illustrations the influence of the single-figure studies is still very noticeable, with figures standing in the fashionable curved posture, attention concentrated on a few figures, and with landscape treated as an ornamental background, often of an arbitrary pink. But the reduced importance of landscape is not universal: there is indeed a contrary tendency that shows it as turbulent, almost matching the energetic figures that inhabit it. A location in Astarabad has been posited for this style, but at present the evidence is suggestive rather than compelling. A further indication of vigour in the painting of eastern Iran is, however, to be seen in the manuscript produced in 1058/1648 for Qarajaghay Khan, governor of Khorasan (no. 86);[19] presented to Queen Victoria on 1839, this is now preserved in the Royal Library at Windsor. Its illustrations have an interesting tension between the passionately charged landscape and the dignity the figures.

Traces of European influence are to be detected intermittently in Persian painting from at least the early fifteenth century onwards, but in the later seventeenth century they become very evident in the work of Mohammad Zaman. Having encountered European prints, and probably also oil paintings, his individual style encompasses volumes that are marked by strong shading, cast shadows, and receding prespectives.[20] A picture of 1087/1676 added to the *Shahnameh* begun for Shah 'Abbas I unites the Persian treatment of the Simorgh, linking picture and margin, with a Europeanising, if perhaps over careful, landscape (fig. 19). In the eighteenth and early nineteenth centuries the influence of oil painting or of European watercolour overtakes that of prints: pictures gain in naturalism and lose sharpness of focus. With the advance of printing, the demand for illustrated manuscripts

fig. 18
Overleaf

Faridun's envoy before the King of Yemen

*c.*1590

Dublin, Chester Beatty Library, Persian 277, 10a

fig. 19
Overleaf

The birth of Rostam

Mohammad Zaman, 1086/1675–6

Dublin, Chester Beatty Library, Persian 277, 3b

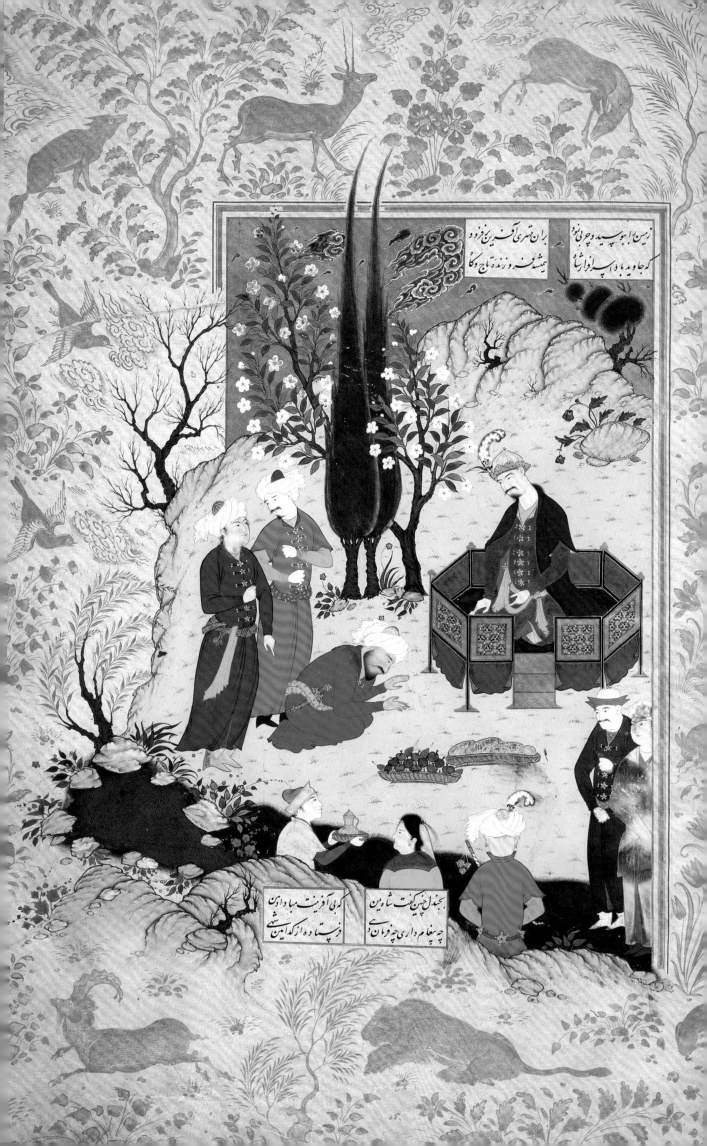

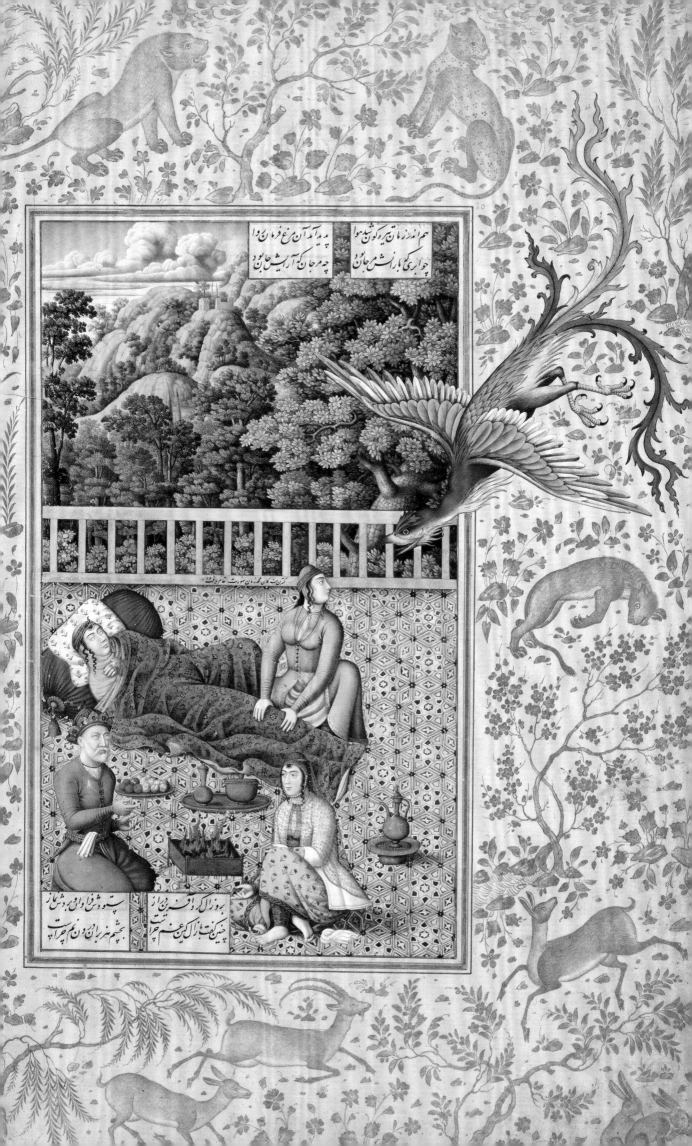

grew less, but in the later nineteenth century figures from the *Shahnameh* continued to be used in schemes of tilework. The heroic image of Rostam continued to inspire, and into the twentieth century could be found painted on cloth in a coffee-house as a background for storytelling. Most recently in 2009, Fereydoun Ave has used the figure of Rostam in the guise of a wrestling *pahlavan* for a series of mixed media works under the title 'Rostam in the Dead of Winter' (fig. 20), in which the traditional hero of Iran pursues his way regardless of vultures and blood – a symbolism that evidently lends itself to interpretation.

fig. 20

**Rostam in the
Dead of Winter**

Fereydoun Ave, 2009

London, British Museum,
2009, 6026.1

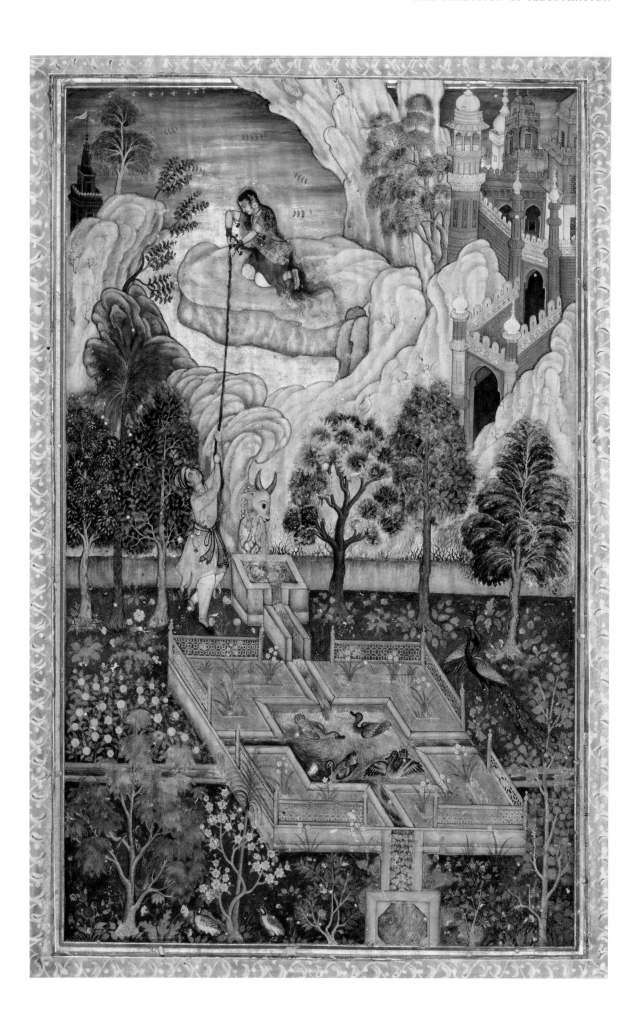

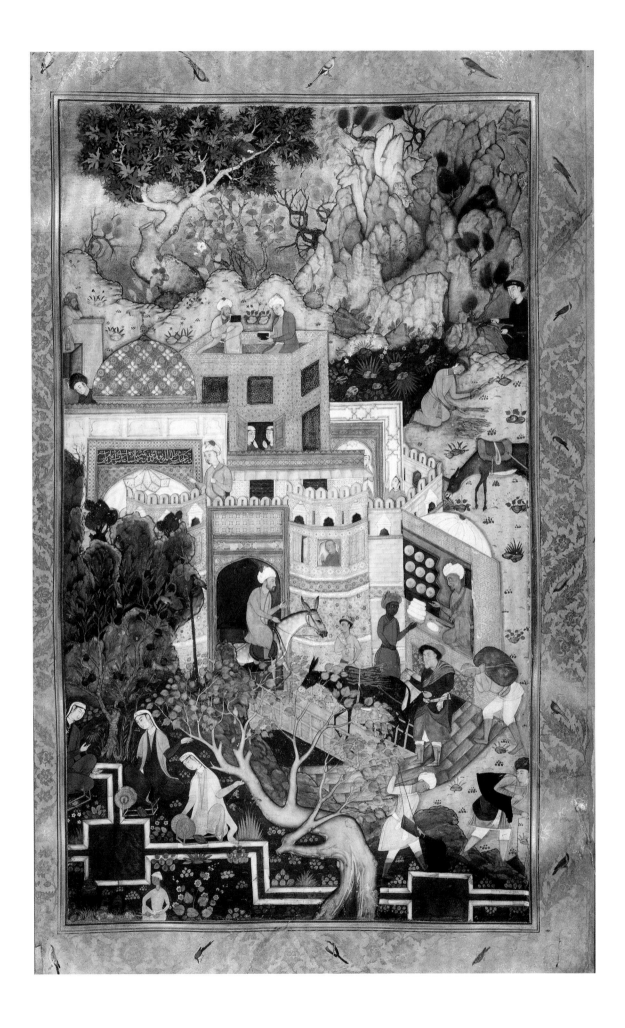

Following the Mughal conquest of northern India under Babur in 1526, and the loss and reconquest of the land under his son Homayun, an astonishing production of illustrated manuscripts is undertaken for the third Mughal ruler, Akbar (*reg.* 1556–1605). Though scattered elements from the Sultanate period may still be detected, the main influences that are united in Akbari style are Safavid from Tabriz, Hindu from Vijayanagar, and European – this being particularly strong following a Jesuit mission in 1580. An historical reference is known to a *Shahnameh* made for Akbar, but only a single beautiful page is thought to survive from it (fig. 21).[21] There is, however, a copiously illustrated copy of a successor epic, the *Darabnameh*. This is undated but should not be far removed in time from the Jesuit mission; it seems likely that the *Shahnameh* would have preceded it. No *Shahnameh* is known to have been made for Jahangir (*reg.* 1605–27), but variations on a painting by Dust Mohammad for Tahmasp's *Shahnameh* may be attributed to his patronage (fig. 22; see also no. 99). About the late sixteenth to early seventeeth century there was some production at the so-called 'sub-imperial' level, presumably destined for courtiers; and there was also some renovation of the illustrations of earlier *Shahnamehs*, whether from Iran or from the late Sultanate period, notably for 'Abd al-Rahim, Khankhanan (see no. 98). From the eighteenth and nineteenth centuries there is a considerable survival of manuscripts of a moderate quality that are usually ascribed to Kashmir; of superior quality and with informative colophons is a manuscript made in Rajaur in 1131/1719 (see no. 100). In the present catalogue it is suggested that a narrative concerning the Black Div, son of the White Div, may have been made for Tipu Sultan, ruler of Mysore (see no. 101). Late developments from the imperial Mughal style that exhibit a strong sense of volume are datable to early the nineteenth century and are ascribable to Lucknow or Lahore (nos 102–4).

Thus the tradition survives long in India, but it is in Iran that it is still carried forward.

fig. 22

**Haftvad's
daughter spinning**

Twelfth regnal year
[of Jahangir]/1617–18

Staatsbibliotek zu Berlin,
Orientabteilung,
Libr. pict. A117, 14a.

THE
'SHAHNAMEH'
IN ART
BY BARBARA BREND

وشعرا سپه بو که سیارات سپهر سخن پروری بو و ند به امثال امر سلطان مشغول شدند در اثنا ی این حال فنه و رسی
بغتی رسید بکنار باغی فنه و رو د و امد و کسی بسهر و ستا و تا بعضی و پسا نرا از رسید ان وا علام و بهرو ضوی ساخت
و دوکانه بکبار و اتفاق شعرای خسر و ی عصری و فنه سرخی و عجدی مریک با غلامی خوب صورت از خریدن ان
کرنجه صحبتی صوب و اشنه و ران باغ و جون فرود و جون سی از نماز فارغ شد نواست که ز مانی اینجا بنشیند و یک ایشان بود
جون توجه شدایشان باخو دکشاویا ین زا بند خشک وقت مانغث خواهد کرد و واجب الله فع است کمی از
ایشان کفت برو و پستی کنیم برو و عصری از ان منع کرد و دیکری کفت ترتیب مصراعی بکویم قفیه تنک و راو او

التماس پس رابع کنیم اکر بکو بید صحبت رسانیده و الا عذری باشد عصری کفت این بقاعده است جون بر پرسید او را
تلقی نمودند و صورت حال نقب بر کرد او در جواب کفت اکر بکو یم و الا زحمت یه یم عجدی کفت
جون عارض فنا ما نباشد روشن فرخی کفت ما تدارت کل بنو و رکلش عصری کفت مکات میکنم زرک بر جو بین

THE SHAPE
OF THE
'SHAHNAMEH'

Reference is made throughout to the English translation by Warner and Warner (ww).[1]

Measurements of text area and of pictures are given in millimetres and include the rulings. Where there is an extension into the margins the main picture size is given in brackets; where an extension is not attached to the picture the measurement is described as 'implied'.

1

FERDOWSI ENCOUNTERS THE COURT POETS OF GHAZNI

British Library, I.O. Islamic 133, 5b | Once owned by Warren Hastings
Folio 374 x 250 mm; text area 264 x 142 mm; picture (200) 284 (implied) x 195 mm
18 Dhu'l-Qa'da 967/10 August 1560 | Safavid: copied in Shiraz
Scribe: Hasan b. Mohammad Ahsan

Ferdowsi drew his material from a variety of sources and put it into verse. Many manuscripts, however, begin like the present example with a preface in prose. According to the preface used here, composed by or for Baysonghor b. Shah Rokh in 829/1425–6, Ferdowsi has travelled to Ghazni in the hope of gaining the patronage of Soltan Mahmud for his poem. In a meadow outside the city he encounters three poets of the court. They are not at all eager to have a newcomer in their midst, and they set Ferdowsi a poetic test, which, however, he passes triumphantly.

The verdant scene suggests the life of comfortable security that Ferdowsi seeks to join. The group of poets is dominated by the figure, mid-left, who wears a red surcoat over a green robe. It seems likely that, out of respect, the artist intends this as Ferdowsi, against the sense of the story, which presents the poet rather as a postulant.

Bibliography: Robinson, 1976 (IOL), nos 269–91; Uluç, 2006, p. 162

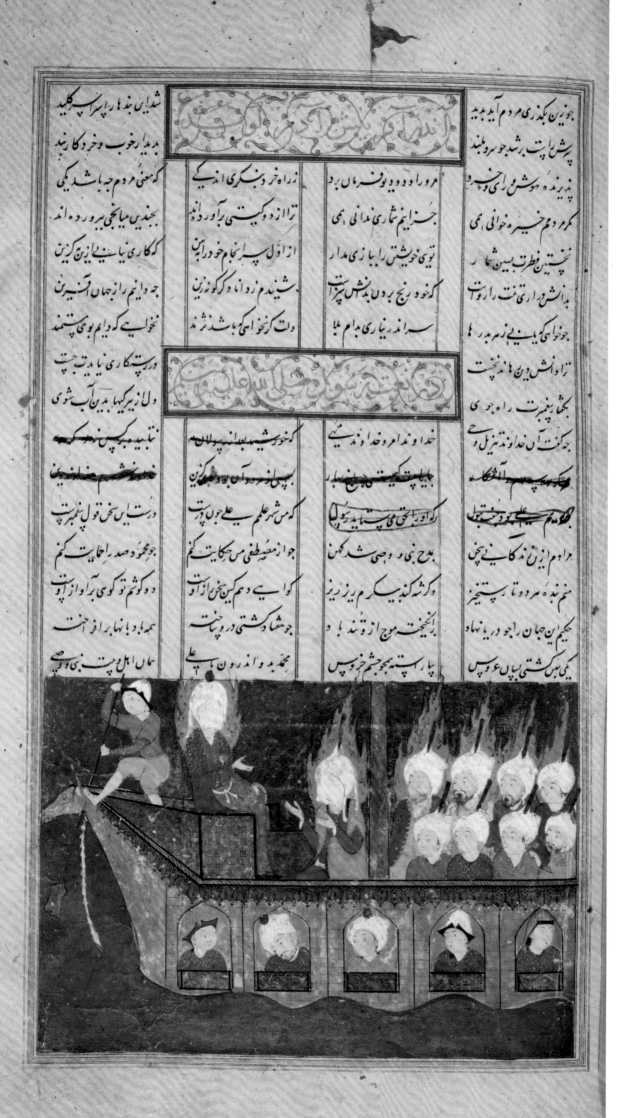

THE SHIP OF SHI'ISM

2

British Library, Add. 15531, 12a | Folio 340 x 215 mm; text area 240 x 145 mm; picture (99) 265 (implied) x 145 mm | Dhu'l-Hijja 942/ May–June 1536 | Safavid (Tabriz) ww, I, 107

The Prophet Mohammad and 'Ali, his son-in-law, both veiled, are shown in a ship that represents the shi'i branch of the Muslim religion. Ferdowsi admits the existence of other approaches to religion in the form of seventy other ships, but his devotion is entirely to shi'ism. This may in part explain his falling out with Mahmud of Ghazni, who was of the sunni persuasion. References to the four caliphs accepted by sunnis as successors to the Prophet have here been scored out. The reference to 'Ali, the fourth caliph, is scored through more lightly than are the others, perhaps because he is revered in shi'ism.

At the period of the manuscript, shi'i affiliation was indicated by a turban wound round a cap with a high central projection. The illustration can be seen as a considerably simplified version of that in the *Shahnameh* for Shah Tahmasp, painted approximately a decade earlier.

The manuscript contains several owners' inscriptions of the nineteenth century.

Bibliography: Rieu, 1881, p. 535; Titley, 1977, no. 109; Shani, 2006, fig.7

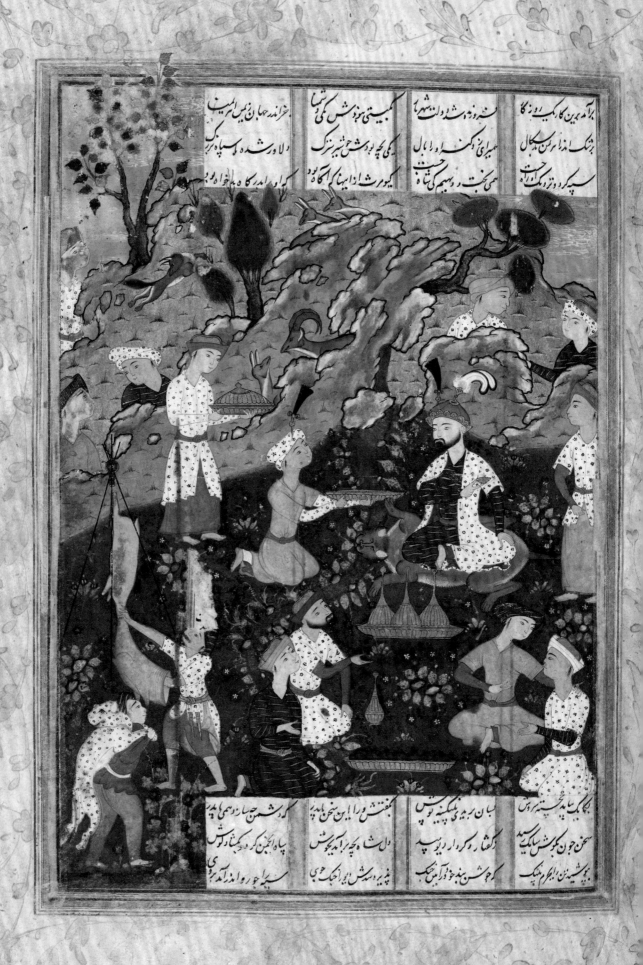

THE COURT OF KIYUMARS

3

Cambridge University Library, Add. 269, 19a | Binding: Indian, early nineteenth century
Folio 372 x 233 mm; text area 254 x 138 mm; picture 254 x 182 mm | c.1580
Safavid (Qazvin/Mashhad) | WW, I, 119

In the early days of the world Kiyumars invents kingship. He holds
court in the mountains, his people dressed in skins. Beasts grow tame
under Kiyumars; he has a son and heir; there is a dawning of faith.
However, Ahriman (the devil, from Zoroastrian terminology) and
his son scheme in secret to take over this world.

The painter has not quite been able to set aside the vision of kingship
in his own day, and so the court is served from golden dishes. It is
not clear whether the snow leopard, bottom left, is enjoying human
companionship or about to be skinned. The human figures have the
slightly feline face that is observable in illustrations about the third
quarter of the century. The manuscript bears the imprint of the seal
of the Qotb Shahi ruler of Golconda, Mohammad Qoli b. Ebrahim
(*reg.* 1580–1611);[2] it was presented to the East India Company in 1806.

Bibliography: Browne, 1896, no. CXCVII; Rose, 2006

ازان رنج بردن جہ آمدش	ازویش بر تخت شاہی بنود	زمانہ ربودش چو جادہ کآ	شدان تخت شاہی وان دستگآ
کز کتی نخواہد کشادت درآ	جہ باید ہمی زندگانی دراز	بدید آوریدہ ہمہ نیک و بد	کذشتہ بروسالیان ہفتصد
بخواہد نمودن بتدبیر جم	یکایک چو بویی کہ کسترد	جہ آوان زنت نیاردبگو	ہمی پروراندت باشہدو
بدولت اندرون در زنم	ہمرا ز دل برکشایی بدوی	یکی نغز بازی برون آور	بدوشاد باشی وناری بدو
خدایا مرا زود برہان زرنج			دلم سیر شد زین سرای سپنج
بروسالیان شد ہزار	پادشاہی ضحاک ہزار سال کردن		چو ضحاک بر تخت شد شہریار

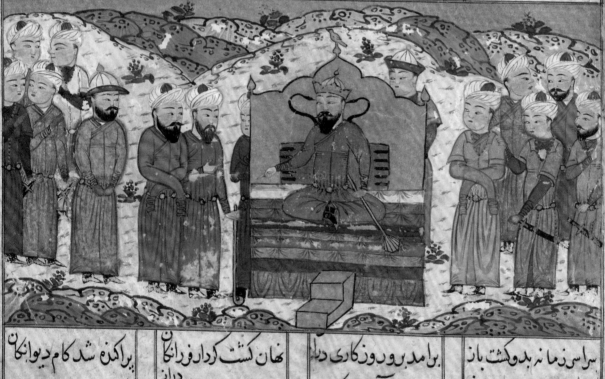

پراکندہ شد کام دیوانگان	نہان کشت کردار فرزانگان	برآمد زمانہ بدو کشت باز	سراس زمانہ بدو کشت باز
بنیکی نبودی سخن جزبراز	شہ بر بدی دست دیوان دراز	نہان راستی آشکارا کند	ہنر خوار شد جادوی ارجمند
سربایوآزاجواہس بدند	کجمشید را ہردو خواہند بد	برون آوریدند زان بند جو	دوپاکیزہ ازخانہ جمشید
بدان اژدہافش سپردندشان	بایوان ضحاک بردندشان	کہ پاک دامن بنام ارنواز	زبوشیدہ دویان یکی شہرنواز
جزاز کشتن وغارت و سوختن	نداست خودجزبدآموختن	یا ماوخنتشان کرئی بختی	پروردشان ازدر جادو

4 ZAHHAK ENTHRONED

British Library, Or. 12688, 22a | The 'Dunimarle' *Shahnameh*
Previously owned by John Drummond Erskine (Benares, 1801), and housed at
Dunimarle Castle | Folio 342 x 252 mm; text area 235 x 180 mm; picture 98 x 180 mm
11 Muharram 850/8 April 1446 | Provincial Turkman: copied in Mazandaran
Patron: Amir Mohammad b. Mortaza | Scribe: Fath-Allah b. Ahmad Sabzavari | ww, i, 145

Zahhak usurps the throne of Iran and rules for a thousand years less
a day. Eblis (the devil, in Arabic) has suborned the young Arab into
patricide; and he has kissed his shoulders with the result that snakes
grow from them that must be fed with the brains of men.

The manuscript is unusually well documented. An initial *shamseh*
('little sun', rosette) notes the patron's ancestry and thus indicates an
origin in Mazandaran. Planned to have 153 illustrations, the manuscript
was clearly intended as an expression of the patron's status. The scribe,
who is named in the colophon, was presumably more adept at the
naskhi script than the *nasta'liq*, which would have been usual in a more
metropolitan centre. The subheading above the picture in *sols* (*thulth*)
script announces the 1,000-year reign of Zahhak. The illustrations are
dependent on the 'Brownish' style that had been developed in Tabriz,
but some landscapes impress in an individual way with thundery,
purplish hues.

Bibliography: Robinson, 1959; Titley, 1977, no. 127, and 1983, pp. 64–6

5

FARIDUN MOURNS OVER THE HEAD OF IRAJ

British Library, Add. 18188, 55b | Folio 345 x 230 mm; text area 230 x 153 mm;
picture (100)118 x 153 mm | 23 Jumada II 891/4 July 1486 | Turkman (Shiraz)
Scribe: Ghiyas al-Din b. Bayazid *sarraf* (banker) | ww, I, 204

Rightful rule is restored under Faridun. He divides his lands between
his three sons: Salm receives Rum ('Rome', the area of the Classical
world), Tur receives Turan (Central Asia) and Iraj receives Iran.
Out of envy, the elder brothers murder Iraj. His head is brought
back to Faridun who takes it to mourn in Iraj's garden, which he
then destroys. The murder of Iraj is the cause of lasting enmity
between the people of Iran and those of Turan.

The contrast is well made between treachery, murder and mourning,
and the youthful promise of Iraj, represented by the beauty of his
garden. Courtiers weep and rend their garments, while Faridun almost
seems to seek to restrain them. Beside him is a cypress embraced by
a flowering bush, the cypress frequently being the symbol of a young
and graceful man or woman. The picture is in the style classed as
Commercial Turkman, which does not often attain this level of
pathos. Some other illustrations are in a variety of the Brownish
style. The manuscript was purchased at Sotheby's in 1850.

Bibliography: Rieu, 1881, p. 535; Titley, 1977, no. 111, and 1983, pp. 66–7, pl. 7;
Robinson, 2001, and 2002, *passim*; Amanat, 2006

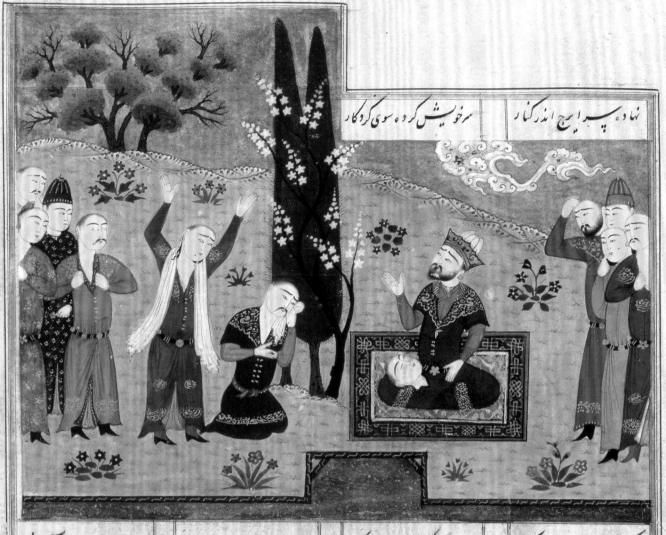

سر خویش کرده سوی کردگار | نهاده سر ایرج اندر کنار

همی گفت کای داور دادگر	بدین بی‌گنه کشته اندر نگر	بجز سرزنش خسته در پیش من	ثش خورد و پیشان آن انجمن
دل مرد و پیدا دراز انسان بسوز	که مرکز به پنداجست نیز روز	بداغ جگرشان بسی کن آزرد	که جشایش آرد بدیشان وزه
همی خواهم ای روشن کردگار	که جندان امان یابم از روزگار	که از نخم ایرج یکی نامور	ببینم بدین بیدکه پسنته کر
جو دیدم حزین زان سپس شاد یم	کجا خاک بالا به بها داده‌ام	بدین که نبریت آن شاه زاد	همی نا کیا رستش اندر کنار
زمین بسته و خاک بالین او	شده تیره زو شن جهان بین او	از بار بسته کشاده زبان	همی گفت زاری کای برده جوان
کس از تاجداران بدینسان نمرد	که تو مردی ای نا مبردار کرد	سرت را بریده بزار ز اهرمن	ثث راشده کام شیران کفن
خروش منا بی و جشم پر آب	ز مردم ده برده آرام وخواب	سراسر همه کشورش مروزین	به هر جایی گردی اخسن
همه دیده پر آب و دل پر خون	نشسته بنیا زو درد اندرون	همه جاه کرده کبود و سیاه	نشسته برابنه برمرک شاه
فریدون بثبنان سرا سرکشت	بران ماه رویان یکی بر شکشت	یکی خوب جهره برسنده زبد	کجا نام او بو د ماه افر یه
کایرج بر و مهر بیار داشت	قضا را کنیزک از و بار داشت	پری جهره را جه بد در نهان	از ان شاد شد شه یار جهان
از ان خوب رخ شد دلش پر آئ	بکین سپر داده را را نوید	جوسکامه زادن آمد بدید	یکی دخترآمد زماه آفرید
جهانی کرفتند پرورد نش	برآمد بیار و بزرگ یکی ثث	بران لاله رخ راز سرتا بپای	تو کفشی نکمک ابر جستی جای
جو برجست واگفت سکام شوی	جو بد یدش شد روی وجون قمر	نیا نام زد شه نامه دار من	بود داد و جندی برآمد درنک
کوی بود از نسل جمشید شاه	نژاد ورا شاهی و تخت وکلاه	بداوش بدان نامه دار شوی	جوگفت کاسی ی برآمد یروی

6 FARIDUN CROSSES THE TIGRIS TO CHALLENGE ZAHHAK

Fitzwilliam Museum, MS 22-1948, 12b | Given by P.C. Manuk and Miss G.M. Coles through NACF, 1948 | As re-margined 248 x 180 mm; text area 172 x 120 mm; picture 115 x 118 mm | *c.*1435–40 | Timurid (Shiraz) | ww, I, 160

Faridun of the royal Pishdadian line is coming with his followers to depose the tyrannical usurper Zahhak. Reaching the Tigris at Baghdad, Faridun calls on the river guard to give him the use of boats to cross. When this is refused, Faridun rides into the water, and his horses swim the river.

Here the focus is on Faridun's face with its fixity of purpose, while the curved necks of the horses oppose the curves of the sterns of the boats denied to him. The script is close to that of ʿAbd al-Rahman al-Khʷarazmi in a *Khamseh* of Nezami of 839/1435–6;[3] and a further comparison is offered by a *Khamseh* of Khʷaju Kermani of 1 Rajab 841/27 December 1437.[4] See also nos 7, 10 and 40–2.

Bibliography: Stchoukine, 1954, pp. 43–4; Wormald and Giles, 1982, II, pp. 406–7

برادر بدانست کاین آن است
برانده بدانش که پیش ن سپاه
باره بدان رود اندر آورد روی
سوم منزل آن شاه آزاد مرد
کشتی وزورق هم اندر
مرا باسپا هم بدان سور سان
جنبش افزایش گشت آن جهان
فریدون چو بشنید خشمناک

دلریده پیکار رود دست
دلش پر زرگینه زحاک شاه
جهان جوی لو ذ مرد هستیم
لب دجله و شهر بغداد او
گذر ذکیمیر بمن روی
ازین ها بکسی را اندین سون
سخن گفت با می نبی درها
وزان ژرف دریا بنیا مد

فریدون کز کرست داشت کشید
براه آشته کاویانی نبش
اگر پهلو اینے ندانے زیبا
جوآمد بترد یک او اندر رود
بدان نمازیان کنت فیروز
پیاورد کشتی نهبان رود
مرا کنت کشتی مراتابخت
بندی میان کیانے ست

کم کرد آن سخن را ابریشان
همایون نمان خسروائی
بازی نوا رو اندر احلط خوا
زودستاد زی روذ بان بنان
کشتی براکن هم اکنون زودذ
بنا مذ کنت جواز نهمرم یاتی
بران بارد بشیدذ دل بر
سرش تنگ شدکد کینه جنک را
باب اندر افکند کارنک را

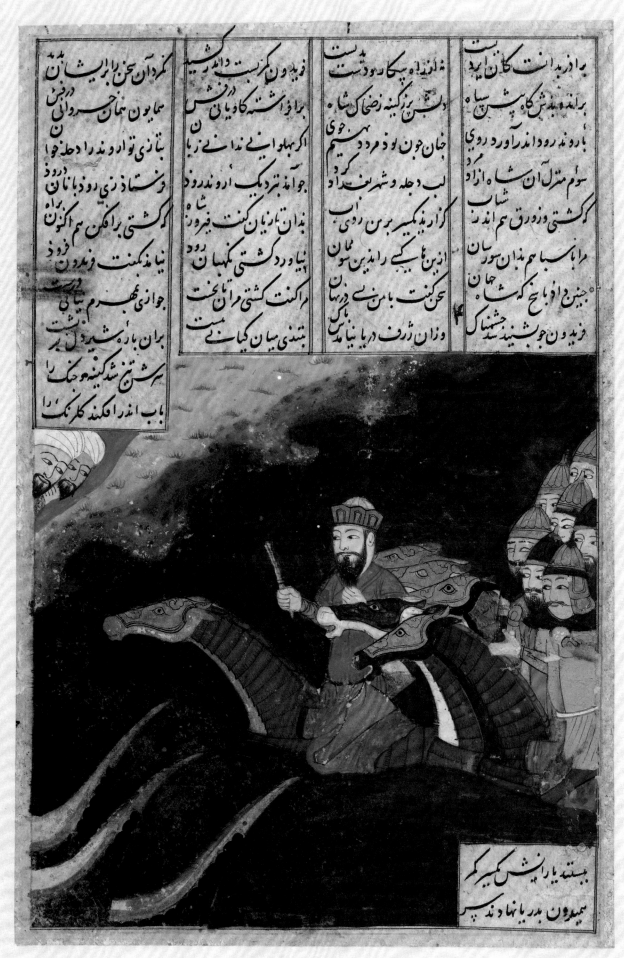

بستنه یا رانش کمیر کم
همیدون بدر یا بنهاده سر

ROSTAM LIFTS AFRASIYAB OF TURAN BY THE BELT

7

Fitzwilliam Museum, MS 22-1948, 22b | Given by P.C. Manuk and Miss G.M. Coles through NACF, 1948 | As re-margined 248 x 180 mm; text area 172 x 120 mm; picture 138 x (116) 142 mm | *c.*1435–40 | Timurid (Shiraz) | ww, II, 14

There is continual warfare between Iran and Turan. With the young king Key Qobad of the line of Faridun established upon the throne of Iran, the forces of Turan threaten. Rostam, who will be the mighty champion of Iran under a succession of kings, offers to take Afrasiyab, king of Turan, prisoner. Rostam is able to lift his adversary by the belt, but this breaks and Afrasiyab is able to escape.

In the ancient material of the epic Turan may have represented an Iranian group, but for Ferdowsi Turan correponds to Turkic groups who by his day had threatened Iran for some centuries. Rostam and his family have their own body of epic material based on Sistan in the south-east. Lifting an opponent is a significant element in unhorsing him because of the shape of the saddle used (see no. 87); shortly before this Rostam had lifted another Turanian from the saddle on his spear point. See also nos 6, 10 and 40–2.

Bibliography: Stchoukine, 1954, pp. 43–4; Wormald and Giles, 1982, II, pp. 406–7

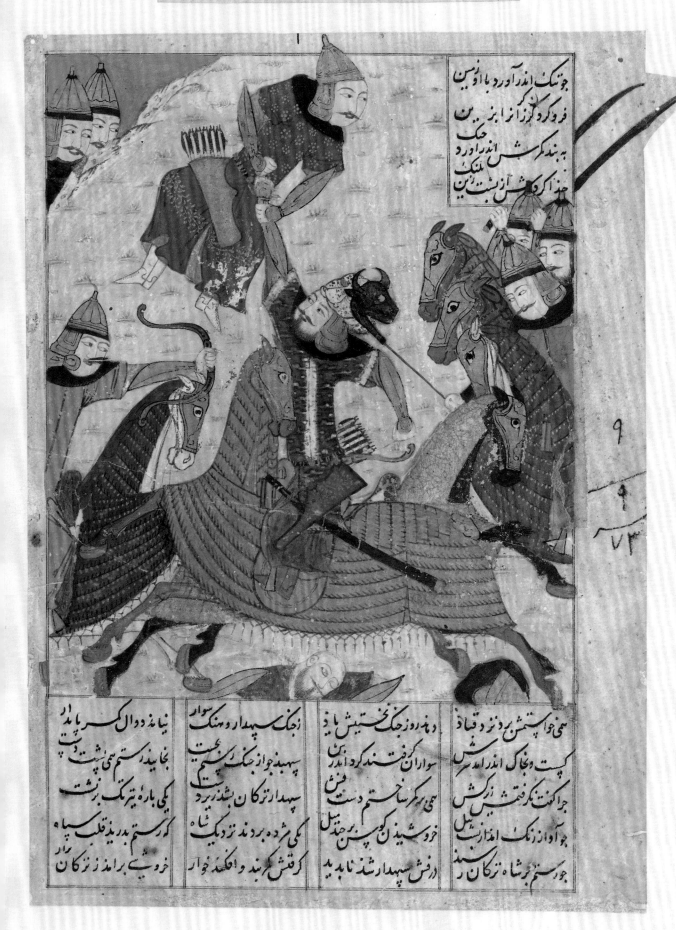

نیامذ دوال کمر باید	زجنک سپهدار وهنک سوار	ودیگر روز جنک نخستین یاد	همی خواستشن بزد نزد وقباد
بنایذ رستم سی بشت بشت	سپهبذ جوازجنک رستم	سواران کرفتند کرد اندر	کست وخاک اندر سر
یکی بارہ تیزتک برنشت	سپهدار ترکان بشذزیر	نیم سر سیاہ ستم دست	جراکفت نک رفت سی بکش
کرستم بذریذ تلک سپاہ	خورشید نک سپن برجذ میل	یکی مژدہ برد نذ نزد یک شاه	جو آواز زنک اندر زبست
خویش براملذ زترکان	کرش سپهدار شذ نابید	درفش سپهدار شذ نابید	جو رستم برشاہ ترکان رسید

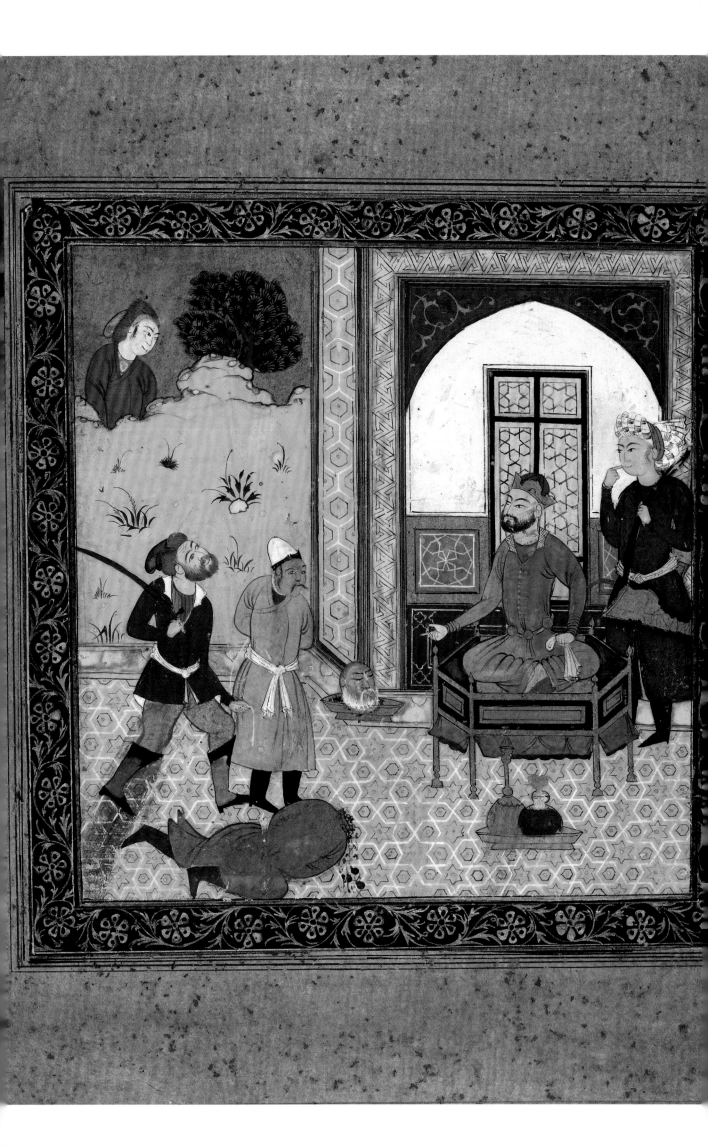

8 THE PUNISHMENT OF AFRASIYAB AND GARSIVAZ

Opposite

British Museum, 1948, 1009, 0.55 | Given by P.C. Manuk and Miss G.M. Coles through NACF, 1948 | As mounted 260 x 230 mm; picture 165 x 157 mm | *c.*1590 | Safavid (Shiraz) ww, IV, 268 (no text present)

Afrasiyab of Turan has been captured by Hum, a hermit of the royal line. He has been charged with fratricide and other murders by Key Khosrow and his head has been struck off. His evil brother, Garsivaz, captured earlier by Rostam, is about to receive a similar sentence.

There is a clear message that justice is being done. The gesture of the noble monarch orders it, and the executioner's hand leads the prisoner forward. Between them are the head of Afrasiyab, still with an expression of pride, and the abject figure of Garsivaz. Some guide as to date is given by the loose turban of the attendant behind the throne. The closest parallel for the style appears to be a *Khamseh* of Nezami of 1591.[5]

9 LOHRASP ENTHRONED

Overleaf

Fitzwilliam Museum, MS 21-1948, 1b-2a | Given by P.C. Manuk and Miss G.M. Coles through NACF, 1948 | Folio 365 x 215 mm; text area (verso) 264 x 135 mm; pictures 255 x 130 mm | 1540s | Safavid (Shiraz) | ww, IV, 317

When Lohrasp ascends the throne he makes an oration. He praises God, but sees mankind as a polo ball sent hither and thither by the heavens, and constantly threatened with death; nevertheless, it is the duty of kingship to uphold justice and peace in this Wayside Inn, lest evil should overtake us. Lohrasp sends envoys to neighbouring lands and builds a fire temple at Balkh.

Framed with illumination in brush-gold and lapis lazuli, the double-page picture has the appearance of a frontispiece, but the beginning of the second part of the *Shahnameh* is often marked by especially ornamental pages, and that is the case here. Nevertheless, the patron or purchaser might have been glad to imagine the courtly scene as a reference to himself. Covers bound in with these folios are probably from the original manuscript.

Bibliography: Wormald and Giles, 1982, II, p. 406

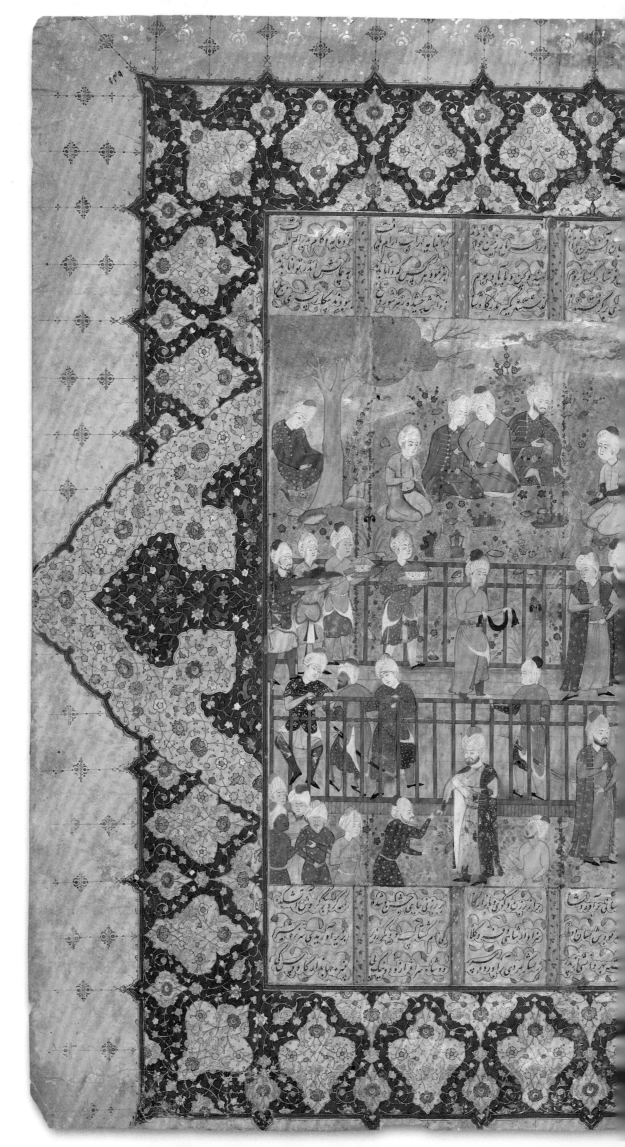

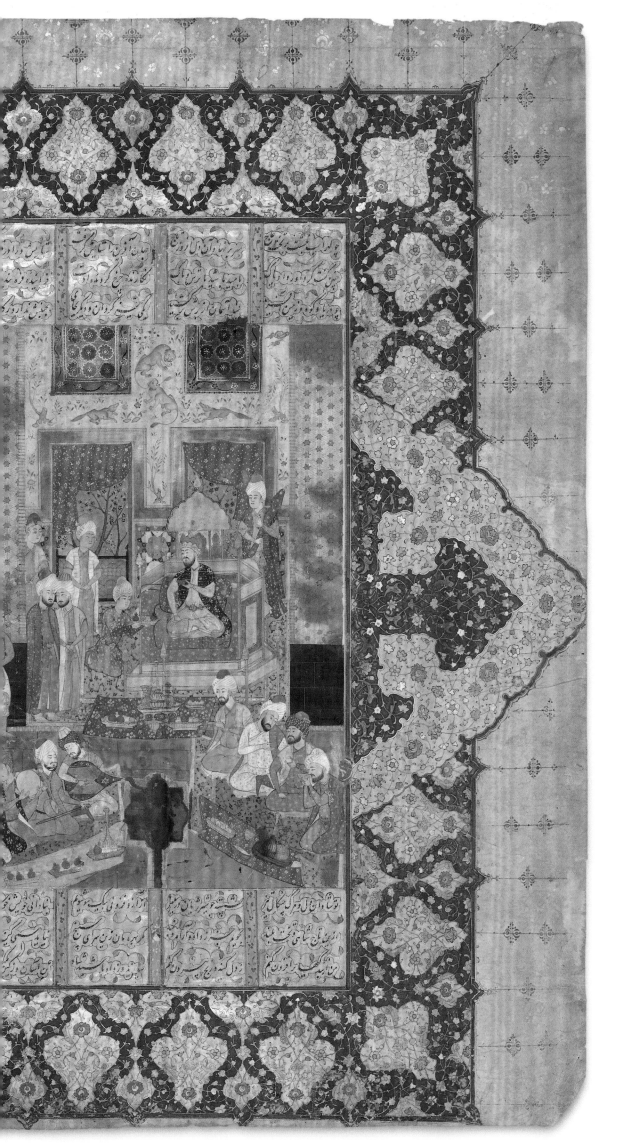

10 ESKANDAR VISITS THE KAʿBA

Fitzwilliam Museum, MS 22-1948, 18b | Given by P.C. Manuk and Miss G.M. Coles
through NACF, 1948 | As re-margined 248 x 180 mm; text area 172 x 120 mm;
picture (110) 127 x 120 mm | *c.*1435–40 | Timurid (Shiraz) | WW, VI, 121

After triumphing in Iran, Eskandar (Alexander the Great) leads
his army to India; he then journeys towards the Kaʿba in Mecca,
the House of Ebrahim (Abraham). Learning that the descendants
of Esmaʿil are living under tyranny he disposes of some of their
oppressors. He then visits the Kaʿba on foot.

Eskandar is seen in the *Shahnameh* as the son of Darab of Iran and
the daughter of Filaqus (Philip of Macedon). Eskandar's visit to the
Kaʿba may perhaps be seen as a parallel to Alexander's consultation
of the oracle of Ammon. The present picture derives some features
from 'Majnun at the Kaʿba' in the Berlin Anthology of 1420,[6] but,
curiously, the Kaʿba has a domed roof, such as might be seen on the
Black Pavilion visited by Bahram Gur in a Nezami manuscript. In
some later versions Eskandar will himself grasp the knocker of the
door of the Kaʿba, as though he were a Muslim pilgrim performing
the rites of the *hajj* (pilgrimage). There is some over-painting, but
the dome appears original. See also nos 6, 7 and 40–2 for the
manuscript; no. 86 for the next step in the story of Eskandar.

Bibliography: Stchoukine, 1954, pp. 43–4; Wormald and Giles, 1982, II, pp. 406–7;
Simpson, 2010, 135–8

11

SORUSH RESCUES KHOSROW PARVIZ

Nasser D. Khalili Collection of Islamic Art, MSS 838 | Folio 330 x 228 mm;
text area 233 x 165 mm; picture 158 x 165 mm | 1490s | Turkman (Shiraz) | WW, VIII, 299

In the period of Sasanian rule, Khosrow Parviz (*reg.* 591–628) is endeavouring to wrest the kingship from a powerful, rebellious vassal, Bahram Chubineh. Khosrow has been forced to flee into a narrow gorge; he dismounts but can find no way through the surrounding rocks. In answer to his prayer, the angel Sorush appears, robed in green and riding a white horse; he takes Khosrow's hand and leads him to safety.

Sorush, the angel messenger of the Divinity in Zoroastrianism, appears in the *Shahnameh* on several occasions. He is usually, though not invariably depicted without wings. The green robe mentioned here suggests an association in the mind of Ferdowsi with Khezr, who is an analogous figure in Islamic religion.[7] The dating of the present page to the 1490s is suggested by the relative spaciousness of the composition and fineness of the horse.

Bibliography: Abdullaeva, 2006, 213; Sims, forthcoming

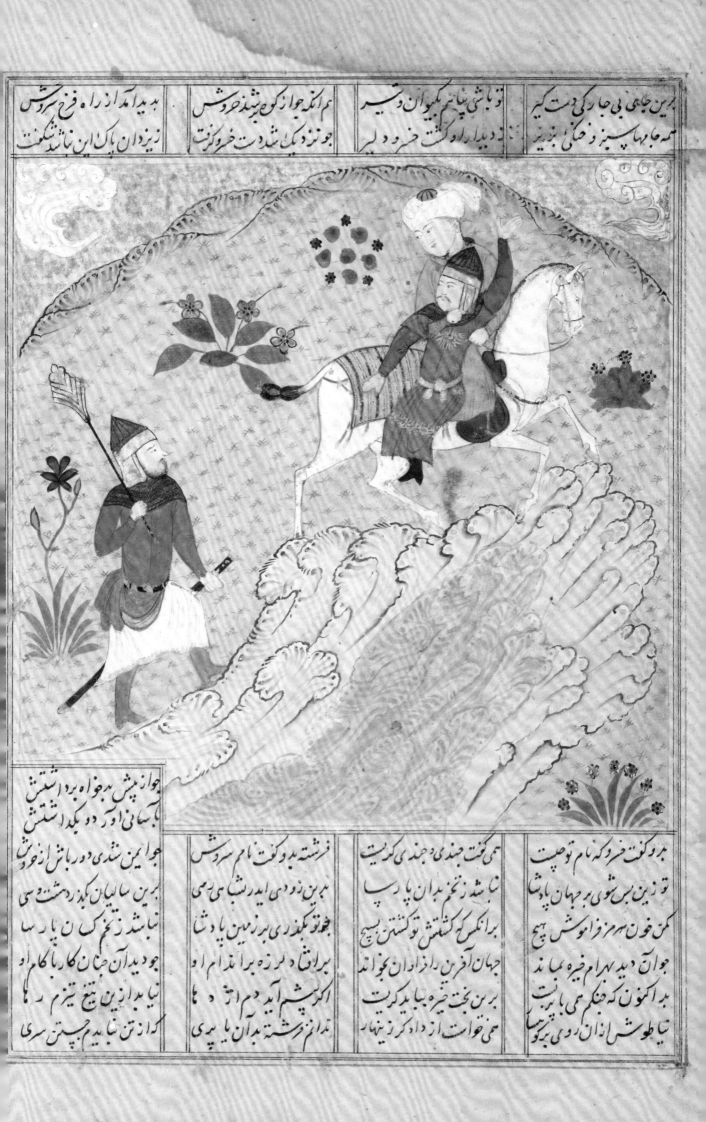

AN EXPLOSION OF IMAGES
THE TWELFTH TO THE FOURTEENTH CENTURIES

12 ROSTAM COMES TO BIZHAN'S PIT

Keir Collection, 73.5.42 | 304 x 302 mm | Fritware with overglaze lustre
Late twelfth to thirteenth century | Rayy style | WW, III, 344

The great hero Rostam is about to rescue Bizhan, who has been thrown into a pit on account of his love for Manizheh, the daughter of the ruler of Turan. The circle behind Rostam's head is the large cap-stone that he is lifting away.

The tile is inscribed 'Coming of Rostam to the top of the pit'. This is not a quotation from the verse of the *Shahnameh*, but it is in the form used for subheadings in the course of the text. At present no similar tile is known, but this piece must have been part of a long and detailed sequence.

Bibliography: Grube, 1976, no. 182; Scarce, 1989, 276; Porter, 1995, pp. 45–6

13 FRIEZE TILE FROM TAKHT-E SOLEYMAN

British Museum, 1878, 12–30, 573(1) | 297 x 303 mm
Moulded fritware, with overglaze lustre, cobalt and copper | 1270s
Il-Khanid: from Takht-e Soleyman | ww, v, 164

A number of large frieze tiles survive from the Il-Khanid Summer
Palace in Azarbaijan, popularly known as Takht-e Soleyman. Of large
size, these bear *Shahnameh* inscriptions in blue on inscribed arches.[8]
One of two in the British Museum, this piece runs: 'Now is the time
to drink the wholesome wine'. The line occurs in a passage that is
transitional and in the voice of Ferdowsi himself. The poet takes up
the celebratory tone of the triumphant conclusion of prince Esfandiyar's
defeat of Arjasp (no. 55), but moves on to his own need for patronage,
and announces Esfandiyar's death. *Shahnameh* inscriptions had already
been used in palaces of the Seljuks of Rum in the thirteenth century.[9]

Arabesque decoration around the inscribed arches seems to be uniform
from tile to tile. In the spandrels above the arches the arabesque is
inhabited by animal heads, a form of ornament known as *waqwaq*
as they are deemed to speak (see no. 39).

Bibliography: Melikian-Chirvani, 1984, 280–2; De Bruijn, 1993, p. 64; Masuya, 2002,
pp. 99–103 (also fig. 49); Auld, 2007

14 BOWL WITH LUSTRE DECORATION

Nasser D. Khalili Collection of Islamic Art, POT 1563 | Height 79 mm;
diameter of lip 182 mm; diameter of foot-ring 77 mm | Fritware with overglaze lustre
Thirteenth century | Kashan style | ww, II, 412; ww, IX, 63

The lustre decoration of this conical-sided bowl combines diverse elements. A free-hand geometrical pattern provides a central six-pointed star, in the interstices of which drop-shaped units contain birds or animals. Ornamental finials proceeding from the drops seem to be influenced by manuscript illumination. Hemistichs of verse are disposed between these finials. In the lower left the sense of the first line of the *Shahnameh* couplet is clear, but the second is more doubtful:

Partake of what you have, then give away,
Give not your hard-won to your enemy

or possibly:

Are you distressed? Blame not your enemy[10]

The lines seem suitable to a vessel that might be employed in the context of hospitality, but their use may have been more general as Melikian-Chirvani notes this inscription on a tile.[11] An outer inscription in reserve on a lustre ground has not been read.

Bibliography: Melikian-Chirvani, 1991, 83; Grube, 1994, no. 280

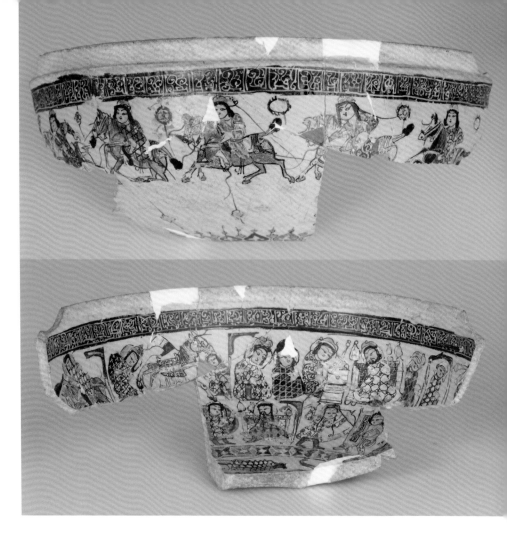

FRAGMENTARY BOWL WITH SCENES FROM THE STORY OF FARIDUN

Nasser D. Khalili Collection of Islamic Art, POT 875 | Height 75 mm; present width 195 mm
Fritware with under- and overglaze colours, *mina'i* | Late twelfth or thirteenth century
Perhaps representing ww, I, 171 ff., no text present

It has been suggested that the story of Faridun and his sons is shown, though not in standard order. The scene top right may show Salm and Tur leaving, through a door, when angered by Faridun's generosity to Iraj; the bottom right may show the murder of Iraj by his brothers, and the bottom left his remains brought to Faridun.

Decorated in *mina'i* technique, this fragment of a delicate bowl of rounded profile is remarkable in having figures on the exterior as well as the interior. The latter may well be derived from book illustration since they can be read as discrete units, sometimes limited by arches of bracket shape. It seems likely that this was an object for display rather than for practical use.

Bibliography: Grube, 1994, no. 228

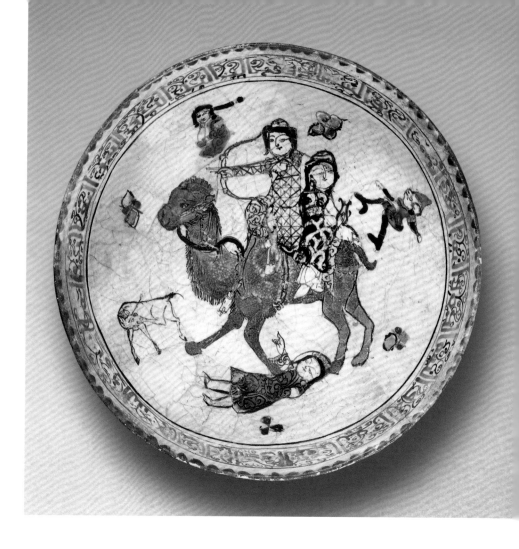

16

BOWL WITH BAHRAM GUR HUNTING WITH AZADEH

Private Collection | Height 64 mm; diameter of lip 158 mm; diameter of foot-ring 64 mm
Fritware with under and overglaze colours, *mina'i* | Late twelfth or thirteenth century
Representing ww, vi, 382 ff., no text present

The young prince Bahram Gur, whose youth is spent in Arabia, goes hunting with the slave girl Azadeh mounted on his camel. A feat that she suggests to him is to nick the ear of a gazelle so that it raises a foot to scratch it, and then to pin the foot and ear together. This Bahram achieves. When Azadeh protests that he must be a devil, Bahram throws her from the camel and tramples her.

The subject is easily recognised and was a popular motif at this period.[12] Bahram is sometimes shown riding with Azadeh, has sometimes thrown her down, or even – as it appears here – both moments may be united. In this example it is the remarkable blue camel that is the heart and soul of the design, while Bahram and Azadeh are shown in a rather different mode, for the most part without colour. The bowl has experienced some reconstruction and some repainting. An inscription round the outside has not proved legible.

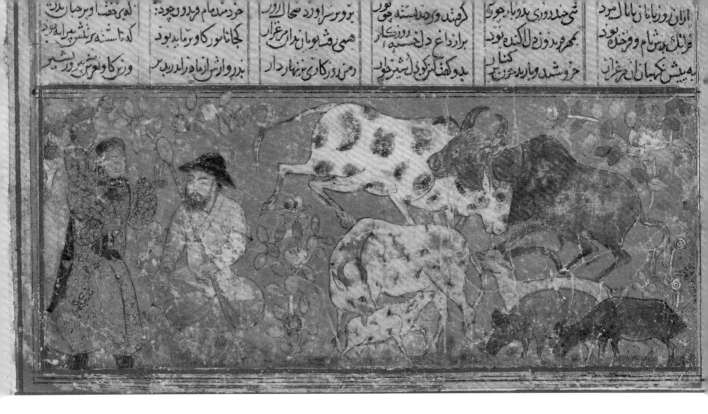

17 THE INFANT FARIDUN ENTRUSTED TO A COWHERD

British Museum, 1948, 1211, 0.20 | Gift of Sir Bernard Eckstein
From the Second Small *Shahnameh* | As re-margined 295 x 200 mm;
text area 165 x 130 mm; picture 56 x 130 mm | 1290s | Il-Khanid (Baghdad?) | ww, I, 151

The throne of Iran has been usurped by Zahhak. This tyrannical ruler dreams that he will be overthrown by a descendant of the true line of kings. When such a child has been born to Abtin and Faranak, Zahhak searches out the father and kills him. For safety Faranak entrusts the child Faridun to a cowherd, to be nourished by the milk of the beautiful cow, Barmayeh.

With the human figures grouped on the left, this tiny picture manages to imply a broad pastoral landscape. Faridun on his mother's shoulder is dressed like a prince. The cowherd is distinctly Chinese in feature and wears an embroidered robe. He holds a looped rod to catch his cattle. The cattle rather resemble an example on a lustre tile dated 689/1290–1.[13] The significance of the cow points back to the Indo-European origins of the Iranians. The parent manuscript, known as the Second Small *Shahnameh*, is similar in many respects to a First Small *Shahnameh*, also divided but mainly in the Chester Beatty Library, Dublin;[14] the two would be close in date. Detailed stylistic comparisons made by Simpson point to a dating at the end of the thirteenth century, at Baghdad.[15] The six columns of verse are in *naskhi*, a practical script, widely used at the period. See also nos 18–20.

Bibliography: Titley, 1977, no. 148; Simpson, 1979; Kadoi, 2009, pp. 198–205

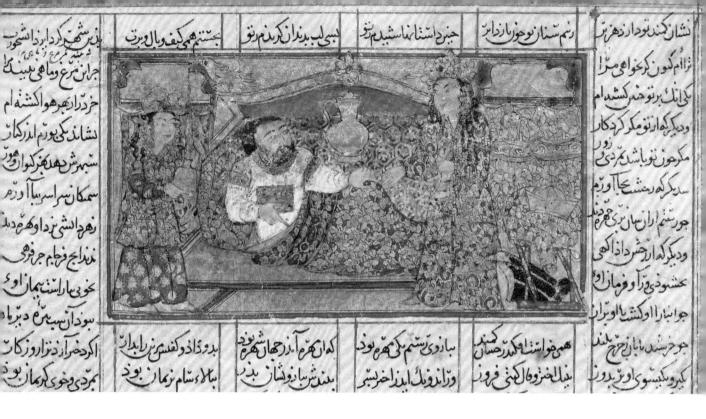

18 TAHMINEH COMES TO ROSTAM

Keir Collection, III.2 | From the Second Small *Shahnameh* | Text area 160 x 122 mm; picture 48 x 85 mm | 1290s | Il-Khanid (Baghdad?) | ww, II, 124

Rostam's horse, Rakhsh, has been stolen by Turkmans. Rostam goes in pursuit and is offered lodging by a local ruler. At midnight, the ruler's beautiful daughter, Tahmineh, comes to Rostam and tells him that she wishes to bear his child. An arrangement is quickly reached.

Rostam's immediate interest is vividly captured in his posture: his right hand seems to ask whether her proposal is with immediate effect. Rostam wears a shirt ornamented with embroidery, *tiraz* bands from the Arab tradition on the sleeves and an embroidered square in Chinese style on the chest. His eager interest is frequent in later versions of the scene, but nowhere is Tahmineh so grandly dressed and confident as here. Her posture and headdress appear to be derived from the Central Asian, Uyghur, painting tradition.[16] Her freedom must reflect the position of women in Il-Khanid society – she is accompanied by a female attendant and not the eunuch of later tradition (compare no. 28; contrast nos 48, 75 and 91). Several of the rich textiles shown have dense patterns based on lotus flowers and leaves; they share an aesthetic with 'Sultanabad' pottery, examples of which are known from as early as the 1270s.[17] There is some indication of perspective in the flooring.

Bibliography: Robinson, 1976 (Keir), no. III.2; Simpson, 1979; Kadoi, 2009, pp. 198–205

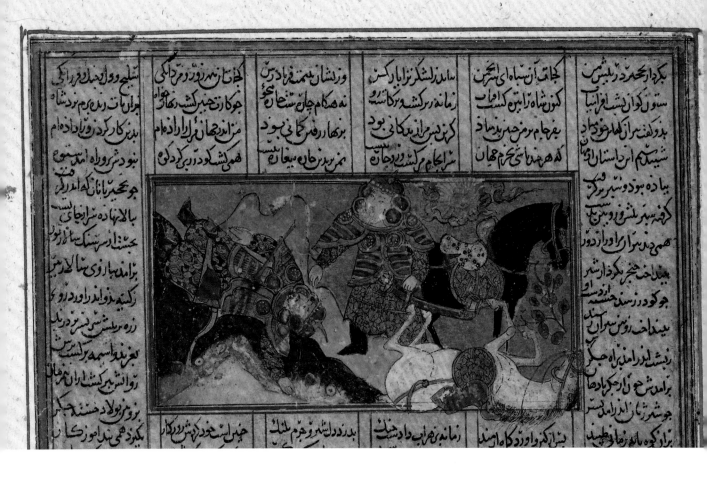

19 GUDARZ SLAYS PIRAN

British Museum, 1948, 1211, 0.21 | Gift of Sir Bernard Eckstein
From the Second Small *Shahnameh* | As re-margined 300 x 198 mm; text area 164 x 132 mm;
picture (44) 50 x (86) 87 mm | 1290s | Il-Khanid (Baghdad?) | ww, iv, 108

Elderly commanders of their respective armies, Gudarz of Iran and
Piran of Turan are in combat. Gudarz shoots his foe's horse, which falls,
crushing Piran's right arm. Piran flees towards mountainous ground.
Following on foot, Gudarz is wounded in the arm, but succeeds in
transfixing Piran with a javelin.

The use of a four-column rather than a six-column width for the
illustration creates a more concentrated focus. Even in such a small
compass, the victor looms over the defeated foe. The disparate positions
of Piran's arms shows that the right is injured; beside him is his inverted
bow case. Elements of armour painted blue probably intend steel.[18]
The sun blazes out of scrolling clouds of Chinese type. Gudarz's
saddle is covered with snow-leopard skin.

Bibliography: Titley, 1977, no. 149; Hillenbrand, 1977, no. 135; Simpson, 1974;
Kadoi, 2009, pp. 198–205

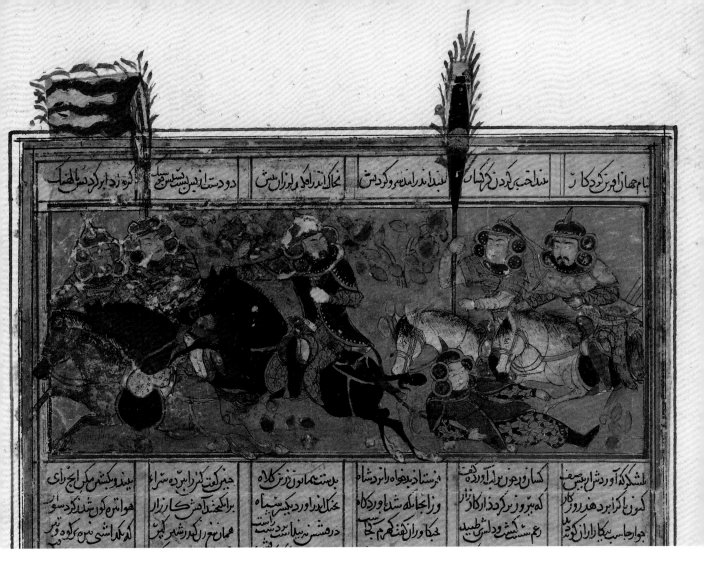

20 ESFANDIYAR LASSOES GORGSAR

British Museum, 1948, 1211, 0.22 | Gift of Sir Bernard Eckstein
From the Second Small *Shahnameh* | As re-margined 183 (remaining 170) x 130 mm;
text area 170 x 130 mm; picture (50) 80 x 130 mm | 1290s | Il-Khanid (Baghdad?) | ww, v, 111

Esfandiyar, prince of Iran, lassoes Gorgsar of Turan. Later he will be
able to use his prisoner as a guide when he sets out to free his sisters,
who have been captured by Arjasp.

The horizontal sweep of the action against a rather indeterminate
background may owe something to Chinese painting. The banners
rising into the upper margin assert that there is space beyond the
ostensible limits of the picture, while the horses' hoofs that pass beyond
the rulings contribute to the impression of space and speed. The red
strokes round the banners are mostly, or probably entirely, of the time
of re-margining. The horses have dished noses and appear to be Arab.

Bibliography: Barrett, [1952], pl. 7; Titley, 1977, no. 150, and 1983, pp. 24–5;
Hillenbrand, 1977, no. 133; Simpson, 1979; Canby, 1993, pp. 29–30;
Kadoi, 2009, pp. 198–205

21 DROUGHT IN THE REIGN OF PIRUZ

Nasser D. Khalili Collection of Islamic Art, MSS 459 | From the Freer Small *Shahnameh*
Folio 310 x 214 mm; text area 245 x 178 mm; picture (102) 103 x 118 mm
Early fourteenth century | Il-Khanid (Baghdad? Fars?) | WW, VII, 162

Early in the reign of the Sasanian Piruz there is a terrible drought. The king lifts taxes and orders the officials of the land to open their barns, and the people to gather and lift their hands in prayer. In the eighth year after its beginning the drought breaks and rain falls like pearls on the earth. Later Piruz perishes when he goes to fight the Haytalians in contravention of a treaty made by his grandfather, Bahram Gur.

The picture shows the people's prayer for rain, the central figure wearing a blue outer robe draped over the head would intend a Zoroastrian priest. Presumably reflecting East Christian clerics, non-Muslim sages are shown with heads covered in this manner in Arab work of the first half of the thirteenth century, and up to the Il-Khanid manuscripts, *Al-Athar al-Baqiyyah* ('Chronicle of Ancient Peoples') of 1307 and *Jami' al-Tawarikh* ('Compendium of Histories') of 1314.[19] In the present picture the significance of adverse meteorological conditions is emphasised by a sky represented by a segment of a circle, within which the sun is still in contention with the clouds. Examples of this type of sky segment are found in Arab manuscripts of the first half of the fourteenth century, though its origins are Byzantine.[20] The present folio is from a manuscript the greater part of which is in the Freer Gallery of Art; and indeed Simpson hypothesises a gap at the appropriate point.[21] The text area is a little larger than that of the First and Second copies, so allowing thirty-one lines and a slightly less cramped used of the *naskhi* script, in which the extended *sin* (letter 's') of a proto-*nasta'liq* character is sometimes used. This degree of relaxation, taken together with a lessening of eastern influences and an increase in Arab, suggests a dating slightly later than for the First and Second copies, when some assimilation would have taken place. In the search for a dating, another factor may be taken into consideration. The subject is very obscure and so may have been selected because of a particular contemporary relevance. This might have been a severe drought recorded around Shiraz in 1299.[22] See also no. 22.

Bibliography: Simpson, 1979; Khalili, 2005, p. 67; Kadoi, 2009, pp. 198–205; Sims, forthcoming

جنا	یافت بخت کنی بر نشست	همی خواهم از داوری نیاز	بدرخوانم چهل بدو یمان خوش	ش
فراو	که را بکه آمد مردم جبه	لی شد مرا زندگانی دراز	لی تیغ بر خضرا کاد اسران	ان
دلیه	زبان حرب و کونید فراوست	به بخشش خرد داد بخشایش	سبک سر همیشه خواری بود	بود
دشن	جو تاجشرب به آه امروز م	فری برتر از فرجمشید سیست	خردمند هم زین جهان بر خورد	خرد
بجو	دکرسال روی بماحاشکل شد	جهمند روز مردی بدی کرند	زهر بدیوندان بنا نهید نوس	س
ننی	زبس من دن مردم وجار بای	رستکی جو آب تراک شد	مواده خشک لاجو زخاک شد	مان
خرا				نت
بخه				ان
کی اه				شاه
زدی				کنید
کاز				به
فس				موا
لکید				باز
کلو				اد
زبز				انا
زبده				شد
نزبد				ش
جها				غار

هوا	همی بارید بر خاک خشک	براه بکی بر با افرن	نبشتم سامز مه نوردن	نبید بند سبزی کان مهان	جها
آ	جهروز از از روز نیکی برست	بهجای بزه نهال کان	زمانه برست ازبدر کان	همی نانت از ار قوس قوح	براو
جنا	دکردماران بسر روز نام	لی آرام شاهان فرخ بدرست	جهان را همن نیکوها راز ست	نفرهود کورا جها لا بدمنام	سرو
سر	درهاد از الشکر ماسوار	دل مردم برخرزشاد کرد	جوان بوجه ایکس راذ کم	لی تیس خرود ارد ازدادمیل	خرد
خرد	لی برورنا باک فیرزند بود	راندجون الشکر براه	قباد ازبست برویشاه	همی رفت با کارسازان نغ	شد
جود	بورود دبه سنره کاندر باش	لی سرخوانش خواندی شیمیار	لی فارسی مرد بس زاهدوار	لهن بسره بوذهام بسرو داد	شاد
زبس	نشانها بخرام ماخشنواد	بیکار جوند کا ماذتر تر	همی انداخت الشکر ولی	هنود جوز بام کی را سند	مشد

22 ROSTAM RECEIVES THE ENVOY OF SA'D B. WAQQAS

Private Collection | From the Freer Small *Shahnameh* | Folio 305 x 213 mm; text area 244 x 175 mm; picture (94) 101 x 117 mm | Early fourteenth century Il-Khanid (Baghdad? Fars?) | WW, IX, 82

When the Caliph 'Umar sends Sa'd b. Waqqas to invade Iran, Yazdegerd choses a warrior by the name of Rostam to lead his army. When battle seems imminent at Qadesiyeh, Rostam, who is also skilled in astrology, sees that the moment is not propitious; he writes to his brother that Persian rule will cease for 400 years and its splendours will be lost under Arab domination. Rostam also writes to Sa'd to ask for an ambassador to explain his intentions. Sa'd replies that the faith of which Mohammad is the messenger must be accepted. Rostam is informed that an envoy is come, old, on foot, poorly dressed, with a sword slung round his neck. Rostam has a richly adorned tented throne enclosure prepared, to which the envoy, Shu'ba Mughira, pays no attention. Rostam has the letter of Sa'd read, and bitterly rejects its call to join the new faith. Battle follows in which Rostam unhorses Sa'd, but, blinded by dust, is unable to strike the final blow. Sa'd strikes down Rostam.

As the text requires, the relatively simple throne is in a carpeted and tented setting. The robes worn by the Persians – doubtless reflecting Il-Khanid costume – have gold embroidery or woven ornament and skirts with extra side panels. The beards of the Persians appear to have been slightly retouched. By contrast, the turbaned Arab is in a plain green robe with wide sleeves, and he leans on a long sword. The object held by an attendant is probably a burning torch. Like the previous exhibit, this folio fills a gap located by Simpson.[23]

Bibliography: Simpson, 1979; Sotheby's, 16.10.96, lot 63; Kadoi, 2009, pp. 198–205

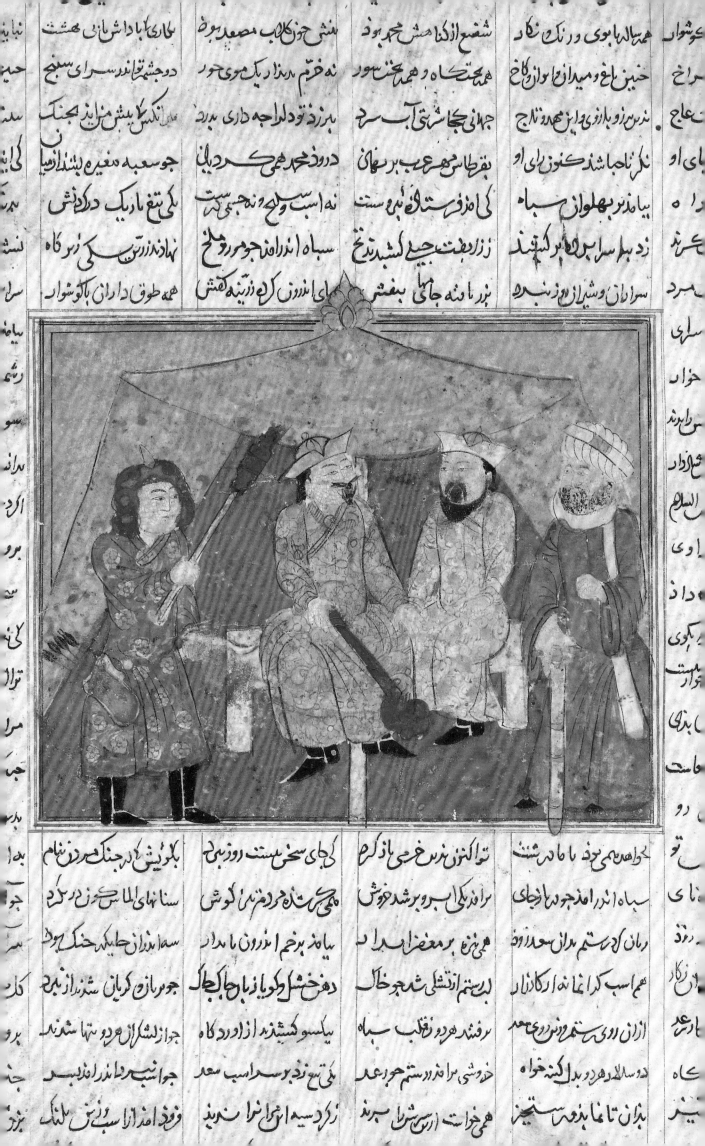

23–6

'JAMI' AL-TAWARIKH' ('COMPENDIUM OF HISTORIES') OF RASHID AL-DIN

Edinburgh University Library, MS. Or. 20 | Once owned by Colonel John Baillie
As re-margined 450 x 330 mm | Il-Khanid (Tabriz) | Datable c.714/1314

Bibliography: Barrett [1952], plates 2–4; Rice and Gray, 1976; Hillenbrand, 2002, pp. 155–67; Melville, 2008; Cho, 2008; Kadoi, 2009, pp. 162–80; Hillenbrand and Hillenbrand, forthcoming; sundry reproductions of individual pictures

23

MANUCHEHR ENTHRONED WITH ROSTAM IN ATTENDANCE

6b | Remaining folio 385 x 273 mm; text area 380 x 270 mm; picture 121 x 262 mm

Produced in the reign of the Il-Khanid Oljeytu (1304–16), the 'Compendium of Histories' aims to establish the place of Mongol history among those of other peoples known to them. The portion of the work now in Edinburgh, which is an Arabic version of the text, begins with an interweaving of material from Jewish history with Persian material from the *Shahnameh*, to provide a wide context prior to an account of the birth of the Prophet Mohammad in Arabia. Another part of the same Arabic manuscript is in the Nasser D. Khalili Collection.[24]

In this illustration a youthful Manuchehr is enthroned centrally, while Rostam, on the left, is a mature warrior. This represents Rostam's early career as a paladin of Manuchehr, rather than illustrating a particular incident in the *Shahnameh*, although in fact Rostam is not referred to in this text itself. The picture owes much to Chinese pen drawing and the limited application of a few colours. Colours may, however, be bright, especially red and blue, and gold is also used. Recent conservation has largely reversed the effects of oxidisation in silver used for highlights.[25] Chinese and Mongol styles are evident in the feet and finials of the throne, the scale pattern on a scabbard and the gadrooned basin in the foreground.

الغفور وأنت أرحم الراحمين فشفاه الله تعالى وزال عنه كل ما كان به من الأمراض والآهات وفي أقرب مدة حسنت
هيئته وتصورت صورة وإمرأ زوجته فتهاتها قالت لقد تركت ذلك المريض وجيد ليس عنده من يأنس به ولا ولد من يهتم بأمره ولا لمت نفسها وأمنا
عليها أن يؤذيه شئ من الحيوانات أو ملكه شئ من الحشرات المؤذيات فرجت وقصدته فلما ابت منه تعرفه ورأت تخصص البدن والجوارح وجميل الصورة
حسن الهيئة فأنه فأنكرته وقالت له ما رأيت ذلك الرجل المريض الذي كان بهذا المكان فلما رآها وعرف أنها زوجته وعرف أنها إذا رأيته تعرفه فقال لها نعم فقال لها
أنا أيوب فعرفته المرأة بصوته فسجدت شكرا لله تعالى ثم إن أيوب لكونه أقسم أن يضرب بها مايه ضرب أخذ ضغثا من النخل فيه مايه شمراخ فضربها به مرة واحدة
وخرج من يمينه وإنا الله تعالى بعد مدة قليلة بقدر ما كان فقد من ذلك أضعاف مما مضى من الثواب والأموال والأسباب ورزح وأولد وعوض ما من
أولاده وبنيه ستة وعشرين سنة وتوفي وله من العمر ثلث وتسعون سنة ووفاته بالشام ومن جملة أولاده بشر بن أيوب كان نبيا وتوفي بالشام وقبره ومسجد مشهورة

وكان من أولاده هج فمنهم من يقول إنه ابن ابنه ومنهم من يقول إنه ابن ابنته وجماعة من بني إسرائيل وغيرهم يقولون إنه من أولاده وقيل بن إسحق
عليهما السلام وليس لهذا الكلام أصل لأن الفرس تنكرون ذلك وملكنات وملكات يكون أو يكون قد أوصى إليه وجعله ولى عهده فلما مات أقاموا إفريدون على الملك على الجادة شور

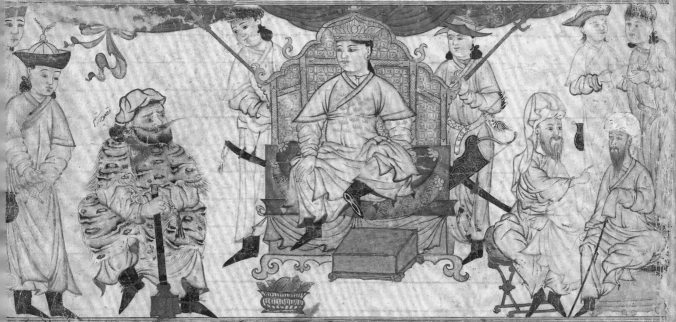

فلما جلس على سرير السلطنة والطاعة كل من كان في طاعة إفريدون وظفر بتوروسلم اللذين قتلاه وأهلكهما وصارت العدالة والإحسان إلى الآن في أيدي هم الجمهور و
الترك وهم الإيرانية والتورانية وعمر البلاد وافد عدل إلى كل إقليم وبلد الملوك ورتب الفقرا والنواحي وأولى الرؤسا إلى الأماكن وحفر الأنهار واستخرجها
من الفرات وأجرى الأنصار والمياه في جميع سواد العراق وكذلك استخرج الأنهار من شط دجلة وعمر البساتين وغرس الأشجار والرياحين ومثل الأشجار
والرجال وتعهدها البساتين وتعهدها عمارة العالم قد فسحت الأقطار والبلاد واندست الآثار فلما اهتم بالعمارة عمر المالك المتعلقة
بعراق الجبال وخراسان وآذربيجان وأظهر العدل والأنصاف ونشر الإحسان وحصل له الذكر الجميل في العالم وكان في زمانه شاه من ملوك
وبعده آل زادقار ج حكاوة وكتاب وقايد الجيوش ومدبر الملك كشواد والد كودرز ولما مضى ستون سنة من ملكه
هيج عليه أفراسياب من ترك بن نور إفريدون وقصد ملك الإيرانية العساكر العظيمة ونشب حرب بينهم منوحهر قد استعد له ولكن
لم يكن له قدرة على مصافته فالتجأ إلى بلاد مازندان وبعد الحرب الشديد مع الاحتياج يقع المصالحة وتقرر أن يكون ما وراء النهر محفوظ إلى المشرق
في حكم أفراسياب ومن محفوظ إلى المغرب . حكم منوحهر ورجع أفراسياب إلى البلاد واستقر الأمر على هذا . وله مايه وعشرين سنة ملك . ولما انتهى توفى ونظر بالملك

أما في الملك سنة وله . رواياته وصلت الأخبار إلى إفراسياب بوفاة منوحهر وسلطنة إبنه نوذر وكان

وهوسبط كيكاوس ومن النَّاس مَن نسبه على هذا الوَجْهِ فيقولون لهراسب بن كيارجان بن كميش بن كثير اخو كيكاوس بن كاموه نركبهاد و نه كان الشا

لهراسب بن ورو بن بشين يعني كثير قال هو اخو كيكاوس و كان اكثر مقاصدہ صلح وجماعة يقولون مدهسه بلغ عمارته وكان سلطانا عادلا وقهر

24 LOHRASP ENTHRONED WITH SCRIBES IN ATTENDANCE

12b | Remaining folio 395 x 275 mm; text area 375 x 265 mm; picture 122 x 255 mm

The scene is equivalent to that in no. 9 (ww, IV, 317). The representation must reflect the reality of the Il-Khanid court, young attendants with bunched hair, wearing the split-brimmed Mongol caps, while bearded figures with aquiline profiles wear turbans. The latter would be the Persian bureaucrats, indispensable to the running of the country – and indeed there are long written scrolls in their hands, and they have pen boxes laid open or hand-held. The ornamentation of the throne and footstool, with lotuses and overlapping leaves, corresponds to that on 'Sultanabad' pottery. A heavy outline serves to lift selected persons into prominence. Immediately before the picture the text refers to the *Shahnameh*.

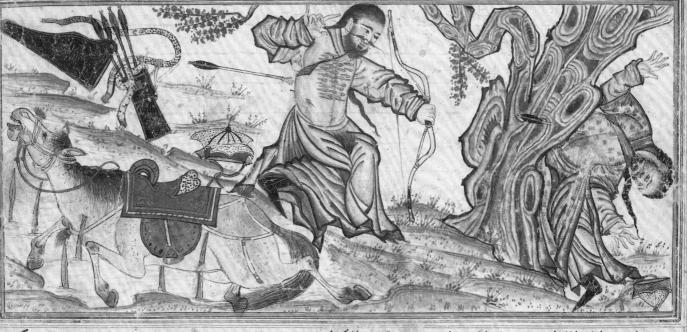

ورتب اسباب النهاب للاصطياد وذهبوا بالاتفاق مع شغاد الى الاصطياد وكان شغاد يمشى قدام رستم وروان على سيل الدلال وروان يمشى على

عقبة حتى وصلوا الى المواضع التى فيها الابار وما لهم خبر من الكدين المواضع للمقدس ومن التعبيه التى فى ستر الغيب وقع رواه حتى وقع رواه فنفنة فى بر وهلك

25 THE DYING ROSTAM
 SHOOTS SHAGHAD

15b | Remaining folio 402 x 275 mm; text area 378 x 275 mm; picture 120 x 253 mm

The *Shahnameh* (ww, v, 272) tells us that in the old age of Rostam, his treacherous brother, Shaghad, plots his death. He induces the king of Kabol to have pits dug, set with blades, and covered over. Rostam's horse, Rakhsh, is unwilling to advance over one such, but Rostam urges him on. Rakhsh falls and is transfixed. Rostam persuades Shaghad to bend his bow, and with his last strength looses an arrow that passes through the tree behind which Shaghad is hiding, and kills him.

The still vigorous Rostam is a central axis of the picture between the agony of Rakhsh on one side and the fall of Shaghad on the other. The tree – a branch of which re-enters the upper line in a Chinese manner – seems to reflect the contorted figure of Shaghad. This is an early example of a procedure in Persian painting by which features of the landscape, tree, rock, ground, in some manner image the situation of the human figures. The composition is closely followed in no. 27.

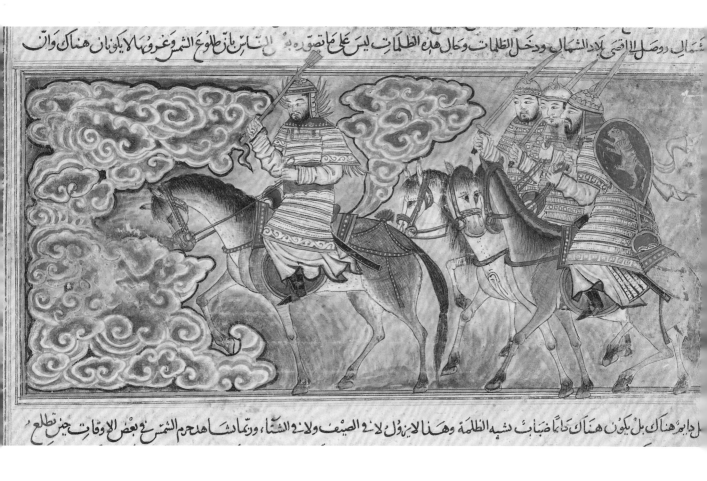

26 ESKANDAR ENTERS THE LAND OF DARKNESS

19a | Remaining folio 380 x 280 mm; text area 373 x 267 mm; picture (123) 128 x 257 mm

The *Shahnameh* (ww, vi, 160) tells us that Eskandar goes into the Land of Darkness to seek for the Water of Life, which he fails to find (no. 59). Eskandar purposefully sends his horse forward into the swirling darkness, whose dramatic mystery is conveyed with variable shading and width of line, and with touches of gold. The flame-like protuberances from Eskandar's helmet probably result from his identification with the Qur'anic figure *Dhu'l-Qarnayn* (Lord, or Possessor, of the two horns). His defensive coat, like that of his companions, seems to be a padded structure with bands of lamellae; curiously, it seems that scabbards protrude from under these garments. A shield of inverted drop-shape carried by a following rider would seem better suited to a foot soldier: it also appears almost European in character. The horses exchange anxious glances; they are of Turkman type as opposed to the Arabians of no. 20.

Bibliography: Cho, 2008

27 THE DYING ROSTAM SHOOTS SHAGHAD

British Museum, 1948, 1211, 0.25 | From the Great Mongol *Shahnameh*
Given by Sir Bernard Eckstein | Folio 460 x 350 mm; text area 407 x 294 mm;
picture 150 x 294 mm | *c*.1335 | Il-Khanid (Tabriz) | ww, v, 272

See no. 25 for the narrative and origin of this composition. Rostam
is shown as though against a sunset glow, and his gown has golden
highlights. The tree trunk that partly frames Rostam also reflects the
form of the collapsing Shaghad in a manner that is almost humanoid.
Rostam follows the ineluctable flight of his last arrow, power exerted
by his left hand and delicacy shaping his right. Rakhsh in death is
an image of strength, his eye, mane and foot lovingly detailed. The
power of the illustrations to this *Shahnameh* (sometimes still known
as the 'Demotte' after the dealer who divided it) has no precedent:
elements from Chinese and Arab painting are still apparent, but they
are embraced in a majestic synthesis.

Bibliography: Titley, 1977, no. 152, with references; Hillenbrand, 1977, no. 193, and 2002, fig. 193; Grabar and Blair, 1980, no. 23; Soudavar, 1996, pp. 104–5; Canby, 1993, pl. 17

28 TAHMINEH COMES TO ROSTAM

Keir Collection, III.4 | From the manuscript commissioned Ramadan 741/March 1341
Text area 280 x 232 mm; picture (90) 105 x 232 mm | Inju (Shiraz)
Patron: Qavam al-Dowleh Hasan, vizier to the governor of Fars
Scribe: Hasan b. Mohammad b. 'Ali Hoseyni al-Mowsili | ww, IV, 182

As in no. 18, Tahmineh, the daughter of the king of Samangan,
comes to Rostam, who is passing the night in her father's castle
(see also nos 48, 75 and 91).

As in the Small *Shahnameh* folio it appears that Tahmineh's attendant
is female: indeed it is not easy to be certain which of the ladies is which,
though perhaps the attendant has the partly obscured central position.
Otherwise, the pictures are very different. An intimate space is here
created by showing a section of exterior wall in the two right-hand
columns. Signs of Mongol and Chinese influence are fewer, though
the curtains have a hazy memory of a motif from a Chinese textile.[26]
The drawing is in the speedy, almost careless style of Shiraz, which
tends to suggest that the artist is working with forms that are very
familiar to him. In this and the majority of its pictures, cheek colour
is distinct. Approximately similar book painting is known from as early
as the *Kalileh va Dimneh* of 1307,[27] but the boldness of the style suggests
that it might derive from a lost tradition of wall painting. The candle
that rises high into the text area is an amusing touch.

Bibliography: Robinson, 1976 (Keir), no. III.4; Simpson, 2000, p. 237

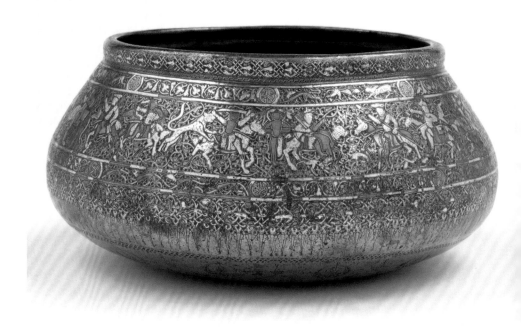

29

INLAID BASIN BY TURANSHAH

Detail overleaf

Victoria & Albert Museum, Inv. no. 760-1889
Brass inlaid with silver and gold, ground filled with black composition | Height 119 mm;
diameter of body 227 mm; diameter of opening 173 mm | 752/1351–2
Inju? (Shiraz? Elsewhere in Fars?) | For: Mohammad b. Mohammad b. ʿAbd-Allah al-Jorjani
Maker: Turanshah

On the grounds of its shape and date, this basin has been attributed
by Melikian-Chirvani to Fars, the region whose principal city is Shiraz.
The frieze of riders round the upper side suggests some familiarity with
Shahnameh pictures in the Inju style, though tradition in the decorative
arts is also important. Readily identifiable are Zahhak with snakes on
his shoulders led by Faridun riding an ox, and Bahram Gur hunting
with his musician Azadeh riding pillion behind him. Other scenes are
less specific to the epic: a polo match, an elephant rider. Most striking
among these is a scene in which two riders, one of whom is crowned,
hold a ring. This appears to hark back to scenes of the investiture
of kings, as they appear on rock carvings of the Sasanian period in
Fars. Melikian-Chirvani suggests that the maker, Turanshah – who
is perhaps using a professional name – and the patron, who uses the
appellation *al-Jorjani*, may together have some association with north-
eastern Iran. Auld does not see a connection to Inju painting and does
not favour an origin in Fars.

Bibliography: Melikian-Chirvani, 1982, no. 104; Carboni, 2002, no. 164; Auld, 2004

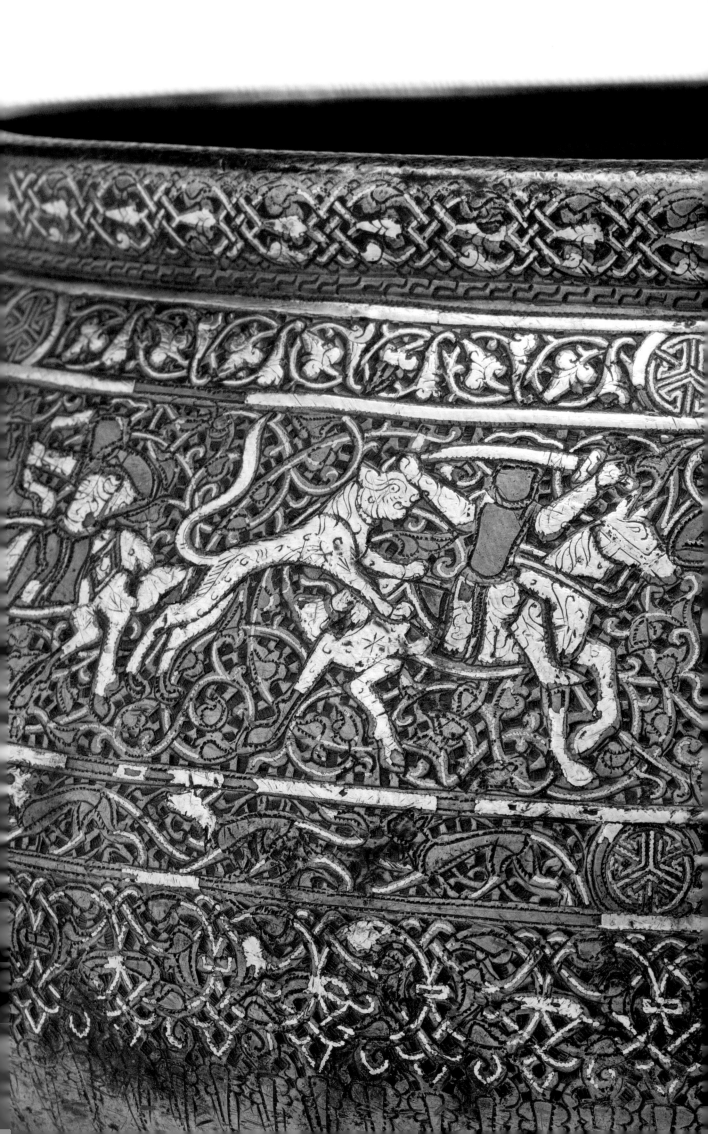

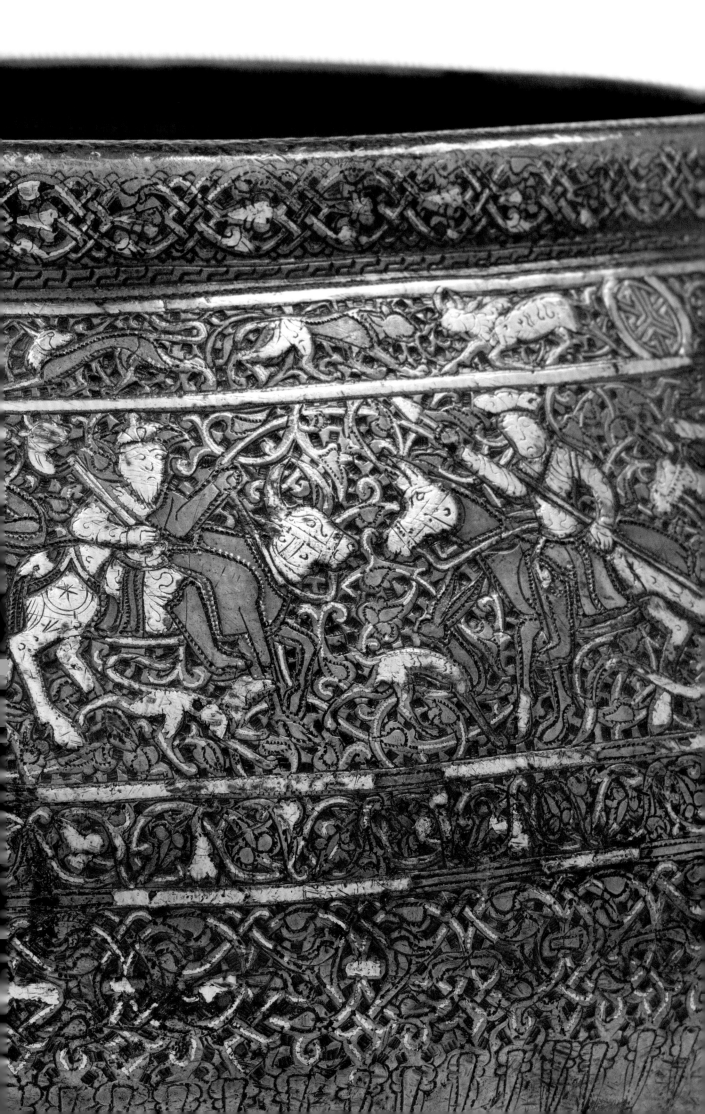

PRINCELY
PATRONAGE
AND BEYOND
THE FIFTEENTH CENTURY

30–9 'SHAHNAMEH' FOR EBRAHIM SOLTAN B. SHAH ROKH

University of Oxford, Bodleian Library, Ouseley Add. 176
Once owned by Sir Gore Ouseley (1770–1844) | Folio 290 x 195 mm; text area 222 x 149 mm
*c.*1430 | Timurid (Shiraz) | Patron: Ebrahim Soltan b. Shah Rokh

Bibliography: Robinson, 1958, pp. 16–-22; Abdullaeva and Melville, 2008

30 ILLUMINATED SHAMSEH

12a | Remaining original folio 221 x 150 mm; restored to 255 x 180 mm

The elaborate *shamseh* acknowledges the patron. The inscription on its central golden rosette in an ornamental *sols* reads:

By command of the treasury of the most mighty, the most just and brave Sultan, strong in dominion, who causes to flourish the truth, the sultanate, the world and the faith, Abu'l-Fath Ebrahim Soltan, may his dominion be perpetual[28]

The patron, grandson of Timur and son of Shah Rokh, is governor of Fars on behalf of his father.

The blue lappets surrounding the central motif have notches at either side that create shapes related to the Chinese 'cloud-collar' in costume ornament. The lappets are defined with a border of lapis lazuli decorated with motifs from the Chinese tradition, lotus flowers and leaves, peonies, and small leaves in gold. Meanwhile, the golden centres of the lappets and the detached lapis lazuli elements beyond them are decorated with scrollwork and split palmettes descended from classical prototypes. In the lower left the librarian's note of an inspection in 30 Rajab 1003/10 April 1595 would have been added in India.

31 ILLUMINATED 'SARLOWH'

17a | Illumination including finials 261 x 170 mm | Illuminator: Nasr al-Soltani

A *sarlowh* is an ornamental page marking the beginning of a work or
a section, this folio being the left-hand side of a double-page scheme.
The epic narrative begins on its verso. As is usual in such pages, a
central area is surrounded by an ornamental frame, while a further
border runs round three sides, the fourth side being towards the gutter.
The outer border here has lappets and finials in a similar mode to
those in the *shamseh* (no. 30). In the frame area, fine looping bands
define an alternation of small circles and round-ended cartouches;
while the use of a black ground in some motifs strengthens the
design. Cartouches above and below the central panel repeat the
salutation of the *shamseh* with slight variations in word order. Below
the lower cartouche, which names Ebrahim Soltan, the signature of
the illuminator, Nasr al-Soltani,[29] is inscribed on a golden ground
that appears as a pale interruption to the lower line of a frame of
golden interlace. The central area of a *sarlowh* would often be devoted
to text, but in the present example there is a geometric interlace of
a complexity that repays concentrated attention as its strap-work
generates the same figures when considered vertically and horizontally.

چو جملهٔ بر این گلستان شگرف
که شمع تابان کنار حرف
زانجمن شمعی که مرا اندوه خستم
پر از کام شد حبیب و امان حکم
جناب خواهست خاطر که بیشی برم
بجای آورم سپاس نکو
خرد بعد از اندیشه این رای زد
حکایتی خرد بوده روزگار
زبان تو بماند زنگ و زیر
که خدای این نسخه نامدار
همه بوده شد حاصل نظم اوست
روان سراییده داستان
پاره بسته بیکی دلپذیر
چو خواهی که بود زنو شادمان
به جان بیار این این چین
کمینه جان مع خاک سیاه وجه
صواب آمد این رأیم از چه عقل
دل آرزوی بجان شیخ صفت پذیر
برایم کنون کاختیاری کنم
به بروی توفیق کاری کنم
گوشنامه گردید دان از رحمت
شود نام شاهان هاضی بلند
چو زین نسخه اینجا بجای وبت
کریم زکول روح را منزه وبت
که فرمان بدهی کاران
که عالم اسرارین اوست جان

32 ILLUMINATED 'SARLOWH'

238a | Illumination including finials 286 x 200 mm (approximately)
Verses not from *Shahnameh* inserted before account of Lohrasp

This is the left-hand side of a double *sarlowh* used to indicate the traditional division of the *Shahnameh* into two books. The mode of illumination is particularly associated with, but not confined to, Shiraz. Grounds of lapis lazuli are contrasted with areas of ground in reserve. Looping bands are absent, and the use of black is limited, though silver may have been used to outline rectangles. Ornament in arabesque style is mainly confined to the outer border and the two inscribed cartouches; instead, flowers wander unoutlined against the lapis ground, and outlined with a relatively naturalistic effect against the reserve. This 'soft leaf' style is to be related to the Il-Khanid textiles seen in Small *Shahnameh* illustrations (no. 18). The triangular motif projecting into the left-hand margin may be related to forms of Qur'anic *sura* headings, and possibly by way of them to the *ansae* of the Classical writing tablet. This element would be used more frequently in the sixteenth century.

The verses, inserted between the two portions of the *Shahnameh*, before the reign of Lohrasp, have been identified by Charles Melville as a *masnavi* (a poem written in rhyming couplets) composed by Sharaf al-Din 'Ali Yazdi, the celebrated Timurid historian (d. 1454), who was commissioned by Ebrahim Soltan to write the history of his grandfather, Timur, entitled *Zafarnameh* ('Book of Victory'). The long poem of 157 couplets, spreading over folios 237b–239b, is on Ferdowsi and the *Shahnameh* and in praise of Ebrahim Soltan.

Taking this folio together with the right-hand page designed to face it, Melville finds the four inscribed cartouches to contain an invocation to the peace of mind of the 'gold-scattering Eskandar (Soltan)' on the surface of the sun, drawing up a fresh design on the beautiful page of the clouds, painted on this margin by the slave of the 'mother of all books'.

Bibliography: 'Ali Yazdi, 2008, pp. 80–5

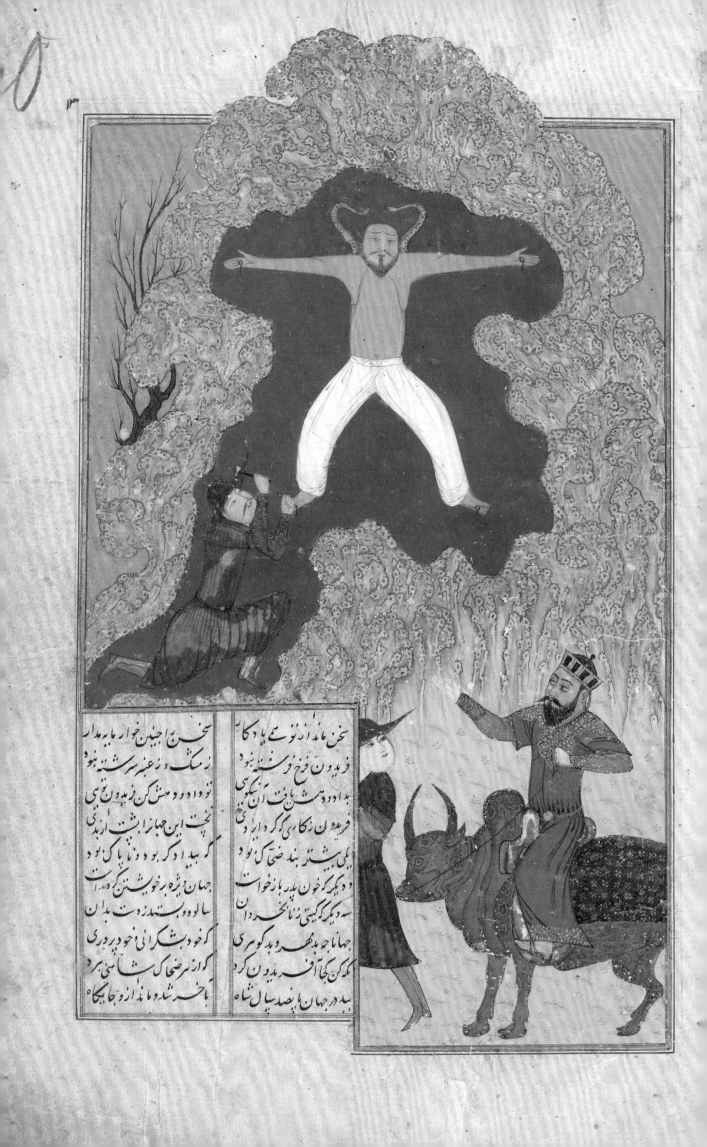

سخن ماند از تو جزاین جوار مدار
فریدون فرخ فرشته نبود
بداد و دهش یافت آن نکوی
فریدون زکاری که کرد از بدی
بلی بیشتر بند ضحاک بود
دگر کین خون پدر باز خواست
سدیگر که کسی زنا خرد آن
جهان جو یه برخویشتن کرد راست
کین جا که آفریدون کرد
بد در جهان با صد سال شاه

سخن ماند از تو جزاین خوار مدار
زمک دز عنبر سرشته نبود
نو داد و دهش کن فریدون تویی
نخت این جهان باشت از بدی
که بد که بو د و نیاک نبود
سالو دو دست مزدت بدان
خود شکرانی خود پر وری
کز مرضیا که شاسی برد
باخبره شد و ماند از و جایگاه

33 | ZAHHAK PINNED TO MT DAMAVAND

30a | Picture (225) 246 x 149 mm | ww, I, 170

Faridun, rightful ruler of Iran, has defeated Zahhak the usurper. He is minded to throw him off a mountain, but the angel Sorush instructs instead that he should be pinned in perpetuity to Mt Damavand.

The mountain towers out of the picture space. The figure of the prisoner is set off by a black background, the usual rendering of a cave. The black ground had been used in earlier versions, but the present painter may be the first to notice that Zahhak is nailed in a chasm and so under tension. It seems not impossible that some image of the Crucifixion may have reached Shiraz. The text tells us that Zahhak was carried to his place of punishment on a camel; it does not tell us that Faridun rode there on an ox, though he had wielded an ox-headed mace against his foe, and he had been fed in infancy by the cow Barmayeh. Evidently a visual tradition existed, independent of Ferdowsi's text, to place Faridun on an ox, for it is seen in ceramics, for example a *mina'i* dish in the Keir Collection.[30] Like the mountain, the ox is treated with texture markings of Chinese origin: this non-naturalistic mode may suggest a symbolic significance. The face of Faridun has been to some extent repainted in India. Damavand, in the Alborz Mountains, is a dormant volcano: occasional tremblings are popularly said to be the groans of the imprisoned Zahhak.

34 ROSTAM SLAYS A DRAGON

68b | Picture 160 x (149) restored to 166 mm | WW, II, 50

On the way to rescue King Key Kavus from the *divs* (demons) of Mazandaran by the shortest route, Rostam encounters Seven Perils. In the third of these a dragon approaches while he is asleep. Rakhsh, Rostam's watchful steed, wakes him twice to no effect, but when he is woken a third time Rostam understands what is happening. He attacks the dragon with the help of Rakhsh, who lays his ears back and bites the creature's shoulder. Rostam strikes off the dragon's head.

The high horizon of Shiraz style at the period marks a diagonal that is reflected in the action. The dragon's movement is indicated by a strong serpentine zigzag, its penultimate section paralleled by Rostam's sword. The viewer is teased by being required to imagine what further length of dragon body there might be beyond the picture space on the left. In contrast to this sinuosity, Rakhsh's downward bite is direct and forceful. As is often the case, Rostam is shown in his tiger-skin coat and snow-leopard cap. The dragon in this episode is unusual in having had the power of speech and territorial concerns, but the artist has not deviated from the usual images of the period. The patch in the right margin probably restores the original rendering of Rostam (compare the composition of no. 54).

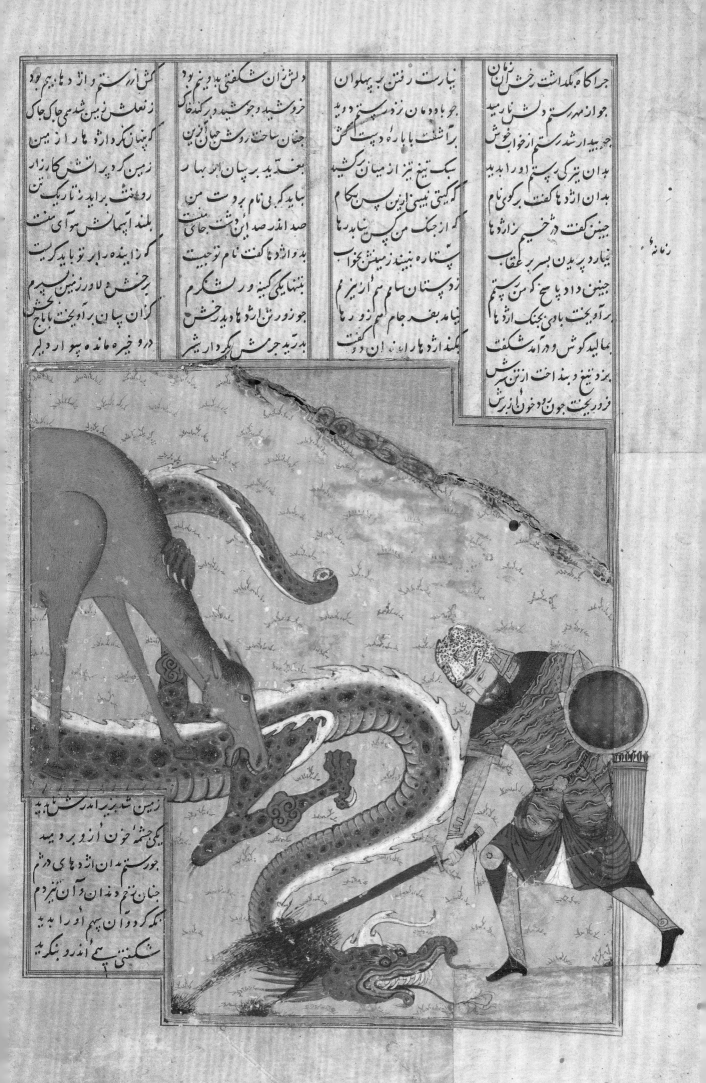

جراکاه بگذداشت رخش زبان
جواز مهر رستم دلش نار مید
چو بیدار شد رستم از خواب خوش
بدان اژدها کفت برگوی نام
چنین کفت درخیم زاده ها
نیارد پریدن بسر بر عقاب
چنین داد پاسخ کزین رستم
برآوبخت باوی بجنگ اژدها
بیالید کوش ودرآمد شکفت
بزد تیغ دبنداخت ازتن سرش
زور بخت چون رو وخون ازبرش

زمانه د

بیارت رفتن به پهلوان
جوا بدو مان یزد رستم دید
براشفت باباره دست آتش
بیک تیغ تیز ازمیان برکشید
که کیتی نبسی ازین پس بکام
که از جنگ من کس نیابد رها
ستاره بیند زمینش بخواب
ز دستان سام مم ازریزم
بیامد بعد جام کم زو رها
بلند اژدها بار نه آن دکت

دلش زان شکفتی بدین وبود
خروشید وجوشید ودرکند خاک
چنان ساخت روشن جهان آین
بغندید بر بیان اهل بهار
بیاید کبی نام بر دست من
صد اندر صد اندشت جای ست
بدوا اژدها کفت نام تو چیت
بنهای یکی کینه ورلشکرم
جوزورتن اژدها دید خشم
بدرید جرمش نکرد ار شیر

کش ازرستم واز دتا بجم بود
زنعلش زمین شمی جاک جاک
کبینش کرد پر اتش زمین
روبنغ برابد زتاریک تن
بلند آیمانش هوای منت
کز آینده ابر نو بباید کریت
برخشم لاورزمین سیم
کزان ببان بر آبیخت ماجم
درو خیره ماند و پور ار دبیر

زمین شد پر ازرستم ماه بد
یکی جشمه ازخون ازو بر دبید
جورستم بدان اژدها های درشم
جهان پنج دندان وآن تیزدم
بکد کرد وآن پهم اور ابید
شکستی پس اندرو بنگرید

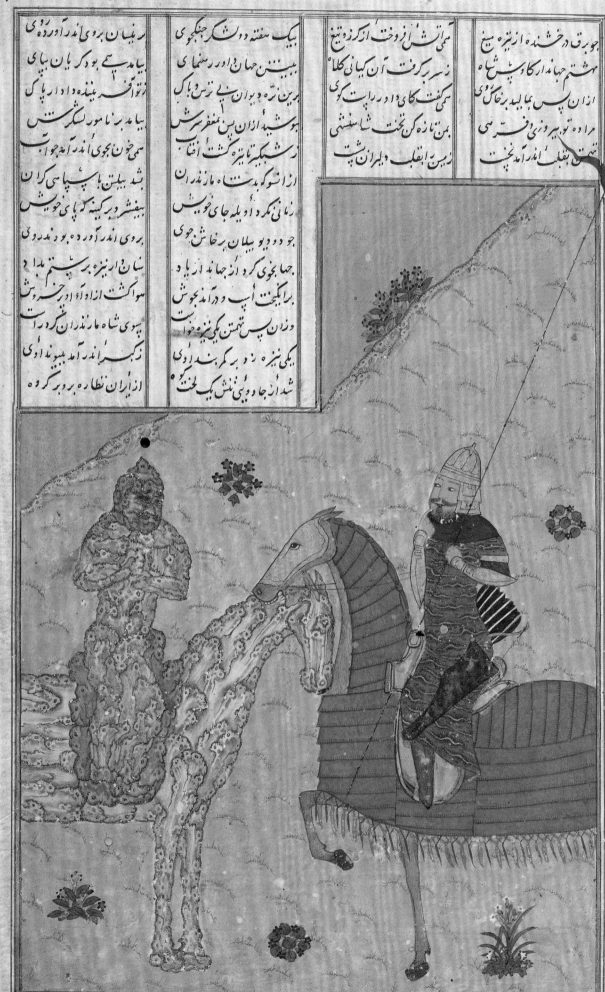

۵۱

جو برق درخشنده از نیزه بسیج

هشتم جهاندار کاوس پیش شاه

ازان پس بمالید بر خاک روی

مراد تو پیروزی وفرسته می

تق بقلب اندرآمد تخت

آمی آتش افروخت از گرز و تیغ

زسر برگرفت آن کیانی کلا

سمی کای واد و رپاست گوی

بمن تازه کن تخت شاهنشی

زین بقلب اندر دلیران پشت

یک سقته دو لشکر جنگجوی

ببینش جهانی و اور رهنمای

برین نرّه دیوان بی رنج و باک

بپوشید ازان پس بنفر سرش

رشبکیه نایزه گشت آفتاب

ازان شو که بنتا مازندران

زمانی نگر دولیله جای خویش

جو دد دیو بیلان برخاش جوی

جهان جوی گرد از جهاند از باد

براگیخت اسپ و درآمد نجوش

وزان پس تهمتن یکی نیزه خواست

یکی نیزه زد بر کمربند اوی

شد از جای وویی نش یک لخت کو

رنیان برویی اندر آورد روی

بیا مدپی بودکر یان بپای

زتوافق بنیزه دادار پاک

بیامد بر نامور لشکرش ت

سمی خون نجوی اندر آمدجوا ت

شد بیلتن باسپاهی گران

بپشتر دیر کینه کوای خویش

بروی اندر آورده بو زند روی

سان ار نیزه بر پشتم نهاد

موکشت ازواو او درخروش

پسوی شاه مازندران کرد رات

زکبر اندر آمد بپیوند اوی

از ایران نظاره برو بر کو ه

35

THE KING OF MAZANDARAN TURNS INTO A ROCK

73a | Picture (200) 211 x (148) 155 mm | WW, II, 74

Rostam has freed Key Kavus from disabling blindness in Mazandaran. Key Kavus calls on the demon, sorcerer king of Mazandaran to pay tribute, but this is refused and instead the latter comes with his army. In the course of the battle Rostam pierces the king's mail with a lance, and to his amazement the sorcerer turns himself to stone. Rostam alone is able to carry this petrified mass to the royal camp where, on threat of being broken up, the sorcerer returns to his normal form. As this is also unwelcome he is dismembered, and rule of Mazandaran is conferred on Owlad, who had previously acted as guide to Rostam.

The petrified king would often be shown as a simple boulder, but here the artist has portrayed a figure equivalent to an equestrian statue – a considerable feat of imagination, since he would at the most have been familiar with small ceramic statuettes of riders. The composition with two confronted warriors has a basic simplicity, but is here treated with a number of refinements. The uneven length of the columns of text and the two slanting segments of horizon bear down on the king of Mazandaran, framing him but suggesting that defeat will be his lot. His horse seems to have understood this better than he, and is in a submissive position compared to the buoyant Rakhsh. In the more spacious half of the composition, Rostam is biting the finger of surprise, while the line of his lance, the instrument of his victory, soars up and out of the picture, its pennant fluttering in celebration.

چو سهراب بازآمد اورابدید
چنین گفت کای رسته از چنگ شیر
دگرباره اسپان ببستند سخت
سرانجام که خشم آورد بخت شوم
زبس گیر تا سایه کسته سور
سرانجام سهراب و آن پهلوان
غمی گشت رستم بیازید دست
زوش برزمین برگرد اندر شیر
سبک تیغ تیز از میان برکشید
بریشیر بیدار دل بر درید

زباوجوانی دل تنگ ردید
جدا آمدی بازه دم دلیر
بسر بر همی کشت بدخواه بخت
نگشتی کرفتن نهاد آندپسر

جواورا بدان فسر وآن پرده
جدا آمدی باز ببیشتم نکوی
نگشتی کرفتن نهاد آندپسر

کرفت آن برو بازهی میکیست
بداپست کوسم نماند بزیر

یکی تیز ترشد بد ونگرید
پی اکستی چون سایی یوروی
کرفنه مرد و دو دال کمر
شود سنگ خار ابکره ز موم
سی این آن این کرد زور
توگفتی که جرخ بلند کش بست
زمانه بیامد بدست یروان

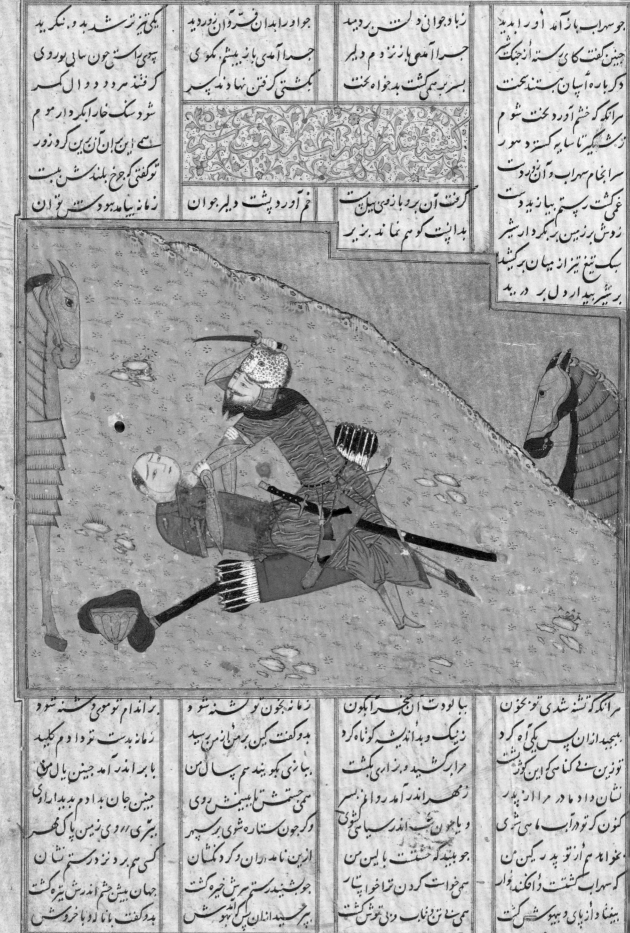

مرانکه تشنه شدی تو نحون
بمجیده ازان پس یکی آه کرد
تو زین سنے کنا سی این کوشت
نشان داد ما در مرا از پدر
کنون که تو جرآب ماہی شدی
نخواهم هم از تو بدرکین من
که سهراب کشتت د افکند خوار
ببنا دازیای و بهبوکش کشت

بلا لود ت آنجه خرا بکون
نیک و بداند یشه کوماه کرد
مرابرکشید و بزاری بکشت
زهراندر آمد روان پسر
وبافون نجب اندر سیاه کشتی
جو ببید که خشتت بااین کار
سی خواست کرد ن تناخر ایار
سی سنا تن زنیاب وی تو خش کشت

زمانه نحون تو شه نشو
بدوکفت کین برمن از زمی سپید
بنازی بکو بیند سم پسال من
سمی جستهش تا ببیش ش روی
وکرجون ستاره شوی برسپهر
ازین نامه برآن ورگرد تکمان
جو شنید رستم سریش خیره کشت
بسر حسبیدازان پس پوش

براندام تو مویه ی شه شو
زمانه بدست نودم وکلید
بابره اندر آمد جنین یال من
جنین جان بدادم بدبداروی
بتری روی رزمین پاک مهر
کسی هم برد نزدک درستان
جهان بیش چشم اندرش نیزه کشت
بدوکفت بابا اورا بخروشی

36 SOHRAB SLAIN BY ROSTAM

92a | Picture 113 x (149) 151 mm | ww, II, 173

Unknown to each other Rostam and Sohrab, the son born to him by Tahmineh, confront each other in battle. Rostam, who has argued his way out of defeat in a previous bout, downs Sohrab and strikes home with his dagger. He will discover his son's identity when he sees on his arm a jewel that he gave to Tahmineh for his child.

At the foot of the stepped upper line on the right, the last verse before the picture (the break-line) sends the eye across to the sinister horizontal line of the dagger; by contrast the horizon behind Rostam falls away. Sohrab is shown as youthful, beardless, surprised, but almost resigned; Rostam is a mature warrior. The opposing horses are hostile but more contained than the human protagonists. The ground is slightly mauve as though in shadow. See also no. 82.

37 ROSTAM SHOOTS ASHKABUS

156b | Picture (163) 165 x 149 mm | ww, III, 181

In a battle of the armies of Iran and Turan, Rostam has elected to fight a dangerous mounted enemy on foot. Unmoved by Ashkabus's taunts, Rostam shoots his foe's horse; then, while Ashkabus showers him with arrows, he selects a shaft and shoots the rider also.

Rostam in his tiger-skin makes a powerful and elastic figure, lent further emphasis by the upstanding tree behind him; while under the lower part of the horizon Ashkabus and his horse have met their death, each curled in a similar way.

Abdullaeva and Melville note that the line immediately preceding the picture (the 'break-line') reads: 'The Kashani gave up his life at once; you would say he had never been born by his mother', and they suggest that horse and rider are depicted in a foetal position. The horse's extended foreleg does indeed suggest a movement towards birth. See also no. 90.

Bibliography: Abdullaeva, 2006

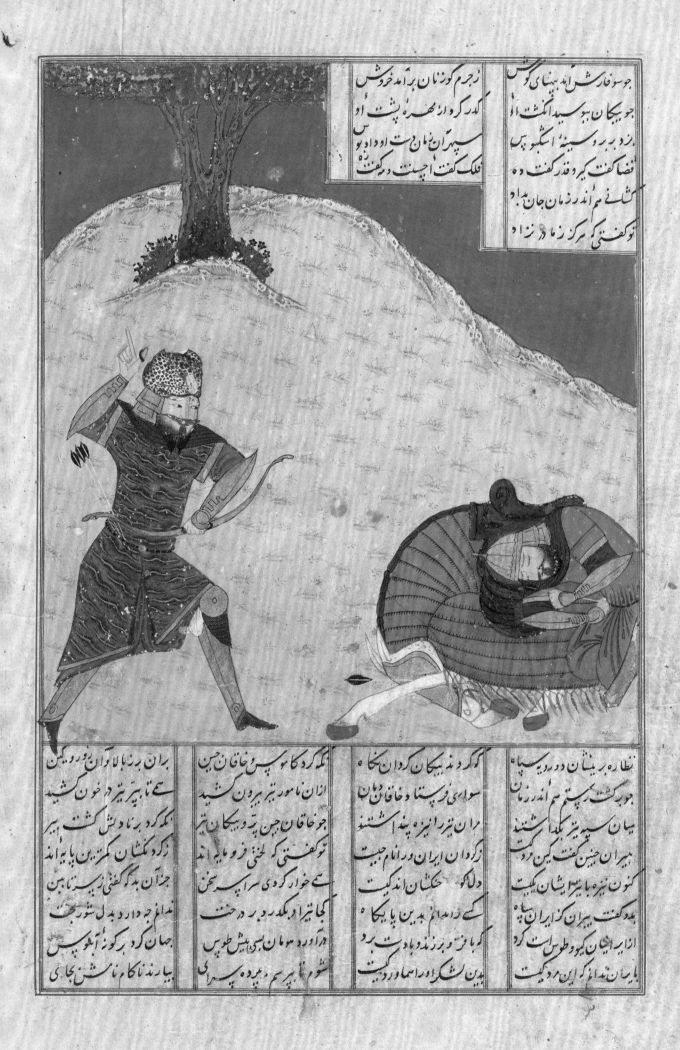

جوسو فارش را به بهنای گوش
جویکان بهو سید انگشت او
بزد بر و بر و سینه اسکبوس
فضا کفت کید و قدر کفت ده
کشاتی هم اندر زمان جان بداد
توکفتی که مرکز زمان درزاد

زجرم کوزنان برامد خروش
کدرکرده بهره انگشت او
سپهران زمان دست او داد بو
فلک کفت احسنت و کفت زه

نظاره بریشان دو روی سپاه
جوبرکشت رستم هم اندر زمان
یان سپید یز کلید اکشتند
پیران حین کفت کین مرد
کنون نیزه یا تیر ایشان یکیت
بدکفت پیران کز ایران پناه
ازابر ایشان کیخسرو طوس است کرد
بایران نداز که این مرد کیت

اکرو بذیکان کردن نگا
سواری و رستا و خاقان دین
بران نیزه ایز بنده اشنند
زکردان ایران و رانام جبیت
دلکو کستان اندکیت
کسی زا ما بدین بایکا
کر با خزو برز ندو باد است برد
بدین شکر و دار اسماء ورد کیت

انکه کرد کا بو سرخاقان جین
ازان نامور بیز برون کشید
جو خاقان جین پرویکان انر
توکفتی که لخنی فرو ماید
کجا تیز اد بککرد و در دخت
ارادرو سومان بسی پیش طوس
شتوم نا برسم وبود پسرای

بران بریز بالا وان زوروکین
سی تا بیز زرد خون کشید
که زرد کسان نکمزین بایند
جزان بدگگفتی زبید یا بین
ندام جدادار بدل شوریخت
جهان کرد بر کز بآبوپس
بیا رند نامکام نامش بجای

38 ROSTAM DEFLECTS A ROCK

72b | Picture 213 x 149 mm | ww, v, 184

Rostam, now an old warrior, has not come to court to make his obeisance to Goshtasp. Esfandiyar, son of Goshtasp, sends his son Bahman to deliver a reproach that ends in the demand that Rostam should come to court in bonds. Bahman first encounters Zal, Rostam's father, who in the hope of averting disaster offers hospitality. The young man is led up a hill from which he looks down on Rostam, who is roasting an onager spitted on a sapling. Thinking to spare his father a conflict, Bahman rolls a rock down towards Rostam, but the hero deflects it with a kick.

Presumably working in conjunction, the scribe and the artist have solved the problem of how to treat the spatial relationship of Bahman and Rostam: a symmetrical panel of text firmly blots out distance between hill and valley. With characteristic nonchalance, Rostam only half turns to kick away the rock. His campsite is minimal, but is nevertheless provided with a flask of Chinese style in blue and white.

بجستی کسی مرد و ازینیان بدید
نورم گربا اوبل اسپنخ پار
من این را یک سنگ بجان کنم
فرومشت از آن کوه بیاریلند
یکی سنگ غلطان شد از کوپیا
زکردش براآن کوه تاریک شد

نور از نامه ازان بیشن شبنما
تیا بد نبخد پبد ازکارهزار
ول زال رود ابه بجان کم
زنخجر کاش زواره بد بد
نخبندرسم نه بنها دکور
نزوپابشنه سنگ بنداخت

سم آور ازان سنگ خار آشبند
زواره سمی کرد از آن کوه نه سور
نزداره برد افسدبن کرد وپوبا

39 ESKANDAR CONTEMPLATES THE TALKING TREE

311b | Picture (259) 263 x 149 mm | ww, VI, , 169 (text on recto)

Eskandar visits many parts of the world; he sees many wonders, and builds a wall against the savage Yajuj and Majuj (Gog and Magog). At length he comes to a palace that contains an enthroned corpse with a boar's head, and where a voice accuses him of greed and warns him of death. He is well received in the next city and told of a tree whose two trunks bear male or female heads that speak by day or by night respectively. The tree marks the world's end. Eskandar visits the tree, both of whose trunks prophesy his death.

The absence of text on this folio lends it a special solemnity. The wonderful tree dwarfs Eskandar, who seems a slight figure crammed against the margin. By contrast the branches of the tree spread luxuriantly in the freedom of the sky that seems to betoken another world. Already in the illustration of this subject in the Great Mongol *Shahnameh* of *c.*1335, the male and female heads prescribed by the narrative had been modified by the notion of a tree with various speaking animal heads. See also no. 13.[31]

Bibliography: Auld, 2007

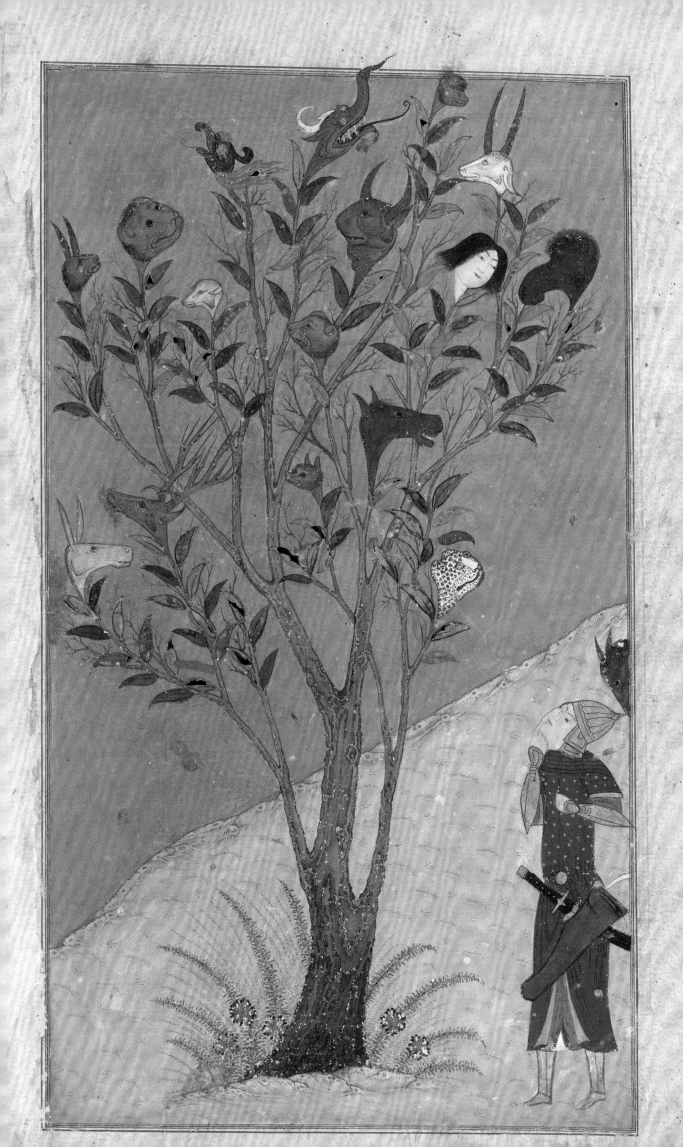

40 JAMSHID'S THRONE BORNE BY 'DIVS'

Fitzwilliam Museum, MS 22-1948, 11b | Given by P.C. Manuk and Miss G.M. Coles, 1948
As re-margined 248 x 180 mm; text area 172 x 120 mm; picture (125) 130 x 120 mm
c.1435–40 | Timurid (Shiraz) | ww, I, 133

Jamshid, son of Tahmuras, the fourth Pishdadian king, is endued
with the royal *farr* (charisma). He teaches his people to make weapons
and clothes. He divides them into four castes and teaches them to
build, to mine, to make perfumes, to practise medicine and to use ships.
He has a jewelled throne on which he is carried through the air by
divs. After a time he comes to think of himself as Maker of the World,
and the *farr* leaves him. This opens the way for the rule of Zahhak,
the Arabian usurper. Zahhak is offered the throne of Iran; Jamshid
flees but is eventually discovered in Chin (China), captured and sawn
in half by Zahhak.

The sense of the text, Jamshid's overweening pride in what he sees
as his own achievement, is mapped out in the composition. Attention
is caught by the face of Jamshid, whose crown just rises beyond the
picture space. His expression is absolutely calm, and his posture,
leaning against a bolster, is entirely relaxed. Below him the toiling
divs form the lower angles of an isosceles triangle. See also no. 102
for an expanded version of Jamshid's story; and nos 6, 7, 10, 41 and
42 for illustrations from this manuscript.

Bibliography: Stchoukine, 1954, pp. 43–4; Wormald and Giles, 1982, II, pp. 406–7;
Soudavar, 1992, p. 75

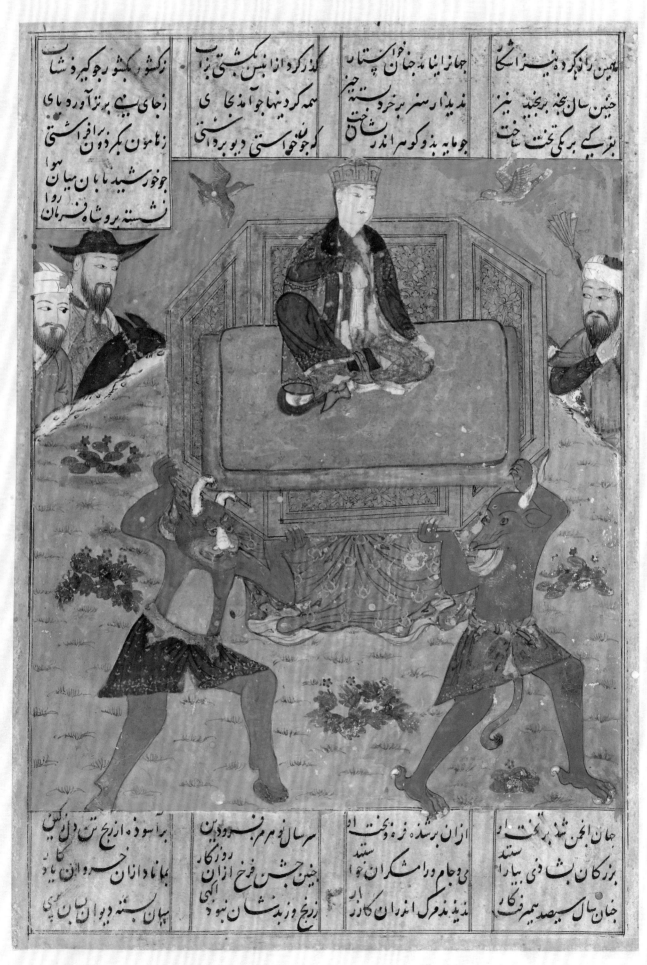

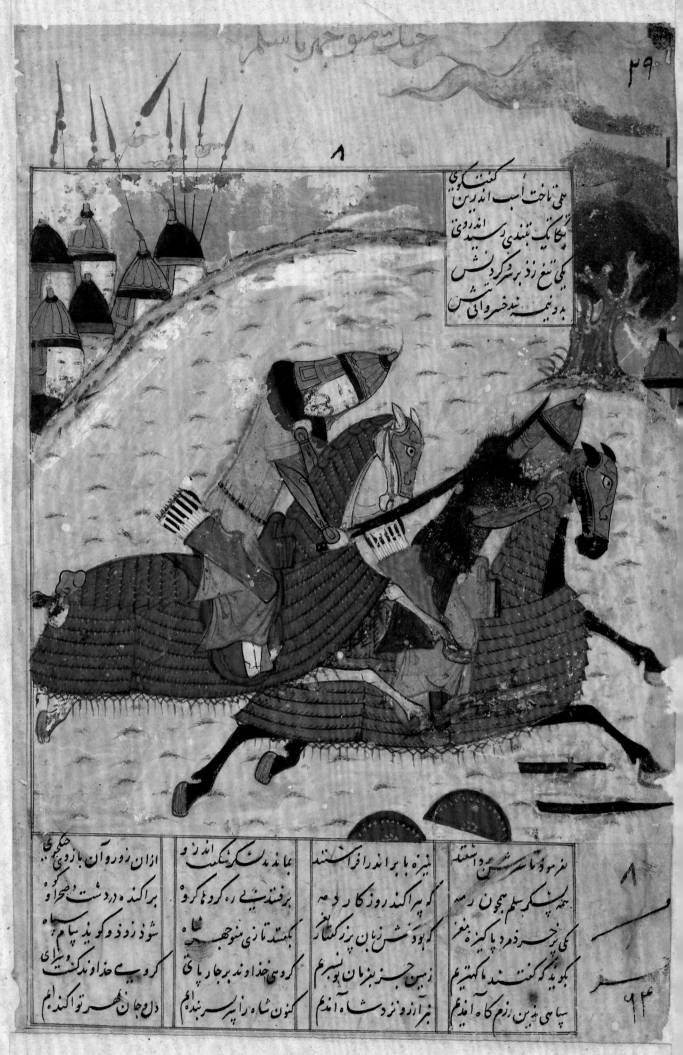

جنگ منوچهر با سلم

کنون کی

می تاخت اسب اندر این
یکایک ببندی رسید اندروی
یکی تیغ زد بر سر کردنش
بدو نیمه شد سنبر خسروانی تنش

٨

نیزه با بر اندر افراشتند
به لشکر سلم بچون رسید
که و نشن زبان بزرگان بغز
زمین جز بر زبان پرسیم
نبر آرزو نزد شاه آمدم

نزد موبدان سر سرده اشتند
که پراکند روزگار ده
به پیکند تازی منوچهر
کروی خداوند بر جا پای
کنون شاه را پیش بندیم

بماندند سنگ اندرو
برفتند شیب ره کرو ها کرو
شد زد ز دو کوید پیام
کروی خداوندکنت
دل جهان بهر تو اکندیم

از آن زور و آن بازوی شگفتی
براکند در دشت و صحرا کو
سپاه سپاه
کروی سپهای

Manojur slaying Salem

41 MANUCHEHR SLAYS SALM

British Museum, 1948, 1009, 0.49 | Given by P.C. Manuk and Miss G.M. Coles
As re-margined 250 x 175 mm; text area 176 x 117 mm; picture (140) 170 x 138 mm
Timurid (Shiraz) | *c*.1435–40 | ww, I, 228

Faridun, father of the murdered Iraj, sends Iraj's grandson, Manuchehr, to wreak vengeance upon Iraj's brothers, Tur and Salm. Manuchehr kills Tur and sends his head, together with a letter, to Faridun. He takes measures to prevent the escape of Salm, and eventually strikes him down as he tries to make for the sea. Salm's head also is sent to Faridun.

This scene of action is very characteristic for Shiraz style of the period. The landscape is spare; human figures are tall and high-shouldered; the horses are large with in-drawn heads. There is speed and a satisfying rhythm – though in logic the forelegs of Manuchehr's mount should be behind Salm's horse. This picture, with four others in the British Museum, is from the same manuscript as the preceding picture; and from the same donors. Some of the Fitzwilliam pictures have, like this, a roughly written heading, while others have more developed labels, which would have been subheadings in the text. See also nos 6, 7, 10, 40 and 42.

Bibliography: Titley, 1977, no. 142

42 KEY KAVUS AIRBORNE

Fitzwilliam Museum, MS 22-1948, 25b | Given by P.C. Manuk and Miss G.M. Coles, 1948
As re-margined 248 x 180 mm; text area 172 x 120 mm; picture (150) 158 x 130 mm
c.1435–40) | Timurid (Shiraz) | ww, ii, 103

Set on by Eblis, a *div* appears to Key Kavus in the form of a pleasant young man and tempts him to explore the mystery of the heavens. Key Kavus faces the problem of flying. He has some young eagles specially nurtured and a throne built. Spears are attached to its corners and legs of lamb to the spears. Four sharpset, young eagles are attached to the throne and strive to reach the meat. When the eagles are exhausted the throne descends in the forests of Amol. Key Kavus spends time in penitence imploring God's mercy for his pride.

The artist has deployed considerable imagination. In addition to numerous clouds, there are sun and stars in the sky. The spears pierce the upper line of the picture space, the joints of meat upon them almost seeming to be tassels; the eagles obligingly clutch the rococo legs of the throne. The valence of the throne is agitated by wind, and soaring height is suggested by a head that leans back to watch. The throne has an extra panel and, unlike the insouciant Jamshid (no. 40), Key Kavus holds this firmly as he looks cautiously up, bow at the ready. The text below the picture mentions that he fought with bow and arrow against the Heavens, and indeed many depictions of this scene show Kavus shooting at an angel. See also: the same subject, no. 104; the same manuscript, nos 6, 7, 10 and 41.

Bibliography: Stchoukine, 1954, pp. 43–4; Wormald and Giles, 1982, ii, pp. 406–7; Abdullaeva, forthcoming 2010

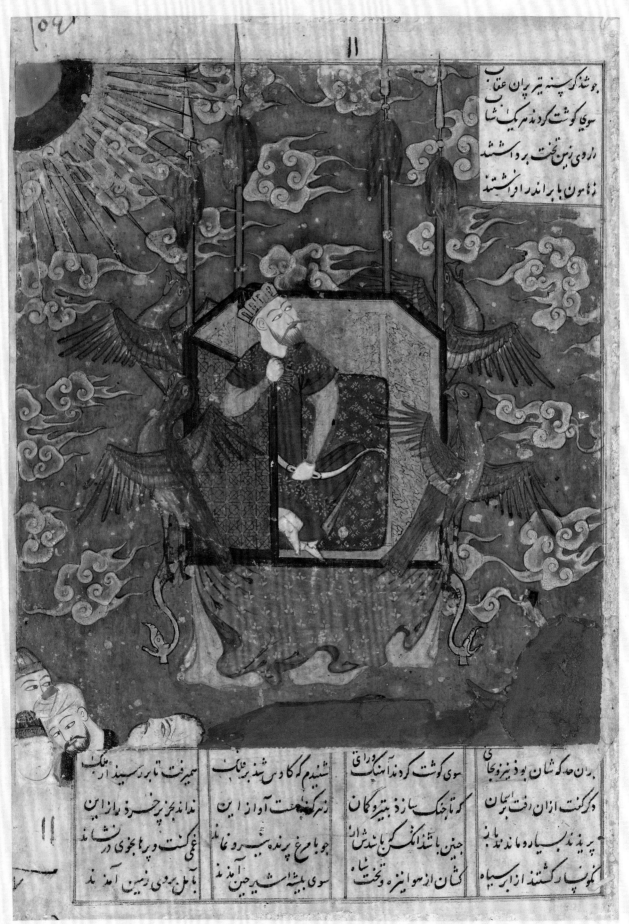

43–55

'SHAHNAMEH' FOR MOHAMMAD JUKI B. SHAH ROKH

Royal Asiatic Society, MS. 239 | Presented by Lieutenant Colonel. C.J. Doyle
As re-margined 338 x 228 mm; text area 228 x 135 mm | *c.*1444 | Timurid (Herat)
Patron: Mohammad Juki b. Shah Rokh

Bibliography: Wilkinson and Binyon, 1931; Robinson, 1951, 17–23, 1979, pp. 83–102,
and 1998, pp. 1–8; Brend, 2010, p. 6, further references

43

ILLUMINATED ''ONVAN'

244b | Illumination 71 x 136 mm | WW, IV, 316

In this manuscript, made for the brother of Ebrahim Soltan,
illumination is applied more sparingly than in the Bodleian
manuscript (nos 30–2), though some ornamented folios may have
been lost, or not completed, owing to the patron's death. The second
part of the *Shahnameh* is marked by an *'onvan* (heading), rather than
a full *sarlowh* or an illustration. Blue finials that would have risen from
its upper line have been lost in re-margining of the late eighteenth or
early nineteenth century. The style with its formalised arabesques is
closer to work produced in Herat for the princes' brother, Baysonghor,
in his *Shahnameh* of 1430, and the looped lines that are much used
in Herat are in evidence. Lower in the page, the subheading in
unoutlined *reqa'* announces the reign of Lohrasp. The main text is
in an elegant *nasta'liq*, which is perhaps to be identified as the work
of the scribe Mahmud.[32]

بدان آفرین کو جهان آفرید	سپهر و زمین و زمان آفرید	هم افزاز رویت و هم نام و	تیم افزاز ازرویت و فرجام ارو
سپهر و بستان زمین کرد ند	کم و پش کستی بر آور د ند	ز جاه شاه تا جذه تا عرش رست	سرا سر هستی یزدان کو است
جره ز او راخ جان کرد کاریان	شاییسنده اکار جهان	وزو برروان محمد در ود	پایانش بره کی بر فزود
که شا عیش خواند علی و وصی	سراتجین مد ز یاران علی	نباید جز از پی پردنش	که یزدان پاتش بسوز دتش
سخنهای ایشان کفت ا ز شمار	همه پاک بودند و برجیه کار	هزاران در ود و مهر ا آل سلام	زبا بر محمد علیه التسلام
پارایم و برشاهم نگار	کنون تاج و اورنگ شاه با	ز دل زنگ وا ز روش از تک کن	بز دکم جه بد نلندچو زنگ
ز دل زنگ خورد ز تی بک کهین	ز ال زنگ خورد و ده زرنگ کهین	چو پی درآمد نبا که برد	چو آتش کنند ب سپا ل خور د
جور او بود گه زنا که با نهاد	زفرزان کو به بود با نهاد	کو به پشت و بابا بش	کندی با ده او راجو خم کند
چو در و به خورد که او شد ش	کیوان بر د جون بود د بهم	ابا کنا د که به آرد پدید	در بسته را برده به باشد کلید
		جور یزمان خورد شا که شود د	برچ ا ر جون ناردا شود
			نجوابه جزاز دامن نای و د
			سخنها مه یک بک یاد گیر
جهان آفرین راستایش کرفت	ستایش و زاد فزا یش گرفت	شاهنشه تاج بر سر نهاد	چو لهرا سب بر تخت بنشست شاد
نگار نده جرح کرد ده آو	برامید بشید و با ز سن نو د	چنین کرد گار و داد با ک	خود پا یا که وز زمین آفرید
که تیز کرد ند وگر حجا بی	بلند آسما نا ز برش بر کشید	چو سخ از بر کوی و ما ملان	ریخ تن آزاد و سود و زیان
توشا دان دل دم که حال سینه	آزر و فری و لی بک سو شوم	آزرو فری و لی بک سو شوم	آرزو فری و لی بک سو شوم
ارزن تاج شاهی و تخت بلند	نا دا نی خوش حست و شوم	کمر ب ما ن ز من سرا ی سنج	کگر بهمان ز من سرای سنج
مناز بد کنج خود و آزو کم	نا جه تجه کیه و در دو رخ	سپا یزد از واز داد با شید شاد	سپا یزد از واز داد با شید شاد
زد لکه در رنگ برون کنم	تن آسان واز کین نکه بیا د		
وراسه ب یار و ز مین خواند	جهان جهان آفریده خواند		

وقت منفصل خوابم کرد و واجب الله گفت کی از ایشان گفت با او ببایستی کنم تا برود عضوی از آن منع کرد دیگری کنت مرک مصلحی
گوییم در قافیه مشکل واز والتماس ربع کنم اگر بکو بصحبت ما شاید والاعذری یاید شد چون برسید اورا القی نمود اورا صورت حال
نمیر کرد ند و در جواب گفت گفت کرنوایم کو یم والا رحمت برم عضوی کنت این قاعده ست

چون عارض تو ماه بنا شد روشن ما تندرخت کل نبود در کشن
مرکانت سی کذ از کنده بر جو شن ایشان کفیت جنگ کو وشن

پرسید نذ تفریج خوش گرد جنگ مجموع فضل اورا مسلم داشته بصحابت و معاشرت آن طایفه موانس شد وشجر او را انتخاب کردید

44 FERDOWSI ENCOUNTERS THE COURT POETS OF GHAZNI

7a | Picture 163 x (132) 150 mm

As in no. 1, Ferdowsi has entered the garden where the court poets of Ghazni are taking their ease, and he is undergoing their test of his skill as a poet.

The setting is exceptionally lyrical, perhaps a reference to the entrance to the world of poetry rather than the city of Ghazni, but the tensions between the new arrival and the court poets are evident in their various postures. Ferdowsi, in brown, makes a gesture that implies exposition tempered by courtesy. The gaps in the text above the picture were intended to receive – presumably in ornamented form – the names of the poets of Ghazni: 'Onsori, 'Asjadi and Farrokhi, and that of Ferdowsi. Compare no. 1.

45

THE SIMORGH RESTORES ZAL TO SAM

16b | Picture 171 x 128 mm | ww, I, 247

Sam has been shocked when his son is born white-haired and has him exposed on a mountain to die. The Simorgh (the mystical bird) takes the child to the Alborz mountains and cares for him. Years later Sam dreams of his son and goes to seek him. The Simorgh delivers Zal to Sam. She gives Zal a feather that he can burn at need to summon her help (see nos 46 and 77). Later in the narrative characters will occasionally make disparaging reference to Zal's having been brought up by a bird.

As is usually the case, Zal is shown as an infant, rather than the youth that the text describes. The rendering of the Simorgh derives from Chinese versions of the Asiatic pheasant. The artist has been inspired to match the colours of the mountain to the Simorgh's plumage, so that its nest and chicks are camouflaged. See also no. 83.

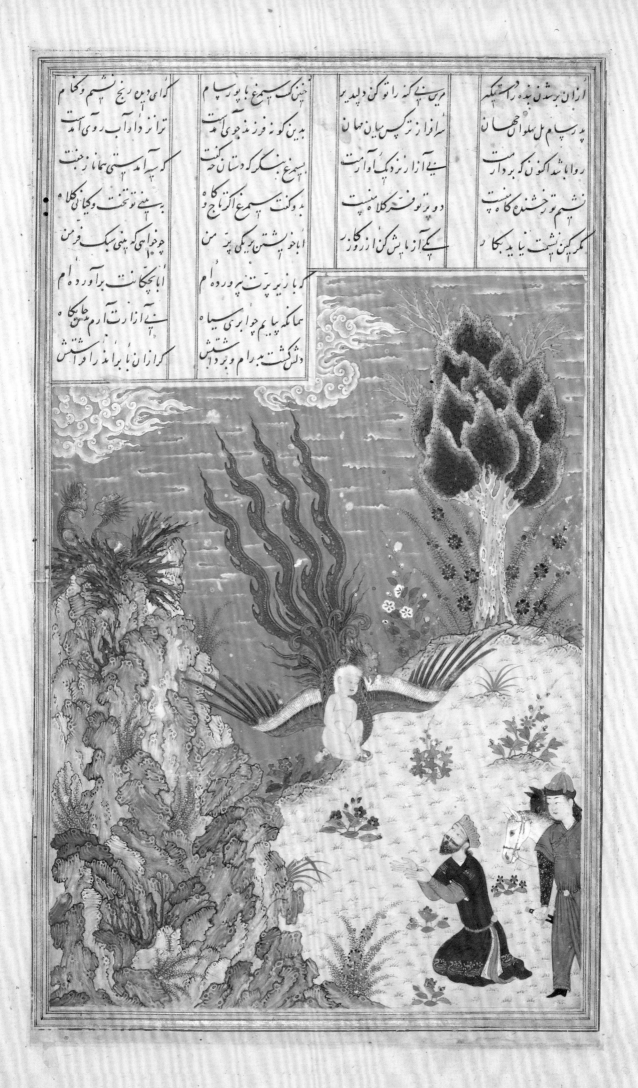

ازان برشدن بدہ درہ شنکہ
مرین شنے کہ راتو کن دل پدیر
خنک سیمغ با پورسام
گرای دین رنج نشم وکام

پرسام بل بلوا جهان
سراواز ترکس پان جهان
بدین کہ نہ فرزند جوی آست
ترا نزد آب روی آمدت

روا باشد اکنون کہ بردار
نے آزار نزد کے آوآست
بیمغ بنگر کہ دستان کفت
کہ شہ آمدستی بہما نہ جفت

نشیم تو رخشندہ کاست
دو پرتو فخر کلا منیست
بدکت سیمغ اگر باج و
بشنے نوخت وکیانی بکلاه

کمر کین نشت نیا بدہ بکار
کے آزار پش کن نز آروز
ابا خو پشتن ریکی پرہ من
چو خوای کہ بینی سبک فرمن

کہ با زیر پرت پروردہ ام
ابا چکانت برآوردہ ام
بہمک پایم جو ابری سیاہ
نے آزار ت آرم جلو کار

دلت کت بدرام و بردا
گران یاں با برانذ راو شتش

46

PORTRAIT OF THE INFANT ROSTAM SHOWN TO SAM

30b | Picture 203 x 128 mm | ww, I, 323

Zal marries Rudabeh. She becomes pregnant with a very large baby. At the birth, Zal summons the Simorgh by burning one of her feathers and, on her instruction, the child is delivered by a Zoroastrian priest in an operation that is – in terms of the narrative, *avant la lettre* – caesarian. The child is given the name Rostam. Zal sends an image of Rostam in the form of a doll of stuffed silk to Sam.

The artist does not depict a doll but instead a painting on silk. As this is anxiously proffered to him, Sam's face radiates a grandfather's pride. Other details convey the life of a moderately grand court. For the story of Zal and Rudabeh, see also nos 65, 81, 93 and 98; for another portrait see no. 86.

یکی جشن کرد اندر کلستان
نشسته بر جای راه کران
بسان نگار رستم که زاد ار

زراولستان تا بکابلستان
زراولستان از کران تا کران
بود نزد یک سام سوار

مه دشت پر باده و نای بود
نبسته ازم که کمی مرفود

بهر کنج صید مجلس آرای بود
یک پسته جان پین بود نارود

ROSTAM SLAYS THE WHITE DIV

44a | Picture 163 x 127 mm | WW, II, 60

When Key Kavus of Iran has been captured by demons (*divs*) in Mazandaran, Rostam sets out to free him (see nos 34 and 35). He learns that Key Kavus has also been blinded and the cure for this will be the application of the White Div's liver. Rostam battles with the White Div in its cave lair; he defeats it, and extracts the liver.

The *div*'s cave is shown in section, the surrounding rock being of a sinister crystalline whiteness that reflects its denizen. Rostam, wearing his habitual tiger-skin coat, is intent on his mission; while tied to a tree, Owlad, who has been obliged to act as Rostam's guide, looks exceedingly anxious. The development of the depiction of *divs* has not been fully traced, though a contribution from China or Central Asia is evident. See also no. 71.

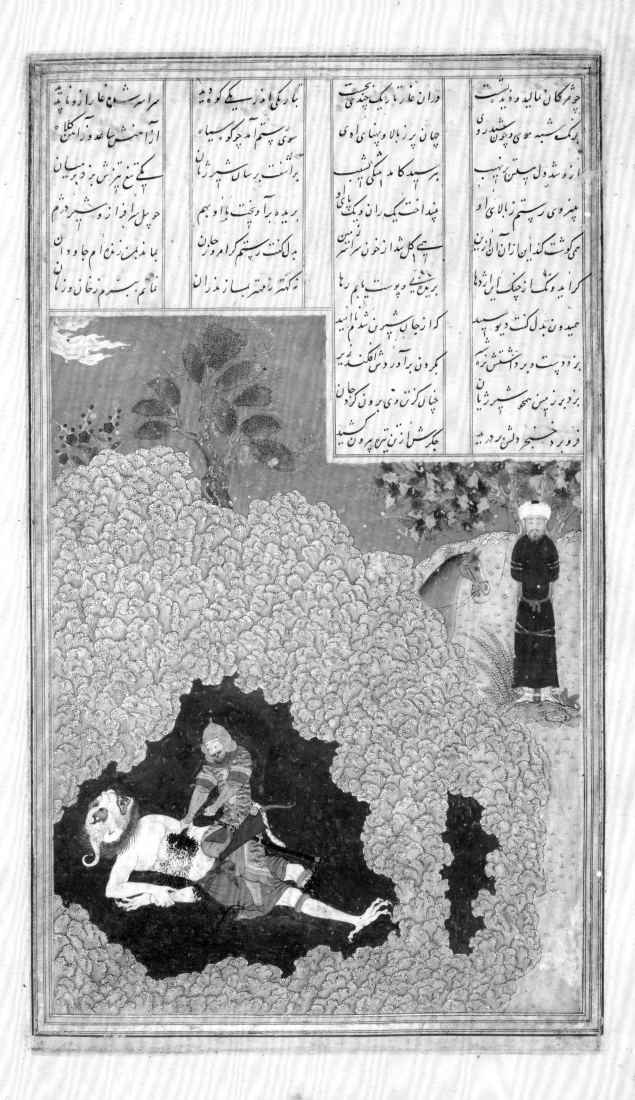

48 TAHMINEH COMES TO ROSTAM

56b | Picture 160 x 128 mm | ww, II, 123

This scene was frequently included in manuscripts (nos 18, 28, 75 and 91), but this may be described as its most celebrated rendering. The frank eagerness of Rostam matches the bashful excitement of Tahmineh, who is now accompanied by a black eunuch. All parts of this interior are seen with equal clarity as though a wall had been removed, or as in the opening of doll's house. Rostam has been sleeping in a carpeted alcove; the lower wall is clad with a tiled dado, the upper wall is whitewashed with stucco-framed windows, and ornamental arches support the ceiling.

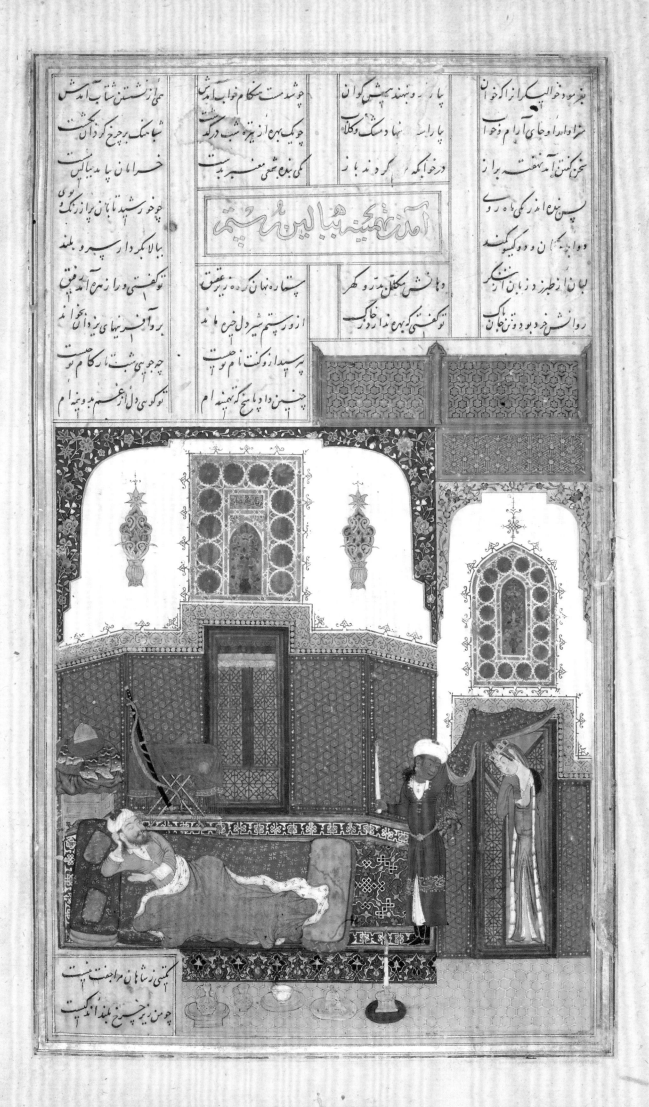

The page is a full-page Persian manuscript illumination with surrounding text in Persian/Arabic script (nastaʿliq). The text is calligraphic verse and difficult to transcribe accurately from this image. Given the nature, the page is image-dominant with decorative calligraphy that cannot be reliably transcribed.

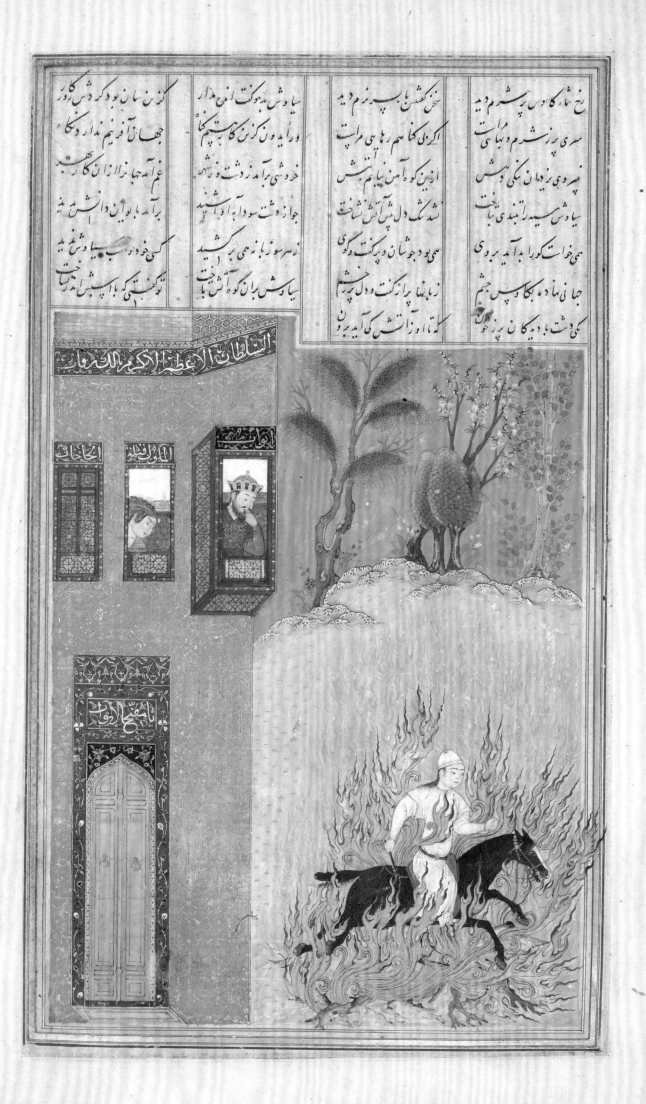

49 FIRE ORDEAL OF SIYAVOSH

76a | Picture 165 x 128 mm | WW, II, 220

A wife of Key Kavus, Sudabeh, has become infatuated with his son
Siyavosh. When Siyavosh rejects her advances, she accuses him of
attempting to violate her. To prove his innocence, Siyavosh agrees to
undergo the ordeal of passing between two huge fires (nos 78 and 92).
Though vindicated, Siyavosh will eventually go into exile in Turan,
where he will be murdered.

Siyavosh is the central focus, a balance between tension and calm.
Flames of Chinese type lick round him and his horse, while delicately
rendered smoke rises above the fire. Key Kavus watches, biting his
finger in amazement, but Sudabeh's head is slightly bowed. The white
tile inscriptions have no particular significance in this picture but
are conventional expressions of piety or the celebration of kingship.

50 FORUD SHOOTS ZARASP

119b | Picture 157 x (128) 138 mm | ww, III, 54

Key Khosrow of Iran, son of Siyavosh, has sent his army to Turan to avenge his father's murder. They are instructed not to go near the castle of Key Khosrow's half-brother, Forud; nevertheless, the commander, Tus, takes the army by this route. Forud offers to join the avenging army, but Tus stubbornly sends champions to attack him. Forud shoots Tus' son, Zarasp.

Forud is drawn a little larger than the other persons; his dramatic posture exploits the fact that the Persian bow is released with the thumb. As Zarasp crumples, his horse also feels the shot. The banner of Iran, sometimes described in the *Shahnameh* as violet, here has sections in that colour and is embellished with a yak tail from the Timurids' Turko-Mongol tradition. See also no. 73.

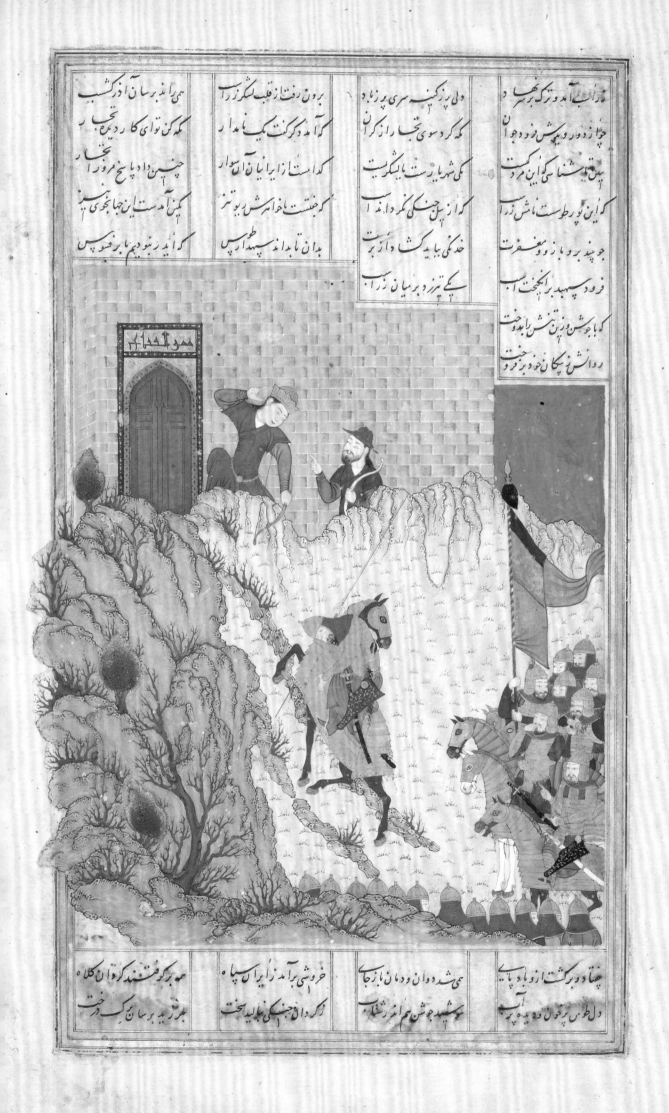

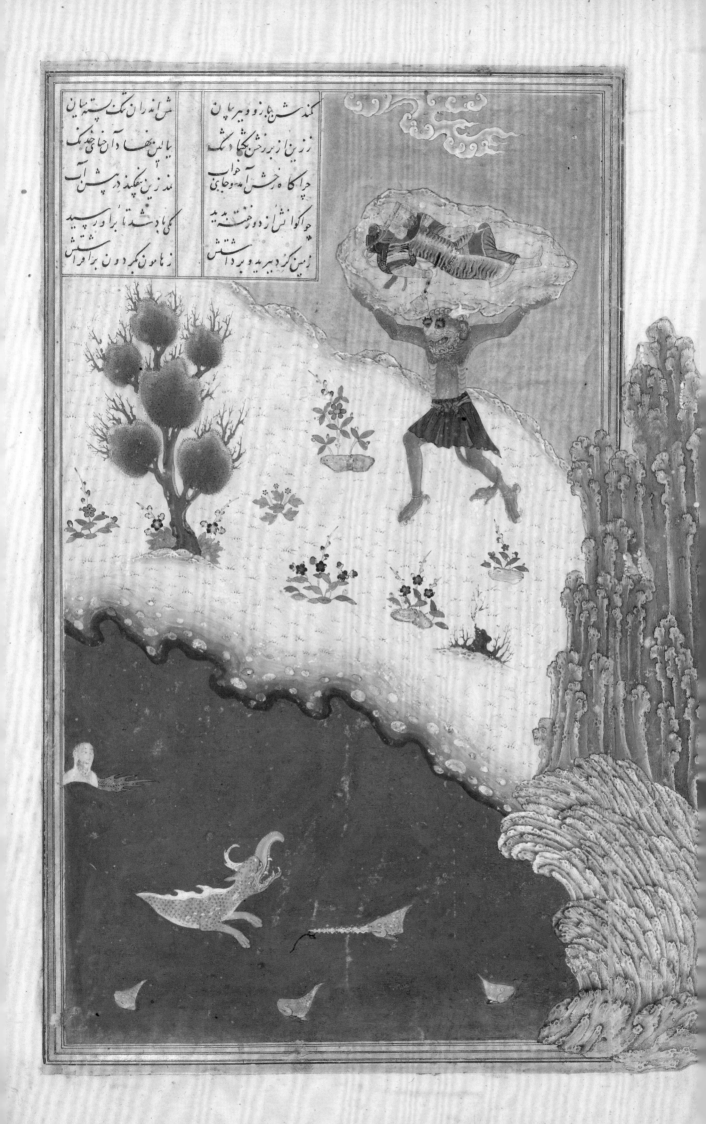

51 THE 'DIV' AKVAN LIFTS THE SLEEPING ROSTAM

165b | Picture (219) 225 x (127) 174 mm | ww, III, 276

Key Khosrow sends Rostam to attend to a div that has been harrying his horses. After searching for three days, Rostam sleeps by a spring. The *div* approaches and lifts Rostam, together with the piece of ground on which he was sleeping. Gloating, the *div* asks Rostam whether he would rather be cast into the sea or on to a mountainside. Understanding the *div* will do the opposite of his request, Rostam chooses the latter and survives in the waters in spite of threatening sea monsters.

The faces of Rostam and the *div* are rendered with considerable humour. The angled lines of horizon and sea lend a sense of instability, while the rock on the right images the splash that Rostam will make. Rock is often used expressively; the manner of depicting it is derived from Chinese painting.

Bibliography: Brend, 1980

52

ROSTAM RESCUES BIZHAN FROM THE PIT

180a | Picture 197 x (127) 161 mm | ww, III, 346

Bizhan, a hero of Iran, has wandered in Turan, and met and fallen in love with Manizheh, daughter of Afrasiyab. Afrasiyab has Bizhan thrown into a pit, where Manizheh is able to feed him with food she has begged. Rostam, who goes to Turan to seek for Bizhan, encounters Manizheh, who guides him to the pit by lighting a fire. Rostam is able to remove the capstone of the pit and rescue Bizhan with his lasso.

Night is indicated by the moon and the stars, while pairs of birds lend an air of romance to the background. Rostam looks business like, and Manizheh steadfast and self-contained. Bizhan's pit is shown as at a distance from his rescuers by the fact that it extends into the margin. Bizhan seems to have been partly repainted in India, probably in the early seventeeth century. Compare nos 12 and 80.

Bibliography: Melville, 2006 (Bizhan)

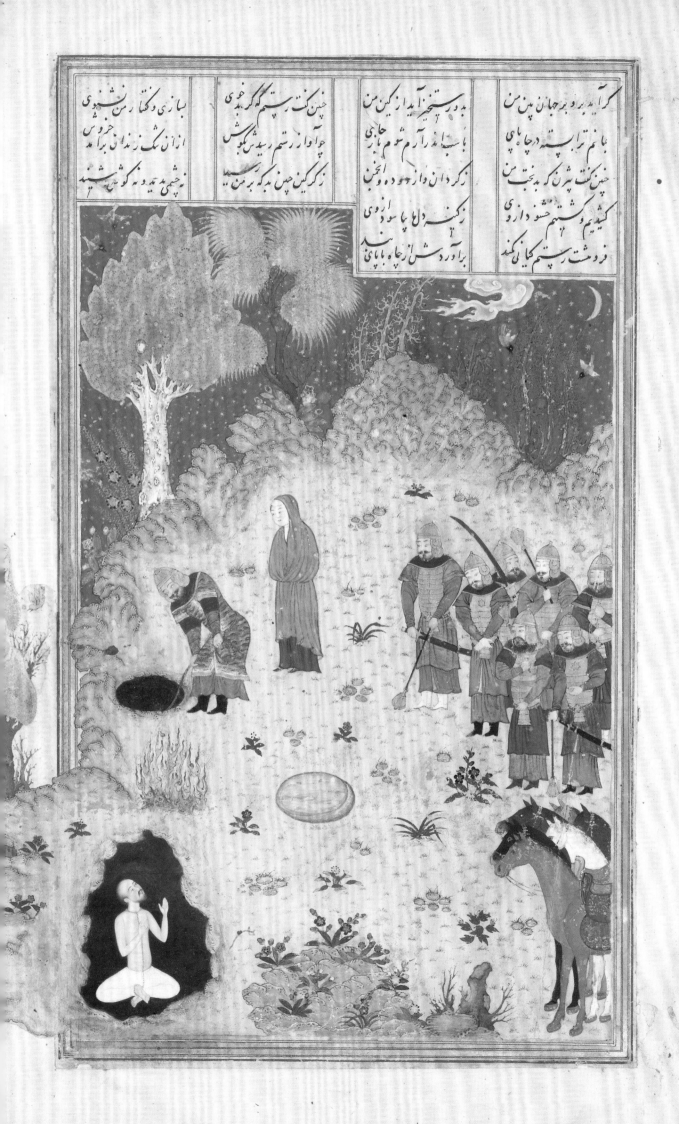

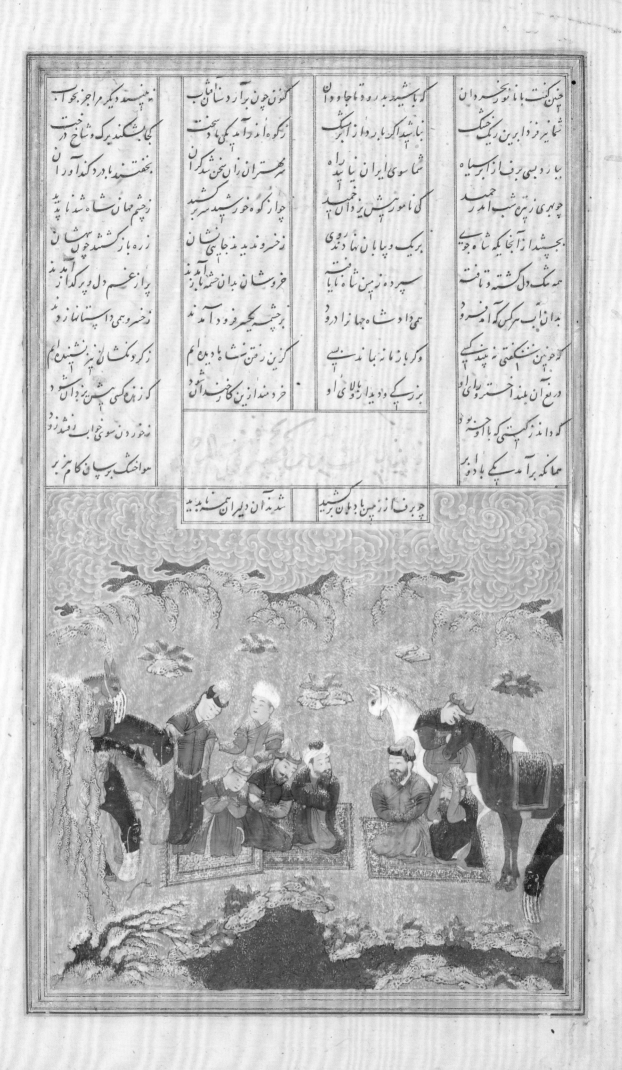

چنین گفت با ناموربخردان که با شید بد رود تا جاودان

شما زیر فرد از برین ریک خشک نباشید اگر با ردراز آبرک

بیا ریدبی برف از آب سیاه شما سوی ایران نیا پده راه

چو بی ریز ن یخ شب امر کی ناموری پش یزدان جهد

بجشید از آنجا که شاه جوی بریک و بابان نها ندوی

همه کشته کشته و تافته سپرده زمین شاه نایا

بدان آب هرکس که آمد فرود همی داد شاه جهانرا درو

کجو بی سنگفتی نه پلنگ پی وکز باز ماز نیا باندیسی

دریغ آن بلند اخترشروای او بزرگی و دیدار بالای او

که دانذ زکستی که با حسن نو خردمند ازین کخرخندانش

همانکه بر آمد سپی باد و ابر

زیبسد دیگر مرا جز بخو آب کنون چون بر آرد سنانش

کی نشکنند یک وشاخ در زکوه آمد یکی با سخت

بخفتند با برد گذا ورد آ مهتران زان سخن شدکرا

زچشم جهان شاه شدنا پید چوار که خورشید سر

زره باز کشد چون پهنان زخرو ندید بدجای نشان

پر از غم دل و پر کدا ند خروشان بدان حشه با دند

زخرو وبمی داستا نها زد برچشمه یکجره فرو د آمد

زکر دنک لا نیز نشینم کزین رفتن نش با دیم

کز نی کسی پش یزدا ش خرد ن سوی خواب رفسد زد

سواخگ بر سپان کام هزر

چو برف از زمین باد هامون کشید شدند آن دلیران همه ناپدید

53 THE PALADINS IN THE SNOW

243a | Picture 120 x 127 mm | WW, IV, 309

After a long reign, Key Khosrow prays that he might die before succumbing to pride. He renounces his kingship, leaving the throne to Lohrasp, and accompanied by his closest paladins, he makes his way into the mountains; there he tells his men that they must leave him and return to the valley. Reluctantly Zal, Rostam and Gudarz obey him. Key Khosrow spends a night reading the *Zend Avesta* and again bids his companions farewell. In the morning the paladins search for Key Khosrow and then fall asleep. They are buried in the snow.

Rather than sticking closely to the text, the artist gives us an engaging picture of travellers who are all too aware that they are caught in the snow. Gestures that seem to be observed from life mingle with motifs from Chinese painting, such as the swirling clouds, and the snow-covered branch of the tree stump.

چو تیغ آتش و سپ برگرفت · مرا وزا بدم درکشیدن گرفت

همی جست مرد جوان زورها · چو کاغذ مذرآمدش بازارها

جوانش زین اندر آویخت تنگ · بر در تیز دندان بر آن حجهٔ شیر

یک خنجر اندر دهانش نهاد · شمشیر بر آن زمان زست شیر

بر و تمز باربد بچون گمرگ

ز دادار نیکی دهش گردیا

همه تنها شه بکام ابدرش

بر دبر سپار نژادهای دلیر

همی رفت معزش بر آن تنگ جت · از آب اندر آمد که یک جت

بزد تیغ بر تارکش گرد چاک · چماکه ز بالا درآمد بخاک

54 GOSHTASP SLAYS THE DRAGON

250b | Picture 180 x (127) 182 mm | WW, IV, 346

Goshtasp, son of Lohrasp of Iran, who does not enjoy good relations with his father, has travelled incognito to Rum and fallen in love with the daughter of the Qeysar (Caesar). He has helped a nobleman who wished to marry the Qeysar's second daughter by killing a *karg* (rhino-wolf) in his place,[33] and here performs the same office for another noble, who wishes to marry the Qeysar's third daughter, by killing a dragon.

The hero is strikingly placed on the rulings and at the intersection of pinkish dragon habitat and the blue rock symbolic of his blade. Thus the moment is critical in time and space. Goshtasp has lodged one weapon in the creature's gullet and strikes at its head with his sword.

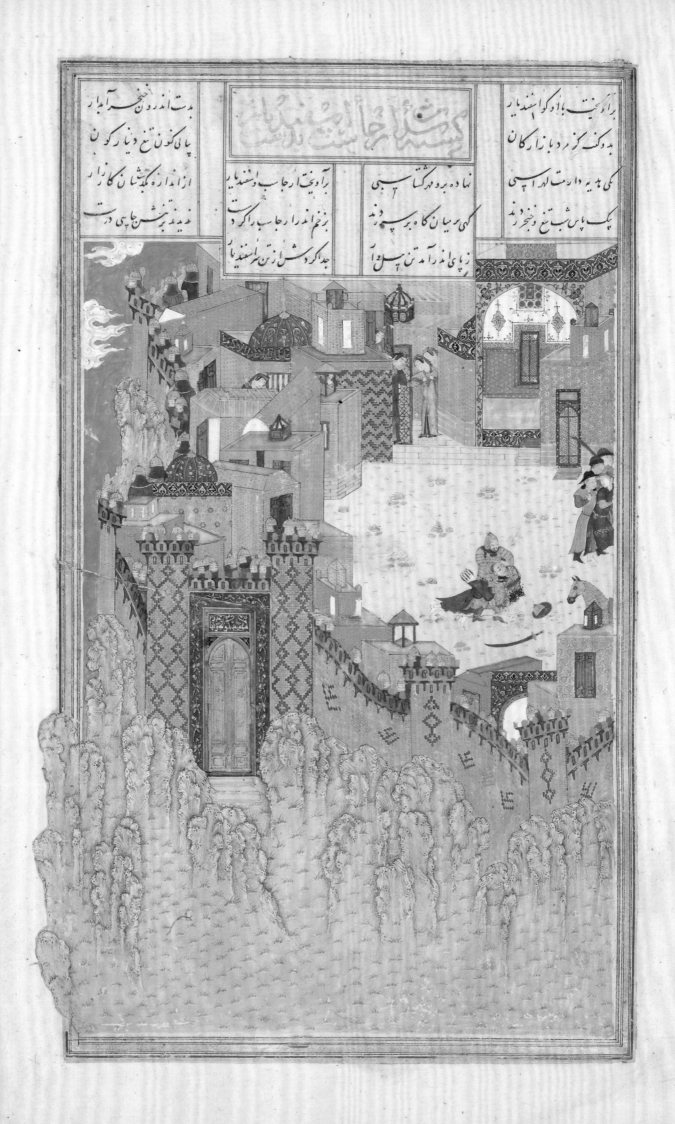

55 ESFANDIYAR SLAYS ARJASP IN THE BRAZEN HOLD

278a | Picture 184 x (127) 138 mm | ww, v, 154

Esfandiyar, son of Goshtasp of Iran, has gone to the Brazen Hold to free his sisters who have been abducted by Arjasp of Turan. Esfandiyar has entered the fortress in the guise of a merchant; he has found his sisters, and has signalled to the army of Iran to attack. He finds and slays Arjasp.

The bird's-eye view distances the main action, while the framing architecture holds it firmly in focus. The detailed depiction of buildings on a relatively miniature scale is found in manuscripts from the west of the Persian lands. A cartouche over the gate reads 'Mohammad Juki *bahador* [warrior]', this together with a reference on a flag in another picture supplies the name of the patron of the manuscript, since there is no colophon. Mohammad Juki died early in 1445 before the manuscript was completed.

Bibliography: Brend, 1999

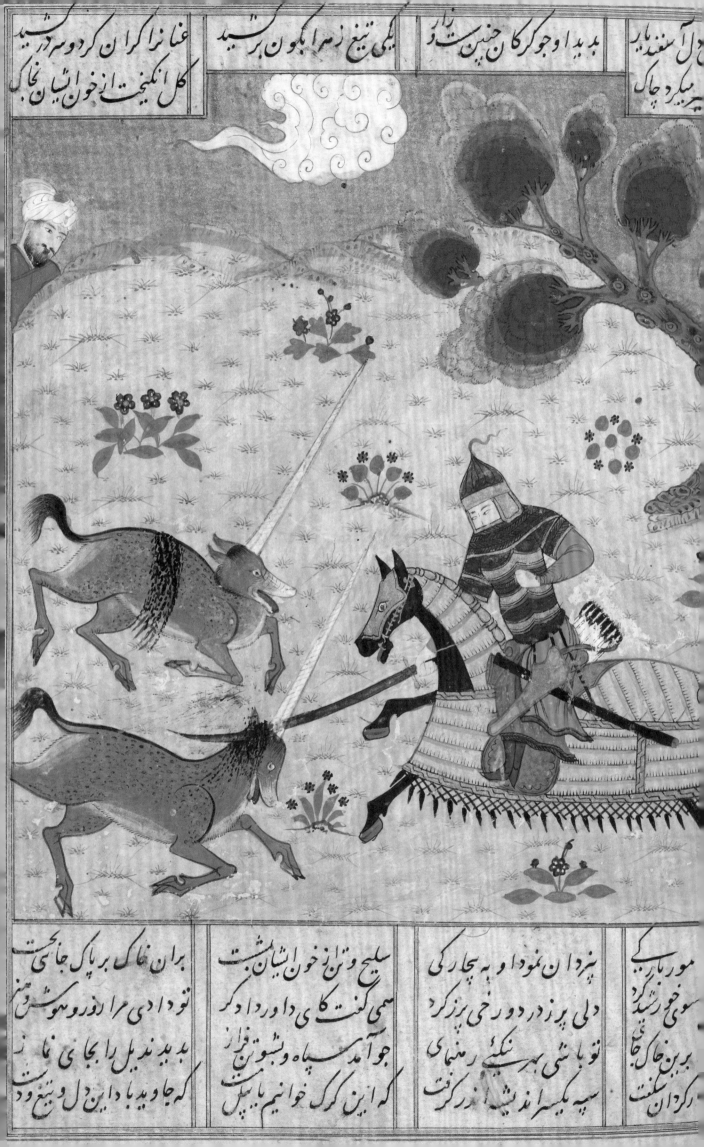

بدید او چو کرگان چنین سهمناک
سکرد چو پیل دمان چاک چاک
یکی تیغ زهر آبگون برکشید
عنان را کران کرد و به در پرید
گل انگیخت از خون ایشان نخاک

مور یاز کر
سوی خون کشید
برین خاک چه
برگردان سنگ
دلی پر زدرد در جهان جی پرکرد
تو بانی بهر بکئ رهنمای
جو آمد سپاه و نشست و نماز
که این کرک خواهیم یا پسر
بیزدان نمود او و به بجاری
همی گفت کای داور دادگر
بدید دلیل را بجای نما
بران خاک بر پاک جائی نشست
نود آدمی مرا ز روی نیوش خوی
که جاوید با این دل و تیغ و

56 ESFANDIYAR SLAYS TWO 'KARGS'

Keir Collection, 284a, III.161 | Folio 320 x 245 mm; text area 215 x 165 mm; 160 x 165 mm
25 Jumada I 879/15 January 1475 | Turkman (Commercial style, Shiraz) | Scribe: Soltan 'Ali
WW, V, 123

On his way to release his sisters from Arjasp in the Brazen Hold, Esfandiyar encounters Seven Perils – the counterpart of those experienced by Rostam, when he goes to rescue Key Kavus (see no. 34). The first is the threat posed by two monstrous horned beasts. Using first arrows and then his sword, Esfandiyar despatches them, and decapitates them.

The monsters, here cloven-hoofed and with a fortuitous resemblance to unicorns, are often portrayed as tusked wolves. This is because of a similarity in appearance in Persian script between *gurg*, wolf, and *karg*, rhinoceros, and the Persian painters' having, at this period, no very clear idea of the appearance of the latter. The type of knot in the horse's tail is still occasionally seen in Central Asia. The manuscript is of a sort described as Commercial Turkman, since they are evidently not produced for specific patrons. Some connection with sufi circles has been suggested.[34] Robinson sees the scribe as probably the father of another, Soltan Hoseyn, who was active in the late fifteenth century (no. 59).

Bibliography: Robinson, 1976 (Keir), no. III.133–75

بنده ی آبدار ور مغا بل بود ندی و نغزار ا ز نیبت رستم تبسکستی بودر ببار

با کسی مرد را بنیزه از پیشت ا سب بر گرفتی

و فرد وسی گوید

جهان آفرین با جهان افسرید ا سر بید جهو د رستم نیا بد بر بدر

بجم سیان کشد نید و آن ا بهی بنا بیکت خوب بو د ا و را جسنهای

57 ROSTAM LIFTS AN ADVERSARY ON HIS SPEAR

'Aja'eb al-Makhluqat of Qazvini in anonymous Persian translation
Royal Asiatic Society, 283a, MS. 178 | Purchased from Edward Galley's collection in 1804
by David Price and presented by him to the RAS in 1836 | Folio 245 x 135 mm (approximately);
text area 173 x 87 mm; picture (87) 104 x 78 mm | *c.*1475 | Turkman (Commercial style, Shiraz)
Scribe: Mohammad b. Mohammad known as *baqqal* (grocer)
Artist: *Al-Mowla* (mullah) 'Abd al-Karim

'The Wonders of Creation' compiled in 1270 approximates to an
encyclopaedia with accounts of cosmology and the natural world.
Heroes of the *Shahnameh* are included in some copies; here Rostam
is mentioned eighth in a list that begins with Faridun. The motif
agrees with Rostam's defeat of Shangol of Hind, but the text does
not mention any particular feat, and instead emphasises Rostam's
habitual ability to lift an adversary from a horse with his spear.
The weapon is here shown as conveniently double-ended. This is
a relatively early and rather refined example of the Commercial style
practised in Shiraz. The artist 'Abd al-Karim is not otherwise known.
Some flaking has occurred where white pigment has been used or
mixed in to represent the face, snow-leopard cap and arrows, and
there has been some corrosion from green pigment on the quiver.

Bibliography: Robinson, 1970, pp. 203–9, 1998, no. III; Hayashi, 2005;
Moor, forthcoming 2010

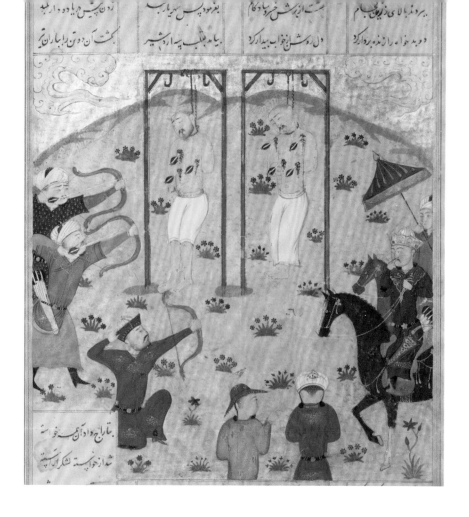

58 ARDESHIR EXECUTES HAFTVAD

Nasser D. Khalili Collection of Islamic Art, MSS 713, 437b
Binding late eighteenth–nineteenth century | Folio 303 x 203 mm;
text area 224 x 134 mm; picture 148 x 134 mm | 20 Rabi' II 891/25 April 1486
Turkman (Commercial style, Shiraz) | Scribe: Na'im al-Din *al-kateb* al-Shirazi
Patron: Abu'l-Fath Baysonghor b. Abi'l-Mozaffar Ya'qub *bahador* Khan | WW, VI, 245

The Sasanian ruler, Ardeshir, has been troubled by the pretension
of Haftvad, who, having become prosperous by the possession of
a diabolical worm (no. 99), has established his own fortress. At
first defeated, Ardeshir kills the worm, and prevails over Haftvad.
As Haftvad and his son, Shahuy, are suspended living from gibbets,
Ardeshir watches from horseback.

The manuscript is important since, though in Commercial Turkman
style, it was produced for a son of the Aq Quyunlu ruler based in
Tabriz, who would himself reign from 1490–3. The scribe is well
known at the period. Executions are well represented in the cycle
of illustration. The present relatively uncommon subject is of interest
since, in treatment and palette, it can be related to 'Bahman watching
Faramarz being hanged' in the celebrated collection of Epics, copied
in 1397.[35] The transmission was probably by a tradition handed down
in Shiraz.

Bibliography: Christie's 12.10.78, lot 61; Sims, forthcoming

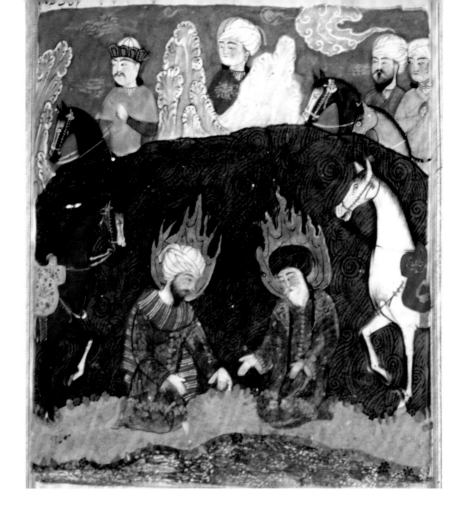

59 ESKANDAR SEEKS THE WATER OF LIFE

Bodleian Library, Elliott 325, 396b | Bookplate of Sir Gore Ouseley;
gift of J.B. Elliott of Patna, 1859 | Folio 340 x 225 mm; text area 222 x 135 mm;
picture 142 x 132 mm | 14 Ramadan 899/27 July 1494 | Turkman (Commercial style, Shiraz)
Scribe: Soltan Hoseyn b. Soltan 'Ali b. Aslanshah *al-kateb* | WW, VI, 160

Eskandar has been told that where the sun sets, in the Land of
Darkness, there is a spring of the Water of Life, which confers eternal
life. He reaches a city and there takes a notable, Khezr, as his guide,
giving him one of two rings that light up when near water. Eskandar
loses Khezr in the darkness. While Khezr, who is a prophet, finds
the water and bathes in it, Eskandar passes on to a mountain where,
amidst wonders, his doom is foretold.

The incident is narrated with a brevity that is puzzling to the modern
reader, though its seriousness is clear. The artist has employed a version
of this illustration that is more appropriate to the account given in
the *Khamseh* of Nezami, in which Khezr is accompanied by Elyas.
Both these figures are considered as prophets and so have flaming
haloes. The differing paths are clearly evident in the two parts of
the composition, the two prophets focusing their excited attention
downwards toward the water, while Eskandar proceeds at a walking
pace with his eyes fixed on a distant horizon.

Bibliography: Robinson, 1958, pp. 48–54, 2002, *passim*

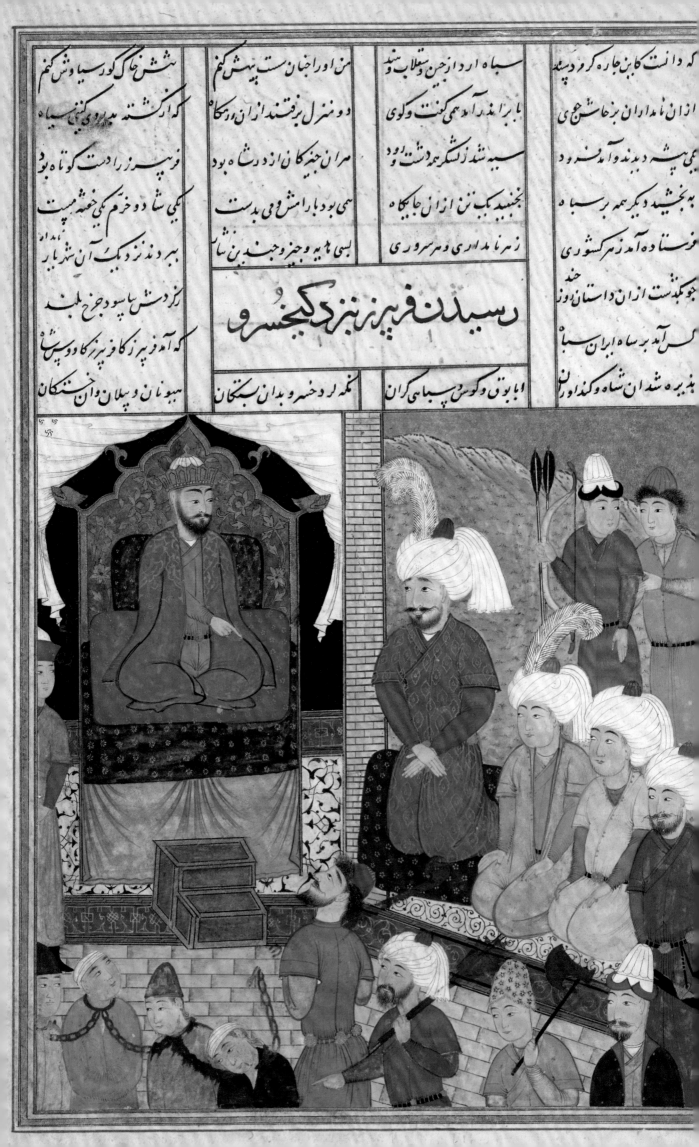

60 FARIBORZ PRESENTS PRISONERS TO KEY KHOSROW

British Museum, 1992, 0507, 0.1 | Folio 345 x 244 mm; text area 244 x 162 mm;
picture 158 x 162 mm | 899/1493–4 | Turkman (Lahijan) | Patron: Soltan ʿAli Mirza
Scribe: Salek b. Saʿid | ww, iii, 239

Rostam has been fighting the army of Turan to exact vengeance
for the murder of Siyavosh; he has acquired much booty, though the
killer, Goruy, still eludes him. He sends Fariborz, son of Key Kavus,
to Key Khosrow, son of Siyavosh, with prisoners, elephants and camel-
loads of spoil. Key Khosrow gives thanks to God for this achievement.

The bright colours, large faces with their dark eyes, and broad turbans
with their flaunting plumes convey energy and excitement. The faces
have indeed earned for the parent manuscript the sobriquet of the
'Big Head' *Shahnameh*; in two heavily illustrated volumes, this is
held by the Türk ve İslâm Eserleri Müzesi and the Istanbul University
Library.[36] The patron is generally understood to be ʿAli Mirza Karkiya
of Lahijan in Gilan. This local ruler played a significant role in history
since he gave refuge to the young Esmaʿil Safavi, later founder of the
Safavid dynasty. The vitality of the style of illustration suggests that
Esmaʿil may have been nurtured in an atmosphere of burgeoning
confidence. The large figures are perhaps a development from Timurid
work of the late fourteenth or early fifteenth centuries in Shiraz, or of
history painting in Herat; they bear a modicum of resemblance to the
main figures in a *Khamseh* of Amir Khosrow of 1496–7, possibly made
in the Caucasus.[37] See also nos 61–3.

Bibliography: Robinson, 1976 (Keir), nos iii.128–31, other pictures and further references;
Lowry and Beach, 1988, pp. 89–95, other pictures; Lowry, 1988, nos 17–23; Sotheby's
30.4.92, with reference to other illustrations; Canby, 1993, pl. 43

61 BIZHAN SLAYS NASTIHAN

Private Collection | Previously in the collections of Rafael de Mitjana and
Viscount S.S. Hermelin | Folio 343 x 243 mm; text area (verso) 244 x 159 mm;
picture (245) 248 x 199 mm | 899/1493–4 | Turkman (Lahijan) | Patron: Soltan 'Ali Mirza
Scribe: Salek b. Sa'id | WW, IV, 54

When the youthful Bizhan has slain the Turanian champion Human,
the Turanians seek revenge in a dawn attack under Nastihan. Bizhan
meets this challenge, shooting Nastihan's horse and then breaking his
head with a blow of his mace. Learning this from a camel rider, Piran,
commander of the forces of Turan, is distraught.

The vigour of the 'Big Head' style informs this picture with its blocks
of strong colour, and the crushing blow is its central focus. The horsetail
hanging before the horse's throat comes into prominence from the later
fifteenth century. It is certainly decorative, but probably to a worthwhile
extent protective against sword slashes. See also nos 60, 62 and 63.

Bibliography: as no. 60 and Sotheby's, 13.7.71, lot 316

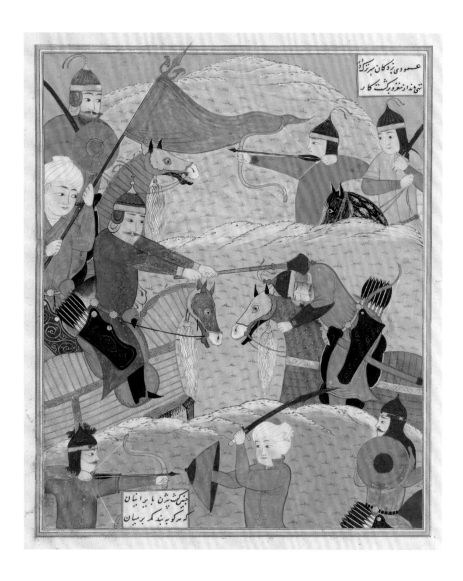

62 GOSTAHAM SLAYS LAHHAK

Overleaf

Nasser D. Khalili Collection of Islamic Art, MSS 669.1 | Folio 345 x 242 mm;
text area 240 x 155 mm; picture (190) 240 x (155) 215 mm | 899/1493–4
Turkman (Lahijan) | Patron: Soltan ʿAli Mirza | Scribe: Salek b. Saʿid | WW, IV, 122

The army of Turan is in disarray and Farshidvard and Lahhak, the
brothers of the dead commander, are making for home, though still
willing to put up a fight. The Iranian Gostaham goes alone in pursuit
of them. First he breaks the head of Farshidvard; then, though severely
wounded by the arrows of Lahhak, he strikes off the second brother's head.
Later Gostaham is found and rescued by Bizhan, who has followed him.

Whether knowingly or by instinct, the artist appears to develop his
own visual symbolism. The whole of the upper part of Gostaham's
body is enlarged, and especially the width of the shoulders of his
surcoat, so that his sword stroke seems to fall with preternatural force.
His tall plume identifies him as of high rank. The staring eye of the
horse suggests a wild gallop, while the skewbald pattern of its coat
– a relatively new feature of the period – seems an image of the beat
of its hoofs. See also nos 60, 61 and 63.

Bibliography: as no. 60 and Grube, 1972, no. 67; Khalili, 2005, pl. 69; Sims, forthcoming

63 GOSTAHAM SLAYS FARSHIDVARD

Overleaf

Nasser D. Khalili Collection of Islamic Art MSS 669.2 | Folio 345 x 243 mm;
text area 240 x 155 mm; picture (240) 275 x (155) 215 mm | 899/1493–4
Turkman (Lahijan) | Patron: Soltan ʿAli Mirza | Scribe: Salek b. Saʿid | WW, IV, 122

The text between this page and no. 62 is continuous, though in the
Persian sequence this (a verso) is the earlier: Farshidvard is killed before
Lahhak. This page has, bottom left, a catchword to link to no. 62,
top right. It is interesting that, in spite of the continuity of narrative,
Gostaham's costume and accoutrements are not the same in both
pictures, though in both he wears the same colours. The picture style
is similar in both so that it does not seem likely that different painters
could be involved. The movement of Gostaham's spear is forcefully
reflected in the whole picture shape: the stepped upper and lower lines,
and the extension into the right and lower margin areas. See also nos
60, 61 and 62.

Bibliography: as no. 60 and Grube, 1972, no. 68

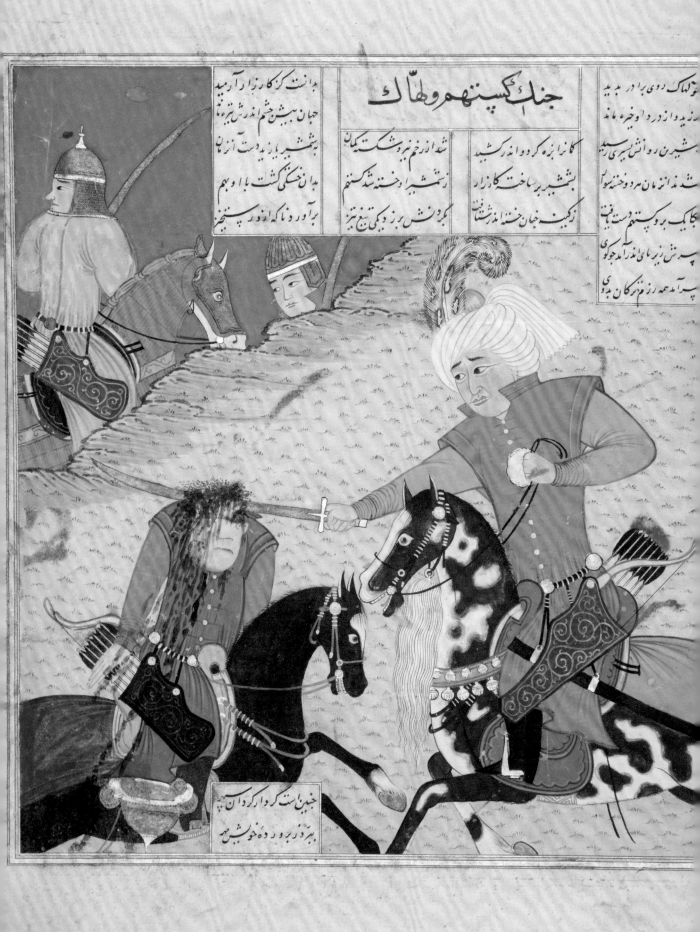

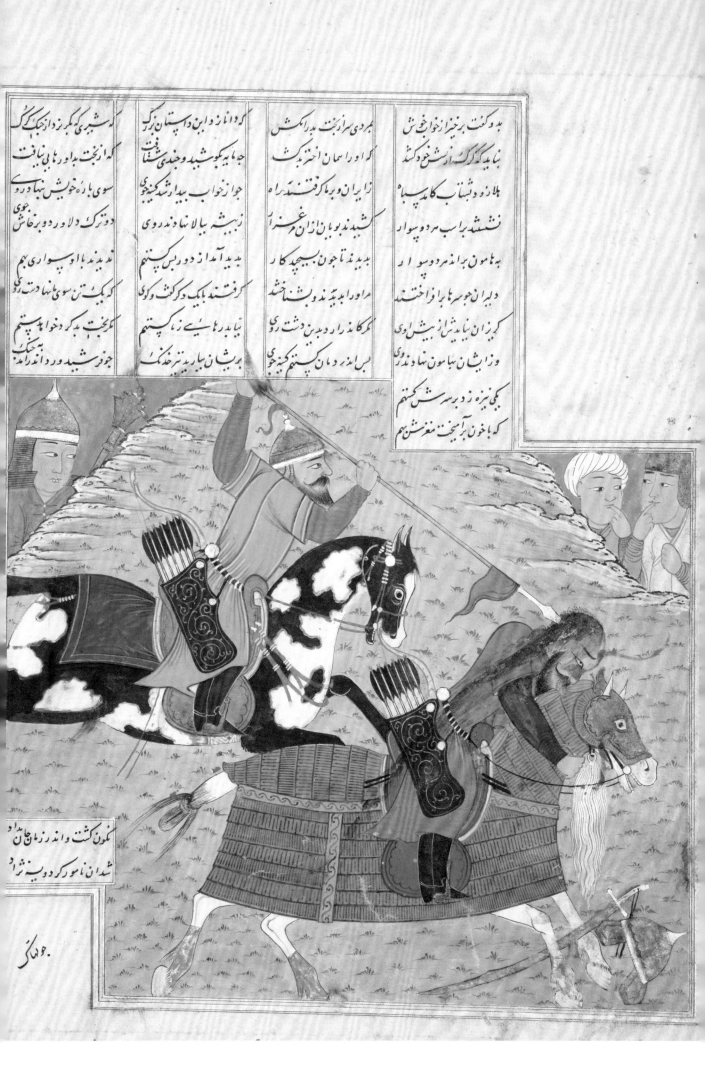

بدو گفت برخیز از خواب خوش
بباید که کار از تنش خود کشد
هلا زود بشتاب کامد سپاه
نشسته بر اسب مرد و سوار
بهامون برآرد مرد و سوار
دلیران چو سرها برافراختد
گریزان نباید ش از پیش اوی
وزایشان بهامون نهاد اندروی
یکی نیزه زد بر سر شش کشتم
که باخون برآمیخت مغز نشن هم

کمردی سرا بخت بدرامکش
که او را سمان اختر نبکشت
زایان و بر ماکرفتند راه
کشید ندبو بان از آن غزار
بدید ند تا چون بسیچد کار
هاورابدید ند و بشنا خنجد
هم کاند راز بدین دشت روی
بس اند رزمان کشتم کینه جوی

که دناز و ابن دابستان بزرگ
چه ما یه کبوشید و جندی نشتاب
جواز خواب بید ارشدک نه جوی
زبشته بالا نهاد اندروی
بدید آمد از دو رس کستم
کرفتند با یک دکر کشت و کوی
پیاد در ها یی زا کستم
بریشان بیا رید بتر خند نک

که ای ناز ی که گم زد از بک بک گک
که ارنخت بد او دها بی نبافت
سوی باره خویش نهاد درو
دو ترک دلاو ر د و برخاش
ندید ند با او سواری بهم
که بک تن سوی ها نها دست ری
کنخت بد کر دعوا پستم
جوفرشید ور د و اند راند

نکنون کشت واند رزمان جان بداد
شدان نامور کرد و بنه نژاد

۱۴۵

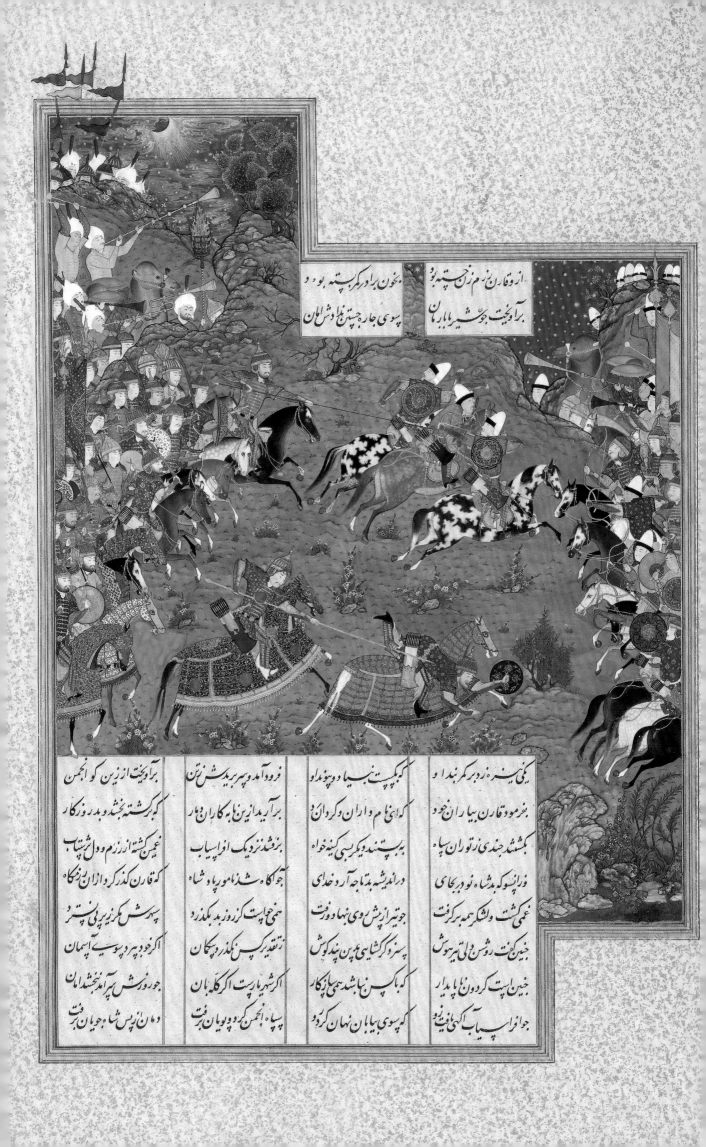

64 QARAN SLAYS BARMAN

Private Collection | Previously owned by Baron Edmond de Rothschild;
then Arthur A. Houghton | 102b, from *Shahnameh* for Shah Tahmasp | Folio 470 x 315 mm;
text area 286 x 186 mm; picture (337) 359 x (238) 240 mm | *c*.1525–30 | Safavid (Tabriz)
Patron: Shah Tahmasp | Artist: attributed to Soltan Mohammad and Mir Sayyid 'Ali
by S.C. Welch | ww, I, 354

Nowzar of Iran, with Qaran commander of his army, has taken refuge
in Dahestan. Qaran learns that Afrasiyab plans an attack on their
undefended womenfolk. Nowzar tells him that others will deal with
this threat, and he retires to rest. Qaran and other paladins leave the
camp at night. At the White Castle they encounter Afrasiyab's force
under Barman, who previously killed Qaran's brother. Qaran pierces
Barman's cummerbund with his spear and unhorses him; he cuts off
Barman's head and ties it to his saddlebow.

Night is evoked by the striking ground colour; the moon breaks
through clouds and touches the rims of rock, stars appear larger where
they are not directly challenged by the moon, and a burning cresset
confirms that there is indeed darkness. Nevertheless, everything is
to be seen with absolute clarity. The composition brings together a
single combat and a wider melee. The combat between Qaran and
Barman, which has become a pursuit, is in the foreground. It is surely
the painter's deliberate irony that Barman is falling towards a nook of
exquisite natural beauty with rocks and vegetation. The larger battle is
orchestrated behind Qaran and Barman. On the left are the Iranians,
identified by the Safavid *taj* worn in the turban of their musicians,[38]
while the men of Turan wear the black-brimmed, white felt cap of
Central Asia. The Iranians attack at speed in a triangular wedge of
riders; three Turanians flee in a similar but looser formation, while
the main Turanian army is in doubt whether to advance or retreat.
The accoutrements of all are rendered in the minutest detail, down
to the ornamental binding of their shields, and the gaps or pockets in
their quivers to facilitate the grasping of arrows. The finest illustrations
from this manuscript surpass all that had gone before in complexity of
composition and richness of detail. Shah Tahmasp, the second Safavid
ruler, is saluted in a *shamseh* at the beginning of the manuscript; there
is no final colophon but the date 934/1527–8 appears in an illustration
towards the end of the manuscript.

Bibliography: Grube, 1968, no. 69; S.C. Welch, 1972, pp. 136–9; Dickson and Welch,
1981, II, no. 79

65 | ZAL SHOOTS A WATERFOWL

Fitzwilliam Museum, PD 3451 | Folio 430 x 313 mm; text area 260 x 140 mm;
picture (315) 319 x 208 mm | 1570s | Safavid (Shiraz) | ww, I, 263

Left in charge of the kingdom of Zabolestan, Zal is visiting his lands.
He is impressed by the appearance and manners of his tributary,
Mehrab, ruler of Kabol and grandson of Zahhak. Zal and Mehrab's
daughter, Rudabeh, fall in love with the report of each other.
Rudabeh's maidens agree to help her and go to pick flowers by the
river. Zal shoots a waterfowl and sends a boy across the river to
retrieve it. The maidens tell him of the state of mind of Rudabeh.

In this romantic scene Zal's shot is both a practical stratagem to make
contact with the maidens and a metaphorical reference to love striking
home. The floriferous ground and carefully painted rocks form a
lyrical background. It appears, however, that some extra clumps of
flowers, resembling peonies, have been added at a later date, since they
overlap the figures in a way that is alien to the conventions of painting
at the time. The complex scene reflects the style developed for Shah
Tahmasp at Tabriz, as exemplified in no. 64. For Zal and Rudabeh
see also nos 46, 81, 93 and 98.

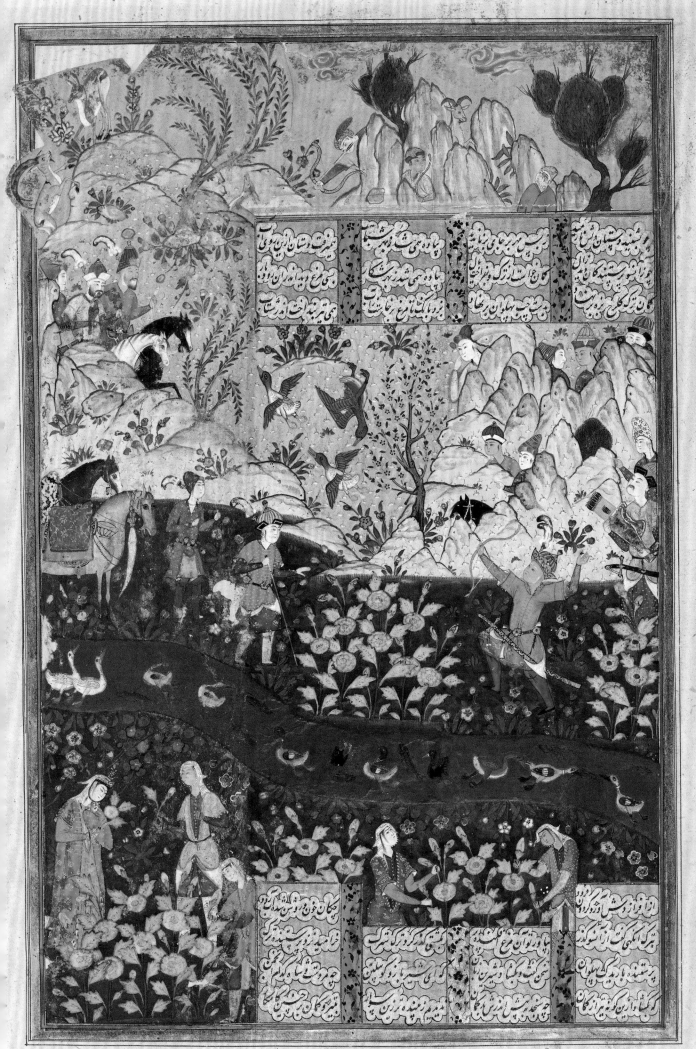

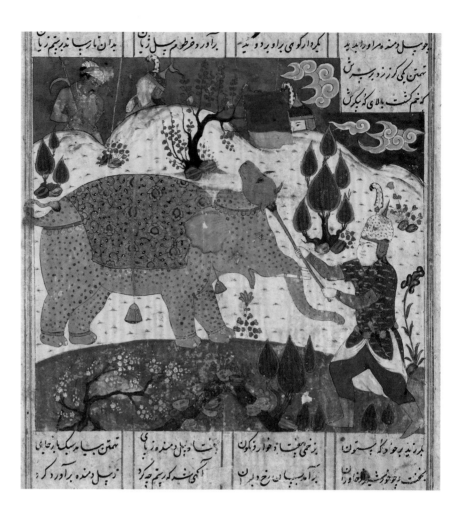

66 THE YOUNG ROSTAM KILLS THE MAD ELEPHANT

British Museum, 1975, 0523, 0.2 | Presented by Douglas Barrett, Esq. and
R.H. Pinder-Wilson, Esq. | Remaining folio 291 x 171 mm; text area 283 x 163 mm;
picture (146) 148 x 163 mm | *c.*1570 | Safavid (Qazvin, Mashhad?) | ww, I, 328

Sam has resolved to visit his son Zal in order to see his grandson
Rostam (see no. 46). At the meeting there is general celebration and
the youthful Rostam goes to bed intoxicated. He is woken by shouts
that a white elephant has run wild. Rostam wields his grandfather's
mace to break its neck, and then returns to bed.

The picture mingles sophistication and naïvety. Rostam, wielding the
ox-headed mace, is a tall and graceful warrior, his coat kirtled up in
Tabriz style. The painter sees a mahout as necessary for an elephant
and duly supplies an Indian with an ankus and the turban of Akbar's
period. In the foreground a branch of flowering prunus breaking
into the scene and some brightly coloured stones suggest traditions
distantly derived from Chinese painting by way of albums in Tabriz.

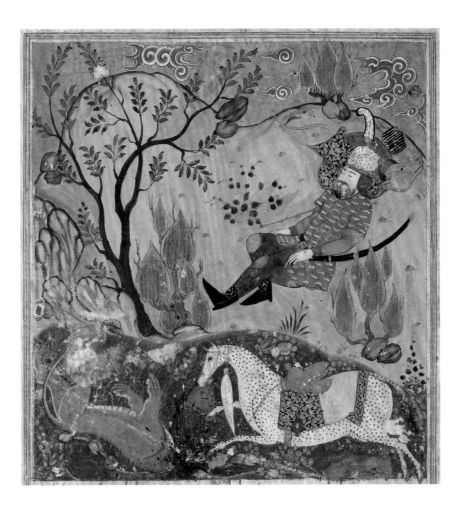

67 # RAKHSH KILLS A LION

British Museum, 1975, 0523, 0.3 | Presented by Douglas Barrett, Esq. and
R.H. Pinder-Wilson, Esq. | Text area 280 x 165 mm; picture (175) 177 x 165 mm
c.1570 | Safavid (Qazvin, Mashhad ?) | ww, II, 45

The first Peril to threaten Rostam on his way to rescue the king, Key
Kavus, is the approach of a lion (compare no. 34). Rostam has fallen
asleep in an unguarded manner and does not know his danger, but
Rakhsh sinks his teeth into the lion and dashes it to pieces. Rostam
is not best pleased to find that Rakhsh has put himself at risk.

The illustration is evidently from the same manuscript as the
previous item, the British Museum having received two further
pictures from the same bequest. Its composition – and in particular
the recumbent figure of Rostam – recalls a version of the same subject
that is thought to have been made at Tabriz for a *Shahnameh* planned
for Shah Esma'il I (fig. 12),[39] but left incomplete, possibly after his
defeat in 1514 at the battle of Chalderan. The subdued palette here
is of course markedly different from that of the earlier picture.

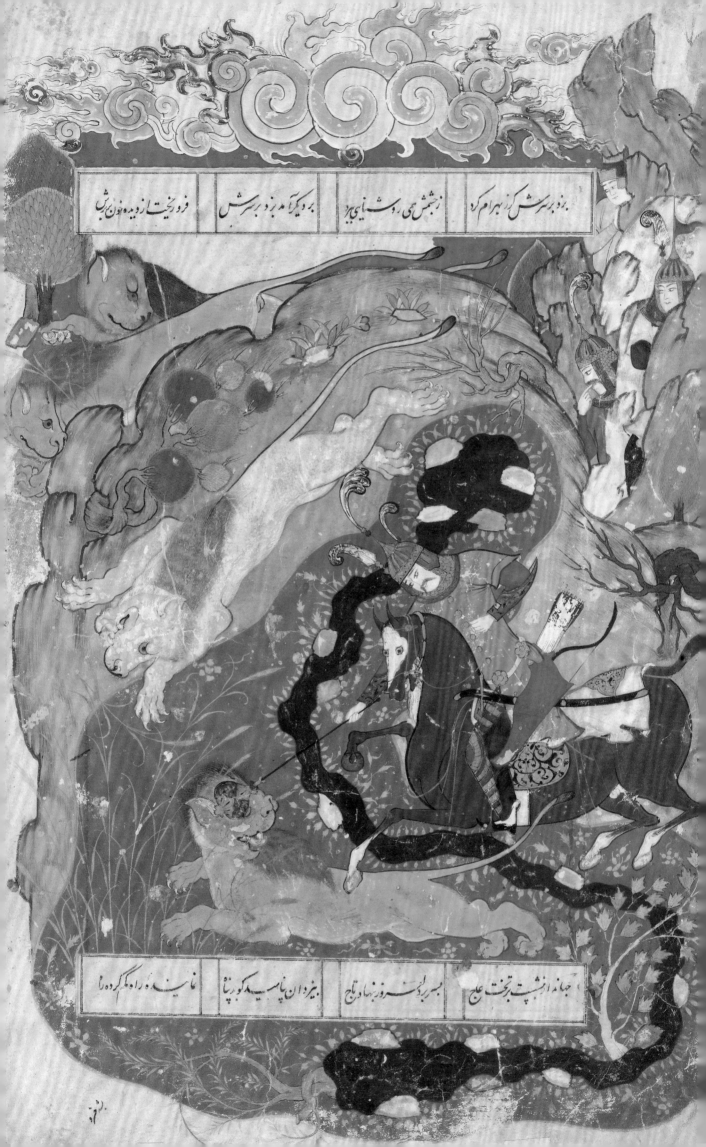

برو بر سرش کز بهرام کرد | زخنجش همی روشنایی بزد | برو کرد آمد بر بر سرش | فروریخت از دیده خون برش

جهان را فشپشت بر تخت عاج | به سر بر از خسروی بنهاد تاج | بیزدان پاسید کو کرد پنا | نیایسه را وکم کرده را

BAHRAM GUR SLAYS LIONS

Private Collection, 380b of dispersed *Shahnameh*
Folio 341 x 238 mm (as repaired); text area 245 x 151 mm; picture 336 x 236 mm (as trimmed)
20 Shawwal 988/28 November 1580 | Safavid (Qazvin, Mashhad?)
Scribe: Qotb al-Din b. Hasan al-Tuni | WW, VII, 21

Bahram Gur, who has recently come to the throne of Iran, rides into
a wood where lions might be found. He is charged first by a male and
then by a female, both of which he despatches.

The date of this and no. 69, together with the name of the scribe,
is taken from Sotheby's catalogue entry for the then complete
manuscript.[40] The hunting of lions is the archetypical sport of Persian
kings, and, though presumably unwittingly, the painter echoes a motif
found on Sasanian silver dishes. In the present picture the lions' power
and their fierce claws are well in evidence; and, as often in Persian
painting, their habitat is seen as a reed bed. The tawny pelts depicted
here resemble that of the lion in no. 67, the scrolling Chinese clouds
have a similarly hard-edged quality, and the palette is broadly similar,
though the present picture is of a superior level and accompanied by
finer calligraphy.

Bibliography: Sotheby's 22.4.80, lot 271

69 BAHRAM GUR SLAYS A DRAGON

Private Collection, 404b of dispersed *Shahnameh*
Folio 342 x 236 mm; text area 244 x 144 mm; picture 323 x 236 mm (as trimmed)
20 Shawwal 988/28 November 1580 | Safavid (Qazvin, Mashhad?)
Scribe: Qotb al-Din b. Hasan al-Tuni | ww, VII, 124

Bahram Gur, who has killed a *karg* for Shangol of Hind, then
undertakes to kill a dragon for him.

Like the previous picture, this is imbued with energy. Their painter
– seen in the auction catalogue as one of at least four hands in the
manuscript – is working in a tradition that, though with a different
palette, owes much to the *Shahnameh* for Shah Tahmasp. This is
evident in the dragon, which is like the form assumed by Faridun;
in the rendering of the hero's horse in both pictures, in three-quarter
view with the shoe of the off fore displayed; and in the plumes in
the hero's helmet.[41] The grotesque faces in the rock are also found in
Tabriz style (fig. 12). A tradition from Tabriz might point to an origin
in Qazvin, and indeed nos 68 and 69 have points in common with
no. 74, which was produced there, and a general similarity to no. 73,
the manuscript associated with Esma'il II, and presumably made in
Qazvin. However, the scribe's *nisbeh* 'al-Tuni', an appellation that here
points to an origin in Tun in Khorasan, together with some rounded
rock forms shown in the auction catalogue, and the baroque twisting
of the tree branches, allows for a possible connection to Mashhad.

Bibliography: Sotheby's 22.4.80, lot 271

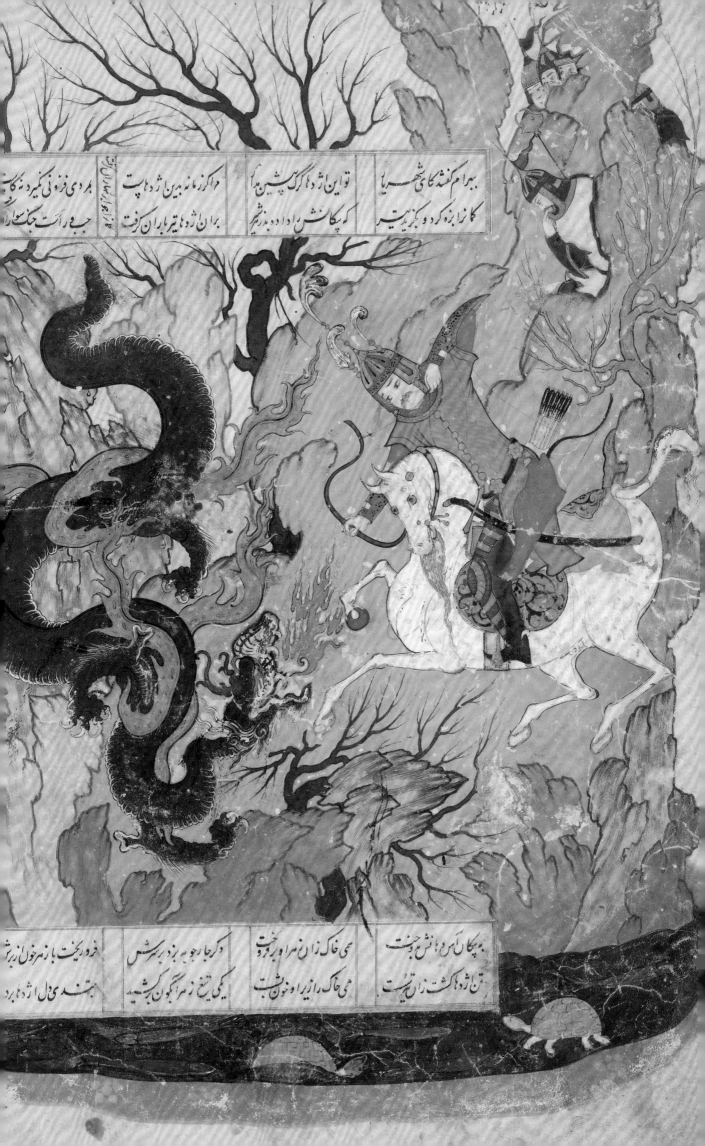

بهرام گفته کای شهریار
توانین از دها گرگ پیشین میآ
کازنا بزوگرد و بکزیده کاست
که پیکانش را داده بدر نشیر
برای اژدها بین از دها پت
بران اژدهای تیرباران کرفت
بردی فرزونی گمیرد به کاست
جبه رائت جنگ سوار

به پیکان سرو دهانش بدوخت
سی خاک زان مراو بریخت
تن اژدها کش زان زیر است
همی خاک را زیر او خون شت
در جا رجو به برد برسرش
یکی تیغ زهر آگون برکشید
فرو ریخت باز مر خون ازبر
بسنده می دل اژدها برد

70 ROSTAM SLAYS THE 'DIV' AKVAN

Keir Collection, bought Sotheby's, 5.4.06, lot 44 | Folio 330 x 221 mm;
text area 248 x 175 mm; picture (212) 220 x 158 mm | From a manuscript of 973/1565
Scribe: Mohyi | Safavid (Bakharz?) | ww, iii, 281

After Rostam has escaped from the sea into which he was thrown by
the *div* Akvan (no. 51), he goes in search of his horse, Rakhsh, and
finds him in a herd belonging to Afrasiyab. Remounted on Rakhsh,
Rostam takes possession of the whole herd, killing several herdsmen,
and then captures four elephants from Afrasiyab, who has come to
inspect his horses. At this juncture Akvan appears and taunts him.
Rostam lassoes the *div*, smashes his head and cuts it off.

Date and scribe are provided by Sotheby's auction catalogue, but the
question is raised as to whether the manuscript was produced in Qazvin
or Mashhad. The manuscript was evidently an elegant production
with plentiful use of gold, here employed relatively unusually for the
ground. The action is portrayed with verve. An unusual feature of the
text is the variation from six columns above the picture to four below,
with an adjustment in column width. The scribe is probably Mohyi
Haravi, who was seen as a resident of Khorasan.[42] This might speak
for Mashhad rather than Qazvin as the place of origin. But the
painting style appears to be similar to that in a *Haft Owrang* of
Jami copied in 971/1563–4 in the Bakharz district of Khorasan.[43]
Compare no. 101.

Bibliography: Sotheby's, 5.4.06, lot 44

بدین‌سان بر او سیل بگذشت آسان ... سرو منع زو به پل سل مست ... بر از سرو جوی لنگ آشگران ... برین کز لگ ...

آیست و پیرون... فرود آمد و اکنون جستن جگر... سرو منع زو باش شبهم در شگفت... بدارانه و پیروز ... شاخ... جال شا واز ...

کسی کو مارا و زیزد... تو مردیو امردم مدشناس... گرود دید پرورزیی وزکین... همی کرد بر بر که دکار اشتر ن...

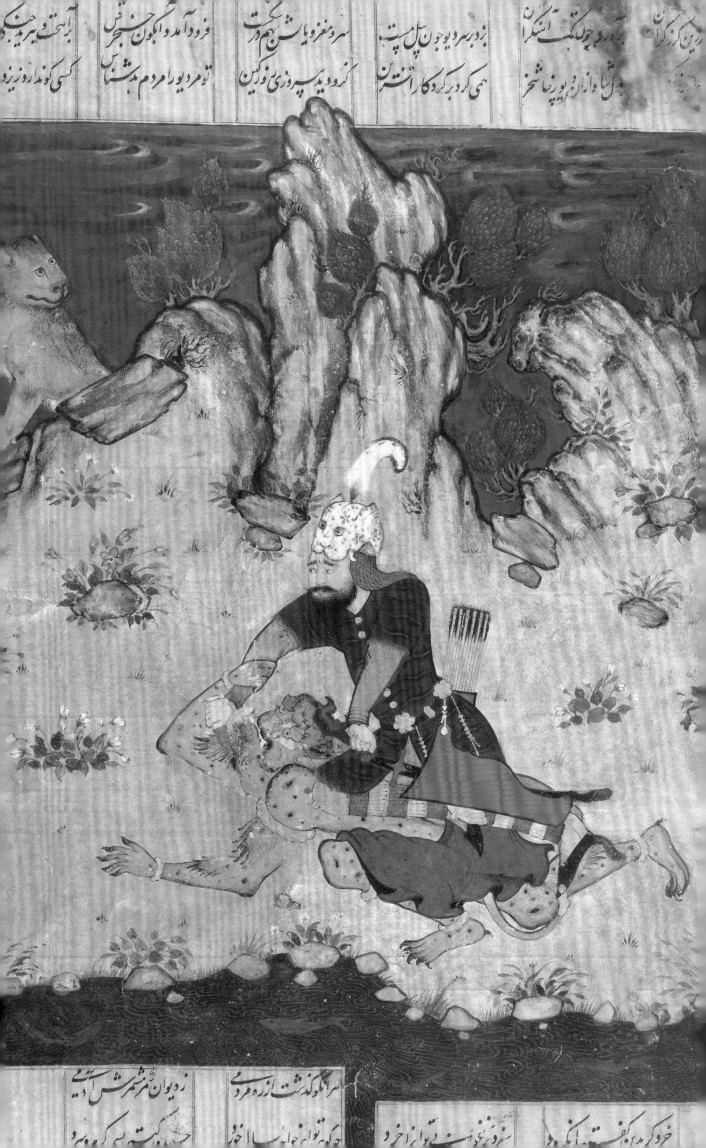

سرا کو گذشت از ره مردی... ز دیوان شر مشهر شش آتی...

خرو کرد کفت تنک برد... سنرو نخ نست تو از خرد... که تو انه خواه سالا خرد... حست سکت نسه کرهبرد...

71 ROSTAM SLAYS THE WHITE DIV

Keir Collection, III.227 | Support 225 x 155 mm; picture 160 x 90 mm | On silk
Mid- to late sixteenth century | Safavid (Qazvin) or Sheybanid (Bukhara)
WW, II, 60 (no text present)

The *Shahnameh* itself attests to the fact that silk was the normal
support for letters exchanged between sovereigns. In the field of
Persian painting examples are known from the late fourteenth or the
fifteenth century – no dates being attached – and they have tended to
be associated with Tabriz or Herat. The present piece is an interesting
example of a celebrated motif or group being selected from the narrative
tradition (see no. 47) for collection in an album, or other decorative
purpose. Though in origin the group is horizontal, it has here been
adapted so that it makes a better effect when viewed as vertical – the
slightly comic interlacing of the *div*'s horns also suggests the top of the
composition. Robinson refers to a picture in a *Shahnameh* produced
in 1008/1600 at Samarqand in relation to this piece, but, interlacing
horns apart, the resemblance is not close. A similar group is found
in an album in the British Museum put together in Mughal India
(1974, 0617, 0.17.85).

Bibliography: Robinson, 1976 (Keir), no. III.227

72 GOSHTASP OR BAHRAM GUR SLAYS A KARG

British Museum, 1925, 0430, 0.2 | Presented by W. Bateson, Esq., F.R.S
Picture 115 x 168 mm | Second quarter seventeenth century | Safavid (Esfahan)
WW, IV, 338 or VII, 122 (no text present)

This drawing of a combat with a monster was clearly intended for an
album – it is unlikely that gold pigment would have been used had
it simply been an exercise. The hero here might be either Goshtasp
or Bahram Gur, both of whom had to do with a single *karg* (rhino-
wolf). The interest of the picture lies not its quality, which is modest,
but in its departure from earlier tradition (see no. 56). The monster is
now more nearly like a rhinoceros in body, though it retains a slightly
vulpine and furry head. Evidently some waft of scientific realism has
been received. In addition, the *karg*'s eye is now treated with a white
highlight.

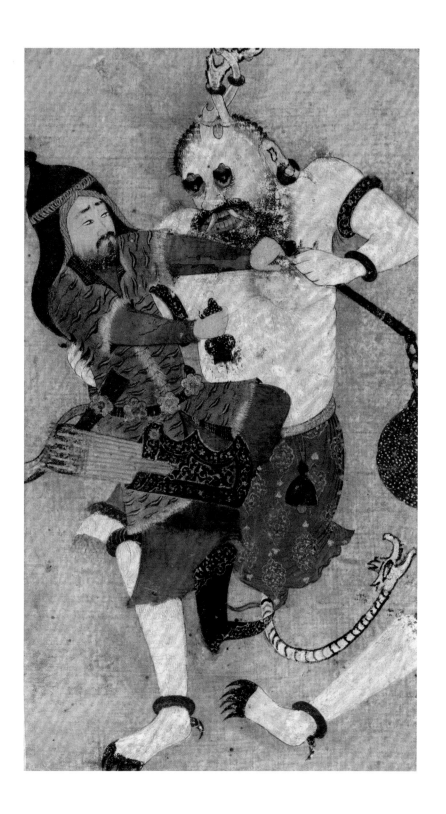

73 BIZHAN CHIDES HIS FATHER FOR FAILING TO DEFEAT FORUD

Keir Collection, III.295 | From the *Shahnameh* believed to be for Esma'il II
Folio 460 x 320 mm; text area 315 x 185 mm; picture 362 x 235 mm | 1576–7 (regnal years)
Safavid (Qazvin) | Painter: Siyavosh | ww, III, 60

Champions of Iran have attacked the castle of Forud, half-brother of
Key Khosrow; he has killed Zarasp, and defeated others by shooting
at their horses. Bizhan remarks scornfully on the lack of success of his
father Giv, and Giv strikes him with his whip. Bizhan is ashamed and
vows to defeat Forud. When Bizhan's mount is shot he will continue
on foot. Forud retreats into his castle. When the army attacks en
masse Bizhan gives Forud a fatal wound.

The composition adopts the main lines of no. 50, but the focus of
the action is now with the riders in the foreground. Bizhan on the
black horse makes a speaking gesture; Giv, on the grey and holding
his whip, turns away affronted. The lady on the roof may be Jarireh,
Forud's devoted mother and first wife of Siyavosh, rather than one
of Forud's eighty damsels who watch for the outcome. An attribution
to the painter Siyavosh, noted by Robinson, is perhaps now more
concealed; other illustrations from this manuscript bear attributions
to other painters, among them Sadeqi, who is known to have worked
for Esma'il II.[44] Siyavosh, a Georgian, was brother to Farrokh Beg,
who is chiefly known for work in India. Paintings by Siyavosh are
characterised by an elegant clarity. The folios of the divided manuscript
are surrounded on three sides by an extra column, which is sometimes
used for variants.

Bibliography: Robinson, 1967, no. 56, references; *idem*, 1976 (Keir), no. III.295, and 1976
(Iran), 1–8

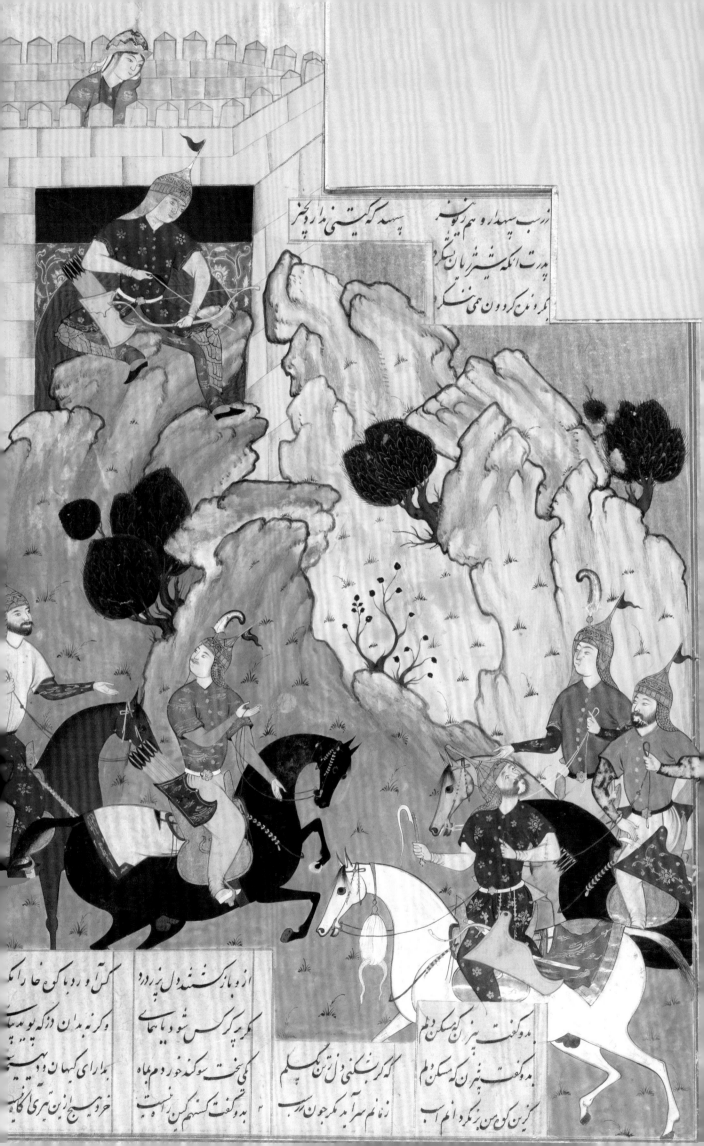

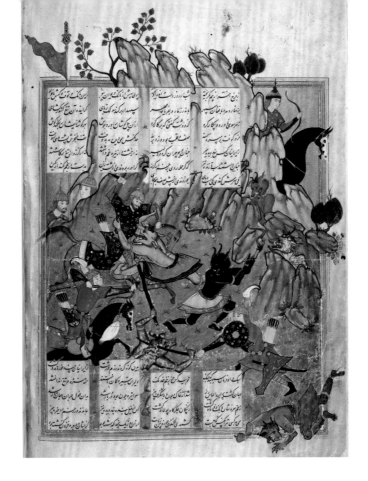

GARSHASP BATTLES WITH THE 'SAGSARS' (DOG-HEADS)

Detail overleaf

Garshaspnameh of 'Ali b. Ahmad Asadi Tusi | British Library, Or. 12985, 45b
Folio 348 x 235 mm; text area 244 x 150 mm; picture (247) 300 x (200) 215 mm
Original binding with cloud scrolls | Sha'ban 981/ November–December 1573
Safavid: copied in Qazvin | Scribe: 'Emad al-Din al-Hoseyni | Painter: Sadeqi

The *Garshaspnameh*, composed in 485/1066, draws on the same
legendary background as the *Shahnameh*, and sites its action in the
time of Zahhak: Garshasp is the great-great uncle of Rostam. The
hero is here visiting the island of Qalun, where live the blue-bodied
sagsars: these are extremely warlike and skilled horsemen, who eat
the vanquished. Garshasp orders the use of strong arrows.

The manuscript is of courtly quality and indeed Qazvin was capital
of Iran in the second half of the sixteenth century. We here encounter
another named painter: Sadeqi, who signs between the first and
second lower columns from the right. This is evidently Sadeqi Beg.
Of Turkman descent, he was a warrior, courtier, man of letters and
eventually an artist.[45] Hemmed in by the purple-shadowed mountain,
which may owe something to the landscape local to Qazvin, we seem
closer than usual to the action. It may be that while depicting demonic
creatures in a more or less traditional way, Sadeqi is asserting that he
has direct knowledge of battle.

Bibliography: Asadi, 1926 and 1951; Titley, 1966, 1977, no. 86, and 1983, pp. 106–7;
Robinson, 1967, no. 48; A. Welch, 1976, fig. 12

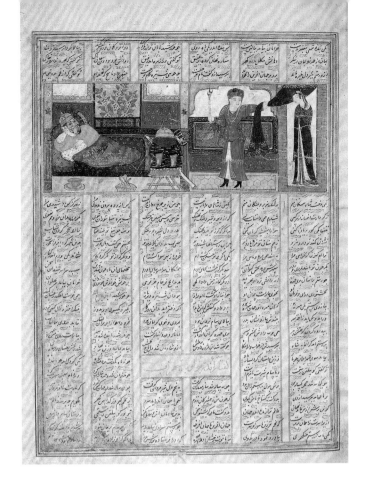

75 TAHMINEH COMES TO ROSTAM

University of Manchester, John Rylands Library, Persian 933, 37a,
Once owned by G.A. Nichetti of Venice | As re-margined 386 x 275 mm;
text area 277 x 207 mm; picture 73 x 203 mm | Manuscript later sixteenth-century
Illustration later sixteenth-century pastiche of second quarter of fifteenth-century style
Safavid (Qazvin or Mashhad)

As in nos 18, 28 and 91, Tahmineh is preceded into Rostam's chamber by an attendant. Now represented as male, this figure is given considerable prominence, being allotted two of its column widths in the composition; Tahmineh is now bashful. Rostam's face has been re-drawn and an owner's seal stamped on his coverlet.

The copying of the manuscript and four of its illustrations have been attributed to Sultanate India by Robinson. However, the character of the script and its presentation throughout in a cloud outline suggest a sixteenth-century date is more probable. It appears that the artist has in mind a style of Jalayerid or post-Jalayerid character, but the high-heeled boots of the attendant would be unlikely at that period. Three further pictures in Il-Khanid styles are more evidently imitations. The majority of illustrations are in sixteenth-century style, but less highly finished. It may be that a compendium of styles was intended but that practicalities enforced a simpler outcome.

Bibliography: Robinson 1980, pp. 111–15

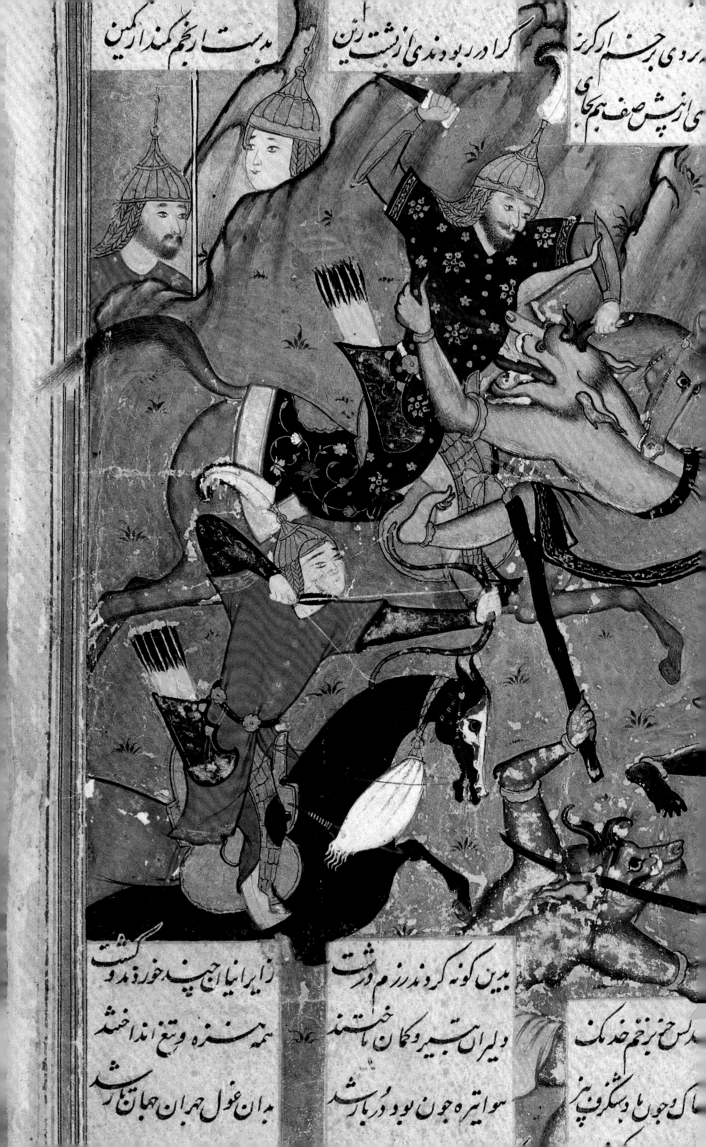

مردی برجستم ارکرز
کرادربرده دندی ازپشت زین

بدست ارنجم کمند ارکین
می ازپیش صف خفیم بجای

بدین کوه کرد دررزم درشت
زایرانیان چپ پشت خورد وکشت

دلیران تبیره وکان داشتند
همه پسنزه وتیغ انداختند

سواتیره جون بوه دربار بار شد
دوان غول جهران جهان باش شد

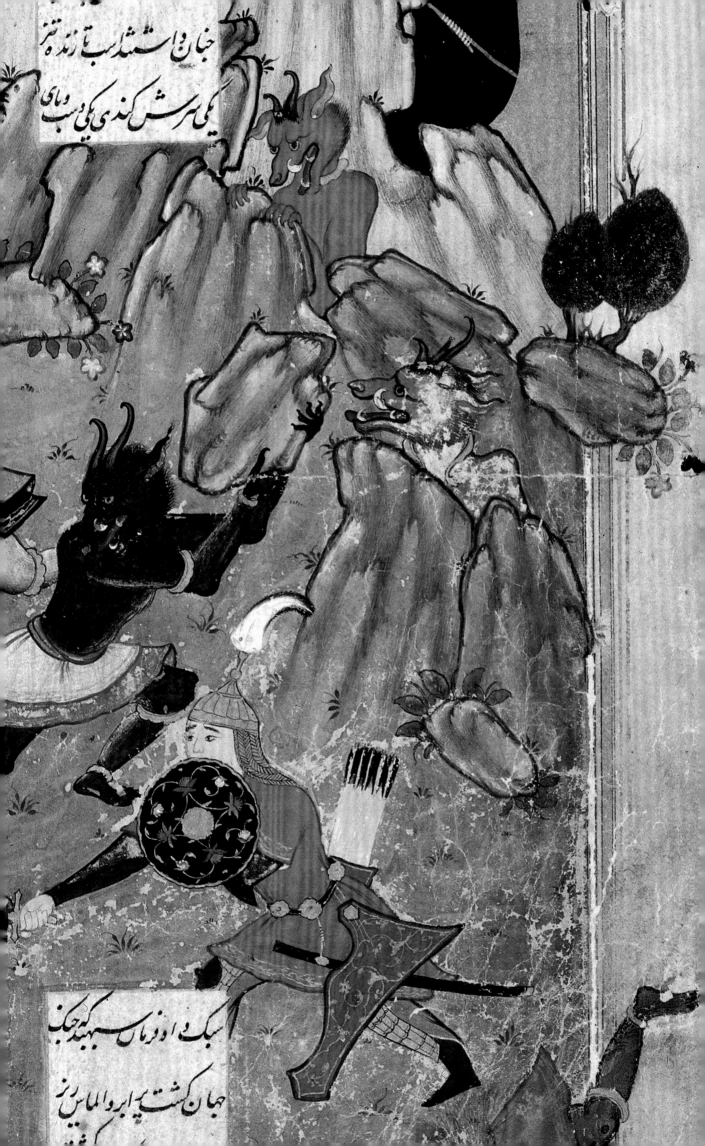

جهان را شناسند تا زنده تر
یکی سرش کندی یکی دست و پای

سبک دراوفرما کن سپه بند که حک
جهان کشت پا ابروالماس رنگ

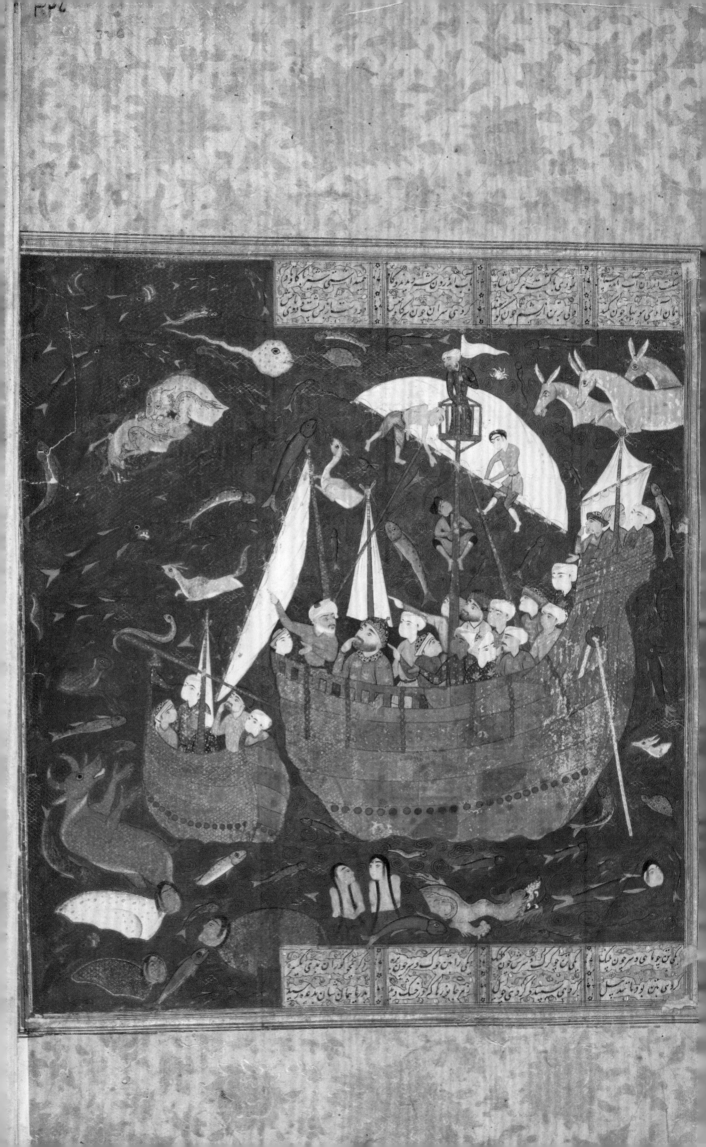

76

KEY KHOSROW CROSSES THE SEA OF ZAREH

British Library, I.O. Islamic 741 (Vol. 1), 326a | Once owned by Tipu Sultan
Covers, probably original, bound into both volumes | Folio 400 x 263 mm;
text area 265 x 153 mm; picture 263 x 235 mm | *c*.1580 | Safavid (Shiraz)
Scribe: Hedayat-Allah al-Shirazi | ww, IV, 246

In pursuit of the fleeing Afrasiyab, Key Khosrow comes to the
Sea of Zareh, a great inland water. With provisions for a year, he
sets sail with mariners from Chin and Makran towards Afrasiyab's
stonghold of Gang Dezh. Strange creatures are seen in the course
of the seven-month voyage.

The scale of this manuscript allows the artist space for an exuberant
rendering of the subject. The ship owes something to a European
model for its presentation, both it and its dinghy being shown
foreshortened, and also for the detail of its structure and working
that include stern-castle, crow's-nest and reefing of the sail.[46] The
sea creatures to an extent match those mentioned in the text, and
are rendered with wit. The epic's mighty Sea of Zareh is now an area
of marsh on the borders of Iran and Afghanistan, fed in part by
the Helmand River. The manuscript is in two, separately registered
volumes, the scribe's signature being in the second.[47] At some point
in the twentieth century netting was applied to the picture as a
conservation measure.

Bibliography: Ethé, 1903, no. 876; Stchoukine, 1959, no. 148; Robinson, 1967, no. 155,
and 1976 (IOL), nos 363–76

77 THE SIMORGH HEALS RAKHSH

British Library, Add. 27257, 305b | Bought by Sir John Malcolm 1808;
sold by Maj. Gen. Malcolm 9 Dec 1865 | Folio 473 x 304 mm; text area 298 x 182 mm;
picture (298) 368 x (182) 248 mm | *c.*1590–5 | Safavid (Shiraz) | ww, v, 237

Rostam and his horse Rakhsh have been wounded in combat with Esfandiyar, and Rostam has retreated to find his father, Zal. Zal burns a feather of the Simorgh, and she descends to him. The Simorgh draws eight arrow-heads out of Rostam and six out of Rakhsh and provides a feather with which their wounds are to be stroked. See no. 95.

This stately page is characterised by classical restraint. White-bearded Zal and the restored Rostam, surrounded with the three braziers mentioned in the text, watch as the Simorgh works on Rakhsh, her questing beak the chief focus of the picture. The Simorgh's tail streams away into the marginal area, connecting this other space to, but limiting it from, the main picture, so that a semi-divine status is suggested for the bird. Rostam's wide turban indicates the period of Shah 'Abbas I; and indeed Stchoukine is inclined to associate the manuscript with a grand hunt enjoyed by Shah 'Abbas at Shiraz in 998/1590.

Sir John Malcolm (1769–1833), soldier, diplomatist and historian, joined the East India Company in 1782. In addition to active and administrative service in India he undertook two diplomatic missions to Iran and wrote *The History of Persia*. In 1808, when he acquired the present manuscript, he had been sent to the Persian court with a view to countering Napoleonic influence.

Bibliography: Rieu, 1881, p. 536; Stchoukine, 1964, pp. 135–6; Titley, 1977, no. 113

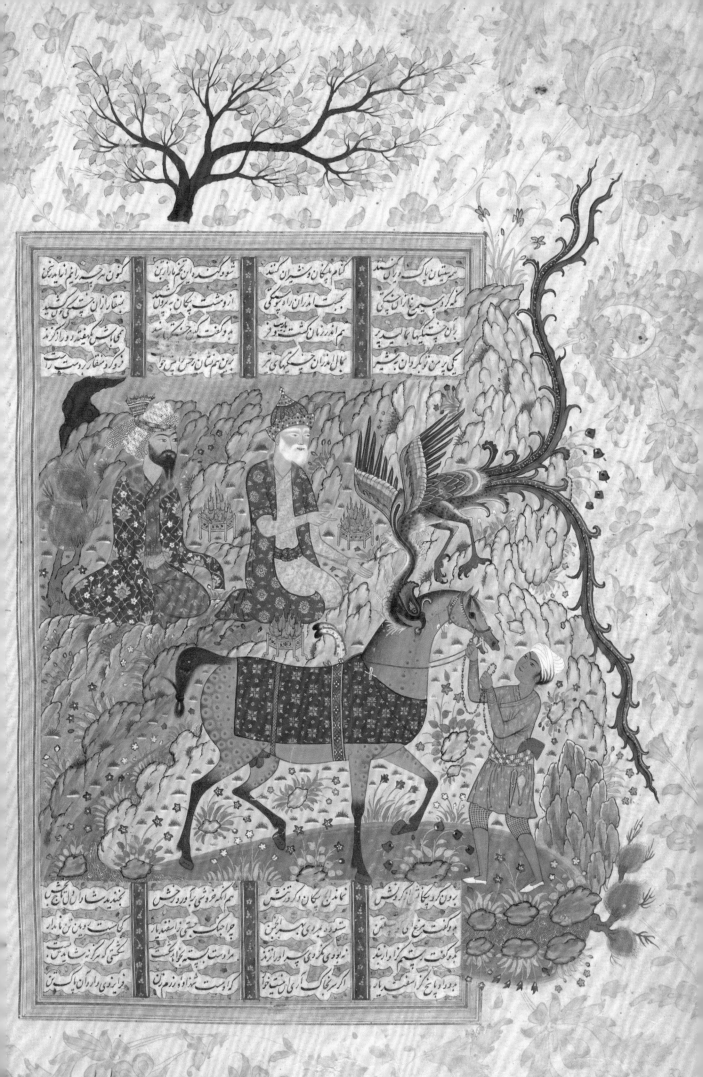

FIRE ORDEAL OF SIYAVOSH

Fitzwilliam Museum, MS 311, 82b | Once owned by William Morris;
later Wilfrid Scawen Blunt | Folio 370 x 245 mm; text area 254 x 150 mm;
picture (140) 225 x 220 mm | 1030/1620–1 | Safavid (Astarabad, Esfahan?) | ww, II, 220

This is the same moment as that portrayed in no. 49 but the treatment
is very different. Here Siyavosh seems happy as he plunges into
the flames, the smoke is dense enough to obscure the heads of the
horses of a number of spectators, and Sudabeh watches with a female
attendant. This slightly naïve but markedly dynamic and colourful
style of illustration has been attributed by Robinson to Astarabad,
as he relates it to a three-part *Shahnameh* copied there in 972/1564.[48]
While there is some resemblance to the treatment of the present
subject in the Astarabad manuscript, the lapse of three score years
between the two works allows for some difference, but also argues
for caution. Astarabad, now Gorgan in north-eastern Iran, was
presumably enjoying a period of trading prosperity, perhaps supported
with some military presence against Turkman raids. The script in the
present example, with considerable width to some letters, may suggest
a provincial centre.

Bibliography: Robinson, 1967, no. 184; Hillenbrand, 1977, no. 32;
Wormald and Giles, 1982, I, pp. 301–3

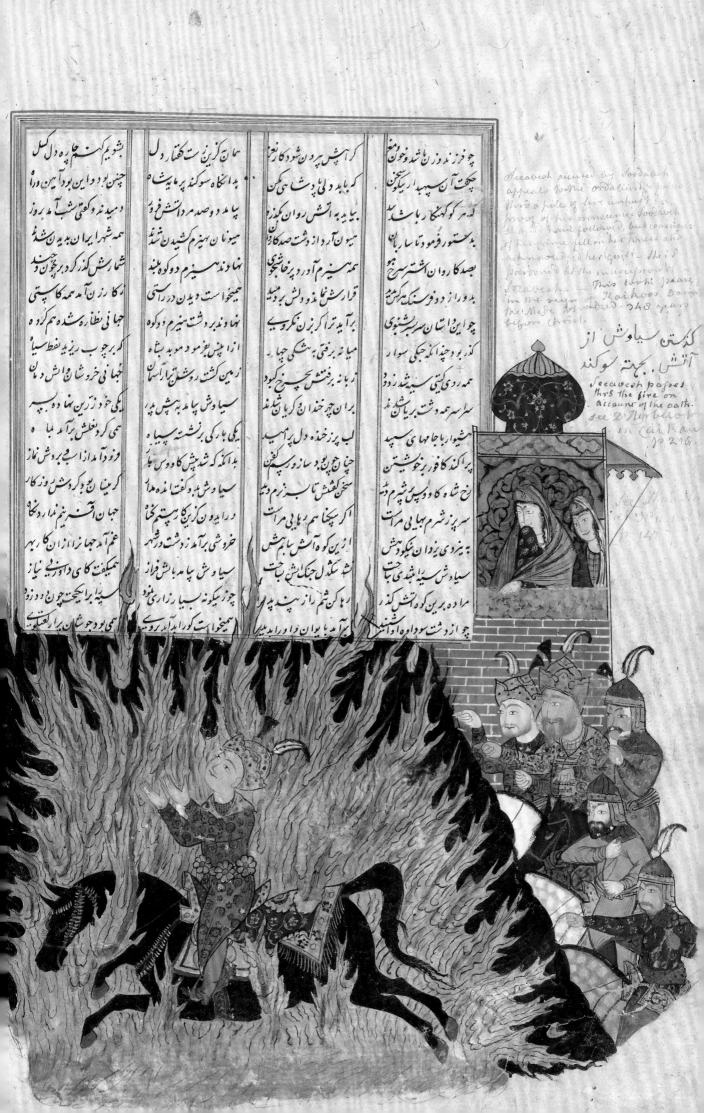

چو فرزند و زن باشد و خون و مغز
که باشد پرستنده را کار نغز
چکت آن سپهدار ریکین
که باید دلی دشت می کن

بیا به آتش روان بگذر
میون آرد و از دشت صد کار
همه سیزم و پر خاشجوی
قرارش نماند و دل بر میل
براید ترا کر بزن نکروی

سمان کزین ست کفتار دل
بدانگاه سوکند پر ماییش
پا آمد و صد مرد آتش فرو
میونان به هیزم کشید شند
نهادند سیزم دو کوه بلند
همیخواست دیدن در راستی
نهاد و بر دشت سیزم دو کوه
ازا پس بفرمود موبد بنا
زمین کشت روشن نزد آسمان
سیاوش پا مد به هیش پدر
یکی بار کی برنشسته سیاه

بشویم کنم پاره دل کسل
چنین بود و این بود آیین ورا
امیدند و کفتی شب آمد بروز
همه شهر ایران بدین شند
شمارش کذر کرد بر چون و چند
کا رزن آمد همه کاسپستی
جهانی نظاره شده هم کروه
بر جوب ریزید لفظ سیا
جهانی خروشان وایش ده بر
یکی خود ز رین بها ده
همی کرد دغش بر آمد بلا
فرود آمد اسب برو نماز

میان برفتش بحری چهار
زبانه برفتش بحر خ کبود
بران چه خذان کریان شدند
لب پرزخنده دل بهید
چنان چون بد ساز و رسپکن
سخن کفش تا بز زرم ولیم
اکر سپگنا هم رهایی مرا
ازین که آتش سام بهش
شهرش دل جنگ لایش جست
چو زنیکوند سیا رزاری مند

که هرش پر دون شد و کار نغز
بدستور فرمود تا سار بان
بصد کار روان اشتر سرخ
بدراز دو دویک دوک کرشت
چو این داستان سر به بشنوی
کز بود وچنا که چکی چهار
همه روی کیتی سیه شد زدد
سراسر سه دشت بریا شند
میشوار با جامهای سپید
پراکند کافور بر خویشتن
رخ شاه کاووس خود شرم دار
سر پرزشرم بهایی مرست
به بنزوی یزدان بر نیکوبش
سیاوش سیا بنده جنبا
ماده برین که آتش گذر
چو از دشت سود او آمد بیر

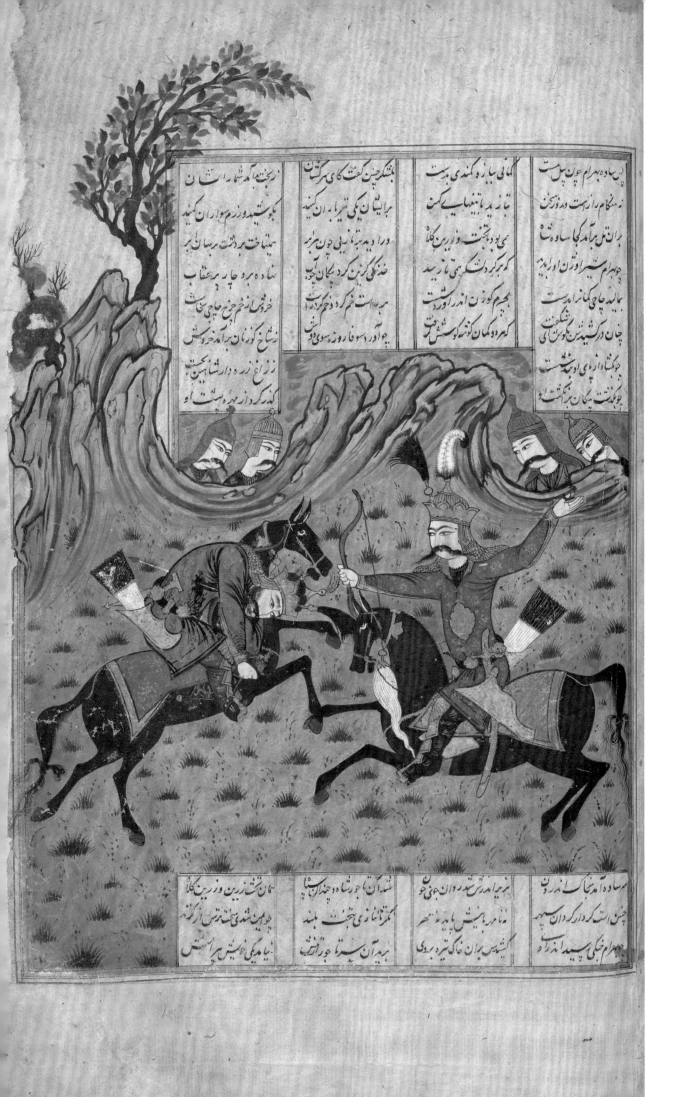

BAHRAM CHUBINEH KILLS SAVEH SHAH

79

Corpus Or. 202, 252a | Second volume of a *Shahnameh*
Folio 370 x 226 mm; text area 260 x 153 mm; picture (150) 204 x (164) 300 mm
Mid-Rabi' II 1053/July 1643 | Safavid (Astarabad, Esfahan?)
Scribe: Hajji Mohammad b. Nur al-Din Mohammad Dasht-e Bayazi
Patron: Mirza Mohammad Taher Beg | ww, VIII, 126

In the Sasanian period, Hormozd of Iran is concerned by the threat posed by Saveh, the Turkish ruler who advances from Herat. The aged Nastuh tells him of a prophecy that leads to Bahram Chubineh, a lord willing and able to lead the army against Saveh. Bahram Chubineh routs the much larger Turkish force. Saveh, who has not taken part in the battle, takes to flight, but Bahram shoots him in the back.

Bahram's commanding and balanced position is contrasted with that of Saveh, who falls forward as his horse rears; the impression of action is heightened by a rocky horizon suggestive of breaking waves. In this example the horizon does not mirror the combatants, being out of phase with them, but linked to them by the use of strong blue. The style of this picture has been identified as that of Afzal al-Hoseyni, who at the same period contributed to a *Shahnameh* for Shah 'Abbas II.[49] This fact points to an origin in Esfahan, as does the rock form, which, often treated more moderately, is a feature of the painting of Esfahan that derives from the local landscape. The vigour, relative simplicity, and the drawing of the black horse relate this picture to no. 78, and thus possibly to the speculative style of Astarabad.

80 ROSTAM RESCUES BIZHAN FROM THE PIT

British Library, Add. 27258, 257b | Once owned by Sir John Malcolm;
sold by Maj. Gen. Malcolm 9 Dec 1865 | As re-margined 362 x 243 mm;
text area 228 x 130 mm; 173 x 130 mm | Ramadan 1037/May 1628 | Safavid (Esfahan)
Scribe: Nezam b. Mir ʿAli[50] | ww. III, 345

As in no. 52, Manizheh has guided Rostam to the pit where Bizhan is imprisoned. Here a keen-faced Rostam has lifted away the capstone and asked Bizhan what has befallen him, but has not yet let down his lasso. As before, the pit is shown in section, but here it is drawn into the middle of the composition and as though enfolded in rocks. Manizheh is shown in the slightly leaning, curved posture that was used for many single-figure studies for collection in albums in the Esfahan of Shah ʿAbbas I. The rather soft attack of the brush in landscape might also be adopted from these. Some of the underdrawing shows through the white of Bizhan's shift, contrasting with the folds deliberately drawn upon it.

Bibliography: Rieu, 1881, p. 537–8; Titley, 1977, no. 114; Melville, 2006 (Bizhan)

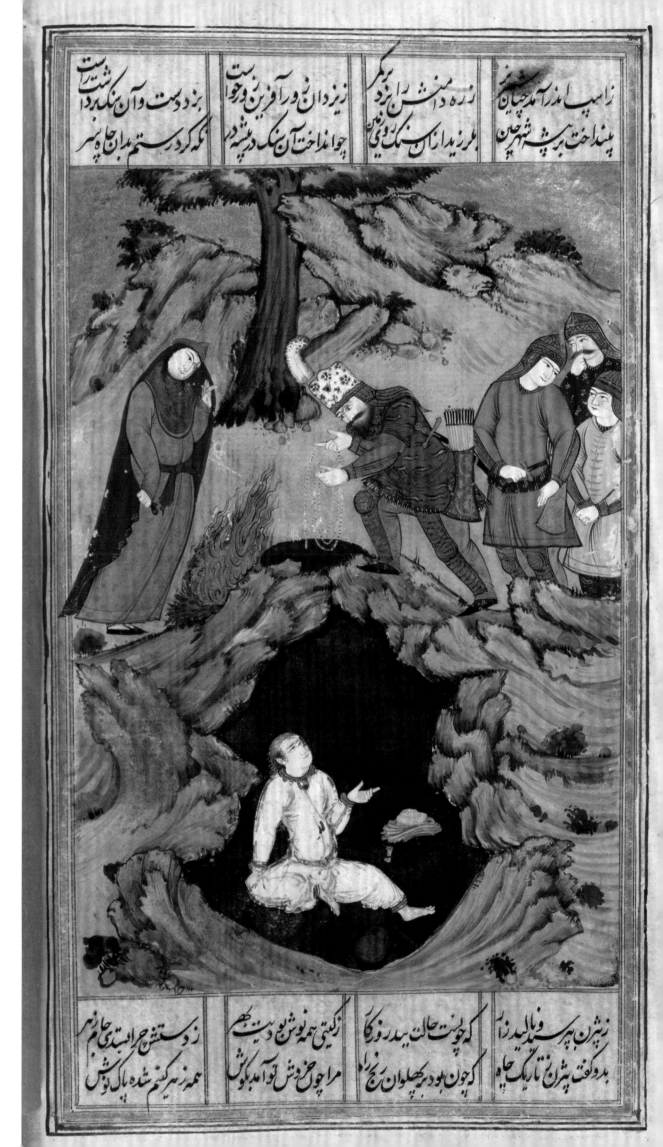

81

RUDABEH LETS HER HAIR DOWN TO ZAL

British Library, I.O. Islamic 1256, 42b | Once owned by Tipu Sultan | Original binding
Folio 430 x 260 mm; text area 258 x 156 mm; picture (258) 315 x (156) 215 mm | 1630s
Safavid (Esfahan) | WW, I, 271

Zal and Rudabeh are in love, though they have never met (see no. 65). Rudabeh's maidens have suggested to Zal that he should scale the walls of the castle where she lives. When Zal comes to the castle at night, Rudabeh lets down her hair to help him ascend. But Zal kisses the tresses and instead throws his lasso up to the battlements. Rudabeh takes him to her pavilion where they plight their troth.

There is no attempt to indicate a night scene; instead a sense of airiness is conveyed by the trees and the clouds passing in the sky. Wall paintings of birds in leafy trees create a charming feminine ambiance, and paired birds betoken love. As Robinson observes, the best illustrations to this manuscript – among which this should be counted – may include early work by the painter Mo'in Mosavver. A pupil of Reza-ye 'Abbasi, Mo'in Mosavver signed album pictures and illustrations from the late 1630s to the 1680s or beyond. Features of Mo'in's style are an elegantly calligraphic line, carefully judged colour and a favouring of the face rather than the body as the vehicle for expression. For Zal and Rudabeh see nos 46, 65, 93 and 98.

Bibliography: Ethé, 1903, no. 868; Robinson, 1976 (IOL), nos 1083–110

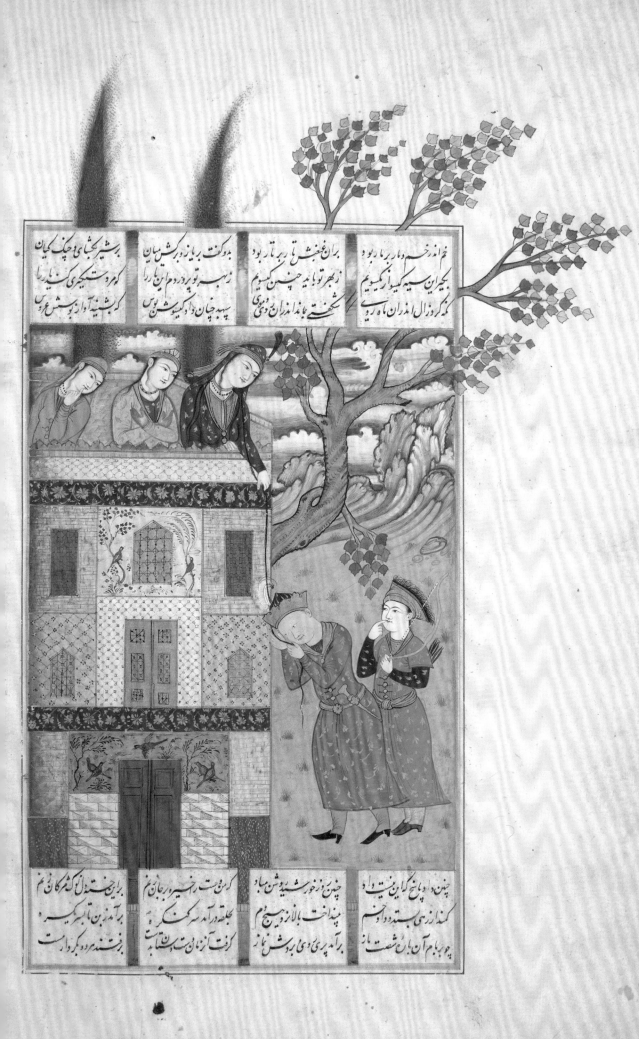

82 SOHRAB SLAIN BY ROSTAM

British Museum, 1922, 0711, 0.2, | Folio 354 x 210 mm; text area 293 x 148 mm;
picture 250 x 148 mm | Ramadan 1059/September–October 1649 | Safavid (Esfahan)
Artist: Mo'in Mosavver | ww, ii, 173

The principal group is much the same as that used in no. 36, but now
Rostam's dagger has descended and he faces the realisation that he
has killed his son – the text refers to a moment when Rostam hopes
against hope that he is mistaken. But there can be no mistake for
Sohrab is wearing the armlet that Rostam had given to Tahmineh.

Attention is focused on Rostam's face, with a secondary focus on
that of his son. The landscape is not intended for detailed attention,
though the autumnal tree buffeted by the wind and the pink ground
may be used to suggest intense emotion. The signature of Mo'in
Mosavver and the date yielding 1649 are in the lower left. Mo'in
is known to have signed illustrations in at least four *Shahnamehs*.[51]
The present picture is from the earliest of these, a dispersed copy easily
recognised by the use of a diagonal column on three sides of the page.[52]

Bibliography: Schroeder, 1942, nos xxvii and xxviii; Grube, 1962, no. 113; Stchoukine,
1964, pl. lxxxvi; Robinson, 1976 (Colnaghi), no. 55; Titley, 1977, no. 134; Farhad, 1990,
pl. 1; Canby, 1993, pl. 73

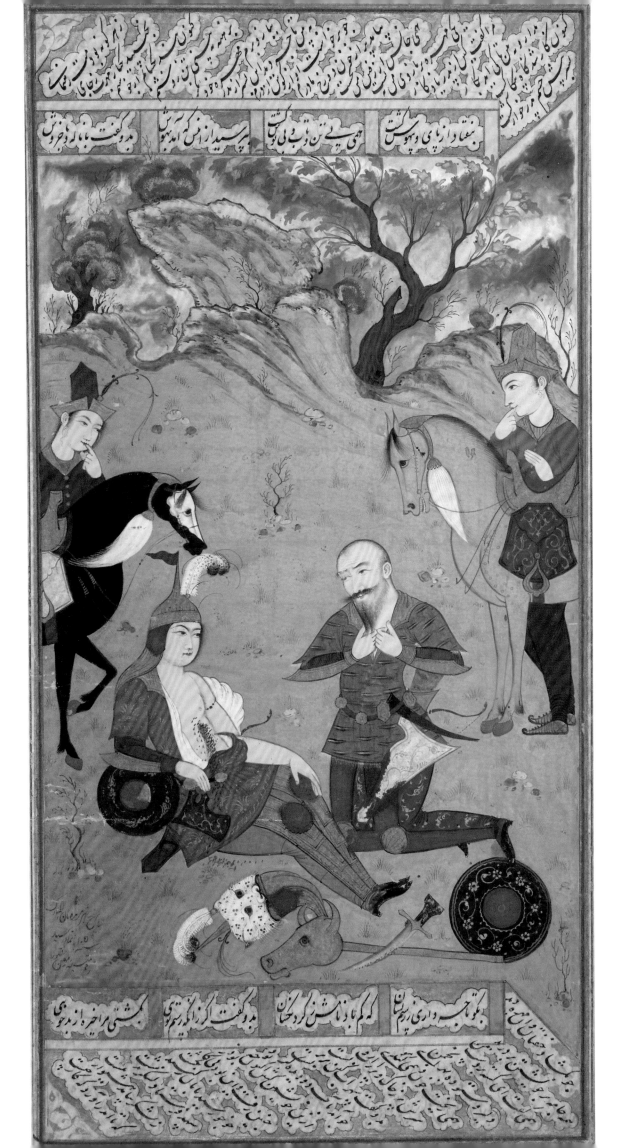

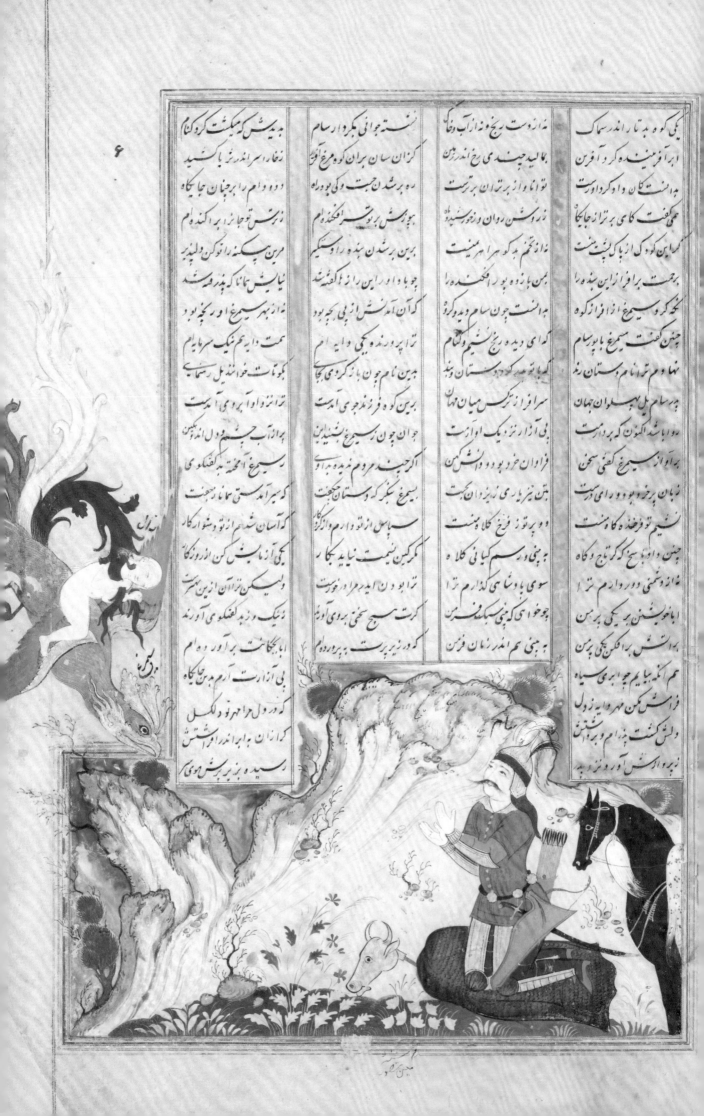

83

THE SIMORGH RESTORES ZAL TO SAM

Nasser D. Khalili Collection of Islamic Art, MSS 1070r | Folio 364 x 224 mm; text area 260 x 152 mm; picture 260 x 195 mm | 1660s | Safavid (Esfahan) Artist: Mo'in Mosavver | WW, I, 247

The composition is similar to that for no. 45, but here the Simorgh comes in from the free space of the margin. The atmosphere is joyful. Zal is shown playfully riding the Simorgh, using a strand of her tail-feathers as a form of safety harness. Sam is ecstatic with the slight smile often seen on faces by Mo'in. The placing of the action low in the page with extensive sky notionally behind the text columns suggests the Simorgh's long descent through the air and lends a sense of freedom. Sam's horse waits with a docile expression and numerous twiggy bushes enliven the landscape. Mo'in's signature is placed centrally below the picture, the note partly on the rulings. Labels to the Simorgh and Zal and a figure six in the left-hand margin, presumably numbering the picture, will be later additions. The picture appears to come from a dispersed copy which is considered to date from the 1660s.[53] See also no. 84.

Bibliography: Grube, 1962, nos 114–16; Swietochowski, 1981, no. 83; Sims, forthcoming

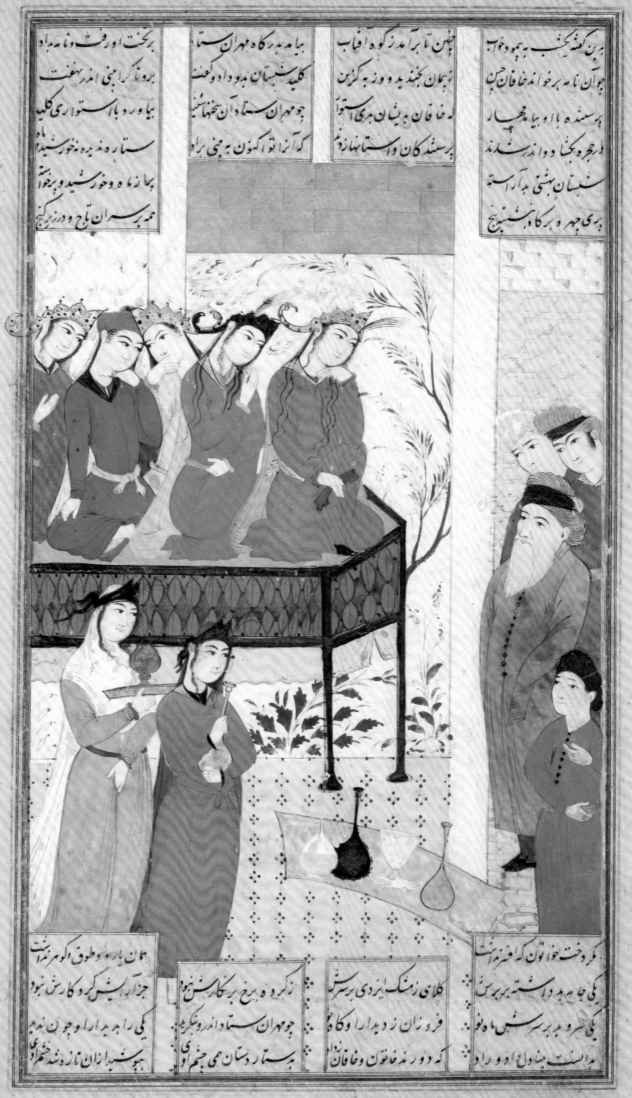

چنین تا برآمد ز کوه آفتاب
این گفته یکشب به همو بخواب

بیامد به دیدگاه مهرگان ستا
جوان نامه برخواند خاقان چین

کلید شبستان بدو داد و گفت
که خاقان بیابان بری استوا

جوهان ستان آن شبها منشین
پرسند کان دوستان هزادم

کآرا تو اکنون به منی برا
شبستان بهشتی بدار آسته

پری چهره و برگه شبیخ

برتخت او رفت و نا به مراد
باما بدید که مهران ستا

بروتابرا بنی اندر بگفت
ستاره دریده به خورشید ماه

بیاورد با با ستواری کلید
بروک کرا منی اندر بگفت

بهازا به و حورشید و برخته
محمه برسران تاج و در زیر گنج

کردد خت خوانون که اعبه آبرنت
جهان پاره او طوق و کوه مربنت

کلای زمنک ایزدی برسرش
جرا آرایش کرد برکارش نبود

فروزان بر بر سرش ماه نو
زکرده یخ بر کارکن بود

که دوره ند خاتون وخاقان زاد
کلی را بدید ار او چون ندیم

بیاست بنیا دق او و داد
جوهان ستا دان و نرکند به

بیستار دستان همی جم او
هوسیهد بزان نازسند خطاو

84

MEHRAN SETAD SELECTS A BRIDE FOR ANUSHIRVAN

Nasser D. Khalili Collection of Islamic Art, MSS 1031r | Folio 363 x 225 mm;
text area 260 x 150 mm; picture 260 x (150) 153 mm | 1660s | Safavid (Esfahan)
Artist: Mo'in Mosavver | ww, VII, 352

In the days of the Sasanian monarch Anushirvan, the Khaqan of Chin
has made some moves towards territorial expansion, but thinking better
of this policy he has decided instead to offer one of his daughters to
Anushirvan in marriage. The latter sends Mehran Setad, a wise elder
statesman, to make the selection. Mehran Setad is permitted to
view four princesses, beautifully adorned, who are the daughters
of concubines, and one, simply dressed and modest in demeanour,
who is the daughter of the queen. He is able to detect and chose
the true princess.

The princess is probably the second lady from the left, who is not
wearing a tiara, and whose hair does not stray across her cheek. The
figure of Mehran Setad, sagacious and just a little plump, draws upon
the fashion for single-figure studies rather than the tradition of the
Shahnameh, and a hint of comedy may be intended. Mo'in's signature
is placed below the picture, and the number 84 has been written in
the margin. It seems that this is from the same manuscript as no. 83.

Bibliography: as no. 83; Sotheby's, 15.10.98, lot 64; Sims, forthcoming

THE DYING ESFANDIYAR WATCHED BY ROSTAM AND ZAL

85

The Royal Collection, RCIN 1005013 (MS. A/5), 194b
Presented to King George III or King George IV by the Marquess of Hastings,
Governor-General of India (1813–23) | Binding early nineteenth century (Lucknow?)
Folio 442 x 303 mm; text area 258 x 190 mm; picture (125) 184 x (182) 212 mm | c.1585
Safavid (Qazvin style) | ww, v, 244

After a long contest and prompted by the Simorgh, Rostam has shot
Esfandiyar in the only way possible, in the eyes with a double-headed
arrow of tamarisk. Esfandiyar falls, but himself draws out the arrow.
His brother Pashutan and his son Bahman run to assist him. Pashutan
laments over Esfandiyar. Esfandiyar answers with resignation, but
observes that Rostam has had the assistance of the Simorgh. Rostam
begins to feel shame. Esfandiyar commits Bahman to Rostam's care.
Zal, who has hurried to the scene, understands that Rostam's life
will now be darkened.

Pashutan embraces Esfandiyar, while Bahman is distraught. Zal seems
to interpose himself between Rostam and the fateful scene. They watch
respectfully. The illustration has a remarkable dignity, with figures
large in the picture; and most unusually it shows the pallor of the
dying man. Rostam's snow-leopard cap and the horses are treated
with considerable naturalism, and textile patterns are shown in detail.
The composition is relatively spare, and Robinson sees it as the work
of an artist trained in the Qazvin style, in contrast to other illustrations
in the manuscript in the style of Shiraz.

Bibliography: Robinson, 1951, no. 84, 1967, no. 57, and 1968 (February); Stchoukine,
1964, p. 136; Waley, 1992, pp. 19–20

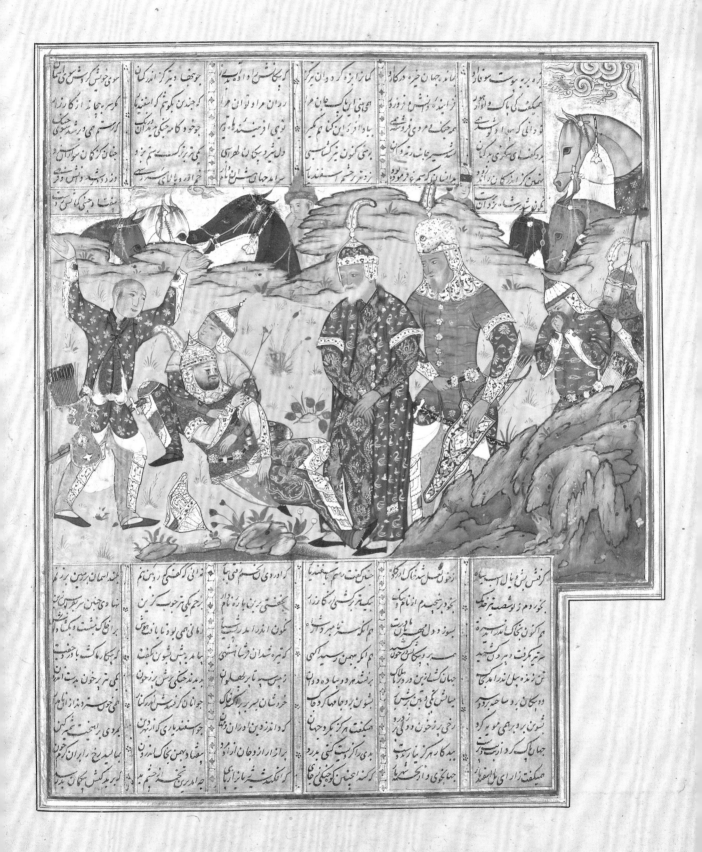

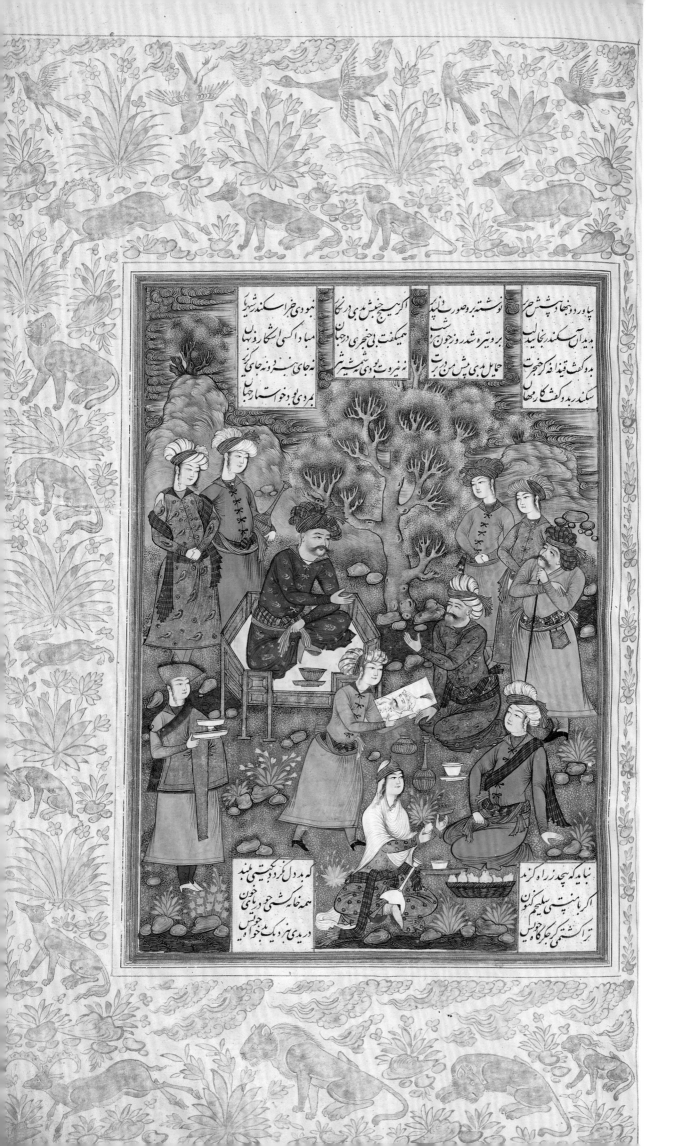

86 ESKANDAR SHOWN HIS PORTRAIT

The Royal Collection, RCIN 1005014 (MS. A/6), 498a
Presented to Queen Victoria in 1839 by Kamran Shah of Herat with a message from his wife
Binding: lacquer by 'Ali Ashraf, Rabi' I 1160/March–April 1747
Folio 457 x 285 mm; text area 273 x 157 mm; picture 273 x 196 mm
Rabi' II 1058/April–May 1648 | Safavid (Mashhad)
Scribe: Mohammad Hakim al-Hoseyni | Patron: Qarajaghay Khan, governor of Mashhad
Artist: attributed to Mohammad Qasem by Robinson | WW, VI, 131

After visiting the Ka'ba (see no. 10), Eskandar leads his troops to Egypt. Queen Qeydafeh of Andalus (Candacc of Meroë) sends a spy to observe him and make a portrait of him.[54] Eskandar sends a letter to the queen demanding tribute; he then comes to her court in the guise of his own ambassador. She, however, recognises him from the portrait. Qeydafeh challenges Eskandar and he is forced to admit his true identity. They come to a diplomatic agreement.

The illustration rather subverts the text. At this moment we should usually expect to see Qeydafeh enthroned, while the picture is shown to Eskandar, who is often seated at a lower level. Instead, Qeydafeh has been eliminated – unless we are to suppose that she looks through the eyes of us, the readers. The dominant figure is now Eskandar, who, as Robinson has observed, appears to be a posthumous portrait of Shah 'Abbas I, and who is clearly discoursing on the portrait. It seems that the traditional illustration of the narrative has been superseded in the artist's mind by what he knows of contemporary court life, and it is this that he paints. The patron, Qarajaghay Khan, is of the third generation of his family to hold a governorship and so would be familiar with the world of the court. He may himself be intended by the figure who kneels extending a hand. The picture has been attributed by Robinson to Mohammad Qasem, and this is supported by Sims by reference to a signed single-figure piece.[55] Two features of landscape in illustrations thought to be by this artist are a ground speckled as though stippled, and a treatment of clouds in tapering horizontal bands of gold, firmly marked with scrolls, that almost resemble *passementerie* – black detail upon gold is also used for a tree in no. 69 and might be an indication of shared origin. Two fashionable items worn by a figure in the lower left are a hat, whose up-turned brim hangs forward, and a jacket slung on one shoulder in what reached Europe as the 'dolman' mode. Some margins have arabesque decoration and some, as here, chinoiserie animals.

Bibliography: Robinson, 1951, no. 120, 1967, no. 78, and 1968 (March); Waley, 1992, pp. 20–2; Robinson, Sims and Bayani, 2007; Farhad, 2004, 121–36; Canby, 2009, no. 51

87 DRESS SADDLE

Nasser D. Khalili Collection of Islamic Art, MTW 289
Height at the front 335 mm; length 580 mm; width at the back 425 mms
Wood, steel damascened with gold, leather, velvet, padding | 1185/1771–2
North-east Iran or Bokhara? | Patron: Sinan Bahador Amin Beg

Though relatively late in date, this saddle represents the type seen in *Shahnameh* illustrations. The essential structure consists of two wooden boards linked by arches (see no. 27). Stirrups would be attached below this structure, below them a broad pliable section (skirt) and below this a girth. The whole might then be placed over some form of saddle blanket. Conditioned by the need of the herdsman to use the lasso or to be retained during sleep, and the need of the warrior to withstand shock, this saddle has a family likeness to the Western saddle, as opposed to the English saddle as it developed in the eighteenth century for racing or jumping hedges while hunting. The very enclosed seat of the Persian saddle is known as *khaneh-ye zin*, 'house of the saddle'. The inscriptions inlaid in gold provide the patron's name, the date and a verse that may be rendered:

This saddle decked with gold and well adorned,
From hijreh, five, eighty, hundred and a thousand.[56]

Bibliography: Alexander, 1992, no. 140

88

SECOND BATTLE OF KEY KHOSROW AND AFRASIYAB
Overleaf

Wellcome Institute, QCC2664.13
Folio (applied to verso, partly trimmed) 370 x 248 mm; text area 302 x 178 mm; picture 250 x 170 mm | Second quarter of the nineteenth century | Qajar | WW, IV, 192

Key Khosrow has crossed the Jeyhun (Oxus) pursuing Afrasiyab to his fortress of Gang Dezh. Afrasiyab comes out to meet him and battle is joined. Seeing the great loss of life, Key Khosrow goes apart and prays for aid, and a great wind rises to blow in the face of his Turanian adversaries. The army of Iran has the best of the battle and, with news of the approach of Rostam, Afrasiyab retreats to Gang Dezh.

The great wind is indicated by black clouds in the distance. The distant landscape is treated with aerial perspective, and colour is applied with a view to creating the effect of a European watercolour. Volume is indicated by variations of tone and by hatching, and shadows are cast. White highlights are applied – a feature more characteristic of oil painting than of watercolour. Many faces have suffered damage: this is from a tendency of white pigment to flake, rather than from deliberate attack, and is observable on the white horses also. The surviving faces have a passionate – albeit a uniform – expression, with eyes rolled, brows contracted and eye sockets carefully shaded. Both commanders wear the tall archaising crown favoured by Fath 'Ali Shah (*reg.* 1797–1834); these and other accoutrements and horse trappings are shown as liberally decorated with rubies and pearls. Attention is also paid to the designs on textiles.

Uncatalogued, identification number is provisional

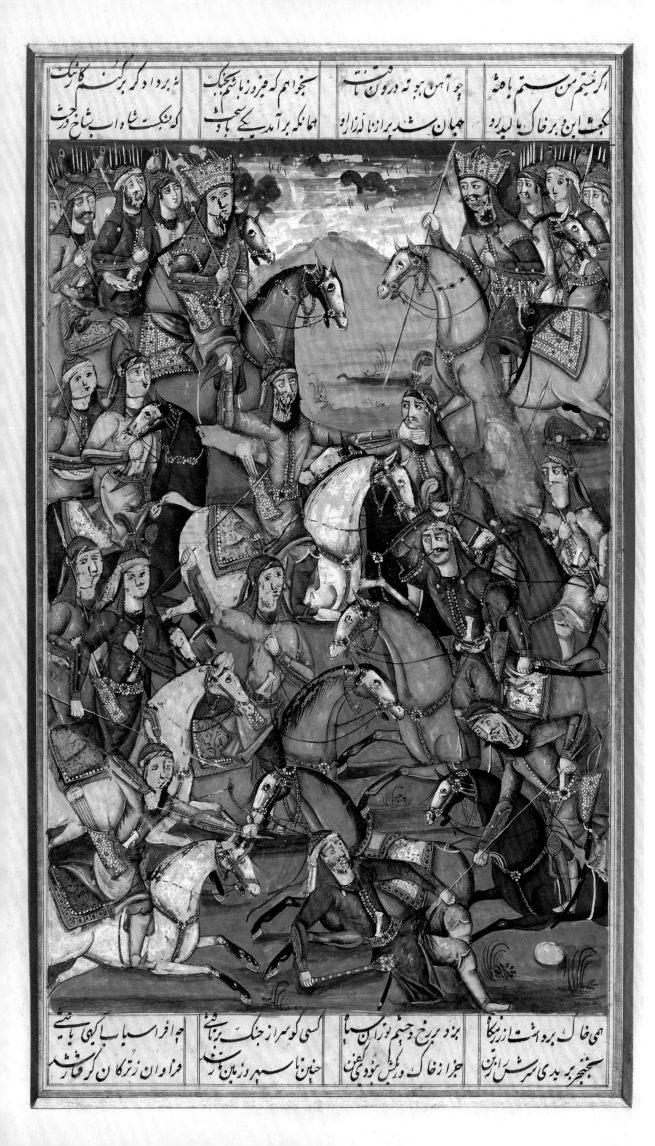

89

SIYAVOSH PLAYS POLO AGAINST AFRASIYAB

Above

British Museum, G.1983.314 | 300 x 300 mm | Fritware tile with underglaze colours
Qajar (Tehran or Esfahan) | Second quarter nineteenth century
Artist: Mohammad Ebrahim | WW, II, 265

After surviving the fire ordeal, Siyavosh has volunteered to repel an incursion by Afrasiyab. The latter, however, dreams that he will meet disaster if he fights Siyavosh and they come to an accommodation. Key Kavus is enraged. Torn between his agreement and his duty to his father, Siyavosh decides on exile in Turan. He is well received and is able to display his skills, including his prowess at polo in a match against Afrasiyab. He will be married to Jarireh, daughter of the counsellor Piran, and to Farangis, daughter of Afrasiyab. But he will be plotted against by Garsivaz, brother of Afrasiyab, and killed by the hand of Goruy.

The nineteenth century sees a revival of production of pictorial tiles, which are often finely drawn. Styles tend to reflect manuscript painting. In the present piece there is a hint of distant landscape, and the suggestion of shading. In small quatrefoils in the upper border the tile is signed by Mohammad Ebrahim: he is perhaps to be identified with Ostad Ebrahim Kashani.[57]

Bibliography: Porter, 1995, pp. 86–7

211

90

TABLE TOP: CIRCULAR COMPOSITION CENTRED ON 'ROSTAM SHOOTS ASHKABUS'

Victoria & Albert Museum, Inv. 559-1888 | Diameter 1,360 mm
Nine fritware tiles with underglaze colours | 1304/1886–7 | Qajar: made in Tehran
Artist: 'Ali Mohammad *kashigar* Esfahani | Patron: Colonel Robert Murdoch Smith
ww, III, 181 (for central segment)

Major General Sir Robert Murdoch Smith, as he later became, having been an officer in the Royal Engineers, was seconded to work on the development of the Persian telegraph, becoming its Director. He became interested in the collection of Persian items for the then South Kensington Museum, and was later Director of the then Edinburgh Museum of Science and Art. Interested in the work of the potter 'Ali Mohammad, he commissioned this piece – apparently when holding the rank of Colonel – and two other compositions of multiple tiles also in the Victoria & Albert Museum.[58] It seems most probable that the circular composition was not seriously intended for use as a table, but was, like its companions, a demonstration of the fine drawing and technical skill of its maker. Scenes from the *Shahnameh* are shown on all three pieces, together with historical personages, as here, or scenes from other works of literature. In the central roundel 'Rostam shoots Ashkabus' (see no. 37) is treated in a landscape that is remarkably developed for painting on ceramic.

Some of the tiles in the outer circle contain numbers, but these do not form a sequence. The persons shown in the individual tiles of the outer circle are as follows, working clockwise from the top of the composition:
1. Hushang, the second king in the *Shahnameh* is enthroned, with his son Tahmuras, the third king, before him.
2. Afrasiyab, principal enemy of Iran in the *Shahnameh*, is enthroned with Ashkabus, before him. The latter's name is spelled differently from the version on the central tile. The numeral '7' is inscribed in Persian and Western mode on a column.
3. Qahraman, an Iranian hero, is enthroned, with Qahtaran before him. The numeral '4' in Persian and Western mode is incorporated into the carpet below the throne.
4. Shah 'Abbas I (*reg.* 1587–1629) enthroned, together with Hoseyn-e Kord ('Hoseyn the Kurd'), a hero of popular storytelling of the time, whose *nisbeh* is Shabestari. He is also seen on another tile. The numeral '2' in Western mode is inscribed on a column base.
5. Shah 'Abbas is again enthroned, here with Khorram-e Chini, the follower of Malek Shah of Chin, a character in the romance of Hoseyn-e Kord (see previous tile).
6. The *Shahnameh* hero Gudarz leans against a bolster with his son, Giv, the father of Bizhan, before him. These are two of the most loyal paladins of Iran. When they have followed Key Khosrow on his last journey into the mountains, Gudarz turns back at his bidding, but Giv does not and dies in the snow (see no. 53).
7. Labelled 'Battle of Rostam with Sohrab' this is a narrative scene from the *Shahnameh* (see no. 82). Rostam tears his garments in despair at having killed his son. The numeral '8' in Persian and Western mode is written below the mace.
8. Hoseyn the Kurd, who appears with Shah 'Abbas on another tile, reclines at his ease. He is attended by a young cup-bearer labelled Yusof the Second: this is the young male dancer, Yusof, with whom Hoseyn the Kurd amused himself after one of his exploits. Yusof, from the biblical Joseph, appears in the Qur'an, but in Iran is particularly known from Jami's narrative poem, *Yusof and Zoleykha*. Yusof is the epitome of the beautiful and virtuous servant. The numeral '3' in Persian and Western mode is incorporated into the carpet.

Bibliography: Scarce, 1976, 278–88; Porter, 1995, p. 82; Naylor, 2004, pp. 136–7

THE 'SHAHNAMEH' IN INDIA

THE FIFTEENTH TO THE NINETEENTH CENTURIES

91 ## TAHMINEH COMES TO ROSTAM

Keir Collection, III. 202 | As mounted 250 x 230 mm; picture 190 x 175 mm | c.1435–50
Sultanate India (North Deccan?)

The subject is as nos 18, 28, 48 and 75; the text has been applied
from another source, which is not a *Shahnameh*. An amusing touch
is that Rostam, surprised, here reaches for his mace. The figures are
tall with broad faces and bear some resemblance to those in a double
Khamseh of 1436 in the Chester Beatty Library, whose origin in Bidar,
North Deccan, has been argued on account of architectural decoration
depicted in its illustrations.[59] Similarly in the present example, the
slightly ogival profile of the dome and the fact that it extends over its
drum point to the Deccan. This apart, the architecture here appears
more a screen than a solid structure, but it is used to good effect to
frame the central action, which is further defined by another ogival
arch. The central area is curtained in red in a manner found in some
Persian pictures of the fourteenth century.

Bibliography: Robinson, 1976 (Keir), III.202

92 FIRE ORDEAL OF SIYAVOSH

University of Manchester, John Rylands Library, Persian 9, 115b
Khamseh of Nezami in the diagonal column | Once owned by Sir Gore Ouseley[60]
Folio 229 x 148 mm; text area 200 x 132 mm;
picture (90) 135 (implied but trimmed) x 111 mm | 1440s
Text: Shiraz, Yazd or Western India | Illustrations: Sultanate India (Gujarat?) | ww, ii, 220

The subject is as no. 49. The page format with diagonal column
on three sides was typical of Shiraz, and also used in Yazd, but may
of course also be found in regions influenced by these. Robinson
attributes the manuscript to Western India, though he sees the painter
of the present picture as Persian. While the origins of the painter's
style are indeed in Shiraz, it is again the architecture that suggests
India. Behind its greenish battlements, the roof of the palace of Key
Kavus is furnished with a small aedicule that has a flanged dome
supported on slim red columns. This cannot be of Persian brick or
wood, and must instead represent an Indian *chhatri* (small pavillion)
of red sandstone. In addition, the rather regular scattering of units of
flame over the ground suggests an impulse to transform the motif into
a pattern, as though on a textile.

Bibliography: Robinson, 1980, pp. 97–111

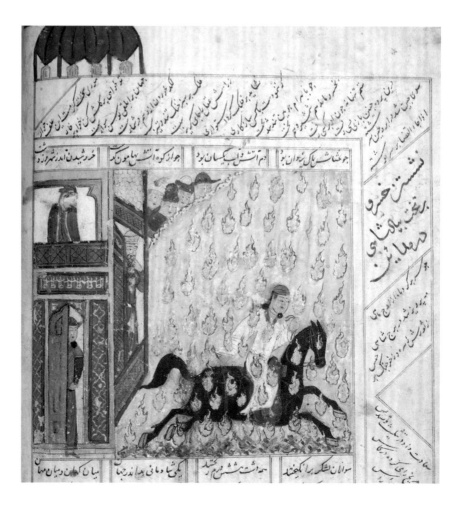

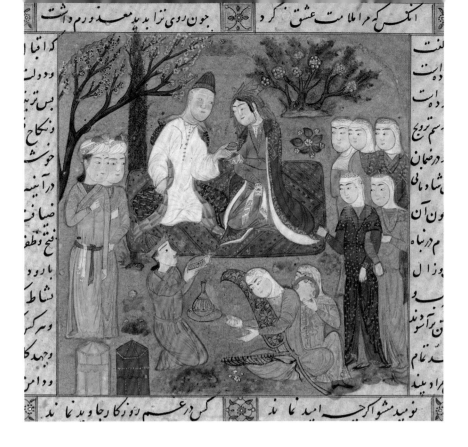

93 ZAL AND RUDABEH ENTERTAINED

British Library, Or. 11676, 46a | *Javame' al-Hekayat* ('Compendium of Tales') of 'Owfi
As re-margined 325 x 233 mm; text area 218 x 160 mm; picture 108 x 108 mm
Jumada I 843/October–November 1439 | Sultanate India (Bidar?)

This collection of stories culled from the *Shahnameh* and from Islamic
history was completed by 'Owfi for al-Joneydi, vizier to Iltotmesh,
ruler of the Delhi Sultanate (1211–36). The present passage offers a
rapid precis of the story of Zal and Rudabeh. As the couple are seated
in a garden this is not so much a reflection of Ferdowsi's narrative as
a symbol of the concept, hinted at in the accompanying verses, that
love inspired by beauty can triumph over opposition and end in
blissful union.

Losty makes the case for a Sultanate origin on the grounds of the
style of the fifteenth-century work in this manuscript, together with
the presence of some pictures in eighteenth-century Indian style
– the latter period accounts for the small illuminated elements in this
opening. The fifteenth-century style bears comparison with that of the
double *Khamseh* in the Chester Beatty Library (see no. 91). Garments
with central openings, Zal's fur-lined coat, and the shaded candles in
the lower left are from the Persian Jalayerid tradition; together with the
white wimples of the attendant ladies, this suggests that the tradition
was received by way of Yazd, rather than Shiraz. For Zal and Rudabeh
see also nos 46, 65, 81 and 98.

Bibliography: Meredith-Owens, 1965, pl. IX, and 1968, p. 46; Robinson, 1967, no. 112;
Titley, 1977, no. 94; Losty, 1982, no. 23

94 BAHMAN-ARDESHIR SWALLOWED BY A DRAGON

Detail overleaf

British Library, Or. 4615, 3b
Darabnameh of Abu Taher Mohammad b. Hoseyn al-Tarsusi | As restored 353 x 238 mm;
text area 240 x 148 mm; picture 340 x 198 (approximately) mm | *c.*1580–5
Mughal (for Akbar at Fathpur Sikri ?)

At the outset of this prose epic, Bahman, son of Esfandiyar and
known as Ardeshir, rules in Iran. He is told that a dragon has
appeared in the mountains and is causing havoc with the herds.
He goes alone to deal with the threat, and suddenly a fire-breathing
dragon emerges and swallows him. This is the only incident in which
a monster gets the better of a hero, and the suggestion has been made
that it represents the mythologised version of a political event.[61]

The present picture was produced at a significant moment in the
development of Mughal painting, when Persian, Hindu and European
streams meet, but can still be seen as distinct. Thus, Bahman is done
in the Persian manner in solid colour, his white, horror-stricken face
the central focus. The form of the dragon, though ultimately Chinese,
comes by way of the Persian tradition but the variable scale of Hindu
art permits it to be sufficiently large; while the rendering of the dragon
and of the scenery borrows from European sources new techniques at
the thinner end of watercolour – notably stippling, and the centrifugal
tendency of pigment in a drop of water. The precise date of the work
is not known, though it is to be associated with the visit in 1580 to
Akbar in Fathpur Sikri of a Jesuit mission, who brought with them
European pictures. The painting is almost certainly the work of the
celebrated Basawan, who matches skill with vision.

Bibliography: Rieu, 1895, p. 241; Tarsusi, 1965; Titley, 1977, no. 18; S.C. Welch, 1978, pl. 5;
sundry publications of other illustrations

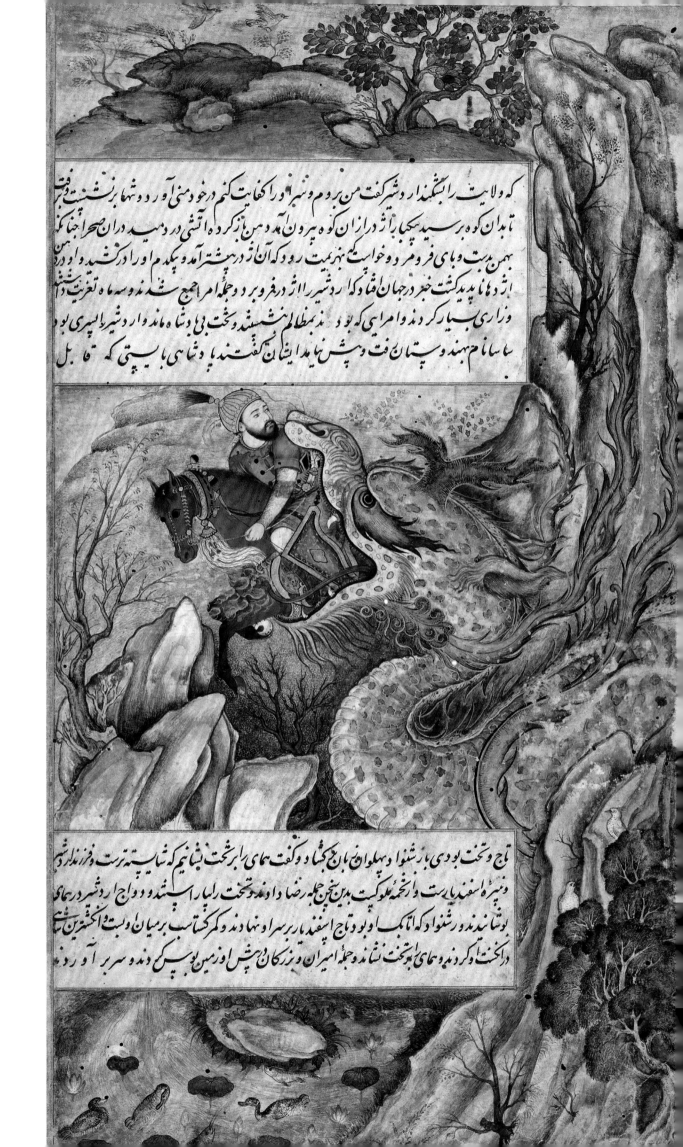

که ولایت را ایشگذار دشیر گفت من بردم و شهر او را کفایت کنم در خود منی آورد و شها برنشست و برفت
تا بدان کوه رسید و یکبار از آن کوه در از آن کوه بیرون آمد و من باز کرده آتشی در دمید در آن صحرا چنانکه
بهمن بدشت و بای فرو مرد و خواست که مهزیمت رود که آن از درپشت آمد و پیکده ام او را درکشید و او در
اژدها پدید گشت خبر در جهان افتاد که دشیر را ژدر فرو برد و جمله امرا جمع شده و سه ماه تعزیت دشیم
وزاری بسیار کردند و امرایی که بودند مظالم نشستند و تخت بی دشاه ماند و دشیر باسپری بود
با سام نام بهند و ستان رفت و پش نها ایشان گفت یا دشاهی باینی که قابل

تاج و تخت بودی باز دشنوا د و پهلوان بان بع کشادو گفت سهای بر تخت نشانیم که شایسته تخت و فرزنذل دشیم
و نیره اسفندیارست و آنکه ملوکیت بدین سخن جمله رضا دادند و تخت را باز اسپشد و تاج ار دشیر در سهای
بنشاندند و دشنوا د که اتابک او بود اسفند یار بر سر او نهاد و کمر کسانب بر میان و لبت از اکشترین شه
درخت او کرد و نیند و سهای ابو تخت نشاندند و جمله امیران و یزرکان دهش او بوسک دند و سر بر آ ورد و

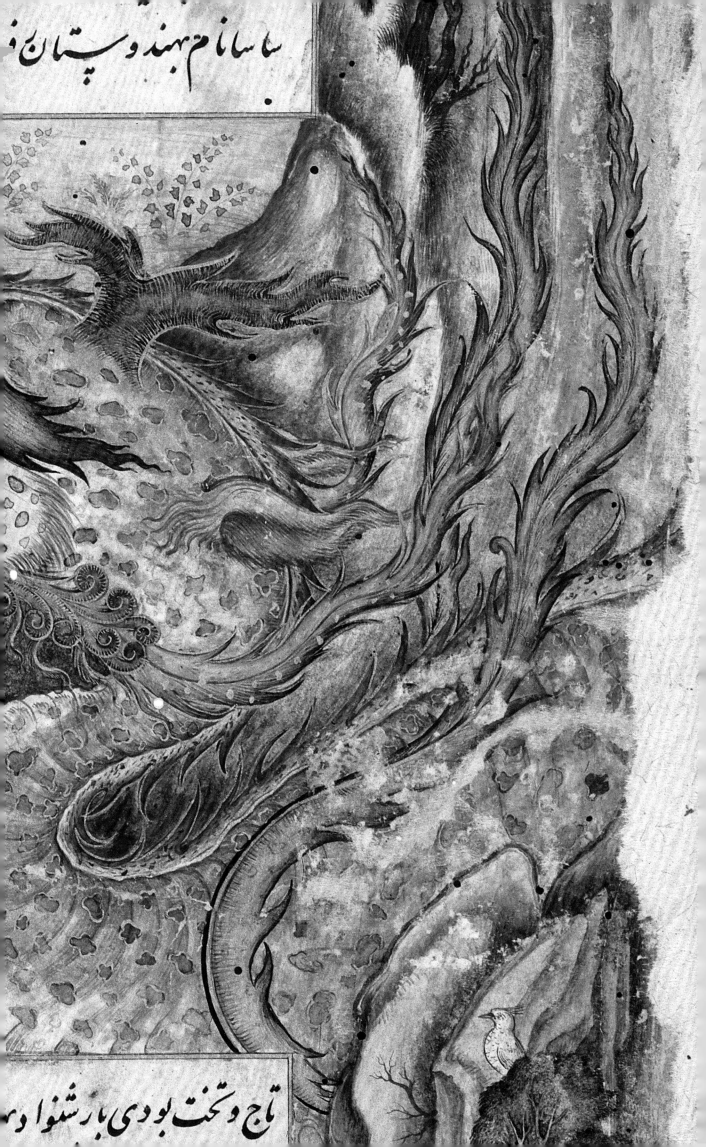

تاج و تخت بودی بار شنواده

95 ROSTAM AND RAKHSH WOUNDED IN COMBAT WITH ESFANDIYAR

Opposite

British Museum, 1920, 0917, 0.248 | Album page 380 x 276 mm; picture 290 x 195 mm
1590s, with over-painting in early seventeenth century and later | Mughal
ww, v, 230 (no text present)

The old Rostam and the young prince Esfandiyar, both proud
warriors, are at loggerheads over protocol. Their armies meet by the
Helmand River but they agree to single combat. Rostam is wounded
with many arrows and forced to abandon his horse, Rakhsh, also
wounded, while he makes for high ground. Zavareh, Rostam's
brother, offers him another horse.

The underlying painting has been seen as Safavid, though the division
of space by ranges of rock is very characteristic of Mughal painting
in the 1590s, especially when accompanied by flat areas in primrose
yellow. Here rocks divide the scene into sectors, distinguishing phases
of the action: the plight of Rakhsh and the beginnings of the revival
of Rostam's fortune. Zavareh's gesture is thrown into relief by a gap
in the rocks, while Rostam, temporarily eclipsed, almost fades into
his surroundings. Possibly from a *Shahnameh* for Akbar, the picture
has experienced considerable repainting and patching, faces perhaps
receiving attention before landscape. The narrative continues in no. 77.

Bibliography: Titley, 1977, no. 131; Rogers, 1993, pl. 48

96 TUS AND GUDARZ ENCOUNTER A MAIDEN IN THE FOREST

Overleaf

University of Manchester, John Rylands Library, OR F40 Q vol. 1, 102a,
Bequeathed by Samuel Robinson of Wilmslow, 1857 | Folio 270 x 160 mm;
text area 221 x 121 mm; picture 68 x 121 mm | 15 Muharram 1006/28 August 1597
Patron: Mirza Abu'l-Qasem Beg[62] | Scribe: Shehab-e Kateb | Sub-imperial Mughal
ww, II, 193

The paladins Tus, Giv and Gudarz have gone hunting. In the forest
they find a beautiful maiden who tells them that she has run away
from her father, who attacked her while drunk. She has lost her horse
and been robbed of her possessions, and she is weeping; she is however
related to Garsivaz, the brother of Afrasiyab, and is descended from
Faridun. Tus and Giv begin to quarrel as to who shall possess her.

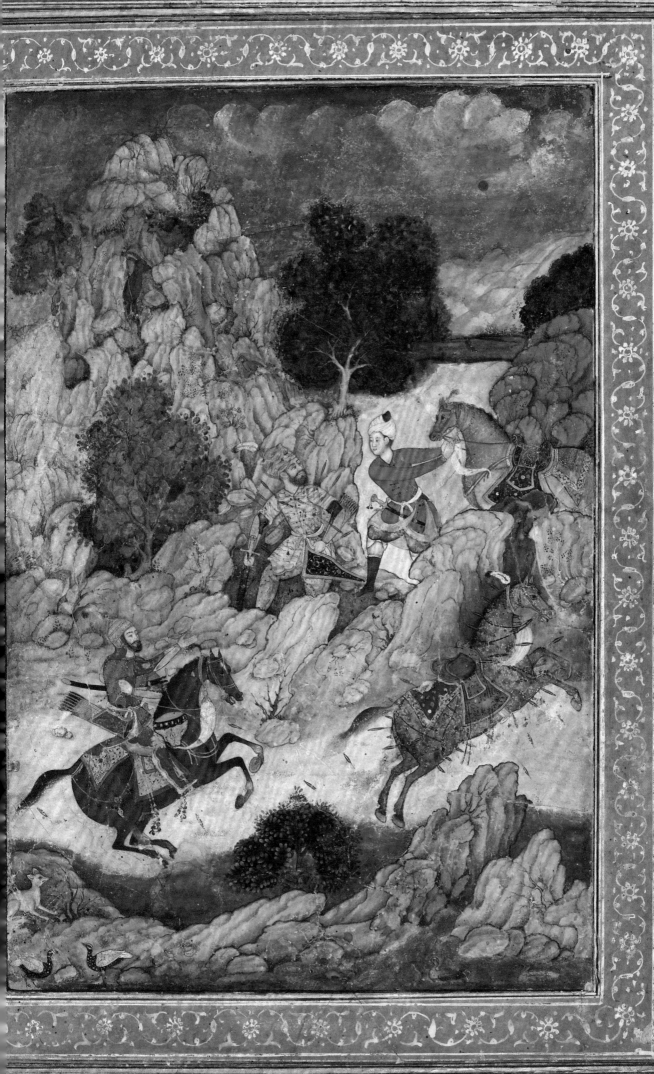

They take their quarrel to Key Kavus, who decides to have the damsel for himself. She will become the mother of Siyavosh.

The painter does not countenance the dark forest and distressed damsel, showing instead an open grove of flowering trees and the lady enthroned: it is as though these attributes were required to convey her beauty. This presentation recalls various paintings of the time of Akbar which, under European influence, show enthroned sibyls or similar. She is portrayed wearing the *chakdar jameh* with hanging points at the sides, which is more frequent in Akbar's time than later. The manuscript contains some stately illumination.

97 THE SIMORGH RESTORES ZAL TO SAM

Opposite

Royal Asiatic Society, Codrington 241, 49a
Previously in the possession of Charles Warre Malet (seal 1196/1781–2)
Presented to the RAS by Sir Alexander Warre Malet, Bt, 1830 | Folio 350 x 250 mm; text area 245 x 165 mm; picture 265 x 195 mm | Sub-imperial Mughal | *c.*1600
WW, I, 247

The Simorgh that has nurtured Zal has returned to her mountain. Sam examines Zal, and his heart is joyful as though in the highest heaven.

The moment is slightly later than that usually chosen for this sequence (nos 45 and 83). Since other pictures in the manuscript have blue skies of relative naturalism, the expanse of gold that here represents the sky but also extends below Sam's feet may be understood as a reflection of his radiant state of mind. Digby, who published the manuscript, ascribes a special intention to this picture. Noting that the headdress worn by Sam – a pyramidal cap, whose split brim is swept up and held by swathes of turban – is particularly associated with Homayun, he suggests that an allusion is intended to his recovery of his son Akbar, after the re-conquest of Kabol in 1544. Such an interpretation would account for the princely garments of the child, who is usually portrayed naked. Digby also speculates that the picture follows a model in a lost *Shahnameh* made for Akbar. The scribe has added omitted lines in the margin with reference numbers in red.

Bibliography: Digby, 1979

98 ZAL IN RUDABEH'S PAVILION

British Library, Add. 5600, 42b
Notes of Mughal ownership include reference to Jahangir
Mughal lacquer covers | As re-margined (Mughal period) 312 x 195 mm;
text area (Persian fifteenth century) 174 x 113 mm;
picture (Mughal period: sub-imperial style) 131 x 113 mm
Renovation presumed to be for: 'Abd al-Rahim, Khankhanan, c.1616
Painter: Qasem | ww, I, 272

Zal has climbed to Rudabeh's pavilion by means of his lasso. They
express their love for each other. Eventually their parents and overlord
will agree to their marriage, and they will become the parents of the
hero Rostam.

As the couple are framed in the pavilion at the side of the picture, we
see them as though from a distance, which allows a certain seclusion
to this romantic scene. The artist may have been unfamiliar with the
story and so have rendered Zal, the albino, as somewhat elderly. The
history and codicology of this manuscript is complex. The attribution
of its extensive renovation to the workshop of the Mughal courtier
'Abd al-Rahim is justified by the names of his painters on the majority
of paintings. The dating derives from a note on folio 274a that provides
the year 1025, equivalent to 1616. Though many of the illustrations
are over-painted or stuck in, the present picture appears to be painted
directly on to the paper. The folio is stiffer than the text folios near it,
as though it had experienced some special treatment, and it is also
trimmed to be a little longer. It is hard to see it as a replacement,
though this might possibly be the case. The artist Qasem is named
in the lower left. For Zal and Rudabeh, see also nos 46, 65, 81 and 93.

Bibliography: Rieu, 1881, p. 536; Titley, 1977, no. 105; Losty, 1982, no. 86;
Seyller, 1997, 293–4, and 1999, pp. 263–73

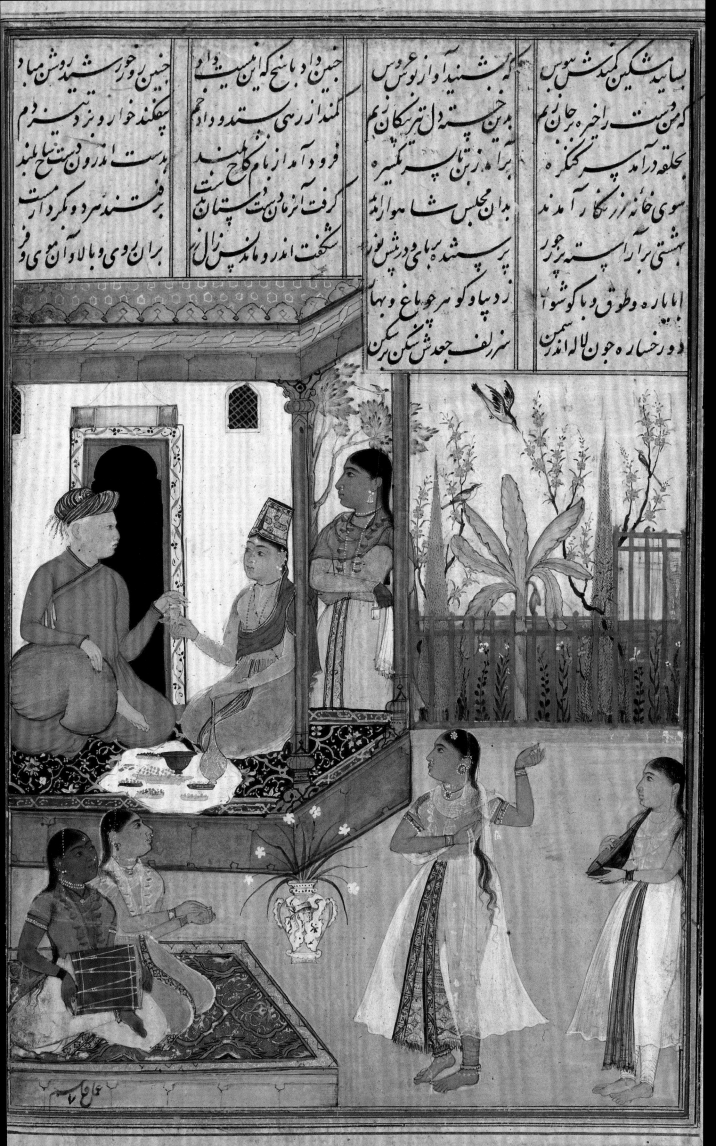

99 HAFTVAD'S DAUGHTER SPINNING

British Museum, 1993, 0510, 0.1 | Presented by Howard Hodgkin
Picture 393 x 270 mm (sections 195 x 270 mm and 191 x 270 mm)
Later seventeenth century | Mughal (Bikaner?) | ww, vi, 233 (no text present)

The story of Haftvad and the worm is introduced into the epic immediately before the account of the Sasanian period, and is probably to be understood as a myth of the arrival of silk production in Kerman.[63] It tells that girls whose families are not well-to-do meet to spin cotton. Haftvad's daughter finds a worm in an apple. Her father, taking this as a token of fortune, feeds the worm, which grows massively, as does his wealth and standing. Haftvad is able to build a city on a hill, which he names Kerman. This arouses the concern of Shah Ardeshir, who presents himself in the guise of a merchant; he offers to feed the worm and pours molten lead into its maw (see also no. 58).

It seems here that the worm is omitted. The drawing is very finely executed in ink with detail or shading in dull crimson; the central division suggests that it was at some point folded. The composition, though in mirror image, associates the drawing with a picture of the subject by Dust Mohammad for Shah Tahmasp's *Shahnameh*, as does the inscription *'Ey Dust'* ('Oh Dust', or 'Oh friend'). The drawing has been seen as the work of Dust Muhammad himself, of *c*.1555, when he was employed at the Mughal court, but this seems less than certain. The situation is complicated by the existence of another version of the composition, now in Berlin, made for Jahangir in his twelfth regnal year, or 1617–18 (fig. 22). Both the Berlin and the London pictures contain items from the original that they do not share with each other – Berlin has the foreground tree, but London has the butcher's shop – though Berlin is closer overall. A direct transmission between them is thus unlikely. Neither of the later versions uses the extensions into the margin that are an amusing feature of the original.

It seems clear that the present picture is a homage to Dust Mohammad, rather than the work of his hand. The women's fashion places it beyond his credible lifetime, since they have the corkscrew curls of Shah 'Abbas' Esfahan and their kerchiefs are tied to leave a small triangular point on the crown, a mode that begins about the last quarter of the sixteenth century. These features do not, however, mean that the picture was produced in Iran. Pointers to the Mughal sphere are the relatively denser rock, the profile of the main dome and the segmented dome on the minaret, the darkly bearded faces of the man on the mule and man with the water bag, and the paired birds near two margins. Skelton has tentatively attributed this and similar pieces to Mughal artists working in Bikaner.

Bibliography: Sotheby's, 30.4.92, lot 291; Skelton, 1994, p. 44

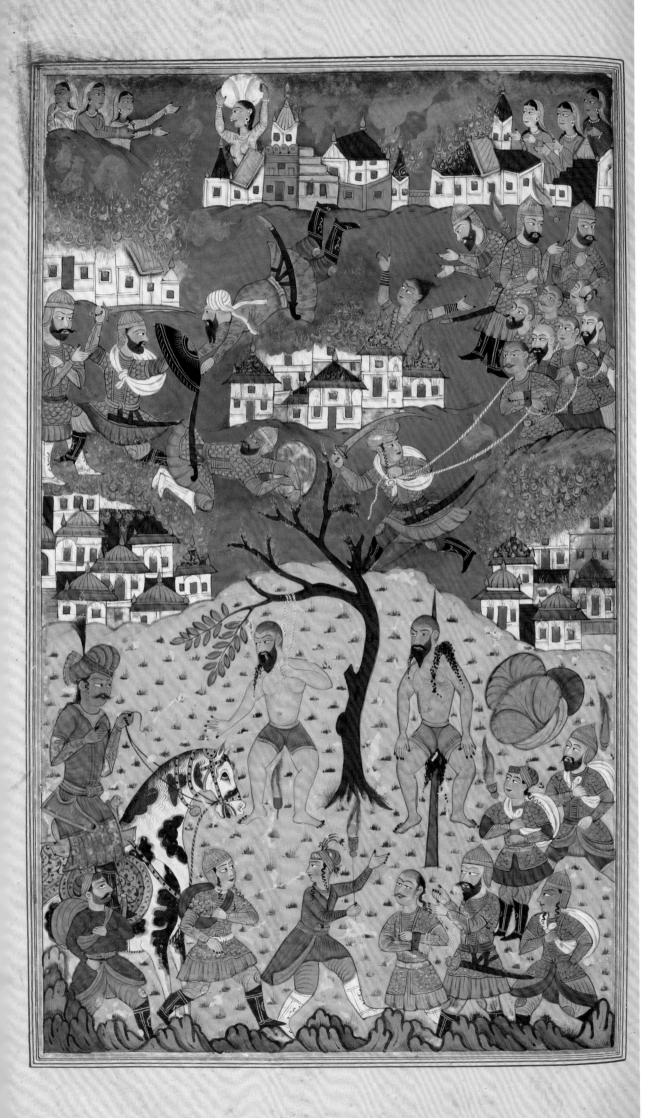

100 ESFANDIYAR WATCHES THE EXECUTION OF KOHRAM AND ANDARIMAN

British Library, Add. 18804, 47a | Second part of *Shahnameh*
Purchased from the Revd John Hooper of Rowenden Kent 13 Dec 1857
Stamped binding (with flap to right) | Folio 360 x 240 mm; text area 238 x 145 mm;
picture 288 x 176 mm | Rajab 1131/June 1719 | Rajaur (Kashmir)
Patron: Mahant Ajagat Singh Jiv, vizier to Raja 'Azamat-Allah Khan
Scribe: Khalil-Allah 'Haft Qalami' | WW, V, 158

Kohram is the son of Arjasp of Turan, and Andariman is Arjasp's brother. When Esfandiyar has slain Arjasp in the Brazen Hold (no. 55), he has a watchman proclaim his victory. Kohram and Andariman, who are outside the fortress, hurry towards it and are defeated in battle. Esfandiyar orders that they shall be executed and the cities of Turan burned. This is because an army under Kohram has killed the aged Shah Lohrasp, who had retired to a religious life in Balkh, has burned the city, killed its Zoroastrian priests, and mortally wounded Esfandiyar's brother Farshidvard.

A complex composition embraces a foreground in which Esfandiyar watches the execution of the prisoners, one hanged as the text has it and one impaled, and a background that gives a vivid account of burning, capture, and attempts to salvage belongings. It seems that the artist may have a knowledge of the effects of warfare that is not solely dependent on the *Shahnameh*. The shape of Esfandiyar's turban and the corkscrew curls of his running footman suggest some degree of Safavid influence. However, Indian tradition asserts itself in the fact that Esfandiyar is shown as larger than the other figures, and perhaps also in the more remarkable fact that his skin is shown as golden. Detailed colophons make this manuscript an important piece for the history of painting in Kashmir.

Bibliography: Rieu, 1881, pp. 538–9; Titley, 1977, no. 112, and 1983, p. 211; Losty, 1982, no. 125

101 ROSTAM BINDS THE BLACK DIV

British Museum, 1928, 1206, 0.1 | Presented by George Tabbagh
Folio 500 x 350 mm; text area 370 x 248 mm; picture 340 x 248 mm
Late eighteenth century | Late Mughal period (Mysore?)

The folio is from a successor epic that concerns the Black Div, son of the White Div. The event on this folio is modelled on the story of Rostam's combat with Akvan (no. 70), as is the composition.

This large picture shows a striking contrast in style between the bold figures, in strong and partly opaque colour, and the lightly tinted landscape, suggestive of European watercolour. The intermediate area has been treated with a light wash and may or may not be considered finished. The figure style varies from Persian norms and suggests an origin in India. There is a strong sense of the physicality of the *div*'s plump body, whose volume is to some extent indicated by hatching, though shape and outline have a larger role; also the *div* may be wearing the type of trunks often shown on strongmen or workmen in Mughal painting. Rostam's eyes are heavy-lidded in an Indian manner. Points of light in their pupils, together with the detail of his armour – ornamented vambraces, a mail of somewhat straight-edged units, the decoration of his bow case – indicate an eighteenth-century dating. It is significant that the *div*'s muzzle and the mask of Rostam's snow-leopard cap are stylised in the same manner, somewhat as though a moustache rose on either side of the nose. This is not a Persian mode and it somewhat recalls various artefacts for Tipu Sultan of Mysore (*reg.* 1782–99).[64] The manuscript is finely written on strong but slightly dull paper, and the scale of the page with its six columns of text suggests assertive patronage. Tipu Sultan's interest in the *Shahnameh* is established by the fact that he owned two of the manuscripts in the present display (nos 76 and 81): it is therefore tentatively suggested that he may have commissioned a manuscript of the successor epic represented by this folio.

Bibliography: van den Berg, forthcoming

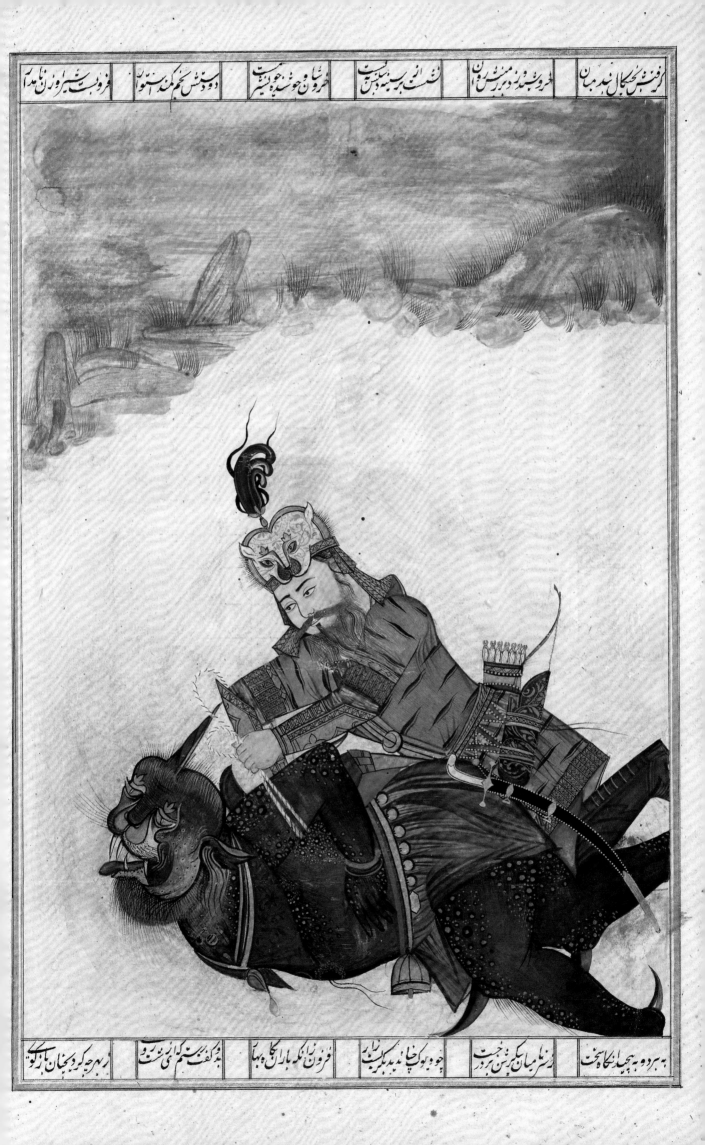

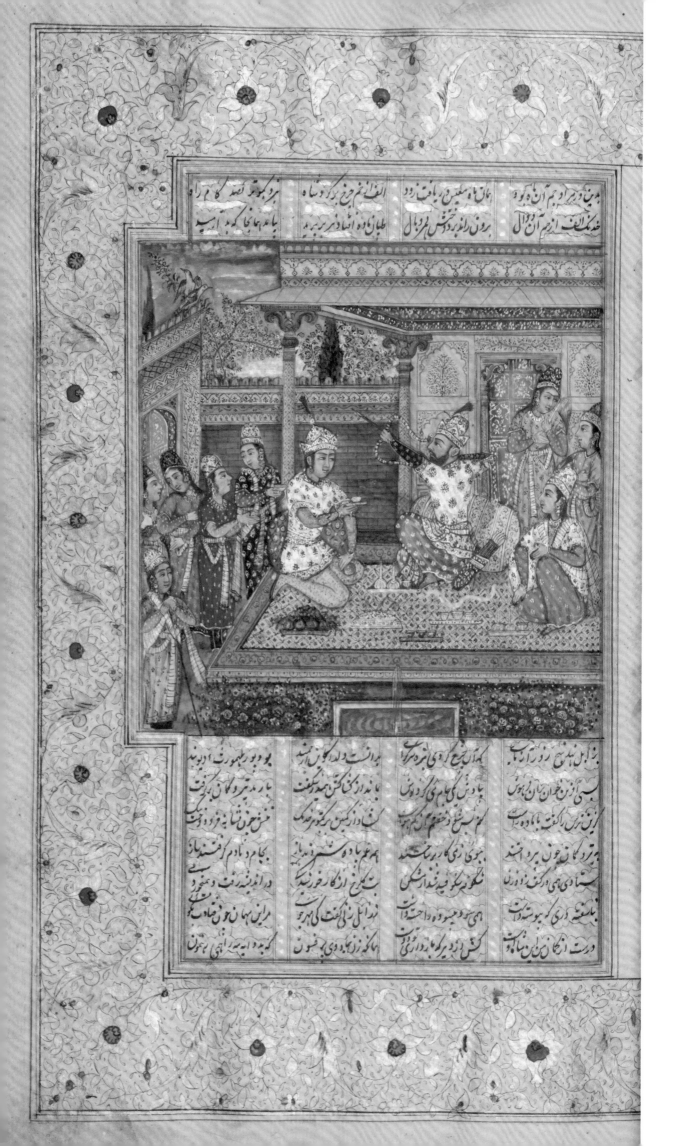

102 JAMSHID SHOOTS AT A DOVE

Nasser D. Khalili Collection of Islamic Art, MSS 145, 19a | Folio 340 x 210 mm;
text area 229 x 131 mm; picture 145 x 137 mm | Text: post 18 Sha'ban 1205/22 April 1791
Scribe of main text: Sarmast Khan | Pictures c.1810–20 | Late Mughal period (Lucknow?)
Atkinson, 11–28

As is sometimes the case, this manuscript introduces a romantic story between the end of Jamshid's rule and his demise. Jamshid has wandered to Zabol, which is ruled by Gurang, who has a beautiful daughter, who is skilled in the arts of war and for whom marriage with Jamshid has been foretold. A servant girl tells the princess that there is a weary man at the gate, and Jamshid is introduced into the court: he and the princess are immediately attracted to each other. Seeing two doves, the princess calls for her bow and announces that she will shoot one; Jamshid takes the bow from her and proposes that if he shoots the female the lady whom he most admires should be his. Jamshid's aim is true. However, Gurang considers handing him over to Zahhak, and Jamshid flees to Chin.

The artist delights in investing this scene with a light-hearted and decorative charm. The facing page follows a tradition for birds in illumination that extends back to work for Akbar in the sixteenth century. The manuscript, which has 719 folios, has two intermediate colophons. The first, at the end of the second section (392b), of the thirty-second year of a reign, of 18 Sha'ban 1205/22 April 1791; and the second, at the end of a third section (566a), of the thirty-third year, of Rabi' II/4 December [1791]. These dates fall in the reign of Shah 'Alam II, and in consequence the manuscript has been attributed to his patronage. However, while folios 566 and 569 contain wormholes, the illustrated and illuminated folios 567 and 568 between them have no holes: they are an interpolation. These folios are on a lighter, waxy paper, as are the illuminated folios at the beginning of each section, the margins, the beginning and end of the text[65] and all the pictures. The latter should thus be seen as datable some twenty to thirty years after the text.

Bibliography: Leach, 1998, no. 43

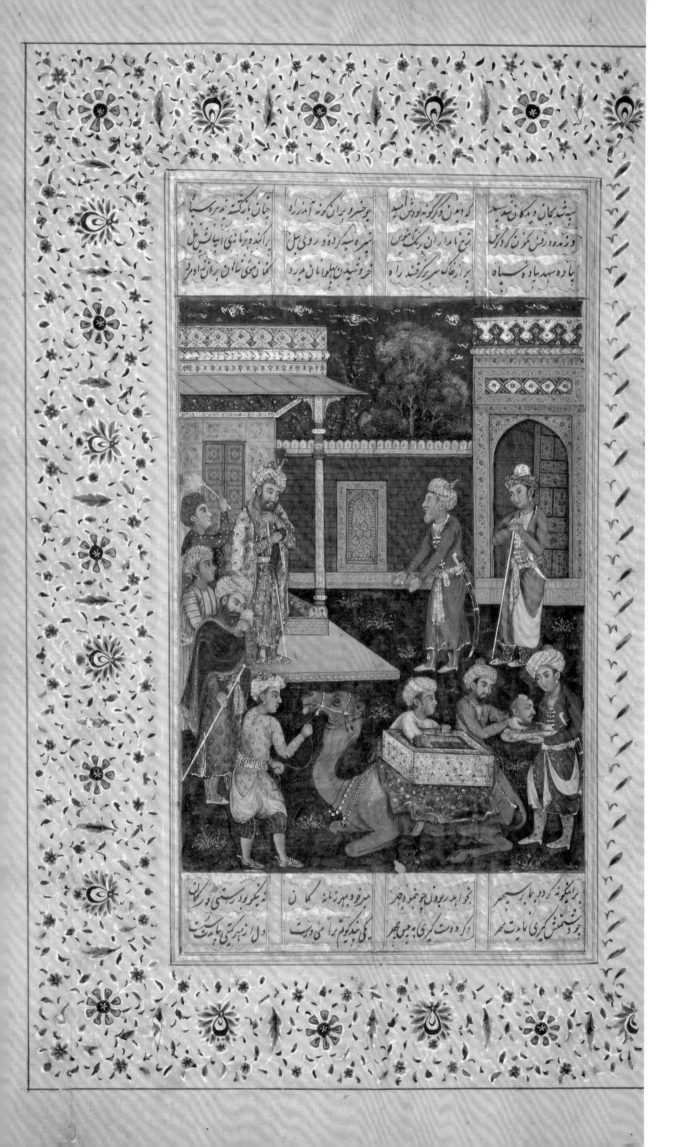

103 THE HEAD OF IRAJ BROUGHT TO FARIDUN

Nasser D. Khalili Collection of Islamic Art, MSS 145, C.47a | Folio 340 x 210 mm;
picture 170 x 130 mm | From the preceding manuscript | Pictures *c.*1810–20
Late Mughal period (Lucknow?) | WW, I, 203

Faridun has prepared to celebrate the return of Iraj, but from the
dusty road comes a camel rider who bears a golden casket containing
the prince's head. His death is hardly believed until the casket is
opened in proof. Attendant warriors begin to mourn. Faridun
cries out, and himself carries the head into Iraj's garden (no. 5).

From the manuscript MSS 145, this picture contrasts markedly with
the gaiety of the previous exhibit. The artist slightly adapts the
scene since he shows Faridun in a garden and not out on the road
in a welcoming party; nevertheless, he gives a detailed and feeling
interpretation of the subject. In the foreground, the couched camel
still bears the golden casket, and an attendant gently lifts the head
on to a dish, one respectful hand supporting the severed neck. In the
middle ground, the messenger, who was scarcely believed, asserts the
truth of his account with a blend of urgency and restraint, while to
the left Faridun, grandly dressed and properly attended, assimilates
the terrible news in silence. It seems that Faridun's handkerchief has
turned black in his hand, and a man in a dark shawl weeps. There
is overall a sombre tonality, though night is not intended.

Bibliography: Leach, 1998, no. 43

104 KEY KAVUS AIRBORNE

Nasser D. Khalili Collection of Islamic Art, MSS 723 | Album page 286 x 180 mm;
picture 190 x 111 mm | First quarter nineteenth century | Late Mughal (Lahore or Delhi?)
WW, II, 103 (no text present)

The subject is as no. 42. It is probable that this picture came from
a manuscript, since the astrologers whom Key Kavus consulted are
included. Indeed, the astrologers almost dominate the scene, as though
they were of our world and Key Kavus were departing into legend.
The picture has been published as of the seventeenth century; however,
the combination of careful shading and rather soft attack may be
compared with that in pictures added to the Kevorkian Album in the
early nineteenth century.[66] This dating is supported by the straight-cut,
long-sleeved coat worn over the shoulders by two attendants. Known
as the *chupan*,[67] this coat is characteristic of the nineteenth century
– and indeed persists in Afghanistan to the present day. It appears
that the picture has been set into a margin paper of the sixteenth
century, adjustments being made by the numerous rulings.

Bibliography: Maddison and Savage-Smith, 1997, pp. 126–7

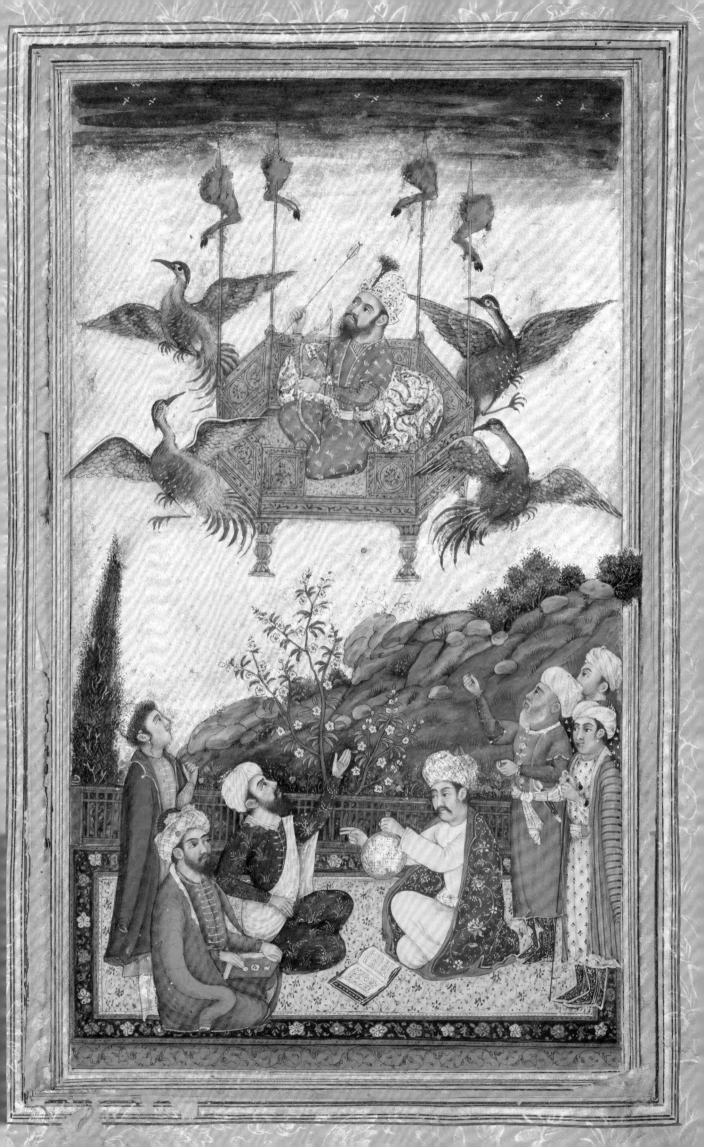

CHARACTERS AND CREATURES IN THE 'SHAHNAMEH'

- *Afrasiyab*: Ruler of Turan, after many battles eventually executed by Key Khosrow.
- *Akvan*: A *div* who in the form of an onager has plagued the horse herds of Key Khosrow. He is pursued by Rostam; catching Rostam asleep he is able to throw him into the sea, but is eventually slain by him.
- *Alexander the Great*: see *Eskandar*
- *Andariman*: Brother of Arjasp of Turan, he commands a wing of the Turanian army; he is hanged upside down by Esfandiyar.
- *Anushirvan (Nushirvan)*: The Sasanian ruler Khosrow I (531–79), often referred to as Nushirvan 'the Just' owing to his reforming measures and the attention paid to his wise counsellor, Bozorjmehr.
- *Ardeshir*: see *Bahman*
- *Arzhang*: A *div* encountered and slain by Rostam, the Sixth Peril that he accomplishes on the way to Mazandaran to rescue Key Kavus.
- *Arjasp*: Ruler of Turan who defeats Goshtasp of Iran and carries off his daughters; slain by Esfandiyar.
- *Ashkabus*: A hero of Turan shot by Rostam.
- *Azadeh*: A slave girl from Rum, skilled with the harp; taken hunting by Bahram Gur, who in anger throws her from his camel.

- *Bahman*: Son of Esfandiyar, he tries to kill Rostam with a boulder; later rules with the name of Ardeshir; in the *Darabnameh* he is swallowed by a dragon.
- *Bahram Chubineh*: An Iranian lord of the Sasanian period, brave but wilful; is made commander of the forces of Hormozd IV (579–90) and defeats Saveh Shah; rebels and usurps kingship; takes refuge in Chin, where he is murdered.
- *Bahram Gur*: The Sasanian ruler Bahram V (421–39), the sobriquet 'Gur' referring to his love of hunting the wild ass; brought up in Arabia, where the episode with Azadeh takes place; he achieves the throne of Iran and thereafter is the subject of numerous tales.
- *Barman*: Turanian hero slain by Qaran.
- *Bizhan*: Iranian hero, son of Giv; victor in many combats, he is also known as the lover of Manizheh and in consequence is thrown into a pit, from which he is rescued by Rostam.

- *Eblis*: Devil by an Arabic name.
- *Esfandiyar*: Son of Goshtasp of Iran, with whom he has an uneasy relationship; rescues his sisters from Arjasp; antagonism develops between him and Rostam, by whom he is slain.
- *Eskandar (Sekandar)*: (Alexander the Great, 356–323 BC) seen as the son of Darab of Iran and the daughter of Filaqus; refuses tribute to Darab's son Dara and conquers Iran, defeats Fur (Porus) of Hind,

visits Mecca, is received by Queen Qeydafeh; during further travels
he seeks in vain for the Water of Life in the Land of Darkness,
finds the Talking Tree and is warned of his approaching death.

- **Fariborz**: Son of Key Kavus, who, though having attempted to
 claim the throne, supports Key Khosrow in his rule.
- **Faridun**: Born of the lineage of the Pishdadian shahs of Iran in
 the time of the usurper Zahhak, Faridun is brought up in secret
 in the care of a cowherd and fed the milk of the cow, Barmayeh;
 having overthrown Zahhak, he comes to rule and eventually divides
 his kingdom between his sons, Salm receiving Rum, Tur Turan
 and Iraj Iran; when Salm and Tur murder Iraj, Faridun receives his
 head with great sorrow; Faridun sends Iraj's grandson, Manuchehr,
 to punish Salm and Tur, and makes him his successor.
- **Farshidvard**: Turanian hero, and brother of Piran and Lahhak;
 when joint commanders of the army of Turan, Farshidvard and
 Lahhak find themselves obliged to retreat; they are pursued by
 Gostaham, who kills first Farshidvard and then his brother.
- **Filaqus**: (Philip of Macedon, father of Alexander the Great) seen
 as Eskandar's maternal grandfather.
- **Forud**: The son of Siyavosh by Jarireh, the daughter of Afrasiyab's
 chief counsellor, Piran; killed when the army of Iran passes near
 his castle.

- **Garsivaz**: Brother of Afrasiyab of Turan, and grandfather of
 Key Khosrow; eventually executed with Afrasiyab.
- **Goshtasp**: Son of Lohrasp; at odds with his father, he journeys to
 Rum, where he marries a daughter of the Qeysar (Caesar); returned
 to Iran and crowned by his father, he fosters the Zoroastrian faith;
 disagreements with his son, Esfandiyar, lead to the latter's death.
- **Gudarz**: Iranian hero and father of Giv; active from the time of
 Key Kavus, he is faithful to the last instructions of Key Khosrow,
 and is last mentioned hailing the accession of Goshtasp.

- **Haftvad**: Becomes guardian of a worm that his daughter finds
 in an apple; killed by Ardeshir at the start of his reign.

- **Iraj**: The youngest son of Faridun, he is granted the territory of
 Iran and Arabia; is murdered by his brothers Salm and Tur.

- **Jamshid**: Son of Tahmuras of the Pishdadian dynasty, he institutes
 various crafts and also a caste system; his throne is carried through
 the air by *divs*; his pride meets its fall when he is overthrown by the
 Arab Zahhak; an extended version of the narrative sees a doomed
 romance with the daughter of Gurang of Zabol.

- **Kaveh**: A blacksmith, he protests when the brains of his children
 are to be fed to the serpents on the shoulders of Zahhak, the usurper,
 and he refuses to join his army; bearing his leather apron as a banner
 he joins Faridun and accompanies him in the overthrow of Zahhak.

- **Key Kavus**: Son of Key Qobad, shah of Iran, is tempted early in his reign to invade Mazandaran, where he is blinded and held prisoner until rescued by Rostam; returned to Iran, his projects include the attempt to fly in a throne powered by eagles; he marries both Sudabeh, daughter of the king of Hamavaran, and the daughter of Garsivaz, brother of Afrasiyab; he presides over the fire ordeal of Siyavosh, son of the second wife, when Sudabeh accuses him of trying to violate her; later in his reign he receives Farangis, widow of Siyavosh back to Iran, and enthrones her son, Key Khosrow, as his successor.
- **Key Khosrow**: Son of Siyavosh, born in Turan after his father's murder; with his mother is guided across the Jihun (Oxus) to Iran by Giv; a valiant and wise king, he continues the struggle against Afrasiyab; at length he resigns his kingdom to Lohrasp, and disappears mysteriously by a mountain spring.
- **Key Qobad**: Founder of the Keyan dynasty.
- **Khezr**: A prophet who accompanies Eskandar in his search for the Water of Life and is privileged to find it.
- **Khosrow Parviz**: The Sasanian Khosrow II (590–682), obliged to contest the throne of Iran with Bahram Chubineh; a hero of the *Khamseh* of Nezami.
- **Kiyumars**: First ruler of Iran, founder of the Pishdadian dynasty, he incurs the envy of Ahriman, the devil.
- **Kohram**: Brother of Arjasp of Iran, executed by Esfandiyar.

- **Lahhak**: Hero of Turan, killed after his brother Farshidvard by Gostaham.
- **Lohrasp**: Shah of Iran from a collateral branch of the Keyan dynasty; his reign is seen as beginning of the second part of the *Shahnameh*.

- **Manizheh**: Daughter of Afrasiyab, encounters and falls in love with Bizhan; supports Bizhan when he is imprisoned in a pit, and guides Rostam to the pit to rescue him; returns with Bizhan to Iran.
- **Manuchehr**: Grandson of Iraj, avenges the murder of his grandfather on his great-uncles, Salm and Tur; enthroned by his great-grandfather Faridun.
- **Mehran Setad**: A wise courtier sent by Anushirvan to select a bride for him from the daughters of the Khan of Chin.

- **Nastihan**: A Turanian hero.

- **Owlad**: Subject of Rostam's Fifth Challenge on the way to Mazandaran, he is taken prisoner and made to guide Rostam to the White Div.

- **Piran**: Cousin and upright counsellor of Afrasiyab.
- **Piruz**: Sasanian ruler (459–84); drought occurs in his reign.

- **Qaran**: Iranian hero, son of Kaveh; as commander of Nowzar's army, he defeats and slays Barman.

- **Qeydafeh**: (Queen Candace of Meroë, Nubia) after diplomatic exchanges she is visited by Eskandar posing as his own ambassador, but she recognises him from a portrait she has had made.
- **Qeysar**: Caesar (ruler at an undetermined period of 'Rum', Rome or Byzantium) has three daughters. Goshtasp, who has travelled to Rum because he cannot agree with his father, wins two daughters for lords of Rum and then the third for himself.

- **Rakhsh**: Rostam's steed, he has a coat, speckled as though with roses; selected for his exceptional strength, he displays great courage in defending Rostam from the attacks of dragon and lion; wounded in Rostam's combat with Esfandiyar, he is cured by the Simorgh; he dies with Rostam in the pit planned by Shaghad.
- **Rostam**: Son of Zal, the Iranian national hero; after his Caesarean birth in the time of Manuchehr, an image of him is sent to his grandfather Sam; at an early age he slays a mad elephant, thereafter he serves a succession of shahs of Iran by his martial prowess, his exploits including the Seven Perils that he faces to rescue Key Kavus in Mazandaran; he also experiences individual adventures, his meeting with Tahmineh leading to the birth of Sohrab, whom he eventually kills inadvertently; in the days of Goshtasp, Rostam comes into conflict with Esfandiyar in consequence of their mutual stubbornness, and he kills him; Rostam is mortally injured in a pit full of spears, as planned by his half-brother Shaghad, but before he expires he induces Shaghad to bend his bow; Rostam shoots Shaghad through the tree behind which he is hiding.
- **Rudabeh**: Daughter of Mehrab, king of Kabol, she marries Zal, and becomes the mother of Rostam.

- **Sa'd b. Waqqas**: An (historical) Arab general, sent by the caliph 'Umar to invade Iran.
- **Salm**: The eldest son of Faridun, he receives Rum (the Roman territories) when his father divides his lands.
- **Sam**: Son of Nariman, father of Zal and grandfather of Rostam, and the ruler of Zabol under the overlordship of the shahs of Iran; when his son is born an albino, Sam has him exposed on Mt Alborz, but following a dream he is able to receive him back from the Simorgh, who has nurtured him along with her own chicks.
- **Saveh Shah**: A Turkish ruler who threatens Iran in the time of Hormozd IV (579–90), but is defeated and killed by Bahram Chubineh.
- **Shaghad**: Son of Zal by a slave girl and hence half-brother to Rostam; brought up in Kabol, he plots with its ruler to compass the death of Rostam in a pit full of spears; though the scheme succeeds, he is shot by Rostam while watching behind a tree.
- **Shu'ba Mughira**: The elderly envoy sent to the Iranians by Sa'd b. Waqqas.
- **Simorgh**: Legendary bird that protects the family to which Rostam belongs, notably in the preservation of Zal; the assistance for Rudabeh after the birth of Rostam, and the cure of Rostam's

wounds in the course of his struggle with Esfandiyar.

- *Siyavosh*: Son of Key Kavus, rejects the advances of his step-mother Sudabeh, but faces ordeal by fire to disprove false allegations by her; chooses exile in Turan where he marries Jarireh, daughter of Piran, fathering Forud, and Farangis, daughter of Afrasiyab, fathering Key Khosrow; his murder at the instigation of Garsivaz is a potent cause of enmity between Iran and Turan.
- *Sohrab*: Son of Rostam by Tahmineh, and a champion of Turan; unwittingly killed by his father, to whom his identity is revealed by a token he gave to Tahmineh.
- *Sorush*: An angel who guides kings and heroes; at one juncture he rescues Khosrow Parviz.

- *Tahmineh*: Daughter of the ruler of Samangan, she approaches Rostam when he spends the night in her father's castle, in search of his horse; she becomes the mother of Sohrab.
- *Tur*: The middle son of Faridun, he receives Turan (Transoxiana, Turkestan) when his father divides his lands.
- *Tus*: Son of the Pishdadian Nowzar, he is in command of the army of Iran that passes close by Forud's castle, giving rise to hostilities that end in the prince's death.

- *White Div*: The White Div blinds Key Kavus, when the latter is plundering Mazandaran; Rostam finds and slays the White Div as his Seventh Peril in order to extract his liver to cure the king's blindness.

- *Yazdegerd*: The Sasanian Yazdegerd III (633–51), the last shah in the *Shahnameh*; when defeated by the advancing Arab armies, he flees eastwards and is betrayed when hiding in a watermill near Merv.

- *Zahhak*: An Arab who, tempted to ambition by the devil Eblis and having received serpents on his shoulders from the kiss of Eblis, seizes the throne of Iran from the Pishdadian Jamshid; he is defeated and fettered to Mt Damavand by Faridun.
- *Zal*: Son of Sam, as an albino he is exposed to die in infancy, but is preserved by the Simorgh; he is returned to Sam; fascinated by what he hears of the daughter of Mehrab of Kabol, he throws his lasso to mount to her balcony; eventually marrying Rudabeh he becomes the father of Rostam, with whom he continues to fight for Iran.
- *Zarasp*: Son of Tus, killed by Forud, son of Siyavosh.
- *Zavareh*: Brother of Rostam, he supports him and offers him a horse during his struggle with Esfandiyar; like Rostam, he dies in a pit planned by Shaghad.

GLOSSARY

- **Beyt (bait)**: Two rhyming hemistichs of verse forming a complete unit of sense, equivalent to a couplet.
- **Chakdar jameh**: A gown worn by men or women in late Sultanate or early Mughal India, whose wide skirts are embellished on either side with two or three hanging points of fabric.
- **Dehqan**: A minor landowner; Ferdowsi himself belonged to the class, which is understood to have been an enduring repository of Zoroastrian tradition into the Islamic period.
- **Div**: A demon, from *daeva* in the Zoroastrian cosmology; a vision of a *div* develops in Persian manuscript illustration from the fourteenth century onwards, usually monster-headed and wearing a skirt.
- **Divan**: A collection of poems.
- **Farr**: The manifestation of the divinity of kingship, sometimes conveyed as a physical radiance.
- **Kateb (katib)**: A scribe.
- **Karg**: As 'rhino-wolf', a chimerical monster found in *Shahnameh* illustrations in consequence of the fact that words for rhinoceros (*karg*) and wolf (*gurg*) can appear similar in Arabic script.
- **Mina'i**: 'Enamel', a technique of decoration for luxury ceramics of the late twelfth century onwards, in which the possible range of colours was extended by applying some pigments under the glaze and some over it to accommodate differing firing temperatures.
- **Naskhi**: 'Copyists' script', a clear script much used for Arabic material or Persian prose, whose use in Persian verse after around 1400 is thus worthy of remark.
- **Nasta'liq**: A script developed about 1400, notionally from a combination of the *naskhi* and *ta'liq* scripts, frequently used for Persian verse; the letter *sin* is often extended into a diagonal curve that sweeps down from the right.
- **Nisbeh (nisba)**: An appellation added to a name, it often refers to a person's place of origin, sometimes to their field of work or some other characteristic.
- **'Onvan**: A heading; in the discussion of Islamic manuscript illumination an ornamental band at the top of an initial page, which may or may not identify what is to follow.
- **Reqa' (riqa')**: A small script with unusual ligatures, used especially for colophons or subheadings, its name conveying the idea of a small piece.
- **Sarlowh**: A richly illuminated page at the beginning of a manuscript or section of a manuscript.
- **Shamseh**: 'Little sun' a rosette of illumination, usually placed at the beginning of a manuscript, where it is frequently used for an ex libris.
- **Sols (thulth)**: A curvaceous script with some unusual ligatures, often used in tilework.
- **Waqwaq (normally in this transliteration)**: In the discussion of Islamic decoration the term is used of trees or scrollwork inhabited by human or animal heads.

ILLUSTRATED 'SHAHNAMEH' MANUSCRIPTS AND SINGLE FOLIOS IN BRITISH COLLECTIONS

There are many illustrated copies and single folios of the *Shahnameh* in collections throughout the UK. The following is a handlist of those found in the main public collections and University Libraries. It does not include private collections, or manuscripts of other verse epics (translations or abridgements of the *Shahnameh*, the *Garshaspnameh*, etc.). The list no doubt remains incomplete but is intended as a guide to the current state of information available.

The entries under each location are listed in chronological order, with those of uncertain date identified by century. Where the place of origin is deduced from style and not confirmed by a colophon it is given in brackets. Names of patrons, calligraphers and painters are given when known. Further details can be found on the Shahnama Project website at: http://shahnama.caret.cam.ac.uk.

BIRMINGHAM

Special Collections, University of Birmingham

Mingana Persian 9 | Mid-seventeenth century (Astarabad) | 441 folios; 72 illustrations

CAMBRIDGE

Ancient India and Iran Trust

PERS 2.01 BD | 23 Dhu'l-Qa'da 1012/23 April 1604 (Samarqand) | 485 folios; 27 illustrations | Scribe: Adineh Kateb Samarqandi

Fitzwilliam Museum

MS 22-1948 | *c.*1435 (Shiraz) | 34 folios; 25 illustrations

MS 21-1948 | *c.*1540 (Shiraz) | 2 folios; 2 illustrations

PD 3451 | *c.*1570 (Shiraz) | 1 folio; 1 illustration

MS 311 | 1030/1621 (Astarabad?) | 440 folios; 68 illustrations

Persian Painting 3453 (Box H) | Sixteenth century (Shiraz) | 1 folio; 1 illustration

University Library

Or. 420 | 841/1437 (Shiraz) | 281 folios; 11 illustrations

Or. 1356 (10) | Dhu'l-Hijja 972/July 1562 (India) | 281 folios; 12 illustrations (nineteenth century)

Add. 269 | *c.*1580 (Qazvin/Mashhad) 559 folios; 13 illustrations

Corpus Or. 202 | 15 Rabi' II, 1053/2 July 1643 (Shiraz) | 338 folios; 12 illustrations | Scribe: Hajji Mohammad b. Nur al-Din Mohammad Dasht-e Bayazi; painter: Azfal al-Hoseyni and one other

LONDON

British Library

Or. 14548 | Early fourteenth century (Shiraz) | 1 folio; 1 illustration

Add. 27261 | 29 Jumada II, 814/26 October 1411 (Shiraz) | Miscellany | 307 folios; 2 Shahnameh illustrations | Patron: Eskandar Soltan b. 'Omar Sheykh; scribes: Mohammad al-Halva'i and Naser al-Kateb

Or. 4384 | *c.*1430 (Herat?) | 307 folios; 9 illustrations

Or. 1403 | 11 Ramadan 841/17 March 1438 (Sultanate India, Gulbarga?) | 513 folios; 92 illustrations | Scribe: Feyz b. Mohammad Shirazi?

Or. 12688 | 11 Muharram 850/16 April

1446, Mazandaran | 734 folios; 89 illustrations | Scribe: Fath-Allah b. Ahmad Sabzavari

I.O. Islamic 119 | Mid-fifteenth century (Shiraz) | 554 folios; 4 illustrations (c.1550–75)

Add. 18188 | 23 Jumada II, 891/4 July 1486 (Shiraz) | 500 folios, 72 illustrations | Scribe: Ghiyas al-Din b. Bayazid *Sarraf*

Or. 13859 | 1490s (Transoxiana) | 429 folios; 28 illustrations and 1 blank space

Or. 14403 | 910/1504 (Bokhara?) | 547 folios; 36 illustrations

Add. 15531 | Dhu'l-Hijja 942/June 1536 (Tabriz) | 543 folios; 48 illustrations

I.O. Islamic 133. 18 Dhu'l-Qa'da 967/20 August 1560 (Shiraz) | 538 folios; 23 illustrations | Scribe: Hasan b. Mohammad Ahsan

Or. 12084–12086 | Rabi' I, 972/October 1564 (Astarabad) | 3 vols, I: 200 folios; 16 illustrations; II: 171 folios; 16 illustrations; III: 171 folios; 4 illustrations

I.O. Islamic 741–742 | c.1580 (Shiraz) | 2 vols, I: 668 folios; 10 illustrations; II: 668 folios; 5 illustrations | Scribe: Hedayat-Allah Shirazi

Add. 27302 | 994/1586 (Qazvin) | 621 folios; 52 illustrations | Scribe: Zeyn al-'Abedin al-Kateb

I.O. Islamic 3254 | c.1590 (Qazvin/Esfahan) 371 folios; 52 illustrations

I.O. Islamic 3540 | c.1590 (Shiraz) | 569 folios; 59 illustrations | Painters: Zeyn al-'Abedin and another

Or. 4906 | c.1590 and later (Iran) | 642 folios; 38 illustrations

Add. 27257 | 1590–5 (Shiraz) | 540 folios; 55 illustrations

I.O. Islamic 301 | 10 Sha'ban 1008/24 February 1600 (Samarqand) | 375 folios; 24 illustrations | Scribe: Adineh al-Bukhari

I.O. Islamic 966 | 1 Ramadan 1012/1 February 1604 (Esfahan) | 523 folios; 63 illustrations | Scribe: al-Mozahheb Mortazaqoli Chavushlu

Add. 7724 | Rabi' I, 1021/May 1612 (Esfahan) | 471 folios; 10 illustrations Scribe: Mohammad Mo'men b. Kamal al-Din

I.O. Islamic 3265 | Dhu'l-Hijja 1022/January 1614 (Astarabad) | 610 folios; 41 illustrations Scribe: 'Alijan b. Heydarqoli al-Haravi

Add. 16761 | 14 Dhu'l-Qa'da 1023/16 December 1614 (Esfahan) | 525 folios;

40 illustrations | Scribe: Ebn Hoseyn Mohammad-Zaman Khatunabadi

Add. 5600 | Fifteenth century (Iran); renovated 1025/1616, Mughal India 586 folios; 90 illustrations | Painters: Banwari, Bhagwati, Bula, Dhanu, Kamal, Qasem, Shamal

Add. 27258 | Ramadan 1037/May 1628 (Esfahan) | 660 folios; 64 illustrations Scribe: Nezam b. Mir 'Ali

I.O. Islamic 1256 | 1630–40 (Esfahan) 622 folios; 28 illustrations

Or. 11842 | Early seventeenth century (Mughal India) | 573 folios; 14 illustrations

Add. 6609 | Seventeenth century (Mughal India) | 611 folios; 5 illustrations Patron: Awaz Beg Soleymani; scribe: Heydar Mohammad Tabrizi

I.O. Islamic 3263 | Late seventeenth century (Esfahan) | 456 folios; 23 illustrations

Add. 6610 | Late seventeenth century (Mughal India) | 311 folios; 47 illustrations

Add. 18804 | Rajab 1131/June 1719 (Kashmir, Rajaur) | 358 folios; 97 illustrations | Patron: Mahant Ajagat Singh Jiv; scribe: Khalil-Allah 'Haft-qalami'

Or. 12483 | c.1820 (Mughal India) 597 folios; 30 illustrations

Or. 2926 | 7 Safar 1246/28 July 1830 (Shiraz) | 349 folios; 9 illustrations

Or. 2976 | 1 Jumada I, 1252/13 August 1836 (Shiraz); vol. 2 of previous MS | 275 folios; 9 illustrations

British Museum
The British Museum's collection consists almost entirely of detached folios, each with a separate accession number, but several of which are from the same manuscript; these have been grouped together in the present list. Note: adjustment for electronic search has caused some changes to the presentation of numbers on the British Museum website.

1948,12-11,020 to 022 | c.1295–1300 (Baghdad?); 'Second small Shahnama' 3 folios, 3 illustrations

1925,2-20,01, 1933,9-29,02. 741/1341 or later, Fars | 2 folios; 2 illustrations | Patron: Qavam al-Dowleh Hasan

1948,12-11,025. c.1335 (Tabriz)

1923,1-15,01. c.1390 (Shiraz)

1948,10-9,048 to 052. c.1435–40 (Shiraz); from same MS as Fitzwilliam 22-1948 | 5 folios; 5 illustrations

1948,12-11,04 | Second quarter fifteenth century (Sultanate India)

1992,5-7,01 | 899/1493–4, Lahijan

1948,12-11,023 | c.1510 (Tabriz)

1975,5-23,02 to 05 | 1560–70 (Tabriz/
Mashhad?) | 4 folios; 4 illustrations

2006,042,01 | c.1570

1930,0607,0.10 | c.1576–7 (Qazvin)

1937,7-10,0327 | c.1580 (Qazvin)

1948,10-9,055 | c.1590 (Shiraz)

1920,9-17,0248 | c.1590 and later
(Mughal India)

1948,12-11,07 | c.1590 (Qazvin)

1922,7-11,02 | Ramadan 1059/September–
October 1649 (Esfahan) | Painter: Mo'in
Mosavver

1920,9-17,0207 | Sixteenth and eighteenth
centuries (Mughal India)

1974,0617,0.17.85 | Seventeenth-century
picture (Esfahan) in late Mughal album

1928,12-6,01 | Late eighteenth century
(India, Mysore?)

1993,0510,0.1 | Seventeenth century (Mughal)

1921,10-11,01 | Second quarter seventeenth
century (Mughal)

1925,0430,0.2 | Second quarter seventeenth
century (Esfahan?)

1993,0510,0.1 | Seventeenth century,
picture in two parts (India, Bikaner?)

1920,9-17.052 | Late seventeenth century
(Deccan?)

1920,9-17,0328 | Late seventeenth century
(Deccan?)

1998,7,21,2 | Eighteenth century (Kashmir)
346 folios; 32 illustrations

1920,9-17,0328 | Eighteenth century (Iran)

1920,9-17,062 | Eighteenth century (Rajput)

1943,10-9,02 | c.1820 (Qajar)

1880,0,2380 | Nineteenth century (Mughal)

Royal Asiatic Society

MS 239 | c.1444 (Herat) | 536 folios;
31 illustrations (one being double page)
Patron: Mohammad Juki b. Shah Rokh

Codrington 241 | Early seventeenth century
(Mughal) | 746 folios; 13 illustrations

School of Oriental and African Studies

MS. 25294 | 912/1506 (Central Asia?,
seventeenth-century paintings) | 542 folios;
20 illustrations

MS. 24949 | Eighteenth century (Kashmir)
646 folios; 79 illustrations

MS. 24948 | Nineteenth century (Kashmir)
310 folios; 22 illustrations

MS. 21381 | Nineteenth century (Central
Asia?) | 352 folios; 17 illustrations

Wellcome Library

A. WMS Per | Seventeenth century (Iran)
115 folios; 28 illustrations

Icc3008 | Nineteenth century (India) | 1 folio;
1 illustration

C.WMS Per 257 | Nineteenth century
2 folios; 2 blank spaces

16 loose folios of paintings of the Shahnameh,
*seemingly all derived from the same
manuscript* | Nineteenth century (Iran)

MANCHESTER

**University of Manchester,
John Rylands Library**

Ryl Pers 9 | Mid-fifteenth century (Shiraz/
Yazd/Western India) | 702 folios; 55
illustrations (including blanks; Sultanate
India)

Ryl Pers 910 | 6 Jumada 1, 924 (?)/26 May
1518 (Tabriz) | 564 folios; 101 illustrations

Ryl Pers 932 | Muharram 949/May 1542
(Shiraz) | 604 folios; 41 illustrations

Ryl Pers 8 | Mid-sixteenth century (Shiraz)
581 folios; 19 illustrations

Ryl Pers 933 | Sixteenth century (Qazvin/
Mashhad) | 266 folios; 79 illustrations

OR F40 Q | 15 Muharram 1006/28 August
1597 (Iran/Mughal India) | 2 vols, I: 273
folios; 7 illustrations (Mughal India); II:
284 folios; 8 illustrations | Patron: Mirza
Abu'l-Qasem Beg; scribe: Shehab-e Kateb

Ryl Pers 909 | 23 Jumada II, 1060/22 June
1650 (Esfahan) | 493 folios; 99 illustrations
Scribe: Yusof b. Mahmud Shah b. Yusof

Ryl Pers 869 | 28 Ramadan 1247/29
February 1832 (India) | 522 folios;
86 illustrations

Ryl Pers 525 | Nineteenth century (India)
717 folios; 76 illustrations

OXFORD

All Souls College

MS 288. 26 Safar 988/21 April 1580
(Baghdad/Istanbul) | 487 folios;
21 illustrations

MS 289. Eighteenth century (India)
209 folios; 49 illustrations

Bodleian Library

Ouseley Add. 176 | *c.*1425–30 (Shiraz)
468 folios; 51 illustrations | Patron:
Ebrahim Soltan b. Shah Rokh; gilder:
Nasr al-Soltani

Pers.C.4 | 4 Sha'ban 852/11 October 1448
(Southern Iran/Tabriz?) | 539 folios;
1 illustration | Scribe: 'Abd-Allah
b. Sha'ban b. Heydar al-Ashtarjani

Elliott 325 | 14 Ramadan 899/27 June 1494
(Shiraz) | 627 folios; 56 illustrations

Ouseley 369 | 10 Rabi' II, 959/14 April 1552
(Shiraz) | 602 folios; 24 illustrations
Scribes: Ahmad b. Hasan b. Ahmad Kateb
and Pir Hoseyn Kateb

Dep.b.5 | Sixteenth century (Shiraz)
507 folios; 24 illustrations

Ouseley 344 | 1010/1601 (Shiraz) | 580 folios;
41 illustrations

Whinfield 1 | Eighteenth century? (India)
545 folios; 40 illustrations

Indian Institute Pers. 32 | Early nineteenth
century (India) | 604 folios; 75 paintings

Fraser 60 | nineteenth century? (India)
628 folios; 1 illustration and 43 blank spaces

Bodl. Or. 716 | eighteenth–nineteenth
century (Kashmir) | 653 folios; 113
illustrations

ST ANDREWS

University Library

MS 28 (0) | 1014/1605 (Iran) | 551 folios;
30 illustrations (of later date, in India)

WINDSOR

Windsor Castle

RCIN 1005013 (A/5) | *c.*1585 (Qazvin)
283 folios; 88 illustrations

RCIN 1005014 (A/6) | Rabi' II, 1058/May 1648
(Esfahan) | 756 folios; 148 illustrations
Patron: Qarajaghay Khan; scribe:
Mohammad Hakim al-Hoseyni; painters:
Mohammad Yusof and Mohammad Qasem

LENDERS TO THE EXHIBITION

Royal Collection, The Royal Library, Windsor Castle

Manuscript volumes:
- RCIN 1005013, *Shahnameh.* 194b, The dying Esfandiyar watched by Rostam and Zal
- RCIN 1005014, *Shahnameh.* 498a, Eskandar shown his portrait

Keir Collection

Manuscript volumes:
- III.133-75, *Shahnameh.* 284a, Esfandiyar slays two *kargs*

Single folios:
- III.2. Tahmineh comes to Rostam
- III.4. Tahmineh comes to Rostam
- III.202. Tahmineh comes to Rostam
- III.295. Bizhan chides father for failing to defeat Forud
- III.227. Rostam slays the White Div Sotheby's, 5.4.06, lot 44. Rostam slays the *div* Akvan

Ceramics:
- 73.5.42. Rostam comes to Bizhan's pit

Nasser D. Khalili Collection

Manuscript volumes:
- MSS 145, *Shahnameh.* 19a Jamshid shoots at a dove
- MSS 713, *Shahnameh.* 437b, Ardeshir executes Haftvad

Single folios:
- MSS 145 C. 47a, The head of Iraj brought to Faridun
- MSS 459. Drought in the reign of Piruz
- MSS 669. 1. Gostaham slays Lahhak; 2. Gostaham slays Farshidvard
- MSS 723. Key Kavus airborne
- MSS 838. Sorush rescues Khosrow Parviz
- MSS 1031. Mehran Setad selects a bride for Anushirvan
- MSS 1070r. The Simorgh restores Zal to Sam

Ceramics:
- POT 875. Fragmentary bowl with *mina'i* decoration
- POT 1563. Lustre bowl

Objects:
- MTW 289. Saddle (1185/1771–2)

Private Collection

- Five single folios
- Ceramic bowl with *mina'i* decoration

Bodleian Library, University of Oxford

Folios from manuscript volume of Shahnameh, Ouseley Add. 176:
- 12a, Illuminated *shamseh*
- 17a, Illuminated *sarlowh*
- 30a, Zahhak pinned to Mt Damavand
- 68b, Rostam slays a dragon
- 73a, The King of Mazandaran turns into a rock
- 92a, Sohrab slain by Rostam
- 156b, Rostam shoots Ashkabus
- 238a, Illuminated *sarlowh*
- 272b Rostam deflects a rock
- 311b Eskandar contemplates the Talking Tree

Manuscript volumes:
- MS Elliott 325, *Shahnameh.* 396b, Eskandar seeks the Water of Life

British Library, London

Manuscript volumes:
- Add. 5600, *Shahnameh.* 42b, Zal in Rudabeh's pavilion
- Add. 15531, *Shahnameh.* 12a, Ship of Shi'ism (942/1536)
- Add. 18188, *Shahnameh.* 55b, Faridun mourns over the head of Iraj (891/1486)
- Add. 18804, *Shahnameh.* 47a, Esfandiyar watches execution of Kohram and Andariman (1131/1719)
- Add. 27257, *Shahnameh.* 305b, The Simorgh heals Rakhsh
- Add. 27258, *Shahnameh.* 257b, Rostam rescues Bizhan from the pit
- I.O. Islamic, 133, *Shahnameh.* 5b, Ferdowsi encounters the court poets of Ghazni (967/1560)
- I.O. Islamic 1256, *Shahnameh.* 42b, Rudabeh lets down her hair
- Or. 11676, *Javame' al-Hekayat of 'Owfi.* 46a, Zal and Rudaba entertained (843/1439)
- Or. 12688, *Shahnameh.* 1, fol. 22a, Zahhak enthroned (850/1446)
- Or. 12985, *Garshaspnameh of Asadi.* 4b, Garshasp battles with *sagsars* (981/1573)

Single folios:
- I.O. Islamic 741, *Shahnameh.* 1, 326a, Key Khosrow crosses Lake Zareh
- Or. 4615, *Darabnameh of Abu Tahir Tarsusi,* 3b, Bahman-Ardeshir swallowed by a dragon

British Museum, London

Single folios:
- 1920,0917.0.248. Rostam and Rakhh wounded in combat with Esfandiyar

- 1922,0711.0.2. Sohrab slain by Rostam (1059/1649)
- 1925,0430.0.2. Goshtasp or Bahram Gur slays a *karg*
- 1928,1206.0.1. Rostam binds the Black Div
- 1948,1009.0.49. Manuchehr slays Salm
- 1948,1009.0.55. The punishment of Afrasiyab and Garsivaz
- 1948,1211.0.20. The infant Faridun entrusted to a cowherd
- 1948,1211.0.21. Gudarz slays Piran
- 1948,1211.0.22. Esfandiyar lassoes Gorgsar
- 1948,1211.0.25. The dying Rostam shoots Shaghad
- 1975,0523.0.2. The young Rostam kills the mad elephant
- 1975,0523.0.3. Rakhsh kills a lion
- 1992,0507.0.1. Fariborz presents prisoners to Key Khosrow (899/1493–4)
- 1993,0510.0.1. Haftvad's daughter spinning

Ceramics:
- 1878 12-30 573 (1). Frieze tile from Takht-e Soleyman
- G. 1983.314. Siyavosh plays polo against Afrasiyab

Cambridge University Library

Manuscript volumes:
- MS Add. 269, *Shahnameh.* 19a, The court of Kiyumars

Corpus Christi College, Cambridge

Manuscript volumes:
- MS Or. 202, *Shahnameh.* 252a, Bahram Chubineh kills Saveh Shah

Edinburgh University Library

Folios from manuscript fragment of Jami' al-Tawarikh of Rashid al-Din, MS Or. 20:
- 6b, Manuchehr enthroned with Rostam in attendance
- 12b, Lohrasp enthroned with scribes in attendance
- 15b, The dying Rostam shoots Shaghad
- 19a, Eskandar enters the Land of Darkness

Fitzwilliam Museum, Cambridge

Manuscript volumes:
- MS 311, *Shahnameh.* 82b, Fire ordeal of Siyavosh

Manuscript fragment:
- MS 21-1948. 1b–2a, Lohrasp enthroned

Folios from a single manuscript, MS 22-1948:
- 11b, Jamshid's throne borne by *divs*
- 12b, Faridun crosses Tigris to challenge Zahhak

- 18b, Eskandar visits the Ka'ba
- 22b, Rostam lifts Afrasiyab of Turan by the belt
- 25b, Key Kavus airborne

Single folio:
- PD 3451, Zal shoots a water-fowl

John Rylands Library, University of Manchester

Manuscript volumes:
- Persian MS 9, *Shahnameh.* 115b, Fire ordeal of Siyavosh
- Persian MS 933, *Shahnameh.* 37a, Tahmineh comes to Rostam
- OR F40 Q vol. I, *Shahnameh.* 102a, Tus and Gudarz encounter a maiden in the forest

Royal Asiatic Society of Great Britain and Ireland, London

Manuscript volumes:
- Persian MS 178, *'Aja'eb al-Makhluqat* of Qazvini in anonymous Persian translation. 283a, Rostam lifts an adversary on his spear
- Persian MS 241, *Shahnameh.* 49a, The Simorgh restores Zal to Sam

Folios from manuscript volume of Shahnameh, Persian MS 239:
- 7a, Ferdowsi encounters the court poets of Ghazni
- 16b, The Simorgh restores Zal to Sam
- 30b, Portrait of the infant Rostam shown to Sam
- 44a, Rostam slays the White div
- 56b, Tahmineh comes to Rostam
- 76a, Fire ordeal of Seyavosh
- 119b, Farud shoots Zarasp
- 165b, The *div* Akvan lifts the sleeping Rostam
- 180a, Rostam rescues Bizhan from the pit
- 243a, The paladins in the snow
- 244b, Illuminated *'onvan*
- 250b, Goshtasp slays the dragon
- 278a, Esfandiyar slays Arjasp in the Brazen Hold

Victoria & Albert Museum, London

Ceramics:
- Inv. 559-1888. Table top: circular composition centred on 'Rostam shoots Ashkabus'

Metalwork:
- Inv. 760-1889. Inlaid basin by Turanshah

Wellcome Institute Library, London

Single folios:
- QCC2664.13. Second battle of Key Khosrow and Afrasiyab

PICTURE CREDITS

ENDNOTES

Foreword
1 Translation, Dick Davis.

Preface
1 Browne, 1906, pp. 142–3; Levy, 1967, p. xix; Davis, 2007.
2 See: http://shahnama.caret.cam.ac.uk. The rendering of Persian names and words
 in English can be made according to many different academic transcription systems;
 Ferdowsi is spelled Firdausi in the Shahnama Project.
3 Hillenbrand, 2004; Melville, 2006 (Studies); Melville and van den Berg, forthcoming 2010.

The *Shahnameh* in historical context
1 For a recent discussion of these points, see articles by Yarshater, 2009, Kennedy, 2009
 and Bosworth, 2009.
2 A highly debated point; see Hintze, 2009 for a recent summary of the situation.
3 E.g. Yarshater, 1983 (World-view), pp. 343–6; Hintze, 1994 and Humbach and Ichaporia,
 1998 for a translation.
4 See for this, e.g. Yarshater, 1983 (National History), pp. 370–83; Shahbazi, 1991,
 pp. 108–18; Robinson, 2002.
5 Amanat, 2006.
6 Pourshariati, 2008, pp. 14–15, 459–62.
7 Davis, 2006.
8 Pourshariati, 2008.
9 Minorsky, 1964 (Preface); Shahbazi, 1991, pp. 27–33, 71–5, 94; Pourshariati, 2008, p. 463.
10 Minorsky, 1964 (Persia), p. 245; Avery, 2007, pp. 260–322.
11 Bosworth, 2009; Kennedy, 2009.
12 Shahbazi, 1991, pp. 78–88; Meisami, 1999, pp. 41–4.
13 See Abdullaeva, this volume, pp. 19–20.
14 Most of them collected by Riyahi, 1993.
15 Khaleghi-Motlagh, 2008.
16 Davis, 2001.
17 Joveyni, tr. Boyle, 1958.
18 *Ibid.*, p. 95, quoting *Shahnameh*, cf. ed. Mohl, II, 1842, p. 146.
19 *Ibid.*, p. 203, quoting *Shahnameh*, cf. ed. Mohl, I, 1838, p. 112.
20 See Hillenbrand, 1996.
21 Shani, 2006.
22 Uluç, 2006.
23 See Brend, 2010, and her essay in this volume.
24 Melville, forthcoming.
25 Soudavar, 1996.

The *Shahnameh* in Persian literary history
1 Depending on the manuscript, it varies between 40,000 and 80,000 *beyts* (double verses).
2 Lazard, 1964; see also de Blois, 2004, pp. 44–51; Huyse and Fouchécour, 2006,
 pp. 410–32.
3 It is believed that only about 2,000 *beyts* out of more than 100,000 of Rudaki's literary
 heritage have survived (Bertels, 1960, pp. 139–40; Braginsky, 1989, p. 8). However, some
 scholars believed that Rudaki's *Divan* (collected poetic works) contained 1,300,000 *beyts*
 (Nafisi, 1955, p. 420).
4 A struggle between non-Arabs (mostly Persian) and Arabs over the cultural orientation
 of Islamic civilisation, involving also issues of social precedence (Bosworth, 1998, p. 717;
 Enderwitz, 1997, pp. 513–16; Norris, 1990, pp. 31–47).
5 Hanaway, 1988, p. 102.
6 A special genre of public *Shahnameh* recitations can be traced back to this tradition.
7 Most probably the image of Siyavosh/Siyavakhsh ('Black horse rider', Avest. Syavaršan
 'the one with a black horse') originated in the ancient Khorezm. It is obviously associated
 with the mythological cycles of the 'dying' and 'reviving' gods, like Osiris-Attis-Adonis,
 symbolising the annual resurrection of nature and widespread in Egypt, Babylon and
 Greece (Ferdowsi, *Shahnameh*, 1994, II, p. 574).
8 Rosen, 1895, pp. 182–3; also Yarshater, 1983 (National History), pp. 359–66; Davis, 1996.
9 Barthold [1915], p. 279.
10 Medieval sources offer differing views as to the size of Daqiqi's unfinished *Shahnameh*:
 from 1,000 *beyts* entered and acknowledged by Ferdowsi (the only part saved from oblivion)

to 3,000 *beyts* in Hamdallah Mostowfi Qazvini (Qazvini, 1910, p. 818) and 20,000 in 'Owfi ('Owfi, 1903–6, vol. II, p. 33); Bertels, 1960, p. 195.

The *Shahnameh* as world literature
1 Khaleghi-Motlagh, 1993, pp. 275–342.
2 Bahar, 1998, pp. 27–8, 236–7.

The tradition of illustration
1 Marshak, 2002. The 'Rostam Cycle' is now in the State Hermitage, St Petersburg.
2 Simpson, 1981 and 1985; Schmitz, 1994; Atıl, 1999; Sims, 2002, no. 135.
3 The closest comparison is with the *Varqeh va Golshah* manuscript of c.1250 (H.841, Topkapı Sarayı Kütüphanesi). Melikian-Chirvani, 1970; Çağman and Tanındı, 1986, nos 21–4.
4 31.494, Museum of Fine Arts, Boston. Pinder-Wilson, 1957, no. 22; Sims, 2002, no. 3.
5 Simpson, 1979.
6 Soudavar, 1996.
7 Melikian-Chirvani, 1991, 95–6, figs 13–15, identifies the picture as such and notes the tile inscription. The point in the narrative is ww, II, 409; another possibility might be 'Eskandar begged for help concerning the Yajuj' (Warner and Warner, 2000, VI, 164).
8 H.674, Topkapı Sarayı Kütüphanesi. Gray *et al.*, 1979, p. 98; Carboni, 2002, fig. 263 (with mistaken number). F
9 Swietochowski and Carboni, 1994.
10 H.1511, Topkapı Sarayı Kütüphanesi. Gray *et al.*, 1979, p. 121.
11 Arberry *et al.*, 1959, I, no. 114; Titley, 1977, no. 99; Wright, 2004.
12 Add. 27261, British Libary, has one *Shahnameh* illustration; H.796, Topkapı Sarayı Kütüphanesi, which should also be credited to Eskandar's workshop, also has one.
13 S.C. Welch, 1985, no. 75; Goswamy, 1988; Brend, 1986.
14 Atıl, 1984, pp. 163–9.
15 Manuscript came into Ottoman hands as a gift, probably in 1568 in acknowledgement of the accession of Selim II in 1566 (Dickson and Welch, 1981, pp. 270–1), though a later occasion is possible. A large portion was returned to the Museum of Contemporary Arts, Tehran, in 1994 in exchange for a painting by de Kooning.
16 Rührdanz, 1991; Kwiatkowski, 2005.
17 Titley, 1981, no. 58.
18 Arberry *et al.*, 1962, III, no. 277.
19 Robinson, Sims and Bayani, 2007.
20 Sims, 2001.
21 Robinson, 1976 (Keir), v.6.

The *Shahnameh* in art
1 Warner and Warner, 1905–25.
3 Gray *et al.*, 1979, pl. 13, British Library, Or. 12856.
4 Lowry, 1988, no. 40; Lowry and Beach, 1988, no. 235.
5 Uluç, 2006, p. 436, H.749, Topkapı Sarayı Müzesi, in which she notes traits of Khorasan.
6 Gray *et al.*, pl. XXXIX.
7 He is first introduced in the *Shahnameh* wearing a leopard skin (ww, I, 119).
8 Melville, 2002, fig. 49; Masuya, 2002, figs. 111 and 112.
9 Masuya, 2002, p. 102, referring to the historian Ebn Bibi.
10 I thank Manijeh Bayani for directing me to the position of these lines and for discussing their meaning.
11 Melikian-Chirvani, 1991, 83. Translation here based on the reading of Manijeh Bayani.
12 Masuya, 2002, fig. 108; Rosser-Owen, 2006, pp. 86–7.
13 13/1963, The David Collection, Copenhagen (Masuya, 2002, fig. 113).
14 Arberry *et al.*, 1959, no. 104.
15 Simpson, 1979, pp. 272–340, favours a dating of c.1300. Recent studies of Il-Khanid art may suggest a slightly earlier moment.
16 Bussagli, 1963, p. 107.
17 Fehérvári, 1973, p. 122, 672/1274 and 677/1278.
18 Weapons, for example, the knife at the birth of Rostam, are sometimes described as *ab-gun*, or 'water-coloured'.
19 Ettinghausen, 1962, p. 77; Hillenbrand, 2000, p. 138, pl. 6; Rice and Gray, 1976, nos 2, 11 and 14.
20 Haldane, 1978, plates 24 and 29, Add. 22114, British Library; Beckwith, 1970, pl. 234.
21 Simpson, 1979, p. 364, gap 33.
22 I thank Charles Melville for supplying me with a copy of his article of 1984 on droughts and famines, in which, p. 130, a drought is noted in 698/1299; and for the further information that Mirkhwand records famine in 699 in Egypt, Iran and Iraq.

23 Simpson, 1979, p. 368, gap 47.
24 Gray, 1978; A. Welch, 1985, pp. 48–52; Blair, 1995; Khalili, 2005, pp. 65–6. This fragment, dated 714/1314–15, was formerly owned by the Royal Asiatic Society and is now MSS 727 in the Nasser D. Khalili Collection. This and the Edinburgh fragment are now usually considered to be from one manuscript (Blair, 1995, Appendix II).
25 Work undertaken by Helen Loveday.
26 Komaroff and Carboni, 2002, fig. 202.
27 Waley and Titley, 1975.
28 Abdullaeva and Melville, 2008, p. 26. Translation slightly adapted.
29 Richard, 2001; Abdullaeva and Melville, 2008, p. 54.
30 Grube, 1976, no. 142.
31 Grabar and Blair, 1980, pl. 38.
32 Brend, 2010, p. 39.
33 See no. 56.
34 Çağman and Tanındı, 2002; Brend, 2003, p. 113.
35 British Library, Or. 2780, 163b. Barrett [1952], pl. 10; Stchoukine, 1954, pl. xv.
36 Lowry, 1988, nos 17–23, and Lowry and Beach, 1988, nos 104–11, publish several extracted folios, including one not in 'Big Head' style. Dispersed folios appear to come from the first volume.
37 M-287/27109, Institute of Manuscripts, Baku (Brend, 2003, pp. 115–19).
38 Tall cap round which turban is wound, which at the time indicates adherence to Twelver shi'i belief.
39 1948, 12-11.023, British Museum. See fig. 12.
40 I thank Marcus Fraser for directing my attention to this.
41 S.C. Welch, 1972, pp. 121, 160 and 93.
42 Bayani, 1964, III–IV, pp. 895–96; Minorsky, 1959, p. 75, a possible son in Herat.
43 MS 55, (former) Prince of Wales Museum, Mumbai (Simpson, 1997, p. 182).
44 A. Welch, 1976, pp. 17–40.
45 *Ibid.*, pp. 41–99.
46 Some eighty years earlier a ship of European character appears in Topkapı Sarayı Kütüphanesi, H.801, 315a (Brend, 2003, pl. 54).
47 Vol. II: 668a, IOI. 742.
48 Or. 12084-86, British Library, dated 972/1565 (Robinson, 1967, nos 182 and 184).
49 Dorn 333, National Library of Russia.
50 Rieu, 1881, p. 537 supplies Mir 'Ali, which is not now legible.
51 Robinson, 1972; Farhad, 1990, n. 10.
52 Schroeder, 1942, nos XXVII and XXVIII; Grube, 1962, no. 113; Robinson, 1976 (Colnaghi), no. 55; Farhad, 1990, pl. 1.
53 Farhad, 1990, note 10.v does not give the source for the date 1077/1666–7.
54 'Qeydafeh' renders the usual form of the name; the version given in this text appears to be 'Qeydhafeh' or 'Qeyzafeh'.
55 Ir. M.91, Collection of Princess Catherine Aga Khan.
56 Based on the reading by Manijeh Bayani (Alexander, 1992, p. 230).
57 Brend, 1991, fig. 106.
58 Inv. 560-1888 and 561-1888. These are not signed but evidently of the same hand.
59 Brend, 2003, pp. 78–9.
60 Also owned by Nathaniel Bland (Robinson, 1980, p. 97).
61 'Darabnameh' in *Encyclopaedia Iranica*.
62 The patron might be Abu'l-Qasem Gilani, whom Jahangir mentions in 1619 as having been in the Mughal world for a considerable time after being blinded and exiled by Shah 'Abbas (Rogers and Beveridge, 1909–14, II, p. 69).
63 The name Kerman can be understood as referring to worms.
64 *Tigers round the Throne*, pp. 60, 81.
65 ff. 1–25 and ff. 715–18.
66 For example, S.C. Welch *et al.*, 1987, nos 79–83, 85–92, 94 and 96–100.
67 I thank Jennifer Scarce for the name. Compare 'General Jean-François Allard and his family', painted Lahore, 1838 (S.C. Welch, 1985, no. 278).

BIBLIOGRAPHY

ABDULLAEVA 2006 | Abdullaeva, Firuza. 'Divine, human and demonic: iconographic flexibility in the context of a depiction of Rustam and Ashkabus.' In *Shahnama Studies*, I, ed. C. Melville. Cambridge, 2006: pp. 203–18.

— forthcoming | Abdullaeva, Firuza. 'Kingly flight: Nimrūd, Kay Kāvūs, Alexander, or why the angel has the fish.' *Persica*, 23 (2009–10): 1–29.

— and MELVILLE 2008 | Abdullaeva, Firuza and Charles Melville. *The Persian Book of Kings: Ibrahim Sultan's Shahnama*. Oxford, 2008.

ADAMOVA and GIUZALIAN 1985 | Adamova, A.T. and L.T. Giuzalian. *Miniatury rukopisi poemu "Shakhnname", 1330 goda* (Miniatures of the manuscript of the Shāhnāmah dated 1330). Leningrad, 1985.

ALEXANDER 1992 | Alexander, David. *The Arts of War: Arms and Armour 7th to 19th Centuries*, The Nasser D. Khalili Collection of Islamic Arts, XXI. London and Oxford, 1992.

'ALI YAZDI 2007 | 'Ali Yazdi, Sharaf al-Din. *Manzumat* ('Poems'), ed. Iraj Afshar. Tehran, 1386/2007.

AMANAT 2006 | Amanat, Abbas. 'Divided patrimony, tree of power, and fruit of vengeance: political paradigms and Iranian self-image in the story of Faridun in the *Shahnama*.' In *Shahnama Studies*, I, ed. C. Melville. Cambridge, 2006: pp. 49–70.

ARBERRY *et al.* 1959 | Arberry, A.J., M. Minovi, E. Blochet and J.V.S. Wilkinson. *The Chester Beatty Library: A Catalogue of the Persian Manuscripts and Miniatures*: I. Dublin, 1959

— *et al.* 1962 | Arberry, A.J., B.W. Robinson, E. Blochet and J.V.S. Wilkinson. *The Chester Beatty Library: A Catalogue of the Persian Manuscripts and Miniatures*: III. Dublin, 1962.

ASADI 1926 and 1951 | Asadi Tusi, Abu Mansur 'Ali Ahmad. *Le livre de Gerchâsp poème persan d'Asadî junior de Toûs*, tr. Clément Huart and Henri Massé. Paris, 1926 and 1951.

ATIL 1984 | Atıl, Esin. 'Mamluk painting in the late fifteenth century.' *Muqarnas*, 2 (1984): 159–71.

— 1999 | Atıl, Esin. 'The Freer bowl and the legacy of the *Shahname*.' *Damaszener Mitteilungen* 11 (1999): 7–12.

ATKINSON 1886 and 1989 | Atkinson, James. *The Shāh Nāmeh of the Persian Poet Firdausí. Translated and Abridged in Prose and Verse*, ed. Revd J.A. Atkinson. 1886. Reprint, Tehran, 1989.

AULD 2004 | Auld, Sylvia. 'Characters out of context: the case of a bowl in the Victoria and Albert Museum.' In *Shahnama: the Visual Language of the Persian Book of Kings*, ed. R. Hillenbrand. Aldershot, 2004: pp. 99–116.

— 2007 | Auld, Sylvia. 'Another look at the waq-waq: Arabesques and talking heads.' In J.-L. Bacqué-Grammont, M. Bernardini and L. Berardi, *L'Arbre anthropogène du waqwaq, les femmes-fruits et les îles des femmes*. Naples, 2007: pp. 139–70.

AVERY 2007 | Avery, Peter. *The Spirit of Iran: A History of Achievement from Adversity*. Costa Mesa, 2007.

BAHAR 1998 | Bahar, Mehrdad. *Az ostureh ta tarikh*. Tehran, 1376/1998.

BARRETT [1952] | Barrett, Douglas. *Persian Painting of the Fourteenth Century*. London, [1952].

BARTHOLD [1915] | Barthold, V.V. *On the History of Persian Epics*. Petrograd, [1915] (in Russian).

BAYANI | Bayani, Manijeh *see* GRUBE, 1994; ROBINSON, SIMS and BAYANI, 2007.

BAYANI 1964 | Bayani, Mehdi. *Ahval-e Asar-e Kh^woshnevisan*. Tehran, 1343/1964.

BEACH | Beach, Milo Cleveland see LOWRY and BEACH 1988.

BECKWITH 1970 | Beckwith, John. *Early Christian and Byzantine Art*. Harmondsworth, 1970.

BERTELS 1960 | Bertels, Evgeniy E. *History of Persian and Tajik Literature*. Moscow, 1960.

— 1988 | Bertels, Evgeniy E. 'Struggle of the court poets of Sultan Mahmud against Firdousi.' In *The History of Literature and Culture of Iran: Selected Works*, ed. G. Yu. Aliev and N.I. Prigarina. General editor, V.A. Livshits. Moscow, 1988: pp. 202–7.

BINYON, WILKINSON and GRAY 1933 and 1971 | Binyon, Laurence, J.V.S. Wilkinson and Basil Gray. *Persian Miniature Painting including a critical and descriptive catalogue of the miniatures exhibited at Burlington House, January–March, 1931*. London, 1933. Reprint, New York, NY, 1971.

BLAIR 1995 | Blair, Sheila S. *A Compendium of Chronicles*, The Nasser D. Khalili Collection of Islamic Art, XXVII. London and Oxford, 1995.

BOSWORTH 1998 | Bosworth, C.E. 'Shu'biyya'. In *Encyclopaedia of Arabic Literature*. London, 1998: p. 717.

— 2009 | Bosworth, C.E. 'The persistent older heritage in medieval Iranian lands.' In, *The Rise of Islam: The Idea of Iran*, vol. 4, ed. Vesta Sarkhosh Curtis and Sarah Stewart. London, 2009: pp. 30–43.

BOYLE 1958 | Boyle, J.A., tr. *Genghis Khan. The History of the World-Conqueror by Ata-Malik Juvaini*. 2 vols. Manchester, 1958.

BRAGINSKY 1989 | Braginsky, Iosif. *Abu 'Abdallah Ja' far Rudaki*. Moscow, 1989.

BREND 1980 | Brend, Barbara. 'Rocks in Persian miniature painting'. In *Landscape Style in Asia (Colloquies on Art and Archaeology in Asia no. 9)*. London, 1980: pp. 111–37.

— 1986 | Brend, Barbara. 'The British Library's *Shahnama* of 1438 as a Sultanate manuscript.' In *Facets of Indian Art*, ed. Robert Skelton *et al.*, London, 1986: pp. 87–93.

— 1991 | Brend, Barbara. *Islamic Art*. London, 1991.

— 1999 | Brend, Barbara. 'The Little People: miniature cityscapes and figures in Persian and Ottoman painting', Proceedings of the Third European Conference of Iranian Studies, part 2: *Medieval and Modern Persian Studies*, ed. C. Melville. Wiesbaden, 1999: pp. 367–83.

— 2003 | Brend, Barbara. *Perspectives on Persian Painting: Illustrations to Amīr Khusrau's Khamsah*. London, 2003.

— 2010 | Brend, Barbara. *Muhammad Juki's Shahnamah of Firdausi*. London, 2010.

BROWNE 1896 | Browne, Edward G. *A Catalogue of the Persian Manuscripts in the Library of the University of Cambridge*. Cambridge, 1986.

— 1906 | Browne, Edward G. *A Literary History of Persia, 2*. London, 1906.

BUSSAGLI 1963 | Bussagli, Mario. *Central Asian Painting*. Geneva, 1963.

ÇAĞMAN and TANINDI 1986 | Çağman, Filiz and Zeren Tanındı. *The Topkapı Saray Museum: The Albums and Illustrated Manuscripts*, tr. and ed. J.M. Rogers. London, 1986.

— and TANINDI 2002 | Çağman, Filiz and Zeren Tanındı. 'Manuscript production at the Kāzarūnī Orders in Safavid Shiraz.' In *Safavid Art & Architecture*, ed. Sheila R. Canby. London, 2002: pp. 43–48.

CANBY 1993 | Canby, Sheila R. *Persian Painting*. London, 1993.

— 2009 | Canby, Sheila R. *Shah 'Abbas: The Remaking of Iran*. London, 2009.

CARBONI 2002 | Carboni, Stefano. 'Synthesis: continuity and innovation in Ilkhanid Art.' In *The Legacy of Genghis Khan*, ed. Linda Komaroff and Stefano Carboni. New York, NY, 2002: pp. 197–225.

CHO 2008 | Cho, Min Yong. 'How land came into the picture: rendering history in the fourteenth-century Jami al-tawarikh'. Unpublished D.Phil. dissertation, Ann Arbor, University of Michigan, 2008.

CHRISTIE'S | Auction catalogue of Christie's, London, dated 12.10.76.

CLINTON 1999 | Clinton, Jerome W. 'The uses of guile in the Shāhnāmah.' *Iranian Studies*, 32/2 (1999): 223–30.

DABIRI 2010 | Dabiri, Ghazzal. 'The *Shahnama*: between the Samanids and the Ghaznavids.' *Iranian Studies*, 43/1 (February 2010): 13–28.

DAVIS 1996 | Davis, Dick. 'The problem of Ferdowsî's sources.' *Journal of the American Oriental Society*, 116 (1996): 48–57.

— 1997–2003 | Davis, Dick. *Stories from the Shahnameh of Ferdowsi*. 3 vols., Washington DC, 1997–2003.

— 1999 | Davis, Dick. 'Rustam-e Dastan.' *Iranian Studies*, 32/2 (1999): 231–42.

— 2001 | Davis, Dick. 'Interpolations to the Shahnameh: an introductory typology.' *Persica*, 17 (2001): 35–50.

— 2006 | Davis, Dick. 'The aesthetics of the historical sections of the *Shahnama*.' In *Shahnama Studies*, 1, ed. C. Melville. Cambridge, 2006: pp. 115–24.

— 2007 | Davis, Dick. *Shahnameh: The Persian Book of Kings*. London, 2007.

DE BLOIS 2004 | de Blois, François. *Persian literature: A Bio-Bibliographical Survey*, v: *Poetry of the pre-Mongol period*. London and New York, NY, 2004.

DE BRUIJN [1993] | de Bruijn, Hans. 'A Persian star tile with lustre decoration.' In *Dreaming of Paradise: Islamic Art from the Collection of the Museum of Ethnology, Rotterdam*. Rotterdam, [1993]: pp. 63–5.

DICKSON AND S.C. WELCH 1981 | Dickson, Martin Bernard and Stuart Cary Welch. *The Houghton Shahnameh*. 2 vols. Cambridge, MA and London, 1981.

DIGBY 1979 | Digby, Simon. 'A Shāh-nāma illustrated in a popular Mughal style.' In *The Royal Asiatic Society: Its History and Treasures*, ed. Stuart Simmonds and Simon Digby. Leiden and London, 1979: pp. 111–15.

ENDERWITZ 1997 | Enderwitz, S. 'Shu'ūbiyya', Encyclopedia of Islam, 2nd edn, ix, pp. 513–16.

ETHÉ 1903 | Ethé, Hermann. *Catalogue of Persian Manuscripts in the Library of the India Office*. Oxford, 1903.

ETTINGHAUSEN 1962 | Ettinghausen, Richard. *Arab Painting*. Geneva, 1962.

FARHAD 1990 | Farhad, Massumeh. 'The Art of Mu'in Musavvir: A Mirror of his Times.'
In *Persian Masters: Five Centuries of Painting*. (*Marg*) Bombay, 1990: pp. 113–28.
— 2004 | Farhad, Massumeh. 'Military slaves in the provinces: collecting and shaping the
arts.' In Sussan Babaie *et al.*, *Slaves of the Shah: New Elites of Safavid Iran*. London, 2004:
pp. 114–38.
FARROKHI 1992 | *Divan-e Hakim-e Farrokhi-ye Sistani*, ed. M. Dabir Seyaqi. Tehran,
1371/1992.
FEHÉRVÁRI 1973 | Fehérvári, Géza. *Islamic Pottery: A Comprehensive Study Based on
the Barlow Collection*. London, 1973.
FERDOWSI 1838–42 | Ferdowsi, Abu'l-Qasem. *Shahnameh*, vols. I, II, ed. J. Mohl,
Le Livre des rois. Paris, 1838, 1842.
— 1994 | Ferdowsi, Abu'l-Qasem. *Shahnameh*, tr. [into Russian] C.B. Banu-Lahuti;
commentary A.A. Starikov, vol. II, Moscow, 1994.
— 2008 | Ferdowsi, Abu'l-Qasem. *Shahnameh*, ed. Dj. Khaleghi-Motlagh,
vol. VIII, New York, 2008.

GABBAY 2009 | Gabbay, Alyssa. 'Love gone wrong, then right again: male/female
dynamics in the Bahram Gur-Slave girl story.' *Iranian Studies*, 42/5 (December 2009):
677–92.
GOSWAMY 1988 | Goswamy, B.N. *A Jainesque Sultanate Shahnama and the Context of
pre-Mughal Painting in India*. Zürich, 1988.
GRABAR and BLAIR 1980 | Grabar, Oleg and Sheila Blair. *Epic Images and Contemporary
History: The Illustrations of the Great Mongol Shahnama*. Chicago, Ill. and London, 1980.
GRAY 1961 | Gray, B. *Persian Painting*. Geneva, 1961.
— 1978 | Gray, B. *The World History of Rashid al-Dīn: A Study of the Royal Asiatic Society
Manuscript*. London, 1978.
— *et al.* 1979 | *Arts of the Book in Central Asia*, ed. Basil Gray. London and Paris, 1979.
See also RICE and GRAY
GRUBE 1962 | Grube, Ernst J. *Muslim Miniature Paintings, from the XIII to the XIX Century
from Collections in the United States and Canada*. Venezia, 1962.
— 1968 | Grube, Ernst J. *The Classical Style in Islamic Painting*. [Venice], 1968.
— 1976 | Grube, Ernst J. *Islamic Pottery of the Eighth to the Fifteenth Century in the Keir
Collection*. London, 1976.
— 1994 | Grube, Ernst J. with Manijeh Bayani. *Cobalt and Lustre: The First Centuries
of Islamic Pottery*, The Nasser D. Khalili Collection of Islamic Art, IX. London and
Oxford, 1994.

HALDANE 1978 | Haldane, Duncan. *Mamluk Painting*. Warminster, 1978.
HANAWAY 1988 | Hanaway, William L. 'Epic Poetry.' In *Persian Literature*, ed. Ehsan
Yarshater. Albany, NY, 1988: pp. 96–108.
HAYASHI 2005 | Hayashi, Norihito. 'The Wonders of Creation; A Study of the Late
Fifteenth Century Qazwini in the Collection of the Royal Asiatic Society, London,
Ms. 178'. Unpublished MA dissertation, SOAS. London, 2005.
HILLENBRAND 1977 | Hillenbrand, Robert. *Imperial Images in Persian Painting*.
Edinburgh, 1977.
— 1996 | Hillenbrand, Robert. 'The iconography of the Shah-nama-yi Shahi.' In *Safavid
Persia: The History and Politics of an Islamic Society*, ed. C. Melville. London, 1996:
pp. 53–78.
— 2000 | Hillenbrand, Robert. 'Images of Muhammad in al-Biruni's *Chronology of
Ancient Nations*.' In *Persian Painting From the Mongols to the Qajars: Studies in Honour
of Basil W. Robinson*, ed. Robert Hillenbrand. London and New York, NY, 2000:
pp. 129–46.
— 2002 | Hillenbrand, Robert. 'The arts of the book in Ilkhanid Iran.' In *The Legacy
of Genghis Khan*, ed. Linda Komaroff and Stefano Carboni. New York, NY, 2002:
pp. 134–67.
— 2004 | Hillenbrand, Robert, ed., *Shahnama. The Visual Language of the Persian Book
of Kings*. Aldershot, 2004.
HILLMANN 1990 | Hillmann, Michael C. *Iranian Culture: A Persianist View*. Lanham,
MD, 1990.
HINTZE 1994 | Hintze, Almut. *Zamyād-Yašt: Text, Translation, Glossary*. Wiesbaden, 1994.
— 2009 | Hintze, Almut. 'Avestan literature.' In *The Literature of pre-Islamic Iran*,
ed. Ronald E. Emmerick and Maria Macuch, companion vol. I, to *A History of Persian
Literature*, ed. E. Yarshater. London, 2009: pp. 1–71.
HUMBACH and ICHAPORIA 1998 | Humbach, Helmut and Pallan R. Ichaporia.
Zamyād Yasht, Yasht 19 of the Younger Avesta: Text, Translation, Commentary.
Wiesbaden, 1998.

HUYSE and FOUCHÉCOUR 2006 | Huyse, Philip. 'Pre-Islamic Literature' and
Charles-Henri de Fouchécour, 'Classical Persian Literature.' In *Encyclopaedia Iranica*,
ed.E. Yarshater, XIII, fasc. 4 (*Iran*): *Peoples of Iran – Iran IX. Religions in Iran*. New York,
2006: 410–32.

KADOI 2009 | Kadoi, Yuka. *Islamic Chinoiserie: The Art of Mongol Iran*. Edinburgh, 2009.
KENNEDY 2009 | Kennedy, Hugh. 'Survival of Iranianness.' In *The Rise of Islam,
The Idea of Iran*, vol. 4, ed. Vesta Sarkhosh Curtis and Sarah Stewart. London, 2009:
pp. 13–29.
KHALEGHI-MOTLAGH 1993 | Khaleghi-Motlagh, Djalal. 'Babr-e bayan.' In *Gol-e
ranjha-ye kohan: bar gozideh-ye maqalat dar bareh-ye Shahnameh-ye Ferdowsi*. Tehran,
1372/1993: pp. 275–342.
— 2008 | Khaleghi-Motlagh, Djalal. 'Dastnevis-e now-yafteh az Shahnameh-ye Ferdowsi.'
Nameh-ye Baharestan, 13–14 (2008): 209–78.
KHALILI 2005 | Khalili, Nasser D. *The Timeline of History of Islamic Art and Architecture*.
Worth Press, 2005.
KOMAROFF and CARBONI 2002 | Komaroff, Linda, and Stefano Carboni, eds.
The Legacy of Genghis Khan: Courtly Art and Culture in Western Asia, 1256–1353.
New York, NY, 2002.
KWIATKOWSKI 2005 | Kwiatkowski, Will. *The Eckstein Shahnama: An Ottoman Book
of Kings*. London, 2005.

LAZARD 1964 | Lazard, Gilbert. *Les premiers poètes persans (IX–Xe siècles)*. 2 vols. Tehran
and Paris, 1964.
LEACH 1998 | Leach, Linda York. *Paintings from India*, The Nasser D. Khalili Collection
of Islamic Art, VIII. London and Oxford, 1998.
LEVY 1967 | Levy, R. (tr.) 1967. *The Epic of the Kings: Shahnama the National Epic of Persia*.
London and Boston, MA, 1967.
LOSTY 1982 | Losty, Jeremiah P. *The Art of the Book in India*. London, 1982.
LOWRY 1988 | Lowry, Glenn D. with Susan Nemazee. *The Jeweller's Eye*. Washington, DC,
1988.
— and BEACH 1988 | Lowry, Glenn D. and Milo Cleveland Beach. *An Annotated and
Illustrated Checklist of the Vever Collection*. Washington, DC, 1988.

MADDISON and SAVAGE-SMITH 1997 | Maddison, Francis, E. Savage-Smith *et al.*
Science, Tools and Magic: Part I, Body and Spirit, Mapping the Universe, The Nasser D.
Khalili Collection of Islamic Art, XII. London, 1997.
MARSHAK 2002 | Marshak, Boris. *Legends, Tales, and Fables in the Art of Sogdiana*.
New York, 2002
MASUYA 2002 | Masuya, Tomoko. 'Ilkhanid courtly life.' In *The Legacy of Genghis Khan*,
ed. Linda Komaroff and Stefano Carboni. New York, NY, 2002: pp. 75–103.
MEISAMI 1989 | Meisami, Julie Scott. 'Fitna or Azada? Nizami's ethical poetic.'
Edebiyat, A Journal of Middle Eastern Literatures, 2/1 (1989): 41–75.
— 1999 | Meisami, Julie Scott. *Persian Historiography to the End of the Twelfth Century*.
Edinburgh, 1999.
— 2007 | Meisami, Julie Scott. 'A Life in poetry: Hafiz's first ghazal.' In *The Necklace of
the Pleiades*, ed. F. Lewis and S. Sharma. Amsterdam and West Lafayette, IN: 2007:
pp. 163–81.
MELIKIAN-CHIRVANI 1970 | Melikian-Chirvani, Assadullah Souren. 'Le Roman
de Varqe et Golšâh.' *Arts Asiatiques*, XXII (1970).
— 1982 | Melikian-Chirvani, Assadullah Souren. *Islamic Metalwork from the Iranian
World 8th–18th Centuries*. London, 1982.
— 1984 | Melikian-Chirvani, Assadullah Souren. 'Le *Shāh-nāme*, la gnose soufie et le
pouvoir Mongol.' *Journal Asiatique*, 272 (1984): 249–337.
— 1988 | Melikian-Chirvani, Assadullah Souren. 'Le Livre des Rois, miroir du destin.'
Studia Iranica, 17 (1988): 7–46.
— 1991 | Melikian-Chirvani, Assadullah Souren. 'Le Livre des Rois, miroir du destin: II,
Takht-e Soleyman and la symbolique du *Shāh-nāme*.' *Studia Iranica*, 20 (1991): 33–148.
MELVILLE 1984 | Melville, Charles. 'Meteorological hazards and disasters in Iran.' *Iran*,
22 (1984): 133–50.
— 2002 | Melville, Charles. 'The Mongols in Iran.' In *The Legacy of Genghis Khan*,
ed. Linda Komaroff and Stefano Carboni. New York, NY, 2002: pp. 37–61.
— 2006 (Ibn Husam) | Melville, Charles. 'Ibn Husam's *Hāvarān-nāma* and the *Šāh-nāma*
of Firdausī.' In *Liber Amicorum: Études sur l'Iran mediéval et moderne offertes à Jean
Calmard*, ed. M. Bernardini, M. Haneda and M. Szuppe, *Eurasian Studies*, 5/1–2
(2006): 219–34.

— 2006 (Bizhan) | Melville, Charles. 'Text and image in the story of Bizhan and Manizha: I'. In *Shahnama Studies*, I, ed. C. Melville. Cambridge, 2006: pp. 71–96.

— 2006 (Studies) | Melville, Charles, ed. *Shahnama Studies*, I. Cambridge, 2006.

— 2008 | Melville, Charles. 'Jame' al-tawarik', *Encyclopaedia Iranica*, vol. 14, 2008, pp. 462–8.

— (forthcoming) | Melville, Charles. 'The *Tarikh-i Dilgusha-yi Shamshir Khani* and the reception of the *Shahnama* in India.' In *Shahnama Studies*, II, ed. C. Melville and Gabrielle van den Berg. Leiden, forthcoming/2010.

MEREDITH-OWENS 1965 | Meredith-Owens, G.M. Persian *Illustrated Manuscripts*. London, 1965.

— 1968 | Meredith-Owens, G.M. *Handlist of Persian Manuscripts 1895–1966*. London, 1968.

MINORSKY 1959 | Minorsky, V., trans. *Calligraphers and Painters: a Treatise by Qādī Ahmad, son of Mīr-Munshī (circa A.H. 1015/A.D. 1606)*. Washington, DC, 1959.

— 1964 (Persia) | Minorsky, V. 'Persia: religion and history.' In V. Minorsky, *Iranica: Twenty Articles*. Tehran, 1964: pp. 242–59.

— 1964 (Preface) | Minorsky, V. 'The older preface to the *Shah-nama*.' In V. Minorsky, *Iranica: Twenty articles*. Tehran, 1964: pp. 260–73.

MOOR (forthcoming) | Moor, Bilha. 'Shahnama heroes in *'Aja'ib al-Makhluqat* Illustrated manuscripts.' In *Shahnama Studies*, II, ed. C. Melville and Gabrielle van den Berg. Leiden, forthcoming/2010.

NAFISI 1955 | Nafisi, Sa'id. *Mohit-e zendegi va ahval-o ash'ar-e rudaki*. 3rd edn. Tehran, 1334/1955.

NAYLOR 2004 | Naylor, Rebecca. 'Major General Sir Robert Murdoch Smith.' In *Palace and Mosque: Islamic Art from the Middle East*, ed. Tim Stanley. London, 2004: pp. 136–7.

NORRIS 1990 | Norris, H.T. '*Shu'ūbiyyah* in Arabic Literature.' *In Cambridge History of Arabic Literature: Abbasid Belles-Lettres,* ed. Julia Ashtiany, T.M. Johnstone, J.D. Latham, R.B. Serjeant and G. Rex Smith. Cambridge, 1990: pp. 31–47.

'ONSORI 1964 | *Divan-e 'Onsori-ye Balkhi,* ed. M. Dabir Siyaqi. (2nd edn). Tehran, 1343/1964.

'OWFI, 1903–6 | Mohammad b. Mohammad al-Bukhari al-'Owfi, *Lubab al-Albab,* ed. E.G. Browne and M.M. Qazvini. London and Leiden, 1903–6.

PIEDMONTESE 1980 | Piedmontese, Angelo Michele. 'Nuova luce su Firdawsi: uno Šahnāma' datato 614/1217 a Firenze.' *Annali dell'Istituto Orientale di Napoli,* n.s. 30 (1980): 1–38.

PINDER-WILSON 1957 | Pinder-Wilson, Ralph H. *Islamic Art*. New York, NY, 1957.

PORTER 1995 | Porter, Venetia. *Islamic Tiles*. London, 1995.

POURSHARIATI 2008 | Pourshariati, Parvaneh. *Decline and Fall of the Sasanian Empire: The Sasanian-Parthian Confederacy and the Arab Conquest of Iran*. London, 2008.

QAZVINI 1910 | Qazvini, Hamdallah Mostowfi. *The Tarikh-i Guzida or Select History of Hamdallah Mustawfi Qazwini, Compiled in A.H. 730 (A.D. 1329),* ed. E.G. Browne. London, 1910.

RICE and GRAY 1976 | Rice, David Talbot and Basil Gray. *The Illustrations to the 'World History' of Rashīd al-Dīn*. Edinburgh, 1976.

RICHARD 2001 | Richard, Francis. 'Nasr al-Soltani, Nasir al-Din Mozahheb et la bibliothèque d'Ebrahim Soltan à Širaz.' *Studia Iranica*, 30/1 (2001): 87–104.

RIEU 1881 | Rieu, Charles. *Catalogue of the Persian Manuscripts in the British Museum,* II. London, 1881.

RIEU 1895 | Rieu, Charles. *Supplement to the Catalogue of the Persian Manuscripts in the British Museum*. London, 1895.

RIYAHI 1993 | Riyahi, Mohammad Amin. *Sar-cheshmeh-ha-ye Ferdowsi-shenasi*. Tehran, 1382/1993.

ROBINSON 1951 | Robinson, B.W. 'Unpublished paintings from a xvth Century "Book of Kings."' *Apollo Miscellany* (June 1951): 17–23.

— 1958 | Robinson, B.W. *A Descriptive Catalogue of the Persian Paintings in the Bodleian Library*. Oxford, 1958.

— 1959 | Robinson, B.W. 'The Dunimarle Shāhnāma: a Timurid manuscript from Mazandaran.' *Aus der Welt der islamischen Kunst: Festschrift für Ernst Kühnel*. Berlin, 1959: pp. 207–18.

— 1967 | Robinson, B.W. *Persian Miniature Painting from Collections in the British Isles*. Catalogue, Victoria & Albert Museum, London, 1967.

— 1968 (February) | Robinson, B.W. 'Two manuscripts of the "Shahnama" in the Royal Library, Windsor Castle I: Holmes 150 (A/5).' *Burlington Magazine* (1968): 73–8.

— 1968 (March) | Robinson, B.W. 'Two manuscripts of the "Shahnama" in the Royal Library, Windsor Castle II: Holmes 151 (A/6).' *Burlington Magazine* (1968): 133–8.

— 1970 | Robinson, B.W. 'R.A.S. MS 178: An unrecorded Persian painter.' *Journal of the Royal Asiatic Society* (1970): 203–9.

— 1972 and 1993 | Robinson, B.W. 'The Shahnameh Manuscript Cochran 4 in the Metropolitan Museum of Art.' In *Islamic Art in the Metropolitan Museum*, ed. Richard Ettinghausen. New York, NY, 1972. Reprint, *Studies in Persian Art*, II, no. 73–86 (1993).

— 1976 (Colnaghi) | Robinson, B.W. 'Rothschild and Binney Collections: Persian and Mughal Arts of the Book.' In *Persian and Mughal Art*. P. & D. Colnaghi & Co. Ltd., London, 1976: pp. 11–164.

— 1976 (IOL) | Robinson, B.W. *Persian Paintings in the India Office Library: A Descriptive Catalogue*. London, 1976.

— 1976 (Iran) | Robinson, B.W. 'Isma'il II's copy of the *Shahnama*.' *Iran*, 14 (1976): 1–8.

— 1976 (Keir) | Robinson, B.W. 'Persian and Pre-Mughal Indian painting.' In *The Keir Collection: Islamic Painting and the Arts of the Book*, ed. B.W. Robinson. London, 1976: pp. 129–219.

— 1979 | Robinson, B.W. 'The Shāhnāma of Muhammad Jūkī.' In *The Royal Asiatic Society: its History and Treasures*, ed. Stuart Simmonds and Simon Digby. Leiden and London, 1979: pp. 83–102.

— 1980 | Robinson, B.W. *Persian Paintings in the John Rylands Library: A Descriptive Catalogue*. London, 1980.

— 1988 | Robinson, B.W. 'The Arts of the Book: Persia, Turkey and Pre-Mughal India.' In *The Keir Collection: Islamic Art in the Keir Collection*, ed. B.W. Robinson. London and Boston, 1988.

— 1998 | Robinson, B.W. *Persian Paintings in the Collection of the Royal Asiatic Society*. London, 1998.

— 2001 | Robinson, B.W. ' "A Magnificent MS": The British Library Shahnama of 1486'. *Islamic Art*, 5 (2001): 167–81.

— 2002 | Robinson, B.W. *The Persian Book of Kings: An Epitome of the* Shahnama *of Firdawsi*. London, 2002.

— SIMS and BAYANI 2007 | Robinson, B.W. and Eleanor Sims with Manijeh Bayani. *The Windsor Shahnama of 1648*. London, 2007.

ROGERS 1993 | Rogers, J.M. *Mughal Miniatures*. London, 1993.

— and BEVERIDGE 1909–14 | Jahangir, *Tūzuki-Jahāngīrī, or Memoirs of Jahāngīr*, tr. Alexander Rogers and ed. Henry Beveridge. London, 1909–14.

ROSE 2006 | Rose, Kristine. 'The conservation of Islamic manuscript material at Cambridge University Library, with particular reference Ms. Add. 269.' In *Shahnama Studies*, I, ed. C. Melville. Cambridge, 2006: pp. 277–86.

ROSEN 1895 | Rosen, Victor R. 'On the problem of the Arabic translations of Khuday-name.' In *Vostochnye zametki*. St Petersburg, 1895: pp. 182–3.

ROSSER-OWEN 2006 | Rosser-Owen, Mariam. 'The poetic environment.' In *Palace and Mosque*, ed. Tim Stanley. London, 2006: pp. 77–90.

RÜHRDANZ 1991 | Rührdanz, Karin. 'About a group of truncated *Shāhnāmas*: a case study in the commercial production of illustrated manuscripts in the second part of the sixteenth century.' *Muqarnas*, 14 (1991): 118–34.

SAMARQANDI 1995 | Samarqandi, Nizami 'Arudi. *Chahar Maqaleh*, ed. M. Qazvini. Tehran, 1374/1995.

SCARCE 1976 | Scarce, Jennifer M. 'Ali Mohammed Isfahani, tilemaker of Tehran.' *Oriental Art*, 22/3 (1976): 278–88.

SCHMITZ 1994 | Schmitz, Barbara. 'A fragmentary *Mina'i* with scenes from the *Shahnama*.' In *The Art of the Saljuqs in Iran and Anatolia*, ed. Robert Hillenbrand. Costa Mesa, 1994: pp. 134–45.

SCHROEDER 1942 | Schroeder, Eric. *Persian Miniatures in the Fogg Museum of Art*. Cambridge, MA, 1942.

SEYLLER 1997 | Seyller, John. 'The inspection and valuation of manuscripts in the imperial Mughal library.' *Artibus Asiae*, 57/3–4 (1997): 243–349.

— 1999 | Seyller, John. 'Workshop and patron in Mughal India', *Artibus Asiae, Supplementum*, 42 (1999).

SHAHBAZI 1991 | Shahbazi, A. Shapur. *Ferdowsi: A Critical Biography*. Costa Mesa, 1991.

SHANI 2006 | Shani, Raya. 'Illustrations of the parable of the Ship of Faith in Firdausi's prologue to the *Shahnama*.' In *Shahnama Studies*, I, ed. C. Melville. Cambridge, 2006: pp. 1–39.

SIMPSON 1979 | Simpson, Marianna Shreve. *The Illustration of an Epic: The Earliest Manuscripts*. New York, NY and London, 1979.

— 1981 | Simpson, Marianna Shreve. 'The narrative structure of a medieval Iranian beaker.' *Ars Orientalis*, 12 (1981): 15–24.

— 1985 | Simpson, Marianna Shreve. 'Narrative allusion and metaphor in the decoration of medieval objects.' In *Pictorial Narrative in Antiquity and the Middle Ages*, ed. Marianna S. Simpson and Herbert Kessler, Studies in the History of Art, 16 (1985): 131–49.

— 1997 | Simpson, Marianna Shreve. *Sultan Ibrahim Mirza's Awrang*. Washington, DC. New Haven, CT and London, 1997.

— 2000 | Simpson, Marianna Shreve. 'A reconstruction and preliminary account of the 1341 *Shahnama*: with some further thoughts on early *Shahnama* illustration.' In *Persian Painting: from the Mongols to the Qajars*, ed. Robert Hillenbrand. London and New York, NY, 2000: pp. 217–47.

— 2010 | Simpson, M.S. 'From tourist to pilgrim: Iskandar at the Ka'ba in illustrated Shahnama manuscripts.' *Iranian Studies*, 43 (2010): 127–46.

SIMS 2001 | Sims, Eleanor. 'Towards a monograph on the 17th century Iranian painter Muhammad Zamān ibn Hājjī Yūsuf.' *Islamic Art*, 5 (2001): 183–99.

— 2002 | Sims, Eleanor. *Peerless Images: Persian Painting and its Sources*. New Haven, CT and London, 2002.

— forthcoming | Sims, Eleanor. *Visions of the Past: History and Epic Paintings from Iran and Turkey*. The Nasser D. Khalili Collection of Islamic Art, xxv. London and Oxford, forthcoming.

SKELTON 1994 | Skelton, Robert. 'Iranian artists in the service of Humayun.' In *Humayun's Garden Party*. (Marg) Bombay, 1994: pp. 33–48.

SOROUDI 1969 | Soroudi, Sorour. 'Akhavan's "The ending of the *Shahnameh*": a critique.' *Iranian Studies*, 2/2–3 (1969): pp. 80–96.

SOTHEBY'S | Catalogues of auctions at Sotheby's London, dated respectively 22.4.80, 30.4.92, 16.10.96, 15.19.98, 5.4.06.

SOUDAVAR 1992 | Soudavar, Abolala. *Art of the Persian Courts*. New York, 1992.

— 1996 | Soudavar, Abolala: 'The Saga of Abu-Sa'id Bahādor Khān. The Abu-Sa'idnāmé.' In *The Court of the Il-khans 1290–1340*, ed. Julian Raby and Teresa Fitzherbert. Oxford, 1996: pp. 95–218.

STCHOUKINE 1954 | Stchoukine, Ivan. *Les peintures des manuscrits Timûrides*. Paris, 1954.

— 1959 | Stchoukine, Ivan. *Les peintures des manuscrits Safavis de 1502 à 1587*. Paris, 1959.

— 1964 | Stchoukine, Ivan. *Les peintures des manuscrits de Shāh 'Abbās 1er à la fin des Safavīs*. Paris, 1964.

SWIETOCHOWSKI 1981 | Swietochowski, Marie Lukens, *et al. The Arts of Islam: Masterpieces from The Metropolitan Museum of Art, New York*. Berlin, 1981.

— and CARBONI 1994 | Swietochowski, Marie Lukens and Stefano Carboni with A.H. Morton and Tomoko Masuya. *Illustrated Poetry and Epic Images: Persian Painting of the 1330s and 1340s*. New York, NY, 1994.

TARSUSI 1965 | al-Tarsusi, Abu Taher Mohammad b. Hoseyn b. 'Ali b. Musa. *Darabnameh-ye tarsusi*. ed. Zabih-Allah Safa. Tehran, 1344/1965.

TAVAKOLI-TARGHI 2001 | Tavakoli-Targhi, Mohamad. *Refashioning Iran: Orientalism, Occidentalism, and Historiography*. Houndmills and New York, NY, 2001.

THACKSTON 2001 | Thackston, Wheeler M. *Album Prefaces and Other Documents on the History of Calligraphers and Painters*. Leiden, 2001.

TIGERS ROUND THE THRONE 1990 | *Tigers round the Throne: The Court of Tipu Sultan (1750–1799)* (Zamana Gallery) London, 1990.

TITLEY 1966 | Titley, Norah M. 'A manuscript of the *Garshaspnameh*.' *British Museum Quarterly*, 21/1–2 (1966): 27–32.

— 1977 | Titley, Norah M. *Miniatures from Persia, India and Turkey: A Catalogue and Subject Index of Paintings from Persian, India and Turkey in the British Library and British Museum*. London, 1977.

— 1981 | Titley, Norah M. *Miniatures from Turkish Manuscripts: Catalogue and Subject Index of Paintings in the British Library and the British Museum*. London, 1981.

— 1983 | Titley, Norah M. *Persian Miniature Painting and its Influence on the Art of Turkey and India: The British Library Collections*. London, 1983.

ULUÇ 2006 | Uluç, Lâle. *Turkman Governors, Shiraz Artisans and Ottoman Collectors: Sixteenth Century Shiraz Manuscripts*. Istanbul, 2006.

VAN DEN BERG 2006 | van den Berg, Gabrielle. 'The *Barzunama* in the Berlin *Shahnama* manuscripts.' In *Shahnama Studies*, 1, ed. C. Melville. Cambridge, 2006: pp. 97–114.

— forthcoming/2010 | Melville, Charles and Gabriella van den Berg, eds. *Shahnama Studies*, II. Leiden, forthcoming/2010.

— forthcoming/2010 | van den Berg, Gabrielle. 'The Book of the Black Demon and the black demon in oral tradition.' In *Shahnama Studies*, II, ed. C. Melville and Gabrielle van den Berg. Leiden, forthcoming/2010.

WALEY 1992 and 1994 | Waley, Muhammad Isa. 'Islamic manuscripts in the Royal Collection: a concise catalogue.' *Manuscripts of the Middle East*, (1992): 5–40. Reprint Leiden, 1994.

— and TITLEY 1975 | Waley, P. and Norah M. Titley. 'An illustrated Persian text of Kalila and Dimna dated 707/1307–8.' *The British Library Journal*, I/1 (1975): 42–61.

WARNER and WARNER 1905–25 and 2000 | *The Sháhnáma of Firdausí*, tr. Arthur George Warner and Edmond Warner. London, 1905–25. Reprint London and New York, NY, 2000.

WATT 2002 | Watt, James C.Y. 'A note on artistic exchanges in the Mongol Empire.' In *The Legacy of Genghis Khan*, ed. Linda Komaroff and Stefano Carboni. New York, NY, 2002: pp. 62–73.

A. WELCH 1976 | Welch, A. *Artists for the Shah: Late Sixteenth-Century Painting at the Imperial Court of Iran*. New Haven, CT and London, 1976.

— 1985 | Welch, A. 'The World History of Rashid al-Din.' In *Treasures of Islam* (Musée d'art et d'histoire). Geneva, 1985: pp. 48–52.

S.C. WELCH 1972 | Welch, Stuart Cary. *A King's Book of Kings*. New York, NY, 1972.

— 1978 | Welch, Stuart Cary. *Imperial Mughal Painting*. London, 1978.

— 1985 | Welch, Stuart Cary. *India: Art and Culture 1300–1900*. New York, NY, 1985.

— *et al.* 1987 | Welch, Stuart Cary *et al. The Emperor's Album: Images of Mughal India*. New York, NY, 1987.

See also DICKSON and WELCH 1981

WILKINSON and BINYON 1931 | Wilkinson, J.V.S. and Laurence Binyon. *The Shāh-Nāmah of Firdausī*. London, 1931.

WORMALD and GILES 1982 | Wormald, Francis and Phyllis M. Giles, eds. *A Descriptive Catalogue of the Additional Illuminated Manuscripts in the Fitzwilliam Museum Acquired between 1895 and 1979*. Cambridge and New York, NY, 1982.

WRIGHT 2004 | Wright, Elaine. 'Firdausi and More: a Timurid anthology of epic tales.' In *Shahnama: The Visual Language of the Persian Book of Kings*, ed. R. Hillenbrand. Aldershot, 2004: pp. 65–84.

YARSHATER 1983 (World-view) | Yarshater, Ehsan. 'Iranian common beliefs and world-view.' In *The Cambridge History of Iran*, vol. III/1, ed. Ehsan Yarshater. Cambridge, 1983: pp. 343–58.

— 1983 (National History) | Yarshater, Ehsan. 'Iranian National History.' In *The Cambridge History of Iran*, vol. III/1, ed. Ehsan Yarshater. Cambridge, 1983: pp. 359–477.

— 2009 | Yarshater, Ehsan. 'Re-emergence of Iranian identity after conversion to Islam.' In *The Rise of Islam: The Idea of Iran*, vol. IV, ed. Vesta Sarkhosh Curtis and Sarah Stewart. London, 2009: pp. 5–12.

ZHUKOVSKIY 1892 | Zhukovskiy, Valentin A. 'Firdousi's tomb. [Notes] on the trip to Khorasan in Summer 1890.' *Zapiski Vostochnogo Otdeleniya Rossiyskogo Arheologicheskogo Obschestva*, 4 (1892): 308–14.

INDEX

'Abd al-Rahman al-Khwarazmi 66
Adineh Kateb Samarqandi 248, 249
Ahmad b. Hasan b. Ahmad Kateb 251
'Alijan b. Heydarqoli al-Haravi 249
'Emad al-Din al-Hoseyni 182
Fath-Allah b. Ahmad Sabzavari 63, 249
Feyz b. Mohammad Shirazi 248
Ghiyas al-Din b. Bayezid *sarraf* 64, 249
Hajji Mohammad b. Nur al-Din
 Mohammad Dasht-e Bayazi 193, 248
Hasan b. Mohammad Ahsan 57, 249
Hasan b. Mohammad
 b. 'Ali Hoseyni al-Mowsili 98
Hedayat-Allah al-Shirazi 187, 249
Heydar Mohammad Tabrizi 249
Khalil-Allah 'Haft Qalami' 231, 249
Mahmud 128
Mohammad b. Mohammad *baqqal* 157
Mohammad Hakim al-Hoseyni 207
Mohammad al-Halva'i 248
Mohammad Mo'men b. Kamal al-Din
 249
Mohyi (Haravi) 176
Na'im al-Din al-kateb al-Shirazi 158
Naser al-Kateb 248
Nezam b. Mir 'Ali 194, 249
Pir Hoseyn Kateb 251
Qotb al-Din b. Hasan al-Tuni 173–4
Salek b. Sa'id 161–3
Sarmast Khan 235–7
Shehab-e Kateb 222, 250
Soltan 'Ali 155
Soltan Hoseyn b. Soltan 'Ali 155, 159
Yusof b. Mahmud Shah b. Yusof 250
calligraphy xiii, 173
Caspian provinces 11
 see also Mazandaran
Central Asia *see* Transoxiana
Ceramics
 32, 78, 79, 80, 82, 85, 94, 118, 211, 213
Chaghatay Khanate 13
Chahar Maqaleh of Nezami 'Aruzi 19
Chakdar jameh 225, 247
Chalderan 171
chess 10
Chin, China, Chinese
 12, 85, 86, 87, 92, 95, 97, 103, 109, 118,
 122, 136, 141, 145, 170, 173, 187, 203,
 213, 235
Cyrus the Great 6, 23, 29

Dante vi, 23
Daqiqi (poet) 6, 17, 18–19, 255 n.10
Dara (Darius, Achaemenid emperor)
 6, 29, 242
Darabnameh Abu Taher al-Tarsusi
 53, 218, 242
Darkness, Land of 96, 159, 243
Dastan 27
 see also Zal
Deccan 38, 215, 250
dehqan (minor landowner) 11, 17
Delhi 238
Demotte, Georges 33
Dhu'l-Qarnayn (Alexander) 96

divs (demons)
 3, 4, 53, 120, 136, 145, 178, 232, 247
dragons 3, 33, 110, 151, 174, 218

East India Company 61, 188
Eblis (Devil) 63, 126, 242
Ebrahim (Abraham) 74
Elyas (Prophet) 159
Esfahan xv, 34, 47, 190, 193, 194, 196, 198,
 201–3, 249, 250
Esfandiyar 26, 28, 78, 87, 118, 153, 155, 188,
 204, 222, 231, 242, 245
Eskandar (Alexander the Great)
 4, 6, 29, 74, 96, 120, 159, 207, 242, 245
Esma'il I (Safavid shah) 38, 171
Esma'il II (Safavid shah) 42, 47, 180

Faramarz (son of Rostam) 22, 26
Faranak 84
Farangis (mother of Key Khosrow)
 211, 246
Fariborz 161, 243
Faridun 6, 20, 28, 32, 64, 66, 82, 84, 89,
 125, 222, 237, 243, 246
Farshidvard 163, 243, 244
farr (royal charisma) 3, 5, 15, 122, 247
Farrokhi (poet) 20, 131
Fath-'Ali Khan Saba (poet) 22
Fath-'Ali Shah (Qajar shah) 22, 209
Fathpur Sikri 218
Ferdowsi, Abu'l-Qasem
 vi, ix, 4, 10–11, 17–18, 20, 29, 57, 79,
 131 *and passim*
Filaqus (Philip) 74, 242, 243
Firuzshah 22
Forud (son of Siyavosh)
 27, 32, 142, 180, 243, 246
Fur (Porus) of Hind 242

Gang Dezh (castle) 187, 209
Garshaspnameh of Asadi Tusi
 22, 33, 182, 248
Garsivaz (brother of Afrasiyab)
 71, 211, 222, 243, 244, 246
Genghis Khan 12
Ghazan Khan (Il-Khan) 13
Gilgamesh (epic) 27
Giv (son of Gudarz)
 7, 180, 213, 222, 243, 244
Gog and Magog 120
Gordiyeh (sister of Bahram Chubineh) 30
Gorgsar 87
Goruy 211
Goshtasp
 6, 19, 26, 28, 29, 118, 151, 178, 242, 245
Gostaham 163, 243
Gudarz 7, 86, 149, 151, 213, 222, 243
Gulbarga 38, 248
Gurang 235

Haft Owrang of Jami 176
Haftvad 158, 243